DATE DUE

DEMCO 38-296

CHRISTO

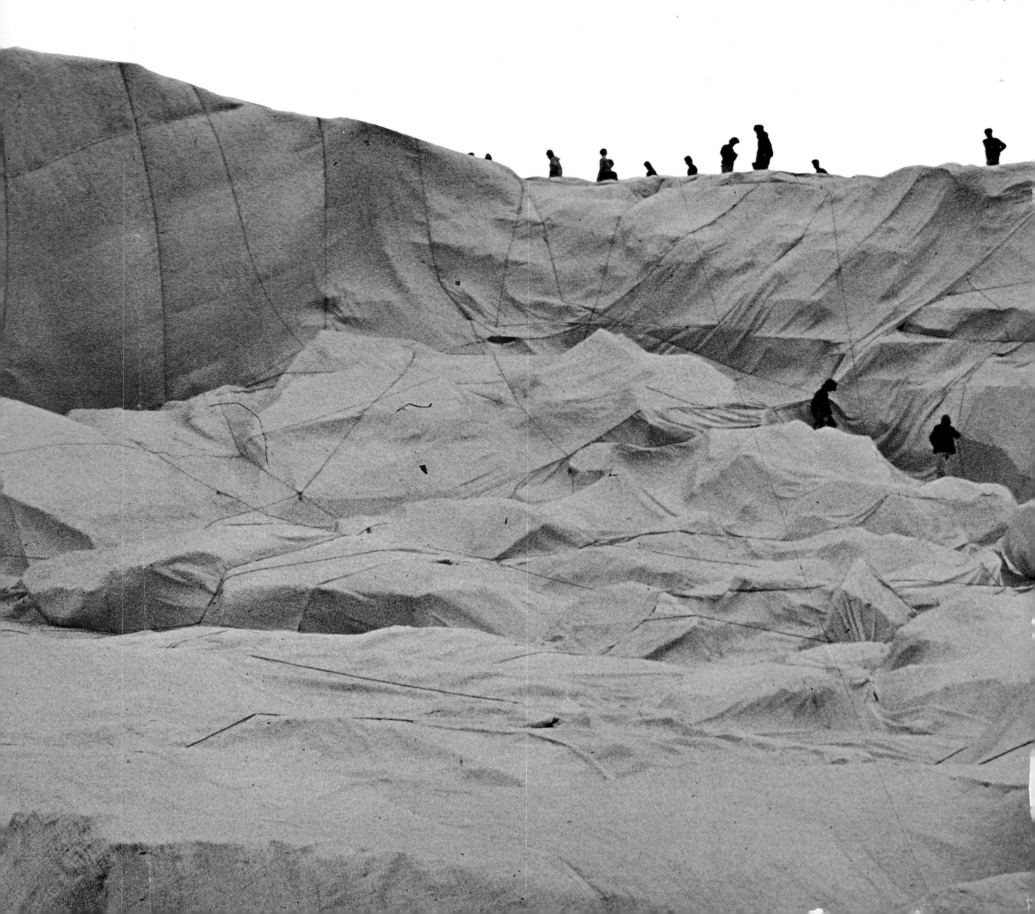
TEXT BY DAVID BOURDON

CHRISTO

HARRY N. ABRAMS, INC., PUBLISHERS, NEW YORK

First of all, I would like to thank Sam Hunter and Milton S. Fox, whose idea it was that I should write this book. I also wish to thank Nai Y. Chang for his excellent advice and assistance in the layout and production of the book, and Margaret Kaplan and Suzanne Levitt, who scrupulously edited the text and elicited more sense than was originally to be found there. I am grateful to many individuals and institutions for providing information and photographs, and most particularly to Shunk-Kender, who photographed many works especially for this volume. My research was greatly facilitated by the artist's wife, Jeanne-Claude Christo, who spent innumerable hours and exhibited extraordinary patience in locating uncatalogued material, checking translations, and verifying all sorts of geographical, technical, and financial data. Most of all, I wish to thank Christo for his unstinting cooperation and the infectious zeal he brought to the project.

D. B.

1. *Wrapped Coast.* 1969 *(frontispiece)*

Standard Book Number: 8109-0051-3
Library of Congress Catalogue Card Number: 70-165543
HARRY N. ABRAMS, INCORPORATED, NEW YORK
Printed and bound in Japan

CONTENTS

TEXT FIGURES

LIST OF PLATES

PACKAGING: revelation through concealment

With ordinary fabric and cord, Christo has wrapped an imposing bundle of work and secured for himself a prominent position in mid-century art. He has packaged everything from tin cans to entire buildings. In his mile-long stretch of wrapped seacoast in Australia, he has provided one of the eeriest visual spectacles of our time. It has been an extraordinary and fascinating career—especially for a Bulgarian refugee who, within the space of a few years, has become an international art celebrity.

In all of his packages, he transforms familiar objects into ambivalent presences, sometimes rendering them unrecognizable and often raising doubts about their past, present, and future identity and function. In his more epic endeavors, he questions the relationship of art to both the urban and natural environments. In a materialistic age, his art is a profound comment on the chronic expectations and frustrations aroused by the increasing number of consumer products and services that are "enhanced" through packaging. No other artist so fully illuminates the twentieth century's preoccupation with packaging.

Christo's art suggests the latent functions and mysteries of all packages. Wrapping plays on basic fears and desires; even if we know for a certainty the identity of the contents, the sight of a shroud or bundle is enough to elicit a nagging doubt about the exact purpose of the wrapping. We tend to regard wrapped objects as either lifeless or, at best, dormant. A wrapped object is removed from use, but this does not preclude a future existence and consequently our expectations are aroused.

Packaging can connote gifts, death, preservation, and eros, but it almost always implies value—that the object is *worthy* of such attention. But while packaging suggests worth, it also reduces everything to the level of object: the contained object is a physical thing before it is anything else. As a result, we are confronted by an isolated thing that, by virtue of its being wrapped, is given more value than it might merit in its unwrapped state. A gift-wrapped object is guaranteed to elicit curiosity, the promise of a surprise withheld. Concealment also implies preservation and, in some cases, suppression and censorship. Egyptian mummies tell us that packaging is related to death and the preservation of matter for the afterlife. The erotic aspect of packaging has been with us at least as long as the striptease. Clothing-as-packaging touches most of us every day. And at nightfall, most of us get into cars or subways (transportation packages) to go to our homes (architectural packages).

Christo does not deny these aspects or overtones of packaging, but he does not encourage them either. If there is any one meaning to his packages, it remains obscure and elusive.

Much of the fascination of Christo's work resides in the strength of the idea. You do not have to see a packaged beach or building to experience some of its potential effect. The idea alone is enough to jar the imagination by disturbing our familiar concepts of space,

time, and the use of the environment. Yet for Christo, the idea is all but worthless unless it can be physically realized, fleshed out in an aesthetically pleasing form. An idea alone may be provocative, but if realized it becomes endowed with unexpected visual and tactile nuances, providing a physical as well as a mental experience.

It may seem that Christo's idea is extremely limited. Once you have absorbed the idea of a wrapped object being presented as art, it does not make much difference, conceptually, whether you are wrapping a bottle or a beach. But Christo has developed this single idea with extraordinary persistence, pursuing its implications both formally and conceptually, thereby demonstrating that a single formal device is capable of surprising variations, ranging from small domestic objects that we probably expect to see packaged to such awesome extremes as large buildings and huge tracts of land. While many of his art packages are generically alike, they touch on a wide range of situations and experiences—from household objects removed from use, to blockaded city streets, to ecologic partitions of natural terrain.

It is easy to assess an artist's originality in terms of verifiable forms and ideas (beauty and quality, the two things that art critics most like to write about, are more difficult to measure by objective standards). But any questions we might have about formal and conceptual innovation recede when we are actually confronted—and sometimes enveloped—by the sheer size of Christo's more epic works. So physical and immediate, yet strange and remote, they grasp the spectator on a more fundamental, almost physiological level.

Since his first project for a packed building in 1961, scale has been a prevailing element in Christo's work, often indicating that more of something is better—that is, quantity is tantamount to quality. The more recent works of such colossal scale, achieved with an air of grandiosity and a flair for extravaganzas, are in some ways comparable to the Hollywood film spectacles of Cecil B. De Mille: they required huge expenditures of material, money, and labor, with as much showmanship going into the production as into the product. Christo's most spectacular achievements—the architectural and terrestrial packages—rival, if only temporarily, the architectural follies that sprouted in England and France during the seventeenth century. Carrying irony and dark humor to absurd extremes, Christo imbues his ephemeral monuments with more than a trace of imperious grandeur.

The success of Christo's work is dependent upon the fine line he maintains between literalism and metamorphosis, two of the predominant themes threaded through twentieth-century art. Literalism, the creation or replication of specific objects, is a chief characteristic of the 1960s. It is central to all the major styles of the period—Pop (literal blowups of cartoon strips and advertising art), Minimal (specific, nonallusive objects, usually in the form of preconceived, severely reductive geometric shapes), and Color Painting (clearly defined bands and fields of color). Metamorphosis thrived in an earlier period and is ubiquitous in Cubism and Surrealism with such formal alterations as occur in Picasso's flattened, planar arrangements of objects seen simultaneously from different vantage points, as well as in the more realistically rendered but dislocated images of Magritte. Most sculpture of most periods can be considered metamorphic, because it is made of one

material representing another. This is as true of a Renaissance bronze representing a human figure as it is of an Oldenburg cloth sculpture representing a hamburger. Even when real objects of the everyday world are used, they are usually given a new function. When Picasso took a bicycle seat and handlebars and joined them together to make his famous *Bull's Head,* he was making an ingenious metamorphosis—converting commonplace materials into a typically Picassoid image.

In Christo's art, materials have the same reality they have in everyday life. A packaged chair, for instance, is literal to the core—it consists of a real chair shrouded in real polyethylene. What is disturbing is that the packages confront us as *almost* ordinary objects of the real world. In one sense, there is nothing abstract in Christo's art: materials are used in a completely materialistic way, retaining their normal identity and function. They are never used abstractly for formalist effects. Rauschenberg, for example, may preserve the identity of his unorthodox materials (a tire, pillow, or stuffed chicken) but then proceed to subvert their original function by employing them in a relatively formalist way, affixing a stuffed bird or pillow to a painted canvas because it provides a more attractive or provocative juxtaposition. There is much less artifice in Christo's work: if he wraps a package in plastic and twine, it is not because he wants to be decorative or shocking, but because real packages are often wrapped the same way.

Christo, however, does seem to conceive of wrapping as an act that falls just short of transformation. On the one hand, the packages are exactly like actual objects: they occupy their normal space, in contrast to the ideal, virtual space occupied by any figurative sculpture that is not the same size as it is in real life and that, in addition, may occupy a niche or be otherwise "distanced." On the other hand, Christo does aesthetically "distance" his objects by wrapping them and making them seem more remote and inaccessible. By obscuring their identity, he effects a partial transformation in which mundane materials retain the same identity while assuming a new meaning. Two of Christo's chief commentators have coped with this meta-metamorphosis. According to Jan van der Marck: "He refuses transformation beyond recognition just as he refuses re-contextualization beyond question."[1] And Lawrence Alloway refers to a "double focus," in which "the identity of the internal, supporting objects was withheld rather than obliterated," because the artist wants to combine "an untransformed object with a new object, the work of art."[2] In obscuring the object's substance and denying its function, Christo makes his packages self-contradictions, caught between the literal and the metamorphic. Encased in a chrysalis, the objects are metaphysically in transit.

Packaging is a particularly appropriate subject for twentieth-century art. Although the technology of packaging benefited by many innovations in the nineteenth century (metal cans were patented in 1810, and folding cartons were invented in 1879), the packaging we take for granted today scarcely existed before 1900. It was not until this century that efficient storage and handling and informative labeling became important attributes of packaging. The three basic services that packaging performs for the consumer—pre-unitizing, protection, and communication—have attained such a level of sophistication

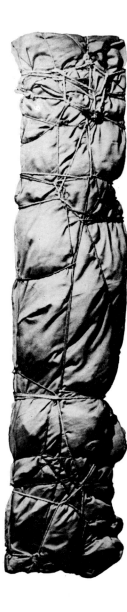

I

that the wrapping, as we are so frequently reminded, is what makes us buy the contents. The package has become the product. According to a report issued by the industrial research firm of Arthur D. Little, Inc.: "No highly industrialized urban society can now exist effectively without sophisticated packages for all types of products."[3]

Increasingly, all kinds of services and goods are presented to us in "package" form. Packaging has come to mean not only the containment and storage of consumer goods, but also the collective presentation and transfer of diverse services and information: there are "financial packages" in banking and all-inclusive "insurance packages." The term "package deal" has entered Webster's Third New International Dictionary, where it is defined as "**1**: an offer or agreement involving a number of related items or one making acceptance of one item dependent on the acceptance of another; **2**: the items offered." (Still another kind of package was brought to my attention when signing the contract to write this book. Following a description of how authors must assemble and submit captions and photographs, the Harry N. Abrams, Inc. contract says: "We look for a complete 'package,' ready in all respects for editing [and] layout.")

As sophisticated packaging is a relatively recent phenomenon, it is not surprising that it seldom appears in art until well into the twentieth century. One of the earliest examples of a package being the prime subject of a work of art is John Haberle's *Torn in Transit* (figure 2), probably painted in New Haven, Connecticut, in the last decade of the nineteenth century. Haberle, one of America's leading *trompe-l'oeil* painters, depicted a wrapped parcel that has been "torn," revealing a painted landscape inside. The paper, cord, and labels have all been meticulously painted in Haberle's own realistic style, while the landscape, which probably derives from a contemporary print, is rendered in a Hudson River School-type style that is certainly *not* Haberle's. In a way, then, the landscape portion is more "fraudulent" than the literal depictions of paper and cord.

Another art package that merits our consideration is Man Ray's *The Enigma of Isidore Ducasse* of 1920 (figure 3), an assemblage of cloth and rope over a sewing machine. This object, which is no longer extant, provided the subject for one of Man Ray's most intriguing photographs. (Man Ray seems rather nonchalant about the physical existence of his assembled objects. Stressing the primacy of idea over form, he is capable of letting the original object vanish, then reconstructing it when the occasion demands.) *The Enigma of Isidore Ducasse* is a literary allusion to the nineteenth-century poet, better known by his pseudonym, the Comte de Lautréamont (1846–1870), who was elevated by the Surrealists to the position of a patron saint fifty years after his death. Man Ray had been introduced to Lautréamont's obscure work by his first wife in Ridgefield, New Jersey, in 1913—two years before Man Ray took up photography and eight years before he settled in Paris, where he became celebrated as America's foremost Dadaist. *The Enigma* was made in New York, undoubtedly under the stimulus of his friend Duchamp, who had been making "ready-made" objects for several years.

Man Ray's shrouded sewing machine is an homage to Lautréamont's famous metaphor of the umbrella encountering a sewing machine on a dissecting table. Thus, while the

Figure 1. CHRISTO. *Package.* 1959. Fabric and string, 28×7×7 in. Collection Mr. and Mrs. Philippe Durand-Ruel, Paris

Figure 2. JOHN HABERLE. *Torn in Transit.* Undated (1890s?). Oil on canvas, 13×17 in. Collection Amanda K. Berls, Amagansett, New York

Figure 3. MAN RAY. *The Enigma of Isidore Ducasse.* 1920. Cloth and rope over sewing machine. No longer extant

Figure 4. HENRY MOORE. *Crowd Looking at Tied-Up Object.* 1942. Pen, chalk, wash, and watercolor, 17×22 in. Collection Lord Clark of Saltwood

Figure 5. ANDY WARHOL. *Brillo Box.* 1964. Silkscreen enamel on wooden box, 17×17×14 in. Collection the artist

2

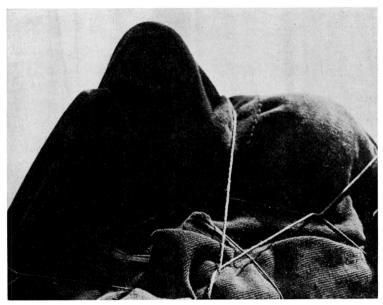

3

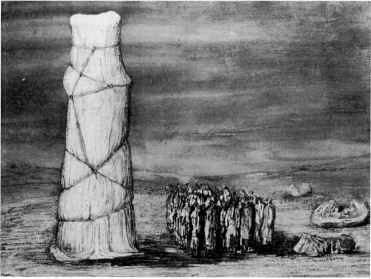

4

Although Christo is the artist most firmly identified with packaging, others have occasionally dealt with this subject in a variety of ways— as form, image, or procedure. One of the most deceptive images is John Haberle's painting of a landscape, ostensibly "packaged" with painted paper, labels, and string to simulate a wrapped canvas which has met with rough handling in parcel post. Years later, in 1920, Man Ray wrapped a real sewing machine in sackcloth, tied it with cord, and photographed it to make a symbolic allusion to the Comte de Lautréamont, the nineteenth-century hero of the Surrealists. Henry Moore, in a watercolor of 1942, most closely anticipated the appearance and effect of a monumental Christo wrapping: he depicted a shrouded totem that attracts a throng of awed spectators. In the early 1960s, consumer packaging became a major motif for the Pop artists, who transliterated commercial design and brand-name labeling in a spirit and style antithetical to Christo's. In Andy Warhol's facsimile cartons, the emphasis is entirely on surface rather than contents.

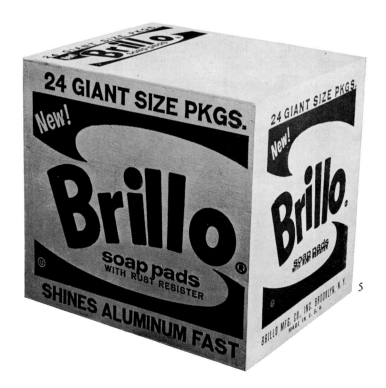

5

contents of Man Ray's package are physically real, the real content is symbolic. Because it anticipates the appearance, if not the intent, of a Christo sculpture, Man Ray's work assumes an added dimension of meaning. In Man Ray's photograph, the shrouded object is isolated against a white ground, cropped at bottom and on the right side, providing few clues to indicate scale, which could be either minute or mountainous. The wheel of the sewing machine creates a hulking peak in the upper left of the picture. The irregular contours of the close-fitting fabric and the crisscrossed cords have a striking relationship to Christo's art. But despite the visual similarity, Man Ray's package sets out to be deliberately mysterious, while Christo's packages are intended to be not so much mysterious as disquieting.

Perhaps the chief mystery is why none of the Dadaists or Surrealists, including Man Ray, pursued the implications of packaging, a subject that lends itself to all sorts of formal and psychological twists. Man Ray himself never developed the idea of wrapping as a sculptural form and *The Enigma* remains unique in his oeuvre. *The Enigma* was reconstructed as a sculptural object in 1967 at the request of The Museum of Modern Art in New York, and exhibited there the following year in the huge show of Dada and Surrealist art. The somewhat lumpier reconstruction is now in the study collection of The Museum of Modern Art.

Henry Moore came close to predicting both the appearance and the effect of a Christo sculpture in a 1942 watercolor, *Crowd Looking at Tied-Up Object* (figure 4), which depicts a throng of people staring expectantly at a large, packaged object. Equally mysterious as the wrapped object is the curious grouping of the spectators, clustered together in the object's shadow, as if in awestruck observance of some arcane ritual.

Packaging became a major motif for the Pop artists of the sixties. Recognizing that "lowly" advertising art could be a subject for "high" fine art, Pop artists cast a cool, discerning eye at industrial packaging and, ignoring the contents, concentrated on the container's sleek surface—the commercial designs, brand names, and advertising slogans, which they either rendered as literally as possible or appropriated wholesale. The archetypal Pop packages are Andy Warhol's Brillo boxes (figure 5) and other brand-name cartons, which at first do not appear to be sculpture at all. Actually, Warhol's Brillo boxes are silk-screened plywood sculptures masquerading as lowly cardboard grocery cartons.

Christo's lumpy bundles are, of course, the antithesis of streamlined industrial packaging, which is designed to be attractive, informative, and easily stored. Christo's packages are improvised rather than designed, obscure rather than informative, and handmade rather than mass-produced (figure 1). They bear a closer resemblance to the clumsy, makeshift bundles hurriedly packed by an impoverished homemaker or shopkeeper with whatever materials are at hand. The wrapping materials are usually of a homely nature (ordinary cloth or plastic) and the contents are, more often than not, on the cheap side (a common kitchen chair, rather than a costly Mies van der Rohe Barcelona chair).

Christo seems to have hit upon the idea of wrapping not through any preconception about how his art should look, but rather through the more arduous process of making

sculpture out of common found materials. He wrapped his first objects in Paris in 1958 as part of a sprawling, room-sized work that he called *Inventory* (plate 5). As the title implies, this was a warehouse-like array of wrapped, painted, or unaltered glass bottles, tin cans, steel oil drums, and wooden boxes, most of which were mixed and stacked in a random way. It is significant that the bottles, cans, boxes, and barrels have one thing in common: all are containers to begin with.

Inventory, which may be considered the first of Christo's transient environments, is no longer extant, but a fragment of it survives in the form of *Packed Bottles and Cans* (plate 2). This modest work consists of a grouping of bottles of pigment and paint cans, about half of which are wrapped in canvas and cord and treated with lacquer and sand to provide a slightly pebbled surface. The wrapped cans and bottles are mixed and contrasted with unaltered containers—a couple of bottles half-filled with colored pigment and a few cans, the sides of which are overrun with lacquer. In packaging conventional art materials, Christo may have intended an ironic comment on the future of painting. But the chief interest of this germinal work today is that it so clearly predicts almost all of Christo's future interests. It forecasts not only the larger packages on an urban scale, such as the Museum of Contemporary Art in Chicago, but also the enormous mounds of stacked barrels, such as the *1,240 Oil Drums* in Philadelphia.

Christo seldom wraps an object as compactly and neatly as possible. More often, there are untidy folds and bulges that result in irregular contours, making the packages distinctly expressionistic around the edges. Like a couturier, Christo drapes the fabric directly upon the object, fashioning baroque swags and bulges, before snaring the object in obsessively knotted twine. The surface is richly articulated with many diagonal folds, so that even an essentially flat-surfaced object, such as a painting, becomes full of volumetric detail and acquires an angular, asymmetric silhouette. The wrapping material functions as a kind of skin, emphasizing the object's physical extremities by cloaking the crevices and depressions. The wrapping alters the contours of the contained object which, in turn, gives shape to the outer skin. No matter how thoroughly disguised, the physical reality of the contained object continues to make its presence felt from within, the indwelling form activating the constricting surface.

We might ask whether such a simple operation leaves any room for stylistic expression or is even capable of any style at all. Apparently not for Jan van der Marck, who writes: "There are no formal relationships apparent in a Christo package. It is a single image, perceived at a glance and experienced as a whole, a 'Gestalt.' Our associations are based on the subject and the context of the package, not on its form. . . . If form is an incidental or secondary consideration to Christo's concept of creation, then there can be neither stylistic nor structural development in his wrappings. Instead, because Christo expresses style more through gesture than form, development occurs on the level of an increasingly compelling, articulate and grandiose application of his basic concept to a broadening range of subjects."[4] This denial of formal style in Christo's work is underscored by Van der Marck's insistence upon seeing the packages as "chance wrappings."[5] A "chance wrapping" implies the artist

has little or no control over his medium and, while this may sound as risky and exciting as a fun-filled Happening, it is far from the truth. Wrapping a package affords precious few happy "accidents," and "chance" is a peculiar word to apply to an artist who has wrapped hundreds of objects over a ten-year period, most of which have turned out to be recognizably "Christo packages."

Christo's packages give several indications of a strong, personal style. Anyone else would probably be more methodical in tying the cords, giving them a certain regularity. Christo's cords, which appear tied in haste, crisscross erratically in angular directions, as if the resisting object had become ensnared in its own noose. There are more knots than would seem absolutely necessary, while the cords are usually too lightweight in proportion to the mass they encompass, but they compensate for this by their superabundance. The eccentrically looped knots with short ends have an unmistakable autograph quality and are as recognizable as the artist's signature.

In the earliest packages, Christo treated the fabric with lacquer and sand to make granular and tonal variations in the surface texture, possibly in the belief that the fabric had to be made more artistic. In Paris, he had become familiar with the work of Dubuffet, whom he admired for his use of found materials. He was particularly impressed by the three-dimensional surface of the Dubuffet paintings in which sand, mica flakes, and other unorthodox materials had been embedded in the paint to yield a pebbled texture. He was also intrigued by the paintings of Fautrier with their heavily encrusted surfaces of powdery pigment. Textural paint surfaces, though used to superb effect by Dubuffet and Fautrier, tended to become a decadent device in the hands of their followers. Though briefly seduced by the textural rage that swept Europe in the late fifties, Christo soon recognized its tendency toward mere decoration and began using his wrapping materials straight.

Having wrapped his first packages with cloth, Christo later sheathed his objects in polyethylene, a translucent plastic that permits the object to be perceived nude, so to speak, in soft focus through the veiling. More recently, Christo has used rubberized tarpaulin in solid colors (dull greens, beige, and orange). In his quest for particular surface textures and particular degrees of opacity and transparency, Christo has necessarily employed a variety of wrapping materials, always choosing whichever material strikes him as appropriate. It is the same with the cords, which may be anything from simple twine to white silk ropes to steel cable.

Like those artists who tend to simplify their work over the years, Christo has found increasingly economical ways to package. To see this transition, we need only compare the expressionistic, swagged drapery of the *Packed Motorcycle* (plates 68–69), so reminiscent of the Hellenistic sculpture of the *Nike of Samothrace* ("Winged Victory") because of its heroic posture, seemingly "frozen" at the height of action, to the thoroughly mundane *Brown Paper Package* (plate 214), an anonymous-looking bundle of ordinary wrapping paper and tape. Some of the early packages have almost violent, expressionistic overtones, with exposed table or chair legs protruding from the wrapped portions (plates 21–22), as if they

had burst through. But even the simplest of Christo's packages have an expressionistic quality that sets them apart from minimalizing purist art.

Although Christo has packaged a great variety of objects, certain types seem to predominate. Among the recognizable categories: containers (bottles, cans, barrels, boxes); furniture (tables, chairs, beds); mechanical equipment (cameras, telephones, adding machines, television sets); organic matter (trees, hay, wool, straw, nude girls); and vehicles. Most of the objects seem to be chosen for their anonymous appearance. They are products without any outstanding features, which represent generalized classes of things and are nearly always without labels, tags, stamps, or signs to denote anything particularly individual.

Among the objects that can be categorized, the most common are those associated with motion and travel: automobiles, motorcycles, bicycles, wheelbarrows, dollies, shopping carts, prams and strollers, traffic signals and lights, and luggage racks. Obviously, there is something perverse about a packaged vehicle to which locomotion has been denied, a flagrant case of utilitarian objects robbed of their usefulness. The vehicular nature reinforces our suspicion that the objects are indeed en route, somehow in transit between everyday reality and Christo's reality. Normally, vehicles are packaged for protection during transport. Christo's packages are vehicles for aesthetic transport.

Beginning in 1962, Christo made several works consisting of packages mounted upon luggage racks. The contents of the packages vary considerably, from the relatively exotic mandolin and rolled Oriental rugs (plate 51), to the relatively commonplace tea kettle (plate 52), stroller and mattress (plate 56), or bicycle (plate 65), to the completely obscure (plate 55). Some of the luggage racks are intended to hang on the wall, becoming essentially pictorial with the objects protruding from a surrogate picture plane (plates 51, 55). Whether hung on the wall or laid on the floor, all of the luggage racks are basically pictorial, being planar backdrops for the protruding packages, which function as a furtive kind of bas-relief. The wall-hung luggage racks contribute to a jarring spatial dislocation, because they are presented in a vertical rather than the customary horizontal position, a change of axis that corresponds to Rauschenberg's wall-hanging *Bed* (collaged with real pillow and quilt) and certain ready-mades of Duchamp, who customarily altered the aspect of his found objects by turning them upside down. But the floor-lying luggage racks (plates 52, 56) are more subtle; they call less attention to themselves as art.

Because much of Christo's sculpture is planar, it relates almost as much to painting as it does to sculpture. Painterly concerns seem to have a persistent importance in Christo's work, possibly because he began his career as a Socialist Realist painter. Over the years, he has intermittently pursued two approaches to the pictorial. The first and more intriguing approach to the pictorial is the transfer of painterly qualities to sculpture. This applies to most of the packages and particularly to the series of luggage racks which, being oriented to the walls, are essentially planar reliefs.

The second approach to the pictorial appears in his use of paintings as subject matter—

portraits and canvases that he either veils in translucent polyethylene or shrouds in opaque fabric. For some of his pictures, such as the *Wrapped Portrait—Holly* (plate 131), he paints the portrait himself in a Palm Beach-type impressionism and then veils it in see-through plastic so that tantalizing glimpses of it remain. In his *Wrapped Portrait—Horace* (plate 132), he is even more mischievous: he rolls up the canvas he has painted and makes it a columnar and distinctly sculptural object. The *Wrapped Portrait—Ray* (plates 133–34) is more ambivalent, consisting of unfinished sketches that may be draped or revealed, according to the spectator's wish. The most interesting of the wrapped paintings are totally shrouded, either individually draped or bundled together in lumpy packages with irregular contours (plates 207–10). Wrapping a painting is, obviously, a perverse denial of one of the principal reasons a painting is made—to be seen. But many a canvas that may go unnoticed in an unwrapped state elicits our curiosity as soon as it is concealed. And when Christo packages one, he strips it of any special status, converting an art object into a mere object of no more aesthetic significance than a baby carriage, an adding machine, or an armchair.

Because packages convey so much secrecy, it is only natural to inquire why Christo should choose to express himself through the act of concealment. For a show at Galleria Apollinaire in Milan in 1963, Christo issued a flyer combining photos of his own work with advertising copy from various packaging companies, using the "found texts" almost as captions: "Last year the average American used a record 210 pounds of paper packaging.... Packaging often ranks next to product in influence upon a buyer.... Why not let our packaging people help you?" Christo is clearly aware of the multibillion-dollar packaging industry. Unfortunately, those "found texts" are the closest thing to a statement of intent that Christo has ever made. The artist not only declines to elucidate his work, he no longer gives even hints in "found texts."

NOUVEAU REALISME: what a Balkan realist found in Paris

The artist was born as Christo Javacheff on June 13, 1935, in Gabrovo, an industrial city in the Balkan mountains of Bulgaria. The Javacheffs were a prominent family with connections in political, scientific, and artistic circles. On the paternal side, Christo's great-grandfather was a Ukrainian administrator who settled in Bulgaria in the 1870s. Christo's grandfather was an archaeologist and a member of the Sofia Academy of Science, and the artist's father became a prosperous manufacturer of chemical products. Christo's mother came from a political family in Macedonia. Her father had been executed by the Greeks, and she herself narrowly escaped death in 1913, when she fled to Sofia at the age of seven. As a young lady in Sofia, she worked as executive secretary at the Sofia Fine Arts Academy and was active in political and artistic circles until her marriage in 1931.

Until 1940, Christo's parents seemed to be constantly traveling, spending only four or five months of the year at home. During their absence, the children were supervised by a governess. (Christo is the middle of three sons: the oldest is now an actor, and the youngest is a chemist.) Their style of life was abruptly changed by World War II and the German occupation of Bulgaria. When the schools were closed in 1943, the Javacheff family retired to an isolated country house in the Balkans, playing host to a constant stream of artist and architect friends who came to stay for a few weeks at a time. The area harbored many members of the Bulgarian resistance movement and consequently attracted the attention of a great many German soldiers. The Bulgarian police, who busied themselves by searching homes for contraband literature, seized Mrs. Javacheff's collection of Russian books and graphics and carted them away for burning. As a child, Christo witnessed aerial bombardment, came across the corpses of partisans in the streets, watched the German army cross Bulgaria into Russia, and finally saw the Russian army enter Bulgaria in 1944. During the period of postwar reconstruction, his father's chemical business was nationalized.

Although the forties had been a time of war with two invading armies, Christo recalls the fifties as a time of "frenzy and upheaval." Following the death of Stalin in 1952, "everything slowed down and decadence set in," Christo recalled. "Art had never been mentioned before," he adds, "but now it was suddenly prized and everything that had gone before was temporary and without value."

Between 1952 and 1956, Christo studied painting, sculpture, and theatrical stage design at the Fine Arts Academy in Sofia. Art instruction followed a political ideology, dictated by Soviet art educators, and students were encouraged to pursue a Socialist Realist style, specializing in factory scenes and portraits of workers and peasants. (The Bulgarian regime, always very close ideologically to the Soviet Union, waged an official campaign against Western influences in the arts and "revisionist" nationalism as recently as 1969.)

As a member of the Union of Communist Youth (a prerequisite to educational and career advancement), Christo became an active participant in "agit-prop," an artistic form of agitation-propaganda that had been popularized by politically radical Russian artists around 1920. He helped design propagandizing billboards and painted quotations from Stalin and Lenin on the sides of buildings and cliffs. Occasionally, he spent entire weeks traveling in a bus with ten to fifteen other students, executing preplanned "agit-prop" works near various villages and industrial factories. Because the Orient Express was the only train that traversed Bulgaria, the area around the tracks had to be made attractive enough to impress European passengers traveling between Paris and Istanbul. Christo and his co-workers told the peasants how to stack and cover their hay, and discouraged factory workers from leaving unsightly industrial wastes within view of the train.

In 1956, Christo journeyed to Prague to study theater direction with Emile Burian, an avant-garde director who let him help design sets for plays by Mayakovsky. Through Burian, Christo was enabled to visit the basement of the art museum as well as private art collections, where he made his first acquaintance with actual works by Matisse, Miró, Klee, and Kandinsky. But three months after his arrival, the Hungarian uprising sparked new

Christo's earliest work was made and shown in the context of New Realism, the most innovative school of art to emerge in France in the late 1950s. Partially inspired by the Dada-Surrealist tradition, the New Realists sought to inject a more immediate reality into their art through the appropriation (and accumulation) of ready-made images and ordinary objects drawn from the urban environment, sometimes reflecting a concern for an industrial, commodity-oriented society. The intellectual stimulus for the group was provided by Yves Klein, best known for the monochrome canvases that he speedily produced with ordinary paint rollers, some of which ended up as a sculptural by-product in the assemblage shown here. The artist who best exemplifies the New Realist style is Arman, whose accumulations of identical or similar objects in glass-faced boxes suggest a sort of wholesale expressionism. Daniel Spoerri, an artist with a culinary flair, frequently invited guests to dinner, then embalmed the remains of the meal with epoxy, fixing the individual place settings in their "chance" arrangements, and thereby making a sort of gastronomic profile of the diner.

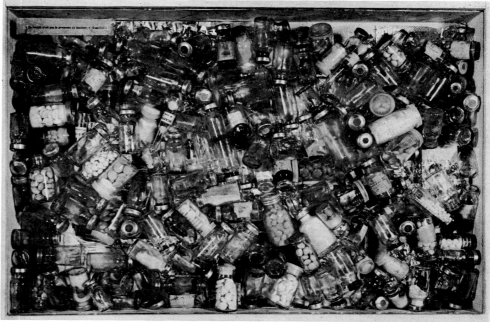

6

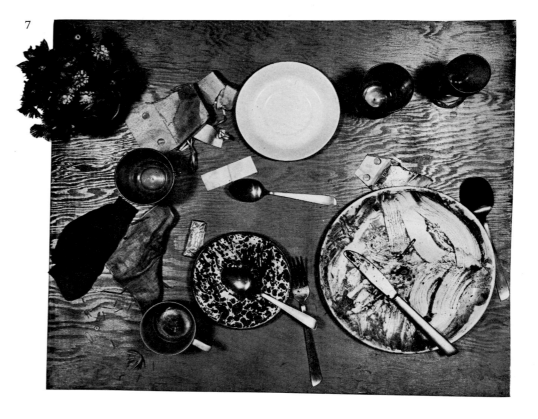

7

Figure 6. ARMAN. *La beauté n'est que la promesse du bonheur—Stendhal (Beauty Is Only the Promise of Happiness—Stendhal)*. 1960. Assemblage of pharmaceutical bottles, pills, and metal foil, $15\frac{3}{4} \times 23\frac{3}{4} \times 3\frac{1}{4}$ in. Collection Philip Johnson, New Canaan, Connecticut

Figure 7. DANIEL SPOERRI. *Variations on a Meal—Alison Knowles*. 1964. Plates, flatware, glasses, cup, napkins, artificial flowers, and paper on plywood, $24 \times 36 \times 8$ in. Collection Letty Lou Eisenhauer, New York City

Figure 8. YVES KLEIN. *Assemblage de rouleaux à peindre usagés (Assemblage of Used Paint Rollers)*. 1962 reconstruction of 1956 object. Six paint rollers on a pierced metal plate, $10 \times 11 \times 9\frac{3}{4}$ in. Collection Mrs. Yves Klein, Paris

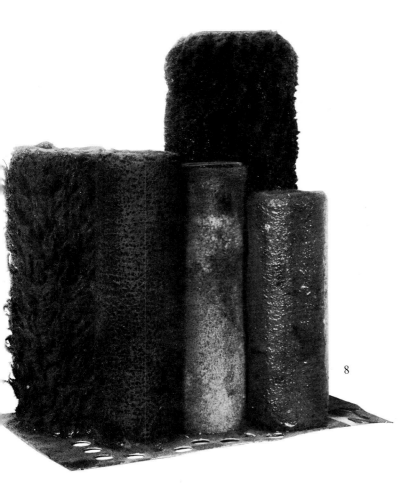

8

uncertainties, and Christo decided to flee to the West. Arriving in Vienna, he enrolled at the Fine Arts Academy where he spent a glum, dissatisfied semester studying sculpture with Fritz Wotruba, whose teaching left no apparent impact. Christo then moved on to Geneva, where he stayed with a cousin and managed to make a living by painting portraits, which he did in a flattering, impressionist-type style. After five months in Geneva, he decided he might as well storm the art capital of Europe.

Christo arrived in Paris in March, 1958. In November of that year, he met the French art critic Pierre Restany, who was to become the influential spokesman for a school of art called *Nouveau Réalisme,* or New Realism, which corresponds in certain ways with American and British Pop art. The following year he met and befriended Arman and Daniel Spoerri, who were to become two of the leading *Nouveaux Réalistes*. It was within this intellectual context that Christo began to make his first packages, wrapped barrels, and boxed constructions that comprised his *Inventory* of 1958–60.

Nouveau Réalisme, the only art movement of international significance to emerge in France during the late fifties, sought to revitalize the languishing School of Paris through the use of commercial images and consumer goods drawn from the immediate environment and reflecting the influence of an urban, highly materialistic society. According to Pierre Restany, the *Nouveaux Réalistes* were dealing with "contemporary nature," which was "mechanical, industrial and flooded with advertisements."[6] Their realism was *nouveau* insofar as the artists dealt with the corporeal reality of actual objects, making *presentations* of things rather than *representations* of them on canvas or in bronze. Consequently, the *Nouveaux Réalistes* appropriated pianos, leftover meals on dinner trays, and motorized equipment into their three-dimensional, and sometimes environmental, constructions.

When *Nouveau Réalisme* was officially formed in October, 1960, the founding members were, among others, Yves Klein, Jean Tinguely, Martial Raysse, Arman, and Spoerri. Christo was not invited to join the ranks until a much later date, and his subsequent involvement was marginal and brief. According to Restany, the *Nouveaux Réalistes* were convened around the personality and work of Yves Klein (figure 8), the charismatic artist who painted monochrome canvases and practiced judo and alchemy. Although Klein unquestionably provided much of the intellectual stimulus for the group, his work bears little formal resemblance to that of the other *Nouveaux Réalistes*. As a style, *Nouveau Réalisme* is best exemplified in the work of Spoerri and Arman (figures 6–7), particularly the latter.

What Christo had in common with Arman and Spoerri was the conversion of found objects into a new kind of *nature morte,* or still life. All three were concerned with arresting time by preserving objects in random arrangements, either by "freezing" them in plastic, embalming them with glue, or shrouding them in canvas.

Spoerri, whose approach to art is so intensely cerebral that he often appears totally indifferent to its visual form, was then involved in the production of "snare-pictures," which he described as "objects found in chance positions, in order or disorder (on tables,

in boxes, drawers, etc.) . . . fixed ('snared') as they are. Only the plane is changed: since the result is called a picture, what was horizontal becomes vertical. Example: remains of a meal are fixed to the table at which the meal was consumed, and the table hung on the wall."[7] (His preoccupation with the circumstances surrounding the chance arrangement of objects on a table resulted in a fascinating book, a nonfiction *nouveau roman* titled *An Anecdoted Topography of Chance*.)[8]

Arman's first important pieces, made in 1959, are the containers of trash that he called *poubelles*, which precede the more familiar, glass-faced boxes containing accumulations of faucets, dolls' hands, bottle caps, or swords, or other groups of identical or similar objects. Arman's boxes clearly showcase the contents while Christo's wrappings conceal the contents, but, because both artists employed a similar formal device of the contained and the container, they were frequently linked. (In fact, Restany sought to dissuade Christo from making packages, apparently in the belief that packaging was a domain already appropriated by Arman and that Christo's wrapping robbed reality of the purity it enjoyed with Arman.)

Christo's work may indeed have appeared too similar to Arman's in the beginning, but a widening gulf separates them today. Arman showed an early tendency to settle complacently into a fixed mode, and his subsequent work became consistently more assured as it became more predictable. Unfortunately for him, the box format was not in itself fresh, falling well within accepted art conventions as indicated by Joseph Cornell (figure 11) and Louise Nevelson. Although, as Restany maintains, "the accumulation of *x* objects of the same nature suggests something *more* and something *other* than the single object considered in isolation,"[9] Arman has not yet succeeded in pushing the idea of accumulation to any interesting limit or extreme. Over the years, his work has become increasingly thin and decorative, undeveloped in conception, and stultified by the necessarily small scale.

The wrapping of objects, an equally limited idea, proved to be more profound, richer in psychological overtones, and capable of greater conceptual and formal elaboration. Wrapping can be as organic as skin, capable of stretching to any size in any direction, so Christo was able to augment his scale to create packages of architectural and landscape proportions. Given Christo's ingenuity, the limited idea of packaging turned out to be surprisingly versatile and adaptable. It is Christo's manipulations of quantity—and more important, *scale*—that secure his reputation.

OIL DRUMS: street blockades and "temporary monuments"

In 1959, Christo began working with oil drums, because they were the largest containers he could find that were both unbreakable and cheap. Since then, he has stacked numerous barrel structures, sometimes with the intent to create massive, freestanding forms, and

sometimes with the intent to create environmental obstructions. At the beginning, Christo was living on the Ile Saint-Louis and doing most of his work in a tiny studio, a former maid's room, on Rue de Saint-Sénoch. Buying used oil drums from drum yards, he carried the dirty barrels one by one to his seventh-floor studio. There, he cleaned and wrapped them, then carried them down seven flights and over to Avenue Raymond-Poincaré, where he stored them in a cellar that had been put at his disposal. Over the months, the cellar accumulated stacks of wrapped and unwrapped barrels, plywood boxes, and packed bottles, becoming the environmental collection of containers that Christo called *Inventory* (plate 5). His laborious journeys across Paris must have looked especially furtive on the days he walked out with wrapped chairs (plate 19), stolen from his "stingy" landlord on the Ile Saint-Louis, and a wrapped wooden table (plate 21), stolen from the maid's room. Later, when he had to vacate part of the cellar, he moved everything to a garage in Gentilly that he rented for storage and working space. When he was unable to pay rent for the garage, he was forced to abandon the work that was stored there, and much of it was subsequently destroyed.

In conjunction with his first one-man show in 1961 at the Haro Lauhus Gallery in Cologne, Christo exhibited his first outdoor barrel structures. The gallery was very near the Cologne waterfront where Christo sighted several stacks of oil drums, cardboard barrels, and paper rolls. Viewing them as familiar art materials, he instantly recognized their sculptural possibilities and set about "borrowing" them. Rearranging the piles of cardboard barrels and rolls of paper, he proceeded to shroud them in tarpaulin, which he secured with cord (plates 9, 11–12). The tarpaulin, which served to protect the paper and cardboard against exposure, was borrowed from the dockworkers, who received a generous tip from the artist for their cooperation and patience.

The large assemblages of oil drums that he erected along the Cologne waterfront (plates 10, 13) were hardly distinguishable from the ordinary stockpiles that are ubiquitous harborside presences. Because of the visual similarity to longshoremen's work, it almost appeared that the artist had merely photographed "found" stockpiles. But this was not the case. All had been composed, rearranged, or at least altered by the artist, who, in order to manipulate these bulky materials, utilized a number of construction machines, including tractors, hoists, and cranes. The structures were an early indication of Christo's predilection for creating sculptures that almost pass for ordinary phenomena that one scarcely notices in everyday life. Christo prefers his work to be disturbingly ambiguous, never announcing itself too blatantly as art and thereby causing the spectator to do a double take.

The existence of the Cologne barrel structures was necessarily brief, because they were comprised of borrowed materials and occupied valuable commercial space. The question of permanence was far less important to Christo than the brief realization, and so he designated them "temporary monuments."

In format, the oil drums were stacked in orderly, symmetrical, and obviously man-made piles, suggesting mastabas, pyramids, and the earliest forms of anonymous architecture. For the visually acute, there were telltale signs that an artist had been at work. In one of the

Cologne structures (plate 13), a single barrel turned sideways functions as a grace note in an otherwise serial composition. This kind of compositional accent is more obvious in smaller works, such as the *56 Barrels* (plate 196), in which only the top barrel is turned sideways. Another telling characteristic in the early barrel structures are the "frayed" edges; the articulation along the top and sides is deliberately uneven. The expressionistic hangover of misaligned and artfully askew barrels is completely absent in the recent barrel structures. The biggest barrel structure to date, the *1,240 Oil Drums* (plates 197–200), shown at the Institute of Contemporary Art in Philadelphia, was a meticulously aligned, room-sized mastaba.

Many of Christo's barrel projects, however huge, are not environmental: they do not modify or alter the surroundings, but remain discrete masses in the landscape. The most provocative barrel structures are the environmental ones that do alter a preexisting situation.

Christo's first barrel environment was the wall of 204 oil drums, which he called *le rideau de fer* or "iron curtain," that he erected in the Rue Visconti on Paris's Left Bank in 1962 (plate 28). On this street, which dates back to the sixteenth century, nearly every address can boast of illustrious former tenants, such as Racine, Adrienne Lecouvreur, Delacroix, and Balzac. Christo chose Rue Visconti not because it is so rich in historic lore, but because it is one of the narrowest streets in Paris. It is a one-way street, as well as a principal cross-street between two main arteries to the Right Bank. Consequently, for two hours on the evening of June 27, the blockade, which was nearly fourteen feet high, thoroughly obstructed all traffic not only in the Rue Visconti, but in several surrounding streets as well.

The wall of barrels was similar to the packages, which rob objects of their usefulness—it denied and canceled out the utilitarian function of the street. The "iron curtain" was also a comment on the Berlin Wall, which had been constructed in August, 1961. Because of their standardized shape and serial arrangement, the stacked barrels focused attention on the often chance harmonies of rust, paint, and metal. By leaving the brand names visible, he blocked any symbolic interpretations and reinforced their literalist use. Christo did not alter the color of the barrels (each oil company uses a different color), so the overall structure had a dappled surface, almost like a hugely enlarged detail from a Pointillist painting. As serial compositions, the barrel structures have a striking correspondence to the orderly arrangement of regular units so prevalent in Minimal sculpture of the sixties, particularly in the work of Don Judd and Carl Andre.

Christo wanted to create a similar obstruction for New York's Museum of Modern Art in the summer of 1968. To mark the closing of the Dada-Surrealism show on the evening of June 9, he proposed erecting a wall of 441 barrels that would have blockaded West Fifty-third Street (plate 140). However, city agencies refused to cooperate, and so the wall was never built. The artist's unsuccessful skirmishes with various branches of city government raise an important question about a political-artistic conflict. When Christo blockades a street—or crams so many barrels into a room that spectators can barely circulate, as was the case with the *1,240 Oil Drums* (plates 197–200) in Philadelphia—the effect is not only

aggressively antisocial, but also physically menacing, because of the sheer weight involved and the possibility of a "barrel slide." Realizing the danger involved, it is easy to understand why city authorities would veto such a project. Yet if the city had granted permission, it would have denied the piece of its capacity for social disruption and turned the temporary street blockade into an art-for-art's-sake event. Perhaps the point of Christo's blockades is not to interrupt the function of streets, but rather to question the identity and function of government agencies. If the city vetoes such a project, it appears hostile to art. And if it approves, it appears mindless and irresponsible.

William S. Rubin, the Museum of Modern Art's distinguished curator of painting and sculpture, has described Christo as "an artist functioning more in the realm of 'events' than in that of painting and sculpture."[10] The fact that many of Christo's "temporary monuments" are short-lived might qualify them as "events." But the main focus of Christo's activity is always on the end result rather than on the process, and while the manifestation may be brief enough to qualify as an "event," it is by no means a Happening.

To confound matters, Allan Kaprow, one of the pioneers of Happenings, dedicated a Happening to Christo in 1968. In Kaprow's piece, titled *Transfer,* a team of participants loaded metal barrels onto trucks, transported them to another site, unloaded and stacked the barrels, sprayed them a different color, posed with the stacked barrels for a "triumphal photo," then loaded them back onto the trucks for delivery to another site. The group made eight such deliveries over a period of three days, during which the stacked barrels were sprayed silver, white, black, Day-Glow red, Day-Glow green, silver, white, and black. Though inspired by Christo's barrel structures, Kaprow's Happening stressed the activity and changes that occurred, making the loading, trucking, and spraying equally important to the periodically stacked barrels.

Christo, who has performed in two of Kaprow's Happenings, draws an important distinction between himself and Happeners. "All Happenings are make-believe situations," he says. "Everything in my work is very strongly literal. If three hundred people are used, it is not because we want three hundred people to play roles, but because we have work for them. When we go to work, there is a tense feeling, not a relaxed, joyous feeling as in a Kaprow Happening. If we use cranes, it's to do real work, and the crane man must be conscientious or it will not work. My work may look very theatrical, but it is a very professional activity."

STORE FRONTS: architectural wrappings without the contents

In 1964, Christo initiated a series of sculptures in the shape of store fronts, facsimiles of commercial store fronts that were made in the same size and same materials as their prototypes. While real buildings may be considered packages for people, Christo's store fronts are like architectural wrappings without the contents.

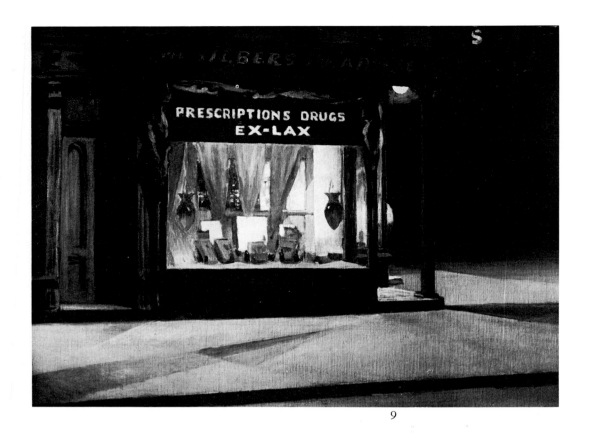

Store fronts and architectural facades have played numerous roles in art, but few are as enigmatic as Christo's facsimile sculptures of store fronts. In their stark frontality and anonymous physicality, Christo's store fronts evoke some of the bleak mood of Edward Hopper's paintings of desolate store fronts along untrafficked streets. Because Christo's store fronts are exterior facades made for interior display, they parallel the Surrealist spatial dislocations of Magritte, who depicted an entire building facade inside a room, possibly "mirroring" the view seen through the open window. Christo's draped windows, which hint at inaccessible recesses and infinite privacy, have an affinity to the boxes of Joseph Cornell, who created a microcosmic realm in a glass-faced box by encasing a "castle" facade (cut out of an antique engraving) in which the windows are blanked out with mirrors, so the peering spectator catches glimpses only of his own reflection. George Segal, in some ways as literal a sculptor as Christo, constructed an actual-sized fragment of a store front to provide an environmental setting with psychological overtones for one of his figured tableaux.

9

10 11

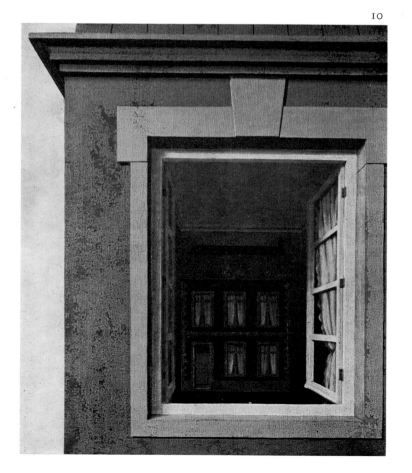

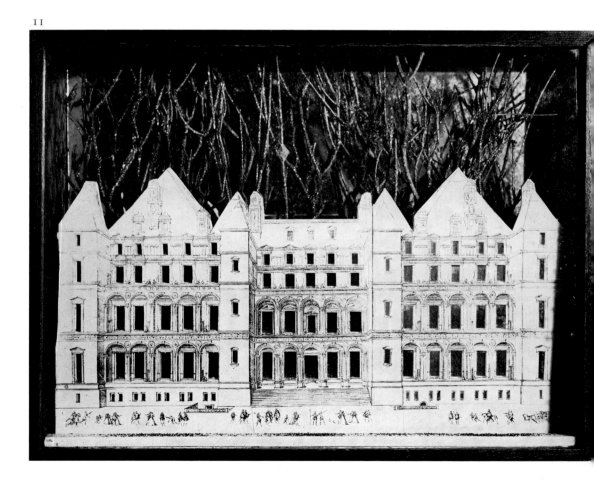

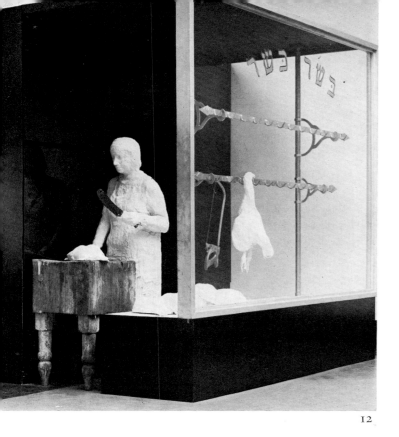

12

Figure 9. EDWARD HOPPER. *Drug Store.* 1927. Oil on canvas, 29×40 in. Museum of Fine Arts, Boston. Bequest of John T. Spaulding

Figure 10. RENÉ MAGRITTE. *L'Eloge de la dialectique (In Praise of Dialectic).* 1937. Oil on canvas, 26×21 in. Private collection, London

Figure 11. JOSEPH CORNELL. *Rose Castle.* 1945. Antique engraving, twigs, mirror, and tinsel in wooden box, $11\frac{1}{2}×14\frac{7}{8}×4$ in. Whitney Museum of American Art, New York City. Bequest of Kay Sage Tanguy

Figure 12. GEORGE SEGAL. *The Butcher Shop.* 1965. Plaster, wood, vinyl, metal, and Plexiglas, $94×99\frac{1}{4}×48$ in., height of figure 62 in. Art Gallery of Ontario. Gift from the Women's Committee Fund, 1966

Like facades on a movie set, the store-front sculptures have real architectural scale without being real buildings. The perversity of having an architectural exterior displayed indoors is compounded by the enigmatically draped windows. In a Magritte painting of 1937, *In Praise of Dialectic* (figure 10), we look into a room through an open window and see the facade of a two-story house against the opposite wall. It is a perplexing turnabout view because we ought to be seeing the house, from inside the room, across the street where it belongs. As with Christo's store fronts, there is a disorienting reversal of expected views by the intrusion of a facade indoors. Magritte's Surrealistic image is an intellectual fantasy that stirs our imagination. Christo's store-front constructions are relatively devoid of intellectual overtones, yet so physically literal as to border on the hallucinatory.

The store fronts developed out of a group of closed showcases that the artist produced in 1963. These consist of real glass vitrines, bought new or picked up secondhand, to which the artist added neon or electric light, before covering the inside of the glass with paper. Most of them are plain, rectangular glass cabinets of the sort ordinarily used to display goods in a store. They differ from the previous packages in that Christo is now packaging interior space, as if to shield it from the viewer. The wrapping paper obscures all of the glass except for a bare strip along the upper and lower edges, so that the spectator is allowed only a teasing glimpse of the interior. By covering the inside of the glass with paper, Christo conceals the interior but, having installed an interior light, he also calls attention to the denied function of display. Two of the showcases are lined at the bottom with satin (plates 72–73), as if to cushion fragile objects, while the windows are faced with ordinary brown wrapping paper. There is a more compelling juxtaposition in the combination of glass and paper, the opacity of the inner material emphasizing the transparency of the outer material.

The showcases mark a decisive shift in Christo's development. They led to the store fronts and architectural scale, freeing him from dependency on preexistent objects and enabling him to package invented shapes and empty spaces of any size he wanted.

Christo began making full-scale store fronts almost simultaneously in three different places. Having moved to New York at the end of February, 1964, he began work on a store front; on a return visit to Paris in June, he began a second; and that summer he made a third in Toulouse. All were carefully prepared for in a number of sketches and working plans, as they were designed to break down into five or six parts for shipping. For the Paris store front (plate 74), Christo assembled portions of old wood and cast-off pieces of actual buildings and reassembled them to make an individual, freestanding store front. The New York store front (plate 75) is constructed of new lumber, a new door, and an old door handle stolen from the Chelsea Hotel, where the artist lived while making the piece. It also boasts a wrapped (but fake) air conditioner over the door, inspired by the covered air conditioners that Christo saw for the first time all around New York when he arrived in the winter. Later he made the orange and yellow store fronts (plates 80–81), both constructed expediently from old molding, panels, and doors which Christo, scavenging at night, salvaged from Lower Manhattan buildings in the process of being razed.

Though the earliest store fronts were made in different parts of the world, there is little to distinguish them from each other or from any real shops that exist in out-of-the-way areas in almost any part of the world. They are so generalized as to be universal—a kind of "everystore." There are no goods or activities to be glimpsed through the un-draped margins of the windows. And there are no signs, emblems, or addresses (except for a portion of an address in a project for a double store front, plate 76) to particularize their location or function.

The early store fronts are pleasantly archaic in appearance and feeling, partly because they are assembled of found materials, and partly because they were deliberately designed to resemble old shops. Their mood is elegiac, suggesting a more prosperous past, when the shops might have been newly bright and more busily trafficked. Now they are freshly painted in warm, high-key colors, in much the same way that any modest shopkeeper might refurbish an old-fashioned store front in a seedy part of town. The mood is reminiscent of certain paintings by Edward Hopper, particularly the row of desolate store fronts shown in the raking sunlight of an early Sunday morning and the nighttime views of shops and restaurants illuminated by the harsh glare of electric light (figure 9). Hopper rendered architecture in broad, simplified planes and he defined a mood through the depiction of light to such an extent that it is often maintained that his real subject matter was light.

Like Hopper, Christo distills specifics to arrive at a generalization, creating a mood of detachment, loneliness, and vacancy. His stark store fronts also create a feeling of alienation. Christo explicitly directs our attention to the concealed interior space, which is brightly illuminated, then denies us any further information or entry. Because the door and window will never open, the facades are actually and symbolically impenetrable. Within these solid-looking facades, the illuminated show windows become isolated and significant voids—zones of unspecified activity or use. Voids and solids, transparency and opacity—all exist with equal importance.

Yet the veiled windows attract the most attention. Throughout the ages, windows have held a special fascination for painters, because they provide spatial and temporal cross-references between indoor and outdoor settings and activities. In addition to contributing formal complexity, windows have a psychological quality that invites symbolic use. But from Jan van Eyck's Romanesque arches, which overlook the detailed microcosm of a distant landscape, to Hopper's bleak hotel and tenement rooms, which stare out upon desolate vistas, most interpretations of windows have centered around looking out upon the world or looking in upon private life. Christo makes the window itself the focus of interest.

Although doors can admit symbolic interpretation, Christo's locked entrances remind us that we are shut out on *our* side of his store fronts. This is contrary to the sensibility of the Surrealists, who often depicted doors as thresholds to the unknown, inviting our wildest speculation. Christo's doors are adamantly closed, especially when compared to

the wide-open thresholds conceived by Marcel Duchamp, whose most celebrated entrance is *11 Rue Larrey*—a sort of Janus-faced door hung in a corner between two entrance ways, alternately closing off two rooms and demonstrating that a door can be simultaneously open and shut. By the 1960s, real doors had become almost ubiquitous in Pop and environmental assemblages. Doors are a recurrent image in the sculptural tableaux of George Segal, who repeatedly places his plaster-cast figures near naturalistic thresholds, leaning against tenement doorways, peering from behind partially opened doors, waiting for elevator doors to open, emerging through the doors of a bus. One of the most intriguing things about Segal's *The Butcher Shop* (figure 12) is the artist's ability to suggest a doorway, even though the stylized store front lacks one.

Christo's store fronts underwent a "modernization" in 1964–65, as he updated them to a "streamlined" style more characteristic of the forties. The chief work in this mode, the *Four Store Fronts* (plates 100–103), was constructed entirely of new materials and made copious use of galvanized metal, marbleized Formica, lacquered Masonite, and colored Plexiglas. The asymmetric rectangles of blue, red, and yellow on the exterior are undoubtedly inspired by contemporary American store fronts, which in turn derive from Mondrian and principles of De Stijl architecture. In exchanging banal, turn-of-the-century designs for an equally commonplace, "moderne" style, Christo's new store fronts still appeared as out of vogue as their predecessors, suggesting the handiwork of an uninspired building contractor rather than an architect. Like their prototypes, the *Four Store Fronts* seemed to be a dilution of high style into vulgar, commercial application.

In the *Four Store Fronts*, Christo reintroduced the recurrent theme of obstruction. Forming a right angle that measures thirty-six feet from end to end, the *Four Store Fronts* occupies nearly three-quarters of a room twenty-four-feet square. As exhibited at the Leo Castelli Gallery in New York, the work could be seen in its entirety only from a narrow vantage point, and many spectators felt squeezed in the corridor-like, "free" space that was not occupied by the construction. The right angle of the store fronts did not correspond to the existing gallery walls, and spectators walking alongside the show windows found themselves in a tapering corridor that ended abruptly in a dead end. In its physical and psychological displacement of space, the *Four Store Fronts* far exceeded the room-sized package, a cumbersome bundle with inscrutable contents that Christo crammed into a twelve-by-fifteen-foot room at the Galleria Apollinaire in Milan in 1963. Just as we know there is something inside Christo's packages, we know there is nothing behind the shallow store fronts. Consequently, the lavish obstruction of space is probably more upsetting than it would be if the space were actually filled.

The idea of size and obstruction was carried to even greater extremes in a subsequent work, the *Three Store Fronts* of 1965–66 (plates 115–18), a row of severely plain store fronts designed to diagonally bisect a room for a show at the Stedelijk van Abbemuseum in Eindhoven, The Netherlands. More "contemporary" in design, the *Three Store Fronts* are also reflections of a debased style—that of the immediate present. Consisting of highly

reflective galvanized metal and Plexiglas, they have an anonymous uniformity. Being entirely identical, they are marked by an unadorned and chilling simplicity. They are so streamlined and generalized as to be abstractions of store fronts. The linear metal frames have been reduced in proportion to the Plexiglas windows, and the white cloth is more tautly draped inside the windows. Though there is more to look at, they are less visible; the spectator walks by and hardly notices them, the *Three Store Fronts* registering almost subliminally with the passer-by. Christo's earliest store fronts, which at first did not resemble art at all, appear relatively warm and ingratiating, especially when compared to the chilling impersonality of this uninflected row of store fronts.

Christo's store fronts, built over a period of four years, recapitulate a century of commonplace architectural styles. As Stephen S. Prokopoff has written: "Christo's choice of the vernacular is based on the assumption that it forms a far more readable, prevalent and characteristic document than the individualistic works of high style."[11] It is ironic to contemplate that Christo's replicas may form a more lasting record than the prototypes themselves, which will almost certainly be razed.

The largest store front to date is the *Corridor—Store Front* (plates 124–29), which Christo designed especially for the 1968 Documenta 4, the international art exhibition in Kassel, West Germany. *Corridor—Store Front* is surely one of the most frustrating art environments ever devised. Unlike the previous store fronts, which are environmental merely in terms of size, this one is a true environment—it absorbs and envelops the spectator, if only in a cul-de-sac.

The aluminum facade features an entrance way rather than a door. The visitor enters and finds himself in a thirty-six-foot-long corridor, a kind of arcade lined with empty and unilluminated display windows, which becomes progressively less inviting as he approaches the glass door at the far end of the corridor. The floor-to-ceiling Plexiglas windows are, for the first time, undraped. At the end of the passageway, the glass door has a steel handle inscribed "push." It is, of course, locked.

The environment does not end there, however, for through the glass door, the spectator gazes into a large white room, brightly illuminated and completely empty. The wall on the right side of the room is broken by what appears to be another corridor. And at the far end of the room, forty-eight feet away, there is a wooden door that is slightly ajar. For the first time, an open door appears in Christo's work, but it is physically inaccessible. The environment literally ends at the open door, although there is the implication that there may be still more beyond the door.

Our initial response to *Corridor—Store Front* might be to dismiss it as a sculptural prank in an architectural format. But looking through a locked door across an empty room at an open door begins to have a disturbing effect. By looking through the glass door, the spectator becomes intensely aware of visually experiencing the expanse of space in the forty-eight-foot-long room. But he sees the room from a fixed point of view, which tends to visually reduce the volume, thereby creating the illusion of a two-dimensional space. The long corridor proves to be essential: it not only arouses the expectations of the specta-

tor by providing a leisurely approach, but it also commits him to make the first steps which enable him to more fully appreciate the enforced halt at the glass door and the paradoxical image of the room.

The bare, white room that is the core of *Corridor—Store Front* suggests certain similarities to Yves Klein's celebrated *Void,* the immaterial environment staged in 1958 at the Iris Clert Gallery, Paris. For this work, which has become a classic example of extremist art, Klein whitewashed the gallery, supposedly exorcizing it of the presences of others and infusing it with his own atmosphere, after which he opened it to the public. Klein's intent was to present "a perceptible pictorial state within the boundaries of an exhibition hall. In other words, the creation of an atmosphere . . . endowed with such an autonomous life as to be literally the best definition of painting in general that has been formulated up to now, 'radiance.' "[12] Accompanied by glittering fanfare, the exhibition—consisting of what appeared to be an empty white room—attracted throngs of visitors, 40 percent of whom reportedly experienced the "palpable pictorial condition."[13] Pierre Restany, the most devoted caretaker of Klein's *Void,* has made the interesting observation that Christo's store fronts "can be considered as packages of the *Void* on an architectural scale."[14] Admittedly, there are many connections to be made between Klein and Christo, probably on a philosophical level, but there are also equally important dissimilarities. In creating the *Void,* Klein was clearly more interested in the concept of an artistic zone than in its visual and physical properties. We need not physically experience the *Void* in order to appreciate the concept of its "radiance." But we must physically experience the *Corridor—Store Front* to get the full, frustrating impact of the spatial and visual effect; indeed, the work is incomplete without the spectator's physical sensation of passing through a long, narrow corridor to arrive at a flat plane of glass through which he sees a room in real perspective, which he is unable to physically experience. The *Corridor—Store Front* is more complicated than the simple demonstration of an idea; the work's material existence is essential.

AIR PACKAGES: wrapping the immaterial

In 1966, Christo abruptly began packaging a relatively immaterial substance: plain air. To date, he has made three air-inflated packages, one of which is the world's largest inflated sculpture. The first such package, simply titled *Air Package* (plate 106), consisted of a ready-made, rubberized canvas balloon which the artist shrouded in polyethylene and rope and moored by steel cables in front of the Stedelijk van Abbemuseum in Eindhoven, in conjunction with his first one-man museum show. As a rule, Christo prefers packaging ready-made objects but, after wrapping the Stedelijk balloon, he realized he could create air packages that are not dependent upon a preexistent core by inventing forms of whatever size he wanted.

There was nothing novel in Christo's use of air as an art material, nor in his use of balloons as a structural form. Many artists have worked with inflatable, balloon-like forms and many sculptures, most notably Calder's mobiles, are activated by air. Air, which has a formlessness that still invites further investigation, has been put to many novel uses. Duchamp put it to conceptual use in 1919, when he filled a glass flask with Paris air, labeled it *sérum physiologique,* and presented it to an American collector friend. Fifty years later, an American "conceptual" artist was still letting the air out of Duchamp's original idea—he released two cubic feet of helium in the California desert, allowing it to expand indefinitely. Artists have also experimented with the more visibly random movement of air, as when an electrically produced air current is directed to make a strip of cloth flutter, or to pneumatically inflate and deflate a flexible material. Two of the chief characteristics of most inflatable sculptures are their buoyancy (as in free-floating balloons) and their capacity to change shape (inflating and deflating through air pressure).

The most significant thing about Christo's *Air Package* is that it did not do anything. Neither buoyant nor free-floating, it was incapable of changing shape or location. It did not pulsate, throb, or move, and was irresponsive to outer air pressure. Wrapped, tied, and secured by guy wires, the captive balloon was contrary to balloon nature. In his denial of the kinetic nature of balloons, Christo makes his air packages consistent with his other packages in which use or function are denied. In effect, Christo knocks the breath out of kinetic air art.

The kinetic aspect of air, the capacity to pneumatically alter shape through pressure, is crucial to many inflatable structures. For kinetic critic Willoughby Sharp, who holds that "form is an error,"[15] the primary characteristic of pneumatic works is "not form, but becoming. . . . The monolithic character of the artifact is mitigated. The works act in space without fixed boundaries. Space is created through the system itself. It is not pictorial space, but dynamic space. It is always in flux. It continually creates its own dimensions. Surface and structure exist simultaneously. Inside and outside are one. The work is part of a single continuum. The works find their meaning in just being. Being and meaning are inseparable."[16] The drawback of most pneumatic works is that they invariably suggest natural organisms. Because the skin of the balloon functions as a membrane, any change of dynamics in the flexible, "breathing" form becomes unavoidably allusive, and the fluctuating surface—whether it be palpitating, tumescent, or inflating—has overly specific connotations to human organs.

Christo's second, and more imposing, inflatable was the *42,390 Cubic Feet Package* (plates 107–12), a 60-foot-long package constructed in October, 1966, at the Minneapolis School of Art with the assistance of 147 students. The core of the package was comprised of four United States Army high-altitude research balloons, each measuring about 18 feet in height and 25 feet in diameter, each independently sealed, plus 2,800 colored balloons, averaging 28 inches in diameter. All the balloons were inflated, sealed, and then wrapped in 8,000 square feet of clear polyethylene, which was sealed with Mylar tape and secured with 3,000 feet of Manila rope. The resulting oblong package was further inflated by two

air blowers. The balloon glistened in the sunlight, which passed right through the layers of translucent polyethylene; inside, the 2,800 confetti-colored balloons bobbed about merrily in ever-changing configurations.

Christo's original intent was to fly the *42,390 Cubic Feet Package* from the school campus to the front lawn of the nearby Minneapolis Institute of Arts, creating an extraordinary, Felliniesque sight of a giant package being carted through the sky. Although the high-altitude research balloons individually weighed a mere ten pounds, the aggregate weight of the air package was five hundred pounds. Because of the weight and gusty air currents, the giant package soon became a monument to nothing going nowhere. The Federal Aviation Agency forbade the airlift, and the helicopter pilot, fearful of air turbulence, refused to lift the balloon more than twenty feet off the ground. As a result, the package was airlifted for only a few minutes—long enough to take some striking photographs (plates 110–12)—then deposited on the same spot.

Christo's most spectacular air package is the *5,600 Cubic Meter Package* (plates 151–87), a colossal column of air-filled, synthetic fabric created for Documenta 4, the 1968 international art show in Kassel, West Germany. The huge, sausage-shaped structure set new statistical records for inflatable sculptures in terms of height (280 feet) and cost ($70,000). Technically, it is Christo's most ambitious undertaking.

When Christo went to Kassel in 1967 to select a site for the work, he had two possibilities in mind. The first was in front of the Fridericianum Museum (plate 153), an obvious choice, as this was the operating base of Documenta and very near the center of town. If Christo had chosen to erect the balloon in front of the Fridericianum, it would have been visible from a great distance, but difficult to see at close quarters, as nearby buildings would have obstructed the view. So he settled on the second site, nearly half a mile away in Kassel's sprawling Auepark, where the monumental balloon would have a commanding scale relationship to the landscape. The precise location was in the center of a large, tree-ringed meadow called the Karlswiese, bordered at one end by the Orangerie, an eighteenth-century château. On the east side of the park, steep flights of stairs provided a precipitous passageway up the hillside to the main part of town. By erecting the balloon in the center of the "sunken" park, Christo enabled viewers to see it from multiple vantage points, from varying distances, and from varying heights. Below, near the Orangerie, spectators saw the *5,600 Cubic Meter Package* tower, several times the height of the forty-foot trees. At the top of the stairs, viewers faced the middle of the balloon and could gaze up as well as down. And from a distance, the balloon was still visible for more than fifteen miles.

Research for the project began in November, 1967, at the Massachusetts Institute of Technology, where Christo worked in close consultation with a technical advisor, Dimiter S. Zagoroff, a specialist in mechanical engineering. In a test for wind resistance, a scale model, one-fiftieth the size of the final balloon, was put in a wind tunnel and found to conform to the theory of air-inflated structures; that is, the wind resistance was directly proportional to inflation pressure. The sculpture might yield and buckle at wind loads higher than the design load, but it would right itself after the wind load had subsided.

The package was designed to have an outer envelope of nylon-reinforced polyethylene, which was ordered from a manufacturing firm in Sioux Falls, South Dakota, and delivered to Kassel, ready for inflation. The outer envelope contained a smaller envelope of clear Mylar plastic, to be inflated with helium to aid in the erection. The flattened envelope was to be inserted into a network of ropes that, upon inflation, would augment its strength. Internal air pressure would be maintained by a centrifugal blower, run by a variable-speed electric motor. The bottom of the envelope rested in a steel cradle, which was hinged to a central steel column and anchored in a concrete foundation. The balloon would be kept upright by guy wires, attached to four steel belts girdling the sculpture at various heights and strung out in six directions, each anchored in its own concrete foundation.

In April, 1968, Christo made a second trip to Kassel to oversee the laying of the concrete foundations and to make arrangements with various contractors. His technical advisor, Zagoroff, arrived in mid-May and stayed on as site engineer for nearly three months. The central foundation had to be nearly ten feet deep; otherwise, the wind might have whipped the 280-foot package around the meadow and turned it into a colossal menace. A total of 180 tons of concrete foundations was laid in five days at a cost of $3,000.

The first attempt at launching the balloon began on a rainy Monday morning, June 24. The rain turned into a storm and the polyethylene skin, after three hours of inflation, was suddenly rent by a ten-foot rip. Having burst its seams, the shimmering, polyethylene colossus, which had been erect a mere ten minutes, thrashed slowly to the ground, collapsing with the majestic throes of a dying whale. The giant package, which Christo had intended to be the looming landmark of Documenta, promised to be the biggest flop. The enormous crane and six winches standing by were never used. But even as a "failure," the colossal balloon attracted more attention than any of the art show's many "successes." The German press had a field day, documenting the disaster in bold headlines, full-page photos, and hour-by-hour accounts.

The rip was repaired, and a second attempt was begun two days later on June 26. This time, the balloon again stayed erect for ten minutes, when the skin developed a big rupture at the base. Once more, it toppled to the ground.

After the second failure, the $5,000 polyethylene skin, presumably "reinforced," was junked and a new $2,500 skin was ordered. The new skin was a synthetic textile named Trevira, a polyester fiber material made in West Germany, which was sprayed with a solution of polyvinylchloride (better known by its initials PVC), a thermoplastic polymer substance thoroughly resistant to water, acid, and alkalies. The Trevira fabric, heat-sealed in Kassel, was filled with air on July 14 and a third unsuccessful erection was attempted. Only two cranes were used, a 140-foot-high crane positioned near the cradle and attached to the center of the balloon, and a 70-foot-high crane stationed at the opposite end, attempting to hoist the nose of the balloon until a 45-degree angle was reached, at which point the taller crane could complete the elevation. But the pair of cranes proved inadequate to the task, causing a 33-foot rip in the lower middle of the balloon.

The colossus was finally erected on **August 3**, with the assistance of five cranes, two of

which were 230 feet high and weighed 200 tons each. The pair of giant cranes, the tallest Europe had to offer, had been operating separately in northern France and Hamburg, Germany, and it took two weeks just to make arrangements for both cranes to arrive simultaneously in Kassel. Their cost for nine hours' use was $8,000. Because the crane company did not wish to be embarrassed by another failure, it insisted upon insuring the erection for $50,000. The crane company paid the $1,000 premium on the insurance and then charged it to Christo, bringing the artist's total crane cost to $9,000.

The first three unsuccessful erections sparked many titters in Kassel's art community about Christo's inability to get his package up. But as soon as the air-inflated structure was successfully erected and held in position by guy wires, the *5,600 Cubic Meter Package* assumed a more universal significance. As the unofficial symbol of Documenta, the air package was prominently featured as the lead illustration in a German news magazine's cover story on the *Sexwelle,* the "sex wave" of erotica that was currently reaching tidal proportions in West Germany. The package's priapic aspect was still being celebrated the following year in New York, where a homophile newspaper published a full-page photograph to accompany an article on Gay Power. Such specific connotations were neither intended nor disavowed by Christo, who believed that his oblong package had a fairly nonallusive shape. If the *5,600 Cubic Meter Package* inadvertently aroused prurient interest, Christo could at least claim that it had redeeming social value—large numbers of people seemed content to while away hours in its presence.

The success of the Kassel package demonstrated that Christo's entrepreneurial skills were on a scale equal to that of the sculpture itself. By sponsoring his own technical research, he maintained total control over the project, assuring that the engineering aspect remained subservient to his initial concept. While he delegated authority to engineers and contractors, he assumed ultimate responsibility for all design and technical decisions. In spite of the costliness of the project, Christo assumed all financial obligations as well. In financing his own work, Christo has displayed a fund-raising ability that is cause for wonder among many people and a source of profound consternation for other artists. And raising funds to pay for the *5,600 Cubic Meter Package,* initially estimated to cost $30,000, proved to be nearly as difficult as raising the balloon physically. Although Documenta gave Christo a $3,000 grant (the same amount was given to other participating artists), and many of the materials were made available at reduced prices (such as the 40,000 cubic feet of helium which Christo was enabled to purchase at the cost price of $4,000, instead of the retail price of $12,000), there remained the unavoidable high cost of labor. The student workers and professional laborers were paid every Friday and, when Christo ran short of cash, Documenta officials helped him borrow money from a Frankfurt bank. Two years after the balloon had come down, Christo was still paying off thousands of dollars of debt.

The increasing size of his epic projects presupposes rising costs. In the past few years, he has almost gleefully announced the staggering cost of each new project with a fanfare worthy of a grandiose movie production: $70,000 for the Kassel package, $18,000 for the wrapped buildings in Bern and Spoleto, $120,000 for the wrapped seacoast in Australia.

Spending vast sums of money excites Christo nearly as much as dealing in vast quantities of materials. For most people, it is sufficiently absurd to want to wrap buildings and seacoasts, to construct a 280-foot-high balloon or 200-foot-high mastaba of oil drums. Although these same people generally tolerate such projects, which they consider to be artistic follies, they are genuinely horrified when they learn of the huge expenditures of labor and materials. The reason why Christo should want to spend so much money on his projects is one of the most insidiously disturbing aspects of his work. As it is highly unlikely that he will ever turn a profit on any of his epic ventures (with the possible exception of the Kassel package), we can only hope that the productions have a cultural, philosophical, or entertainment value for the public that merits the artist's investment.

The temporary physical existence of the large projects heightens our awareness of the monetary "waste." Nobody cares any more about the initial cost of carving the 65-foot-high Great Sphinx in Giza, or the initial cost of constructing the 270-foot-high Cathedral bell tower in Florence, because they are still standing and somebody, presumably, got his money's worth. Though it is difficult to believe, Christo is so pleased to have his projects realized that any cost seems reasonable.

PHOTOGRAPHS: a vision of what could be

All of Christo's large projects are carefully planned in meticulously detailed studies, most often in the form of sketches, photomontages, relief-collages, and three-dimensional scale models, suggesting the preliminary presentation an architect might make in seeking a commission. In his projects for store fronts, Christo employs the same materials (glass, cloth, metal, and electric light) that are to appear in the final structure (plates 76–78, 82, 85, 115). Perspective lines and architectural dimensions are scrupulously penciled in, and the detailing is often ingeniously crafted, as in the use of wire screen for grilles and carved strips of balsa wood for molding. Only the most complex projects necessitate the making of scale models: *Corridor—Store Front* (plates 122–23), the Minneapolis *42,390 Cubic Feet Package* (plate 107), the wrapped seacoast (plates 253, 255), and such proposed packed buildings as the Lower Manhattan skyscrapers (plate 90), the National Gallery of Modern Art in Rome (plate 137), the Whitney Museum of American Art (plate 138), and the Museum of Modern Art in New York (plate 139). While the scale models of wrapped buildings provide detailed information as to color and design and give an indication of how the building will actually appear under wraps, the photomontages serve to indicate how the wrapped building will appear in the context of the site.

Photographs play a key role both in the conception and execution of the projects. Before initiating a project, Christo often studies photographs of the site, which isolate

particular details or emphasize specific aspects. Occasionally, he merely alters photographs or photostats by painting directly upon them, as in the project for the *Barrel Wall on Fifty-third Street* (plate 140), a photostat upon which he drew enameled colored circles. At other times, he applies colored pencil to the photostat, making the already grainy picture resemble an impressionistic, hand-tinted photograph. In some collage projects, a photostat of the site becomes the support for additional collage elements, usually of plastic or canvas and twine (plates 217, 245, 252, figure 16). In this way, photographs are used as a technical short-cut and graphic aid to better visualize the final result. As Stephen S. Prokopoff has observed: "The *trompe l'oeil* technique of the photograph is particularly useful for the vivid definition of the characteristics and proportions of the site through the inclusion of scale references such as pedestrians, vehicles and architecture. But the immediacy and 'truth' of the photograph also suggest the situation as it *could* be."[17]

Once the project has been realized, it is ready to be photographed, usually providing the only lasting record of the "temporary monument." Christo frequently directs the photographing of his works-in-progress, then selects the photographs that are in effect the "official" record of the work. As the project has been initially conceived with the aid of photographs, the final product is inevitably photogenic. He studies photographs of his work with relish and is delighted to discover details (close-ups, peculiar angles, fleeting moments of action) that he may have missed at the actual moment.

For the Kassel balloon and the Australian wrapped coast, Christo selected the most telling photographs and then published a picture album of each project, supervising the layout and book design himself. In the books he publishes, he includes photographs of the work-in-progress "to make people realize the physicality and labor involved," he says, not to accentuate the theatrical activity. "The book will be the only remaining record and proof that the art once existed," Christo points out, "but the realization is more important than the book-record." The photographs are never presented as works of art in themselves and Christo, unlike some "conceptual" artists, does not consider them to be an end product, but simply photographic documentation of a necessarily impermanent project. "Permanence being so indefinite, I am not concerned with it," he says. "But the works are neither necessarily permanent or impermanent. It's not a very permanent world anyway."

WRAPPED BUILDINGS: monumental packages for urban spaces

Pursuing the implications of packaging, Christo devised a plan in 1961 to wrap a public building. He made his first proposal for a packaged edifice in the form of collaged photographs (plate 15), showing a large, eight-story building, unrecognizably altered by lumpily wrapped fabric. In making the collage, Christo first photographed a small, rectilinear package, which he then cut out and glued into place, superimposing it on the huge, empty

area at the base of the Eiffel Tower looking toward the Champ-de-Mars. A scale reference is provided by the row of parked cars and clusters of pedestrians who, ironically, seem to be taking the monumental package in stride.

While there is no clear reason to account for this huge leap into architectural scale, it seems probable that Christo was more intrigued by the prospect of installing a monumental package in a widely-trafficked, urban place than he was by the idea of wrapping a building. He did not designate a specific building for wrapping, and he exhibited scarcely any interest in the original function and architectural style of existing buildings. In selecting buildings for wrapping, his chief stipulations seem to have been size and centrality. He was not making a social comment upon government buildings, corporate headquarters, or architectural design. If he subsequently packaged only museums, it did not mean that he had any hostile motives toward art, but instead merely indicated that museum directors were more interested in advancing his ideas than were leaders of other institutions.

By cloaking a public building or structure, Christo effects a partial and ambiguous transformation, creating a giant object that resembles neither sculpture nor architecture. The shrouding not only drastically alters the visual appearance of the structure, but affects its relationship to the site as well. Unlike the facsimile store fronts, which are objects masquerading as real architecture, the wrapped buildings are real architecture masquerading as objects. The chief similarity between the two is that both seem temporarily closed. Contrary to the packaged vehicles in which the object is deprived of its functional use, and contrary to the store-front constructions that we cannot enter, the wrapped buildings are intended to retain their normal function, even though they are concealed. Christo foresaw the technical and operational problems in depriving a building, even temporarily, of its normal use; so he recommended that the wrapped building remain operative by constructing an underground entrance, which he maintains "can be added to any normal building." He even specified the ways in which a shrouded building could be utilized: as a stadium, concert hall, museum, parliament, or prison.

A 1963 photomontage (plate 24) shows another packed public edifice, the Arch of Triumph, wrapped in such a way as to disguise its central archway. The photomontage is illusionistically more convincing than the collaged photographic prints, because collaging in the darkroom yields a single print with uniform surface. The photographers Shunk-Kender, who have dutifully chronicled Christo's work for many years, took the original photographs and printed the photomontage themselves, following Christo's directions.

The following year in New York, Christo embarked on a series of collages and photomontages showing two shrouded Wall Street skyscrapers in the midst of Lower Manhattan (plate 91). It is easy to imagine what an awesome sight this would have provided trans-atlantic passengers entering New York Harbor. The appearance of a pair of giant parcels forming part of the skyline would certainly have rivaled the Statue of Liberty as a colossal landmark.

Although the early projects for wrapped buildings were not realized, the photomontages and scale models indicated the scope of Christo's imagination and made an intellectual

impact upon those who saw them. Because the concept of a wrapped building is so clear and so easy to visualize, we might question the need to actually realize such a project. But a concept alone is merely provocative, while a building which is actually packaged affords a visual spectacle that has a much more forceful and richer effect. Due to the large scale involved, requiring thousands of yards of wrapping material, there is no way to anticipate the precise visual and sensuous effect of so much fabric caught up in immense folds and crevices, or the play of natural and artificial light over such an extensive surface.

For a while, all indications were that Christo would never succeed in his ambitions. The first promising projects for wrapped buildings had one thing in common—they all fell through. All were museums, the most sympathetic of institutions, yet the most bedeviled by civic and administrative problems. The first opportunity came in 1967 with the National Gallery of Modern Art in Rome, a six-story building with a 450-foot-wide, Neo-classic facade that Christo proposed wrapping in plastic fabric and 15,000 feet of rope (plate 137). This project collapsed when the museum staff proved incapable of handling administrative responsibilities. The second opportunity was provided by the Whitney Museum of American Art in New York, for which Christo's wrapping would have accentuated the already compelling configuration of Marcel Breuer's inverted ziggurat (plate 138). Packaging the Whitney Museum was Christo's proposed contribution to the 1968 Sculpture Annual, but the project was abandoned when the curator in charge, who wanted to sponsor the project, left the museum. The proposed packaging of the Museum of Modern Art (plates 139, 143), a six-story, International-style edifice, was to celebrate the closing on June 9, 1968, of the exhibition, "Dada, Surrealism and Their Heritage." This project floundered because it would have increased the museum's insurance premiums to a prohibitive level, not because of increased risk of fire, but because it might have contributed to, or been the target of, considerable political unrest. (Civil disorder in New York seemed an imminent threat that year, and the museum chose to follow a cautious tactic.) As alternatives to the packaging of the Museum of Modern Art, Christo advanced other proposals to commemorate the closing of the Dada–Surrealism show: erecting a barrel wall across West Fifty-third Street (plate 140), wrapping the sculpture garden (plates 141–42), and packaging live, nude girls to be exhibited on pedestals in a small gallery adjoining the main hall (plate 202). All of these projects seemed impractical for a variety of reasons. Nevertheless, the museum felt its public would enjoy seeing scale models, photomontages, and drawings for what it called a "non-event," and so it held a small exhibition of these and other projects in June, 1968.

That same year, in conjunction with the Festival of Two Worlds, Christo almost wrapped the Spoleto opera house, the three-story-high Teatro Nuovo, an eighteenth-century building that is one of the principal attractions of the small mountaintop town in central Italy. Again, Christo was prevented from wrapping the building, this time by fire laws. In place of the opera house, he was invited to package a medieval tower (plates 146–48) on the perimeter of town, and a Baroque fountain (plates 149–50) in the center of town, which were wrapped according to his plans while the artist himself was in Germany at

work on the Kassel balloon. The square tower, standing like a shrouded sentinel at one end of a medieval causeway, was one of the first landmarks on the road winding into Spoleto, providing an eerie indication of the curious blend of old and new cultures at the Festival of Two Worlds. In a piazza in the center of town, the packaged fountain struck a festive note, with the white plastic fabric, a woven polypropylene, extending over the entire side of a four-story building, the silhouette of which resembled a Baroque church facade. The plastic fabric shimmered like white satin in the sunlight and became tremulous in the slightest whisper of a breeze. Both packages remained up for three weeks, the duration of the festival.

A Swiss art museum, the Kunsthalle in Bern, gave Christo his first opportunity to fully package an entire building (plates 188–91). July, 1968, marked the fiftieth anniversary of the museum, and the event was celebrated with an international group show of environmental works by twelve artists. As one of the dozen participants, Christo showed nothing inside the museum, but literally packaged the entire show. "I took the environments by eleven other artists," he remarked with amusement, "and packaged them. I had my whole environment inside." Christo shrouded the Kunsthalle with 27,000 square feet of reinforced polyethylene, which was left over from the discarded first skin of the Kassel balloon, secured it with 10,000 feet of nylon rope, and made a slit in front of the main entrance so visitors could enter the building. The Kunsthalle is a bulky-looking building, despite its curved walls and sloping roof, but its hulking silhouette was considerably softened by the mantle of translucent polyethylene. The only architectural elements that remained visible with any sharpness and clarity were the contours of the roof and cornices. The sides of the building were luxuriously swagged and the plastic veiling was continually animated by soft, billowing folds and an always-changing pattern of glimmering highlights.

The wrapping process took six days with the help of eleven construction workers. Because no nails could be driven into the building, special wooden supports had to be built for fastening the plastic to the building and, at one point, to facilitate work on the roof, the local fire brigade was called upon to lend a hydraulic ladder. Insurance companies refused to underwrite the Kunsthalle and its valuable contents during the period it was to be wrapped, so to guard against possible fire and vandalism, museum director Harald Szeemann had six watchmen posted around the building at all times. As this proved to be quite expensive, the building was unwrapped after one week.

Following his successful summer activities in Kassel, Bern, and Spoleto, Christo returned to the United States in the fall of 1968 and immediately paid a brief visit to the Museum of Contemporary Art in Chicago, where he had been offered a modest exhibition of his projects for packaged buildings. Asked if he would consider making a series of wrapping proposals for the Chicago museum, to be displayed alongside other collages and scale models, Christo countered with a proposal to actually wrap the building (plates 217–18). As Jan van der Marck, director of the museum, was to observe later: "A proposal makes no sense to him unless it can be turned into reality."[18] Van der Marck was eager to sponsor Christo's first wrapped building in the United States and, conceding that "an exhibition of

visual references and esthetic tantalizers would have been a timid evasion of the real challenge of Christo's defiant proposals,"[19] he promptly set about getting the proper clearances and permissions.

If any building ever needed wrapping, it was Chicago's Museum of Contemporary Art, a banal, one-story edifice (with a below-ground gallery) having about as much architectural charm as an old shoe box. Built in the early 1900s, it had once been a bakery and, later, the headquarters of Playboy Enterprises. Christo considered the building "perfect," because "it looks like a package already, very anonymous. Its facade is a fake wall covering the original structure." Although he had just wrapped the Bern museum in translucent plastic, Christo decided "for aesthetic reasons" to shroud the Chicago museum in brown tarpaulin, which would give greater physical presence to the building and make a better contrast with the snow.

The wrapping commenced on January 15, 1969 (plates 219–31). Volunteer students from the school of the Chicago Art Institute and the Institute of Design assisted for two days on the outside of the building, which was garbed in 10,000 square feet of heavy tarpaulin and 4,000 feet of Manila rope. Every precaution was taken to assure the public's safety. No exits were covered, no windows existed to cover, and small openings were cut in the tarpaulin to keep the building's air vents unobstructed. To be doubly safe, Van der Marck prevailed upon Christo not to wrap the roof of the museum. The finished package had a stateliness and sobriety that considerably enhanced the building. In contrast to the Bern museum, with its veil of translucent plastic billowing like a loose summer garment, the Chicago museum was tightly swathed in heavy tarpaulins, as if bundled against the city's blustery winter winds and snow. As a finishing touch, Christo wrapped the vertical signpost outside the museum in transparent polyethylene.

The wrapping process, which was necessarily public, elicited from passers-by the expected jeers and innocent questions: Was the museum being wrapped to keep the pictures safe? Was there a heating problem? Were they closing down the museum? A couple of building inspectors wandered in, thinking the museum was under construction. A number of people, scarcely aware that Chicago even had a museum of contemporary art, were suddenly exposed to "modern art" right there on the street and could scarcely remain indifferent, thereby demonstrating that a museum can be an effective instrument of social change. "As questions and wisecracks subsided," says Van der Marck, "the packed museum had an ultimately unsettling effect on the community that surpassed the initial reactions of absurdity or amused outrage. By entering the museum, one became an actual part of the package, making effective rejection more difficult."[20]

The packaged building was expected to be controversial, but not in so many ways—Van der Marck found himself assailed on all sides. "With the museum's approval and financial support," he reported, "Christo packaged a building that needed no protection, was considered more beautiful without covers and became a fire hazard to the authorities. Our expenses were less than those for the usual six-week exhibition, yet we were called extravagant and wasteful. The museum's exterior can boast of little distinction, yet we were

called enemies of beauty. In answer to the charges of creating a fire hazard and jeopardizing public safety, we gave the Fire Department ample scientific evidence to the contrary and complied with every city code and special regulation; yet the order to dismantle within 48 hours, presented by the Chief in person at the exhibition's preview, remained in effect though it was never enforced."[21]

Christo's packaging of the Chicago museum occurred at a time when the identity, role, and social responsibility of art museums were being widely questioned. In his catalogue preface to the show, Van der Marck had stated: "With the whole idea of a modern museum and its usefulness somewhat up for grabs, Christo's packaged monument succeeds in parodying all the associations a museum evokes: a mausoleum, a repository for precious contents, an intent to 'wrap up' all of art history."[22] Because of this statement, Van der Marck was severely rebuked by members of his own profession. The sharpest rebuke probably came from Sherman E. Lee, the director of The Cleveland Museum, who referred to the wrapping as a "catastrophe" and described Van der Marck as a "cheerfully self-exploding museum director."[23]

In a probing review of the affair, Chicago art critic Franz Schulze concluded that the wrapped museum was "a disturbing piece of sociology," but he also allowed that the "show *is* the most important event in the history of the Museum of Contemporary Art, because Christo has done more to make people think about art in an ultimate sense than any other single exhibitor we have seen there."[24]

In conjunction with his packaging of the Chicago museum, Christo made a complementary work for the interior. The *Wrapped Floor* (plates 234–42) was in some ways the most impressive part of the exhibition, because it was a more radical departure in terms of Christo's development than the packaging of the exterior. The exterior, after all, was a fairly noticeable structure to begin with. The gallery floor, however, had been a scarcely noticeable architectural element until Christo's wrapping gave it a new kind of object status.

The *Wrapped Floor* was in the museum's lower gallery, which had first been emptied of almost everything and then painted white. When the painters were through, they removed their dropcloths and Christo laid his. The painters' dropcloths were not art. They were just messy pieces of canvas used in a strictly utilitarian and unimaginative way: to catch dripping paint. Christo's dropcloths were art not only because he conceived them as such, but also because he was able to make a coherent visual statement with them. His dropcloths, rented from a Chicago house-painting company (at the bargain fee of $1.35 each per month), were carefully selected for their particular color and texture, in much the same way as a fine furrier would discriminate among pelts. Deliberately avoiding random composition, Christo did not simply drop the canvas and let it assume chance configurations; he carefully arranged every portion of it into rhythmic ripples and folds of his own design, before fastening it with string to the base of each of the gallery's eight supporting columns. The soft, paint-dappled fabric had a high degree of textural interest and surface nuance, and a subtle sensuality suggesting the lapping currents of water that result in

swirled patterns of wet earth or dried mud. At one end of the gallery, he piled up an assortment of museum furniture and installation props, which he covered with the same material and tied into a bulky package. Then he draped the stairway connecting the upper and lower galleries, shrouding not only the steps but the banister and handrails as well. He finished off by wrapping the pay telephone and exit signs in polyethylene.

Far from being an "idea" piece, the *Wrapped Floor* was fully intended to be visually pleasing. Yet it was almost naturalistic enough to pass for the "real thing," as if the painters had just finished and would momentarily return to reclaim their dropcloths. As a result, it created an element of doubt and uneasy expectation in viewers' minds, which would not have been the case if the artist had brought in a more obvious "non-art" material such as dirt, shells, leaves, ice, or colored gelatin and dumped it on the floor. Unorthodox materials, while at first startling and sometimes shocking, call attention to themselves because they are so blatantly out of context inside an art museum. But the most logical and natural place for a painter's dropcloth is on the floor. The only clues that the dropcloths were more than they appeared to be were that they too rationally shared the same perimeter as the room itself, and that they were secured by cord to the bases of the columns.

The transformation was minimal, yet it more than sufficed to drastically alter the appearance and feeling of the space. The wrapped floor seemed to generate an atmosphere of spiritual tranquility. Although Christo never intended to ask museum visitors to remove their shoes, the insurance company required it as a safety precaution and this regulation increased the tactile effect for spectators, who possibly felt they were entering a mosque to walk upon luxurious carpets in their stocking feet. A few young visitors were prompted to remove all their clothes, thereby demonstrating that the setting was conducive to liberated feelings. On the whole, the wrapped floor was most appreciated by students, many of whom visited several times to sit on the floor and meditate in the vacant space. The wrapped floor did not entice everyone, however. A group of elderly museum visitors descended tentatively in their bare feet but, before faltering to the bottom of the stairs, the one in the vanguard halted, announced "there's nothing there," and without a moment's hesitation the entire group did a smart about-face and retreated to the upper gallery.

AUSTRALIAN COAST: a terrestrial wrap-up

Christo's wrapped buildings and oil-drum blockades, which initially appeared of monumental size, indicated that the artist saw his work in terms of an imposed confrontation with society. He had removed his work from the usual precincts of art—museums and galleries— and put it outdoors, where it was capable of engaging the man-in-the-street, who was probably oblivious to the aesthetic issues involved. From these early inclinations toward large scale and covert monumentality, he has focused his aspirations on even greater spaces

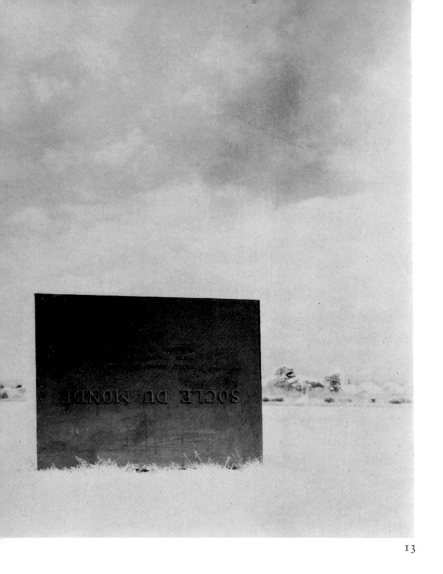

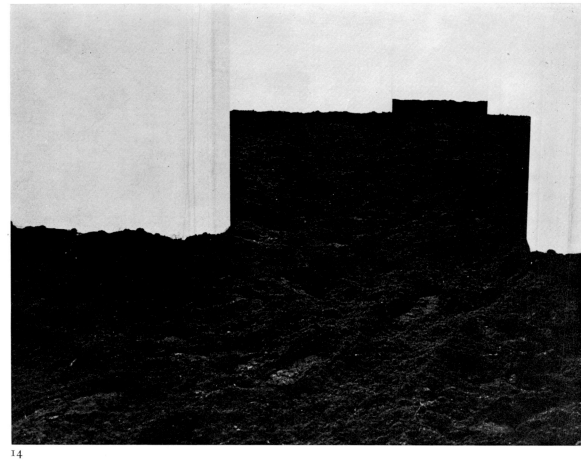

Figure 13. PIERO MANZONI. *Socle du Monde (Base of the World)*. 1961. Iron pedestal with raised letters that say: "Socle Magic No. 3 de Piero Manzoni—1961—Hommage à Galileo"

Figure 14. WALTER DE MARIA. *50 M³ (1,600 Cubic Feet) Level Dirt/The Land Show: Pure Dirt/Pure Earth/Pure Land*. Installation view at Galerie Heiner Friedrich, Munich, 1968

Figure 15. MICHAEL HEIZER. *Double Negative*. 1969. Forty thousand tons of earth displaced, 1,100 × 42 × 30 ft. Virgin River Mesa, Nevada (70 miles northeast of Las Vegas)

Since Christo shrouded nearly a million square feet of cliffs and shore in his colossal *Wrapped Coast*, he has been linked with a recent trend in sculpture, a sprawling kind of landscape art that uses Mother Earth as its medium, variously described as "earth art," "earthworks," and "land art." One of the leading earthworkers is Michael Heizer, who generally prefers to carve his art in the desert wilderness of Nevada, where he gouged out this pair of geometric voids which are aligned to create a taut, man-made "line" along the naturally sloping crest of a mountain. More concerned with making a provocative gesture than with creating a pleasing sculptural form, Walter De Maria exhibited 1,600 cubic feet of earth in a German art gallery, carpeting three rooms with a two-foot layer of wall-to-wall dirt. Perhaps the most comprehensive earthwork was conceived by Piero Manzoni, who designed the metal pedestal shown here in a Danish park. If the viewer stands on his head (or turns the photograph upside down), Manzoni's base can be interpreted as supporting the entire earth—the largest found object yet.

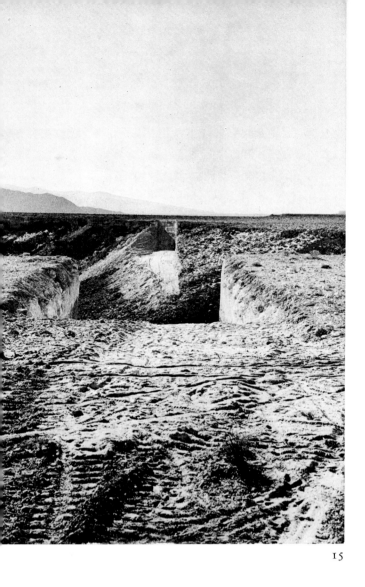

15

and spectacles, displaying terrestrial ambitions that culminate most dramatically in his wrapping of a one-mile coast in Australia. The epic Australian venture suggests a desire to have design control not only over the urban, man-made environment, but over all of nature as well, and certainly points to a brand-new role for the artist—perhaps a self-aggrandizing role as arbiter of natural resources, environment, and ecology. In activating outdoor spaces on a gigantic scale, Christo displays heroic and potentially romantic ambitions that link him to the recent sculptural development known as "earth art" (figures 13–15). A mere ten years ago, "environmental" still sounded big when it described an art work that sprawled through one or more rooms. The art environments of several years ago now look merely room-sized in the light of an entirely new kind of spatial sensibility advanced by the "earth artists," who impose their patterns and forms upon vast stretches of nature. It is surely no accident that the proliferation of earthworks coincides with the first manned space flights to the moon, which have stretched our consciousness of distance, and the first lunar photos of the earth, which have heightened our awareness of the planet as a coherent, whole object.

One of Christo's earliest attempted assaults upon nature was in a 1966 project for *Packed Trees* (plate 105), which involved bundling in plastic the crowns of about forty live trees near the City Art Museum in Forest Park, St. Louis. Nursery trees are commonly found with both their roots and crowns wrapped, and it is also common to see trees temporarily wrapped as protection against frost or during transport. But it would have been a startling sight to see a grove of trees with shrouded crowns in a natural park setting. Christo wanted to wrap the trees in winter, when they were leafless and dormant, but the project fell through because the university that owned the park opposed it.

Along similarly vegetative lines, Christo has draped tarpaulin over baled hay (plate 203), a project that recalls his propagandistic student days in Bulgaria, and he has wrapped the roots and crowns of a couple of reclining trees—a thirty-three-foot-long birch (plate 104) and a fifty-eight-foot-long oak (plate 206). The recumbent trees are unmistakably anthropomorphic, probably because their elongated silhouettes recall the attenuated figures of Giacometti. The anthropomorphic quality prompted *Time* magazine to observe that Christo "can embalm a slender sapling so that it lies with the mute pathos of Pearl White bound and gagged on the railroad track."[25] The reference to the human figure seems intentional, especially if one compares the projects for packed trees (plates 204–5) with the project for a wrapped nude girl (plate 202). Indeed, Christo has actually packaged nude girls (plates 42–46) on several occasions, the first being in 1963 for a European film, titled *Packaging a Woman*.

The idea of wrapping ground first occurred to Christo while developing a series of proposals for New York's Museum of Modern Art in the spring of 1968. One of his projected schemes was the packaging of the Abby Aldrich Rockefeller Garden in plastic fabric (plates 141–42), shrouding the entire area: trees, pools, statuary, stairs, and all of the terrace garden, sixteen feet above the sculpture garden. The wrapping was designed to extend all the way up the garden wall along West Fifty-fourth Street, as well as along portions of the

museum's walls. In indiscriminately blanketing elements of nature, architecture, and statuary, Christo would have created an extraordinarily unified landscape, wholly artificial, yet disturbingly factual.

Christo pursued the idea of ground-wrapping a few months later in a series of projects for a wrapped coast (plates 246–47). He had in mind a continuous, fifteen-mile stretch of "any possible shoreline" anywhere in California, a state he had never visited. As he conceived it, the coast would be blanketed in about thirteen million square feet of plastic fabric, reaching from the ocean's edge and extending across the coastal highway, and secured by an irregular network of ropes. "I picked the shoreline," the artist said, "because the earth starts where the sea ends. The sea gives the only real geological relief of the earth." From the water, it would have been a startling vision to see the ocean lapping away at a continental package. By wrapping the edge of a continent, Christo would have transformed what was merely "peripheral" into something more concrete and discrete, giving a quasi-architectural entity to natural terrain. In terms of sculpture, it would have been a flat, ground-plane work that reached 0-degree sea level. Christo intended from the beginning that the plasticized terrain provide a tactile as well as visual experience, with spectators being permitted to walk upon the wrapped ground. He sent plans, sketches, and photomontages to a couple of California museums, which he hoped might help sponsor the project, but he never received a favorable reply.

Christo did succeed in wrapping a shoreline the following year, 1969, when he created his most spectacular "package"—the mile-long wrapped coast at Little Bay, near Sydney, Australia (plates 257–304). The rock-bound coast, blanketed in opaque plastic fabric, had the guise of a totally synthetic landscape, a setting worthy of science fiction, or as Jan van der Marck described it, "the most fully artificial landscape experience this side of the Sea of Tranquility."[26] At the very least, the wrapped coast was one of the most extraordinary images and memorable art spectacles of the 1960s. As a uniform surface, the extensive wrapping had the effect of masking out coloristic and textural details while, at the same time, it also seemed to emphasize existing contours, bulges, and depressions, bringing them into sharper and more perceptible relief. The actual shapes and contours of the site became prominently displayed in a way that was not previously discernible. The shrouded coast contrasted decisively with the surrounding "unwrapped" environment. Natural phenomena such as sea, sky, wind, sun, and rain seemed, from the center of the package, to be strangely unreal (the sea and sky were much too blue!), as if all of nature had been put into a new context.

From the first day, the actual wrapping attracted throngs of visitors, particularly on weekends when curious sight-seers drove to the beach to see how it was progressing. The official "opening" day lured 2,500 spectators. The sheer size of the project seemed to impress most viewers. Even those who had come prepared to scoff, and who still refused to accept it as art, had to concede the site was dramatically transformed. The wrapped coast appeared deceptively soft and elastic, but the billowing swags and folds of plastic fabric concealed jagged rocks and gaping holes. Visitors, seldom certain of where they were

walking, had to tred cautiously in order to avoid impaling themselves on sharp stones and spiky scrub, or plunging into dangerously deep crevices. The physical ordeal was complicated by the blinding reflectiveness of the plastic, which was smooth underfoot, and especially treacherous near the surf's edge, where it was often wet and slippery. Still, it was possible to imagine that you might slide down the draped cliffs without fatal injury. And despite the hazards, many adventurous spectators fully enjoyed the combined sensations of sight, smell, and touch that were offered in such abundance.

The Australian venture originated in the fall of 1968, when Christo had the good fortune to receive a visit from John Kaldor, a Hungarian-born textile man from Sydney, who was in New York on a business trip. Being an art collector, Kaldor sought out Christo with the intention of purchasing a work and ended up buying a small black package. When he returned to Australia, Kaldor wrote to Christo, asking whether he would be interested in visiting Australia and, while he was there, "perhaps give a couple of lectures" and "arrange an exhibition."[27] The Sydney textile company that Kaldor worked for sponsors an annual sculpture scholarship of $3,000, and Kaldor thought it would be "much more interesting for the development of art appreciation in Australia, if instead of sending a promising local artist overseas, we would invite an outstanding young person to Australia, so that both the local artists and the public would benefit from his presence."[28] To his surprise, Kaldor received a hasty reply from Christo, saying that while he was in Australia he would like to execute a most ambitious project—a packaged coast.

Kaldor was amazed by the idea but, in February, 1969, he set about looking for a site. "You can't ring up the various departments and ask to speak to somebody to borrow a piece of land for packaging,"[29] Kaldor explained. "First of all, it's quite a strange idea for most people. Then if you have longer hair than the normal citizens of Sydney, speak with an Hungarian accent, and ask for a coast to be packaged up, it's somehow a little bit too much for the ordinary civil servant. Just to make an appointment to explain what I wanted to do, I had to be as cagey as an insurance salesman. After two or three weeks, I got to see the Minister for Lands, who thought I was absolutely crazy but said so very politely. Then I saw the person in charge of all the parks and wildlife, who thought I was absolutely crazy—and said so *not* so politely. He was terribly worried what damage it would do to the insect life. The parks people said it was completely out of the question and they would try to oppose it wherever they could."

Kaldor's next step was to contact Sydney's art establishment, soliciting letters of endorsement from critics, curators, dealers, and professors. "They all wrote glowing letters," he reported, "saying how important it would be for art in Australia for this project to take place. While some people expressed their personal dislike for Christo's work, or would not have chosen him as the one artist to come out, they thought that to give Sydney an opportunity to witness Christo's work would be tremendous for the general improvement of the art situation in Australia. They all tried to help the project, even if they didn't like it, or understand it, or weren't interested in it. There was not one professional in the art field who tried to do something to jeopardize the project."

Kaldor at no point attempted to obtain the full fifteen miles of coast that Christo requested, explaining that "to get fifteen miles you'd have to go thousands of miles outside Sydney." He was determined that the wrapped coast should be accessible to as large a public as possible, so he concentrated on getting one mile of "representative and interesting" coast near Sydney. He soon discovered, however, that there was not even that large a stretch of coast in private hands; in fact, there were few places within city limits that were not government owned.

Then Kaldor learned that Prince Henry Hospital, situated on Little Bay, nine miles south of Sydney, owned an extensive tract of shore. Moreover, it proved to be a surprisingly varied piece of land, sloping from eighty-four-foot headlands at the northern end to a sandy beach at the southern end. He promptly contacted the head of the hospital, saying he was "sponsoring an artistic project and would like a sculpture to be executed on the beach. If I had said I wanted the beach wrapped up, I would have been directed to the medical department right down the corridor." To Kaldor's surprise, the hospital's chief executive officer was intrigued by the proposed wrapping and offered to present the project at the next directors' board meeting, where, to everyone's amazement, it was approved. The immediate result was that the nurses went on a one-week strike in protest of the wrapping of the beach, which was one of their prime recreational facilities.

The next step was to have the coast photographed and surveyed, so that Christo could get some idea of the topography—a variegated terrain with jagged cliffs, averaging fifty feet in height, a deep gully, often used as a rubbish dump, and a flat, sandy beach. The site was documented so thoroughly in aerial photographs and contour maps that Christo, without leaving New York, was able to make accurate scale models and collages (plates 245, 252–53, 255–56) which closely approximated the final results.

Christo and Kaldor, though separated by half the world, together investigated various wrapping materials—reinforced paper, aluminum sheeting, canvas, jute, and dozens of others, some of which were put through extensive tests for strength and durability at the University of Sydney. They finally settled upon a loose-woven polypropylene, normally used to prevent soil erosion caused by wind and rain. Polypropylene is lightweight, extremely strong, and relatively impervious to salt spray and water. But its chief advantage in this case was that it was porous enough to disperse the wind without too much billowing.

From the moment the project was publicly announced, it received massive and relentless attention from the news media. The wrapped coast was satirized by cartoonists, condemned by conservationists, defended by culture-hungry columnists, and ended up as a national *cause célèbre,* the most controversial art project in Australia since the still uncompleted Sydney opera house. By the time Christo arrived in Sydney on the first day of October, he was greeted as an international celebrity.

Most of the adverse criticism was addressed to the issue of ecology, which proved to be one of the most positive contributions of the packed coast: it actually heightened the public awareness of Sydney's citizens of their own coastal environment. An editorial in the *Sun*

(June 12, 1969) warned: "It threatens to result in the biggest blow-around of litter Sydney has ever seen."[30] From a simple litter problem, the project was escalated into a more serious menace by the *Sun-Herald* (July 20, 1969), in an article headlined "Wrapping Little Bay Could Hurt Wild Life," which observed that the packed coast "could lead to the death of insects and the killing off or stunting of plant life."[31]

In August, Kaldor wrote a letter in which he explained: "The press assumed from the rough mockups that a continuous plastic filament will be used, which could cause damage to whatever living vegetation and marine life there may be there. In fact, Christo will use a woven polypropylene fabric of the type used to prevent soil erosion, which is of loose enough construction to allow air and moisture to circulate. I am convinced that there will be no damage done, as on top of this precaution, we will not cover areas affected by the tide where there is some plant and marine life. The covering will be restricted mainly to the cliff face which is completely barren."[32]

A reporter from the *Daily Telegraph* went out to investigate the site and informed his readers (October 13, 1969) that "the organizers assured me that no shrubbery would be covered. Since in this shrubbery live and feed hundreds of birds, any covering with plastic would mean they would die of starvation. . . . There is, of course, still a chance that in the rock crevices some young fairy penguins will slowly starve to death because their parents have been too frightened to brave the mass of plastic."[33] Certain official sources maintain that fairy penguins have not been seen in the area for fifty years.

About a week before the project started, according to Kaldor, "we got terribly worried about the safety aspect and we went to see the man in charge of the Sydney Police Rescue Squad—they pick up people off cliffs who want to commit suicide, or fishermen who are trapped, and things like that. They said that while they could not help in an official capacity, they would rescue anybody who was stuck. They suggested that we engage the services of a retired major in the army engineering corps, who is also the president of the Sydney Rock Climbing Club and a conservationist as well, and so we hired the chap as site engineer." In addition, because of potential dangers to workers and sight-seers, the project was heavily insured with general liability coverage, which resulted in a high premium, even though both the underwriter and broker donated the cost of their services.

Initially, the coordinators had hoped that a large manufacturing company would donate the plastic fabric, but it turned out that the particular kind of fabric they wanted was produced only by a small company, which was not in a position to donate it, but instead reduced the price by half. The initial order of 20,000 yards of 152-inch-wide woven polypropylene cost $10,000.[34] By the time the project was finished, the total cost of the original and additional orders of plastic fabric was reckoned at $16,000. To expedite the wrapping process, the polypropylene, which had been woven on special looms to the already exceptional width of 152 inches, was transferred to another factory, where three to six rolls at a time were sewn together to provide working lengths of two sizes: 38 × 600 feet, and 72 × 300 feet. The cost of sewing, rerolling, and delivering the larger bolts of fabric to

the site was $5,000. In addition, 35 miles of polypropylene rope were ordered at a list price of $4,125 but, because of a donation from the Australian Rope and Cordage Association, the actual cost was only $2,200.

Having secured materials and technical assistance, the coordinators set about obtaining labor. But gathering labor for the project proved to be neither as easy nor as cheap as anticipated. Besides the site engineer and four foremen, all of whom were on a weekly salary, there were a dozen or so professional rock-climbers, whose dangerous and exciting task it was to scale the cliff face, stitch together the lengths of fabric, and fire threaded steel studs into the sandstone with Ramset guns, after which the ropes were affixed to the rivets. A few of the rock-climbers were retained on a weekly basis, while the rest were paid a daily fee of $20.

To facilitate vocal communications, which were often difficult because of high winds and the long distances involved, portable two-way radio transmitters were set up and the broadcasting, which passed through a central control in Sydney, could be monitored by people at home and ships at sea.

The actual wrapping commenced October 5, with an enthusiastic, if sporadic, labor force comprised of Sydney college students. Among the unpaid volunteer workers were ten first-year architecture students from the University of Sydney, who worked full time over a thirty-day period, an additional sixty to eighty university students, who were available for four days, two to four Australian artists, who worked full time during the thirty-day period, and one student from East Technical College. The students seemed to enjoy the work, stimulated perhaps by the grandeur—or the absurdity—of the project, and apparently pleased to be participating in what they took to be an event of momentous significance for Sydney. Unfortunately, the wrapping coincided with exam time, and many of the students were unable to appear regularly. On Sunday, October 19, not a single student appeared on the site. The coordinators were forced to hire more paid laborers (there were forty to sixty hired workers, paid by the hour) in order to finish the job in the scheduled time. In the meantime, a night patrol of four watchmen was engaged to prevent nocturnal vandalism. (At dawn, October 13, hoodlums started a fire at the nearby garbage dump, but the watchmen called out the fire brigade, which extinguished the blaze before any damage was done.) Upon completion of the packed coast, total man-hours were logged at 17,000. Once realized, the wrapped coast required a four-man maintenance team during the four weeks it was open to the public.

Despite the attempted arson and the almost daily toll of bodily injuries (which made everyone appreciate the nearness of Prince Henry Hospital), the greatest calamity came from the South Pole in the form of a violent storm. On October 15, the polypropylene wrapping, designed to withstand winds of ninety miles an hour, was subjected to an unexpected gale of one hundred miles an hour, which thoroughly lacerated about a third of the fabric along the cliff face. The destroyed section was at the northwestern end, the highest and most difficult section to drape, and the most vulnerable to wind. The wrapping that had been well secured with ropes resisted the gale well. But along the northwestern

section, the enormous sheets of plastic fabric, which had just been draped over the cliff-side, had not yet been secured with ropes when the gale suddenly arrived. Along the upper edge of the cliffs, a sharp upward draft intersected the lateral wind, causing the fabric to thrash about in contradictory directions, heaving and tossing like a white plastic land mass in an apocalyptic earthquake. The tattered fabric had to be junked and replaced with $4,000 worth of new material. Because of this setback, the wrapped coast was not completed until October 28.

Of the many questions that were raised, the most recurrent was: How did Christo's wrapped coast differ from a collapsed circus tent? This seemingly naive question, which figured in much of the critical discussion, was in fact a hostile attempt to deny any art quality to the endeavor by claiming to find it indistinguishable from a non-art event. Admittedly, there is a slight visual correspondence between a large canvas tent lying flat on the ground and a large area of land shrouded in plastic fabric. Most tents, of course, have a geometric form, usually polygonal or circular in design. A circus tent has pretty much the same form wherever it is erected, and no matter how wildly it collapses, some trace of its original shape remains. Being portable, a circus tent can be transported almost anywhere without significantly altering its configuration. More important, a circus tent, whether up or down, remains distinct from the setting, an additive element in the landscape. Christo's coastal wrapping has a more ambiguous, almost symbiotic relationship with the environment, having no real existence apart from the particular terrain of Little Bay. A rocky coastline requires custom packaging and, while the fabric covering may be transported, the terrain that informs it is not movable. The wrapping objectifies the landscape without becoming a discrete object in its own right. It is both object and environment at the same time.

Even if a spectator were incapable of discerning any visual distinction between a collapsed circus tent and a tract of wrapped land, he might be expected to comprehend the enormous discrepancy in method and intention. Christo did not simply drop or drape a canvas tent—or any other similar ready-made object—on the ground and then designate the act to be a work of art. He had to make a number of aesthetic decisions: the choice of material (fabric of a particular color, weight, and texture), the particular location (a seacoast, rather than a riverbank or valley), the extent to which it would be wrapped (stopping just short of the horizon line and just short of the water's edge), the manner in which it would be wrapped (loosely fitted or tightly swathed), how the ropes should be tied (in a regular grid or following the contours of the terrain). Because Christo's version looks so authoritative, it is easy to believe this is the one and only way to wrap a coast. But once accustomed to the idea, it is possible to imagine that someone else might have wrapped the same site quite differently. In artificial grass, for instance, or blue velvet with gold tassels.

The most common complaint, as usual, was about the enormous cost, the much-publicized "waste" of materials, money, and human labor. The engineering department of the University of Sydney estimated that, if the sponsors had had to pay the full price for all the materials and services, the cost of the packed coast would have been about $120,000.

Because so much was donated, the actual cash outlay was only $56,000. Even that cut-rate sum might make someone ask: Was it worth it? Which in turn leads to the question: What is the worth of any art work in relation to the public's material and moral values? Unfortunately, there is no way of measuring the aesthetic worth of an art work against its ultimate value to society. Clearly, it was the seemingly absurd scale of the endeavor, as well as its temporariness, that made cost a prominent issue. But Christo's success in enticing money, materials, and labor from so many sources would seem to indicate that society (or at least some segments of it) is less hardheaded and materialistic than we might suppose. So far as Christo was concerned, the cost was negligible—no more than what many communities might spend on an art festival. The project was, in fact, a "bargain" in terms of its yield: a vast public spectacle that entertained thousands of spectators for two months and, through the news media, engaged the minds of millions all over the world.

Having restricted himself to the seemingly limited idea of packaging, it is amazing that Christo should have been able to uncover so many unexpected implications and pursue them with such unnerving logic. In the process, he has cut across many styles and concerns of art, and brought into sharp focus several vital questions about the social responsibility of the artist and the changing role of patronage. At the same time, he has illuminated broader public issues and concerns: his temporary spectacles, or so-called waste, focus attention on the implications of a product-oriented society and heighten the public's awareness of the importance of urban planning and the conservation of natural resources. By appropriating and wrapping familiar objects, buildings, and sites, making them visible in new ways, he has created a wide range of disturbing and strangely beautiful art works that collectively call for a double take.

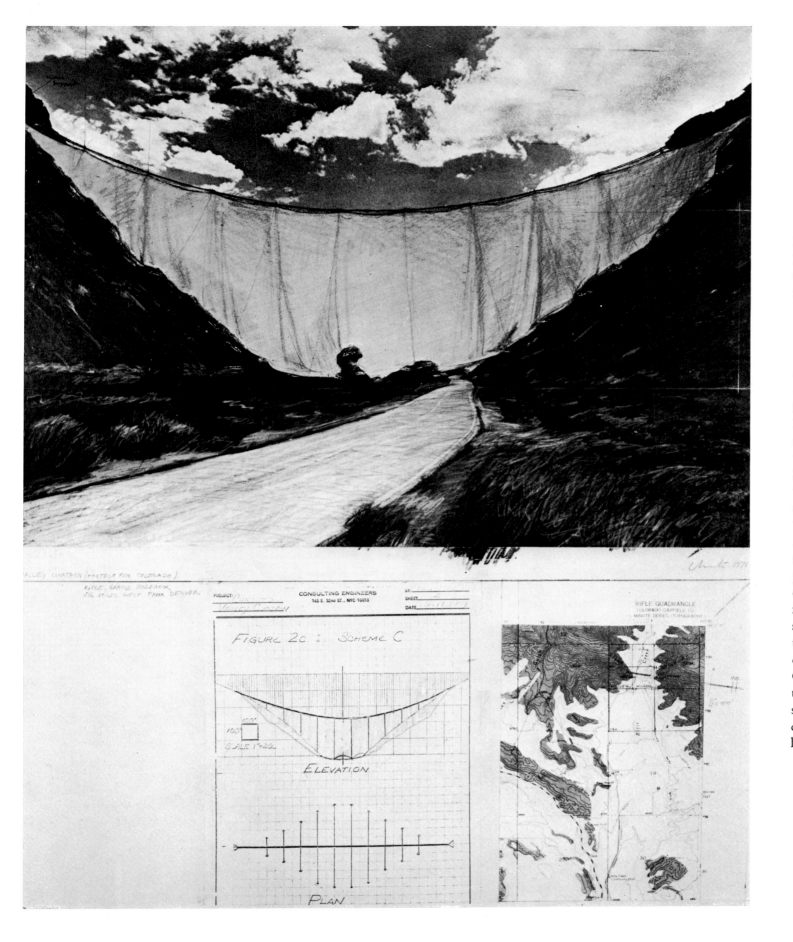

Figure 16. CHRISTO. *Valley Curtain*. Project for Colorado. 1971. Photostat, colored pencil, fabric, and map, 28 × 22 in.

Christo plans to erect the *Valley Curtain* during the summer of 1971, in the Grand Hogback area of the Rocky Mountains near Rifle, Colorado, 216 miles west of Denver. It will consist of approximately 250,000 square feet of an orange woven-synthetic fabric. Weighing some 25 tons, it will span 1,250 feet, with a height sloping from about 365 feet at either end to about 200 feet at the center. The curtain, suspended by about 1,400 feet of steel cable, will be anchored in concrete foundations to the two mountainsides. The specifications were drawn up by Lev Zetlin Associates, Inc., consulting engineers in New York City. The *Valley Curtain* will partition the valley on a northwest-southeast axis, so that its appearance constantly alters in the changing light.

NOTES TO THE TEXT

Christo's quoted remarks, unless otherwise attributed, were made to the author in conversation.

1. Jan van der Marck. "Why Pack a Museum?" *Arts Canada* (October, 1969), p. 35.

2. Lawrence Alloway. "Christo and the New Scale," *Art International,* vol. 12, no. 7 (September 20, 1968), p. 57.

3. Arthur D. Little, Inc. *The Role of Packaging in the U.S. Economy,* report to the American Foundation for Management Research, Inc. (1966), p. 3.

4. Jan van der Marck. Essay in *Christo,* catalogue of the exhibition at the National Gallery of Victoria, Melbourne (October, 1969), p. 12.

5. *Ibid.*

6. Pierre Restany. Excerpts from "A Metamorphosis in Nature," preface in *The New Realists,* catalogue of the exhibition at the Sidney Janis Gallery, New York, 1962.

7. Daniel Spoerri. *An Anecdoted Topography of Chance,* New York: Something Else Press, Inc. (1966), p. 181.

8. Originally published as *Topographie Anecdotée du Hasard,* Paris: Editions Galerie Lawrence, 1962. Subsequently published as *An Anecdoted Topography of Chance,* in a "re-anecdoted version" with English translation by Emmett Williams, New York: Something Else Press, Inc., 1966.

9. Pierre Restany. Preface in *Arman: A New Look Upon the World,* catalogue of the exhibition at Galleria Schwarz, Milan, 1968. ("L'accumulation des objets de même nature suggère *davantage* et *autre chose* qu'un objet unique, considéré isolément.")

10. William S. Rubin. Preface in *Christo Wraps the Museum,* brochure of the exhibition at the Museum of Modern Art, New York, 1968.

11. Stephen S. Prokopoff. Essay in *Christo: Monuments and Projects,* catalogue of the exhibition at the Institute of Contemporary Art, University of Pennsylvania, Philadelphia, 1968.

12. Yves Klein. *Le dépassement de la problématique de l'art,* La Louvière, Belgium: Montbliart, (1959), p. 4. Quoted by Sidney Simon in "Yves Klein," *Art International,* vol. 11, no. 8 (October 20, 1967), p. 24.

13. Ronald Hunt. "Yves Klein," *Artforum* (January, 1967), p. 34.

14. Pierre Restany. "Yves Klein: Latest Prophet of Europe," in *Yves Klein,* catalogue of the exhibition at the Jewish Museum, New York (1967), p. 12.

15. Willoughby Sharp. *Air Art,* New York: Kineticism Press (1968), p. 8.

16. *Ibid.*

17. Prokopoff, *op. cit.*

18. Jan van der Marck. "Why Pack a Museum?" *op. cit.,* p. 34.

19. *Ibid.*

20. *Ibid.,* p. 35.

21. *Ibid.,* p. 36.

22. Jan van der Marck. Preface in *Christo: Wrap In Wrap Out,* catalogue of the exhibition at the Museum of Contemporary Art, Chicago, 1969.

23. Sherman E. Lee. *Art News,* vol. 68, no. 2 (April, 1969), p. 27. Van der Marck evidently saw himself as the target of even harsher criticism. In his article "Why Pack a Museum?" he noted: "Sherman E. Lee, as quoted in the *New York Times,* March 9, 1969, counts me among 'the heathen who have defiled the sanctuary' for allowing Christo to package the museum thus proving that 'the new Museum of Contemporary Art in Chicago is dedicated to vaudeville.' In fact, Van der Marck was not quoting Lee but was instead quoting John Canaday, who was obviously paraphrasing Lee's remarks in his article "Dayton, Dayton, Rah, Rah, Rah!" *New York Times* (March 9, 1969), section II, p. 25.

24. Franz Schulze. "Why the Wrap-In?" *Panorama—Chicago Daily News* (January 25, 1969), p. 5.

25. "All Package," *Time* (February 7, 1969), p. 60.

26. Jan van der Marck. Essay in *Christo, op. cit.,* p. 14.

27. John W. Kaldor. Letter (February 12, 1969) reproduced in *Christo: Wrapped Coast, One Million Square Feet,* Minneapolis, Minnesota: Contemporary Art Lithographers, (1969).

28. *Ibid.*

29. Kaldor's quoted remarks, unless otherwise attributed, were made to the author in conversation in October, 1969.

30. "All Wrapped Up," *Sun,* Sydney (June 12, 1969).

31. Peter Simon. "Wrapping Little Bay Could Hurt Wild Life," *Sun-Herald,* Sydney (July 20, 1969).

32. John W. Kaldor. Letter (August 1, 1969) reproduced in *Christo: Wrapped Coast, One Million Square Feet,* Minneapolis, Minnesota: Contemporary Art Lithographers (1969).

33. "Wrap-Up," *Daily Telegraph,* Sydney (October 13, 1969).

34. John W. Kaldor. Letter (August 1, 1969), *op. cit.*

BIOGRAPHICAL OUTLINE

1935 Christo Javacheff born June 13 in Gabrovo, Bulgaria

1952–56 Studied at the Fine Arts Academy in Sofia

1956 Studied stage design in Prague

1957 Studied one semester at the Vienna Fine Arts Academy

1958 Established residence in Paris. First packages and wrapped objects

1961 First one-man exhibition (Galerie Haro Lauhus, Cologne). Exhibited stacked oil drums and dockside packages alongside Cologne Harbor. First project for the packaging of a public building

1962 *Wall of Oil Drums,* a temporary "iron curtain" of oil drums, erected on Rue Visconti, Paris

1964 Established residence in New York City. First store fronts

1966 First one-man museum show (Stedelijk van Abbemuseum, Eindhoven, The Netherlands). First air package (Eindhoven). Second air package *(42,390 Cubic Feet Package)* made at the Minneapolis School of Art in conjunction with a show at the Walker Art Center, Minneapolis, Minnesota

1968 One-man show at the Museum of Modern Art, New York: "Christo Wraps the Museum; Scale Models, Photomontages, and Drawings for a Non-Event." Largest inflated sculpture *(5,600 Cubic Meter Package)* made for Documenta 4 in Kassel, West Germany. Largest store front *(Corridor—Store Front)*, covering an area of more than 1,500 square feet, also exhibited at Documenta 4. Packaged tower and fountain at the Festival of Two Worlds in Spoleto, Italy. First packaging of a public building (Kunsthalle, Bern). *1,240 Oil Drums* exhibited in one-man show at the Institute of Contemporary Art, Philadelphia

1969 Second packaging of a public building (Museum of Contemporary Art, Chicago). *Wrapped Floor* made for one-man show at the Museum of Contemporary Art, Chicago. *Wrapped Coast, One Million Square Feet* realized at Little Bay, Sydney Australia. One-man show at the National Gallery of Victoria, Melbourne

1971 Project for *Valley Curtain,* Rifle, Colorado

2. *Packed Bottles and Cans*. 1958–60. Cans, bottles, lacquered canvas, and twine, 11 × 29 × 11 in. Collection Jeanne-Claude Christo, New York City

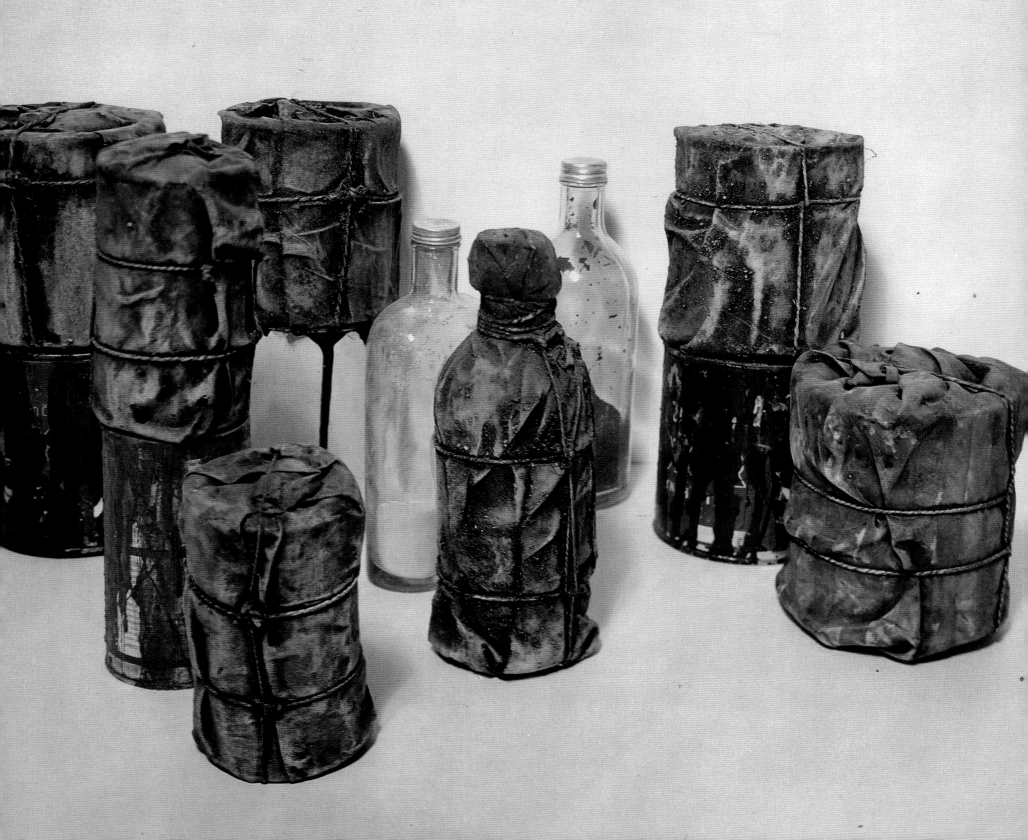

3. *Packed Car (Renault)*. 1961. Automobile, canvas, and rope, 4 ft. 11 in. ×4 ft. 11 in.×14 ft.
4. *Packed Chair*. 1960. Wooden chair, canvas, and cord, 32×19×18 in.
5. *Inventory*. Studio view. 1958–60. Barrels, canvas, and rope
6. *Dark Package*. 1963. Cotton and rope, 15×12×5 in. Collection Mr. and Mrs. Martin Visser, Bergeyk, The Netherlands
7. *Package*. 1961. Fabric and rope, 18×16½×6½ in. Collection Jean-Louis Faure, Paris

3

4

5 ▶

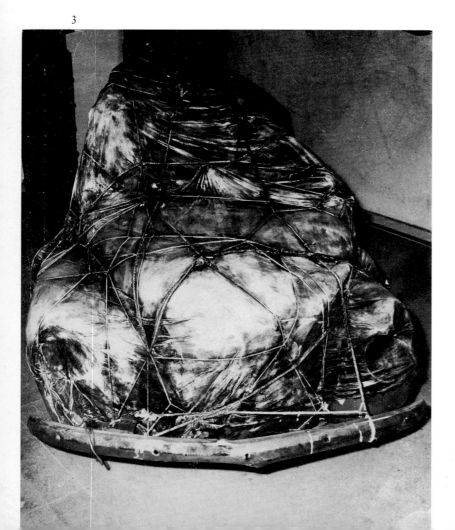

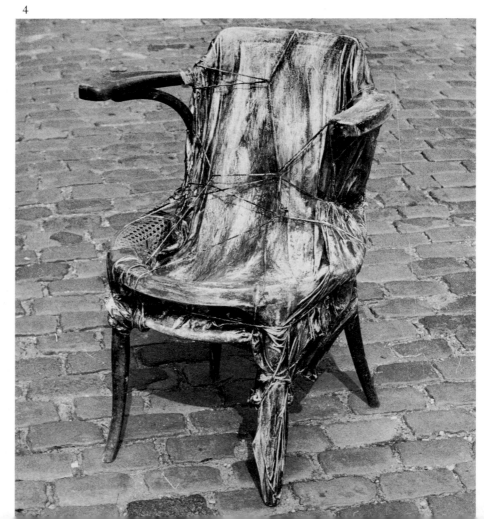

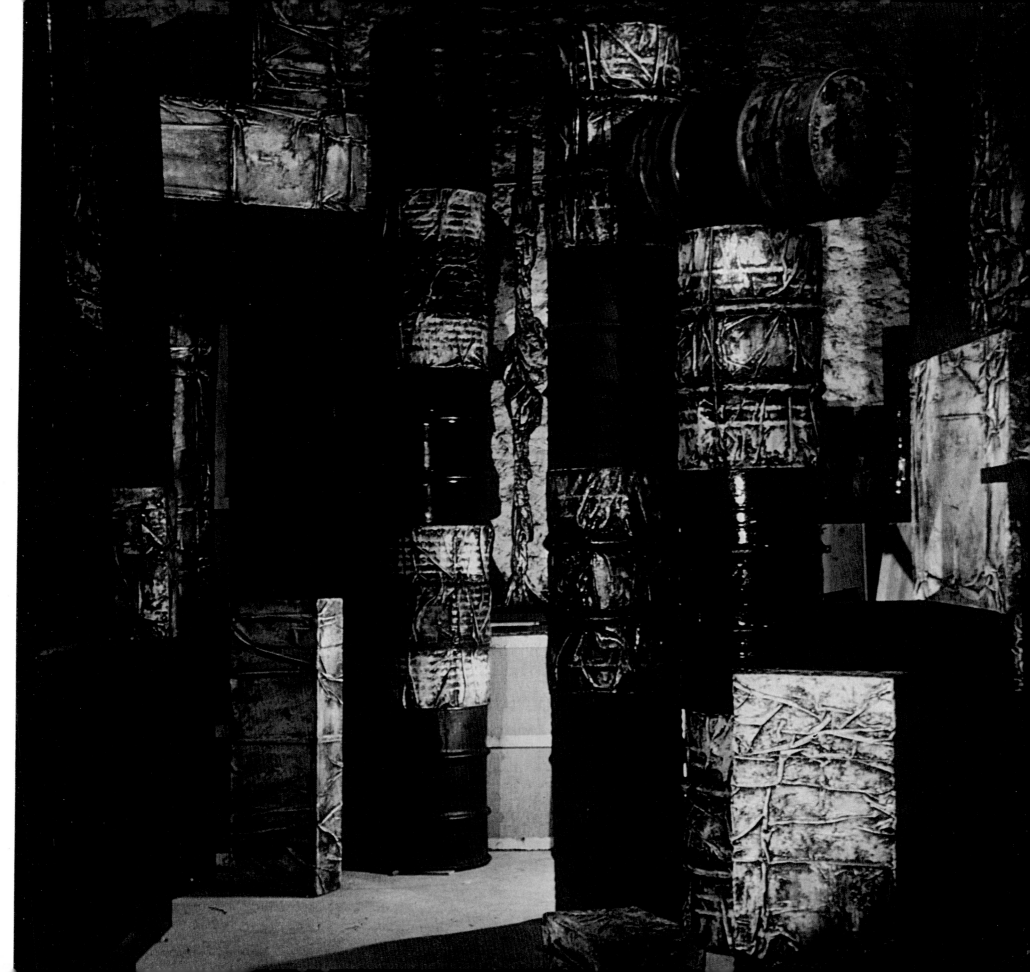

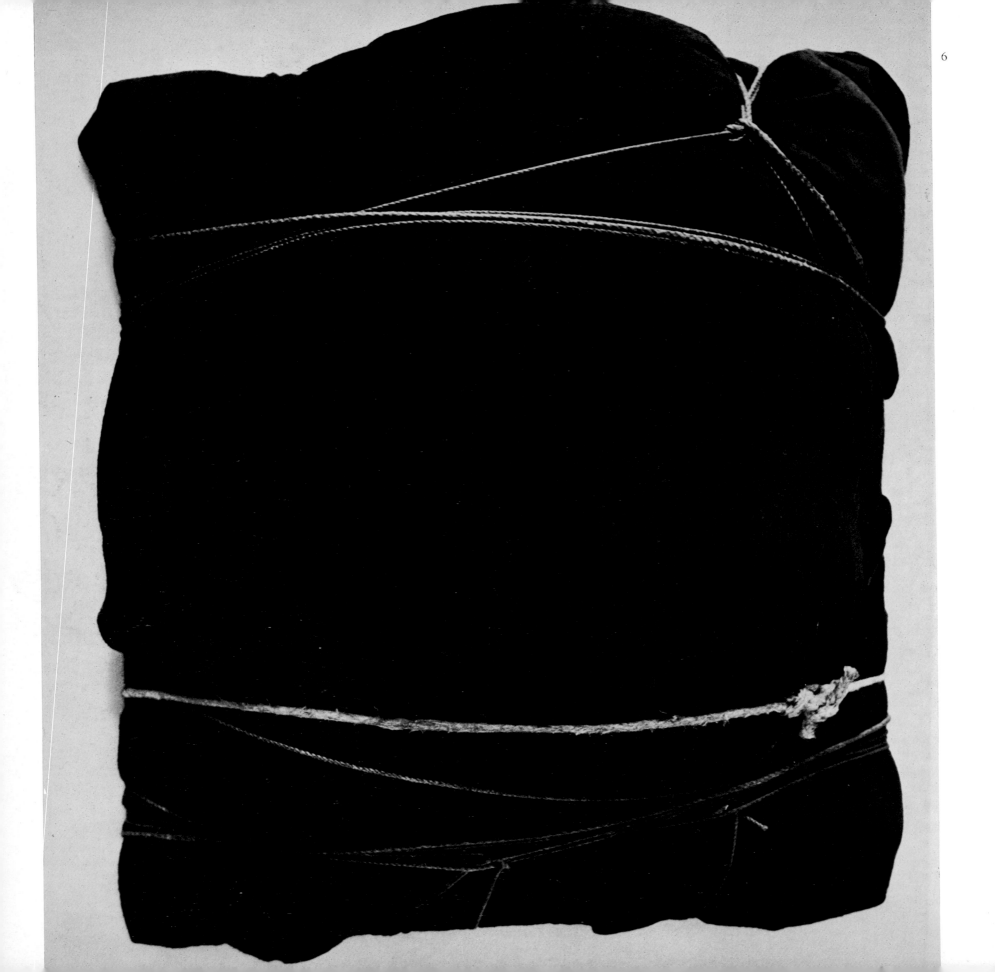

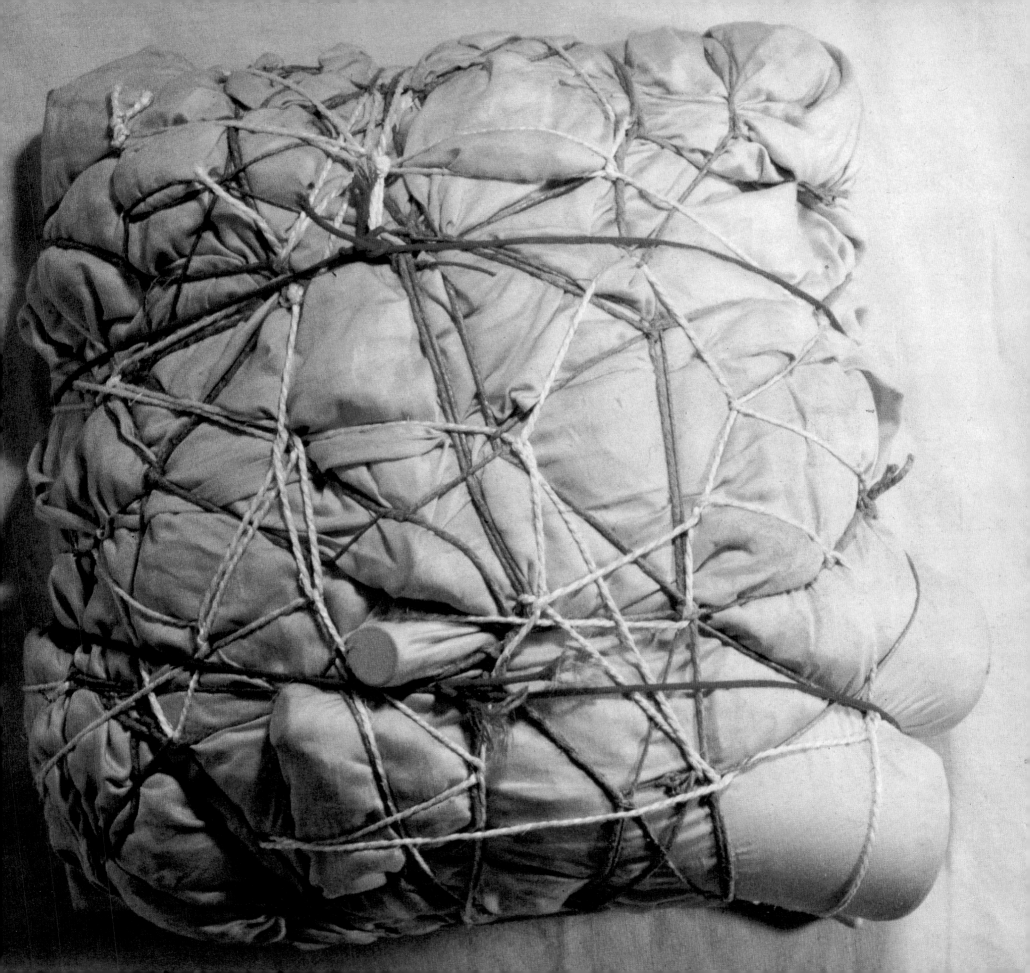

8. *Group of Packages*. 1960–62. Courtyard view. Paris
9. *Dockside Package*. 1961. Rolls of paper, tarpaulin, and
 rope, 16×6×32 ft. Cologne Harbor

8

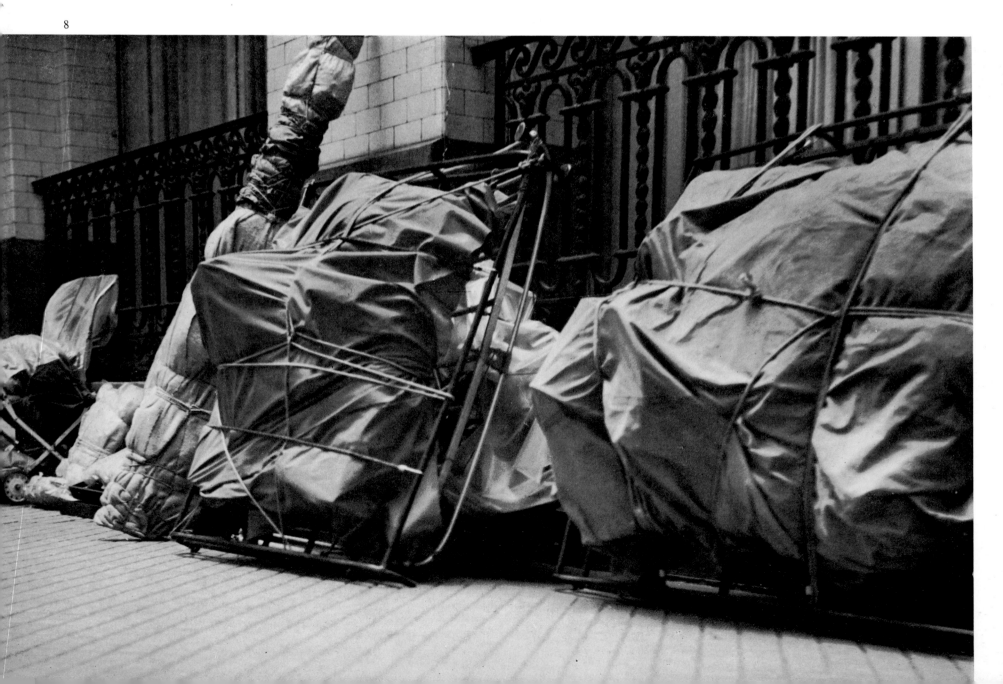

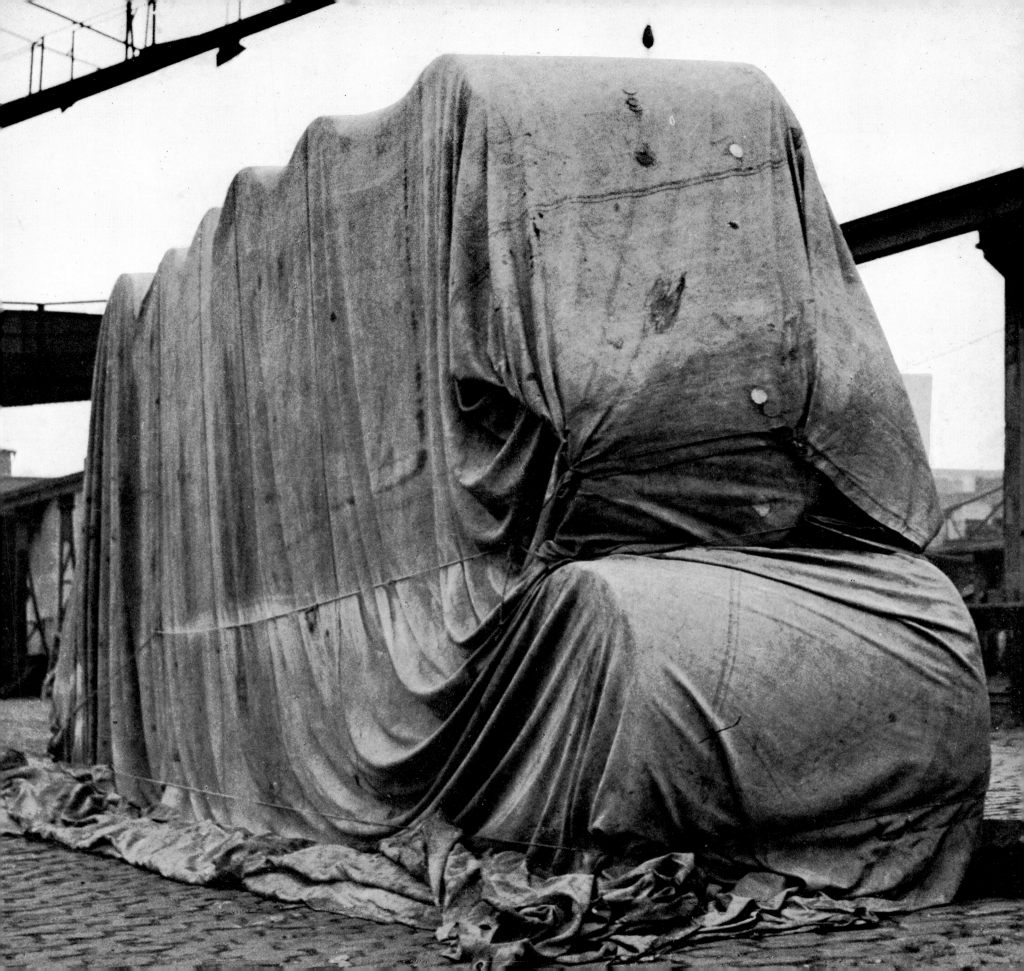

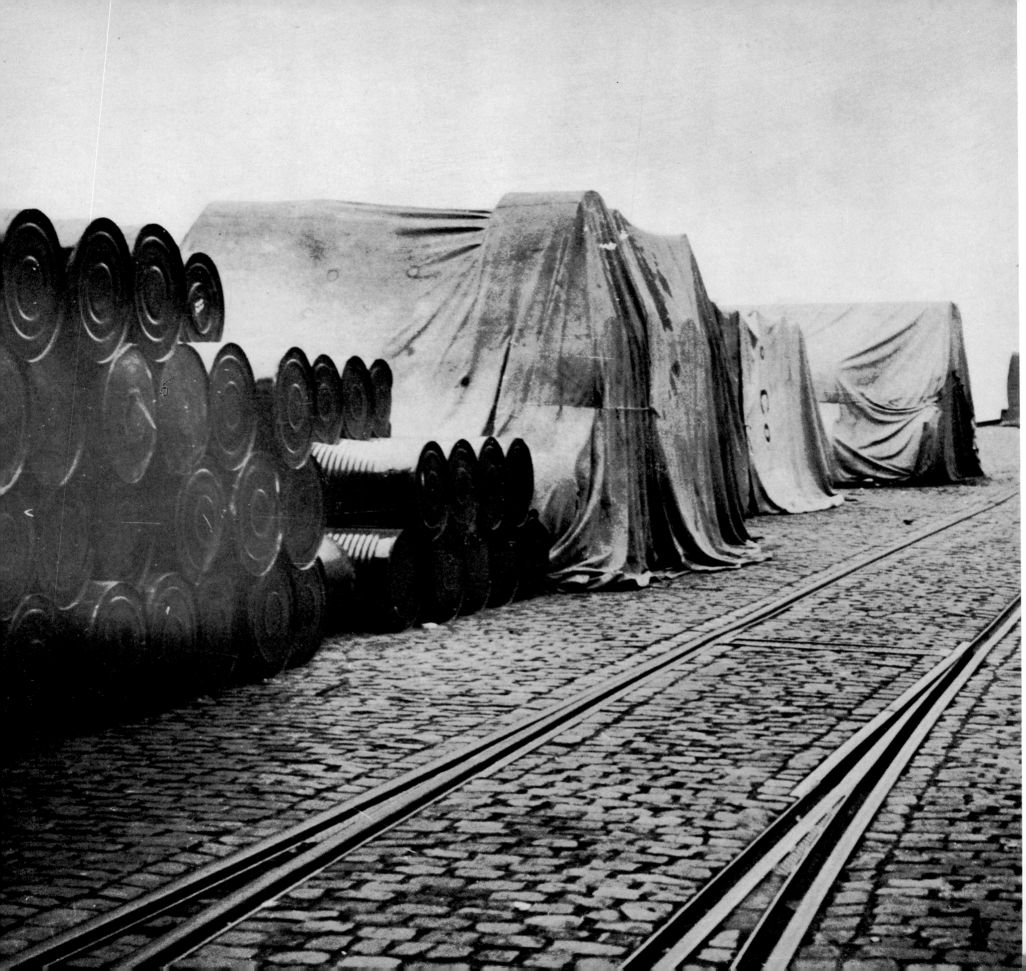

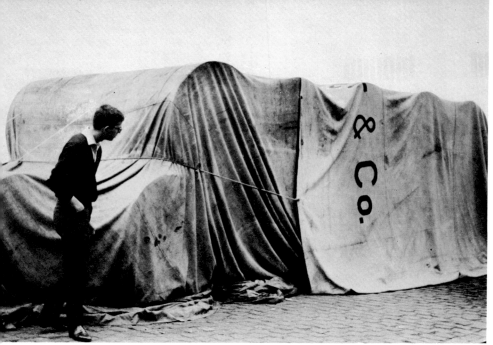

11

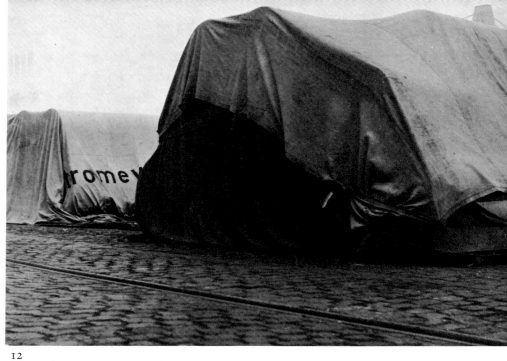

12

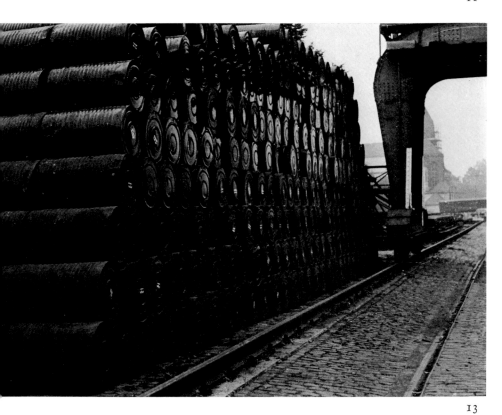

13

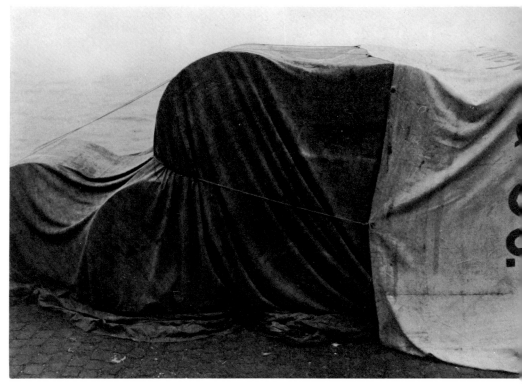

14

10. *Dockside Packages and Stacked Oil Drums*. 1961. Cologne Harbor
11. *Dockside Package*. 1961. Cardboard barrels and tarpaulin. Cologne Harbor
12. *Dockside Package*. 1961. Cardboard barrels and tarpaulin. Cologne Harbor
13. *Stacked Oil Drums*. 1961. Cologne Harbor
14. *Dockside Package*. 1961. Cardboard barrels and tarpaulin. Cologne Harbor

The building should be situated in a vast and regular space. The edifice should be freestanding and have a rectangular base. It will be completely closed up, packed on every side. The entrances will be underground, placed about 50 to 65 ft. from the building.

The packaging of this building will be done with rubberized tarpaulin and reinforced plastic, averaging 33 to 65 ft. in width and with steel cables and ordinary rope. Using steel cables, it will be possible to secure the strong points needed for the packaging of the building.

To obtain the desired result will require about 90,000 sq. ft. of tarpaulin, 6,000 ft. of steel cable, and 25,000 ft. of rope.

The packaged public building can be used as:

1) Stadium with swimming pools, football field, Olympic arena, or hockey and ice-skating rink.
2) Concert hall, conference hall, planetarium, or exhibition hall.
3) Historical museum of ancient and modern art.
4) Parliament or prison.

<div align="right">

CHRISTO
Paris, October, 1961

</div>

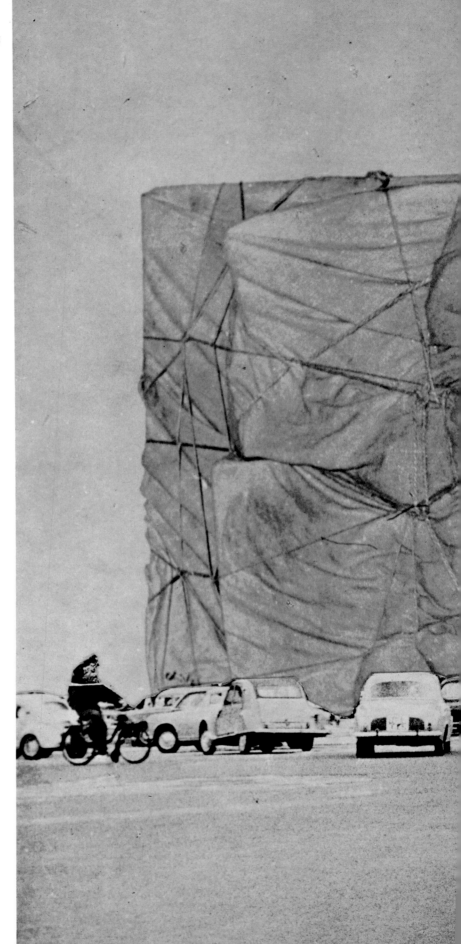

15. *Packaged Public Building*. Project. 1961. Collaged photographs, $7 \times 9\frac{1}{4}$ in.

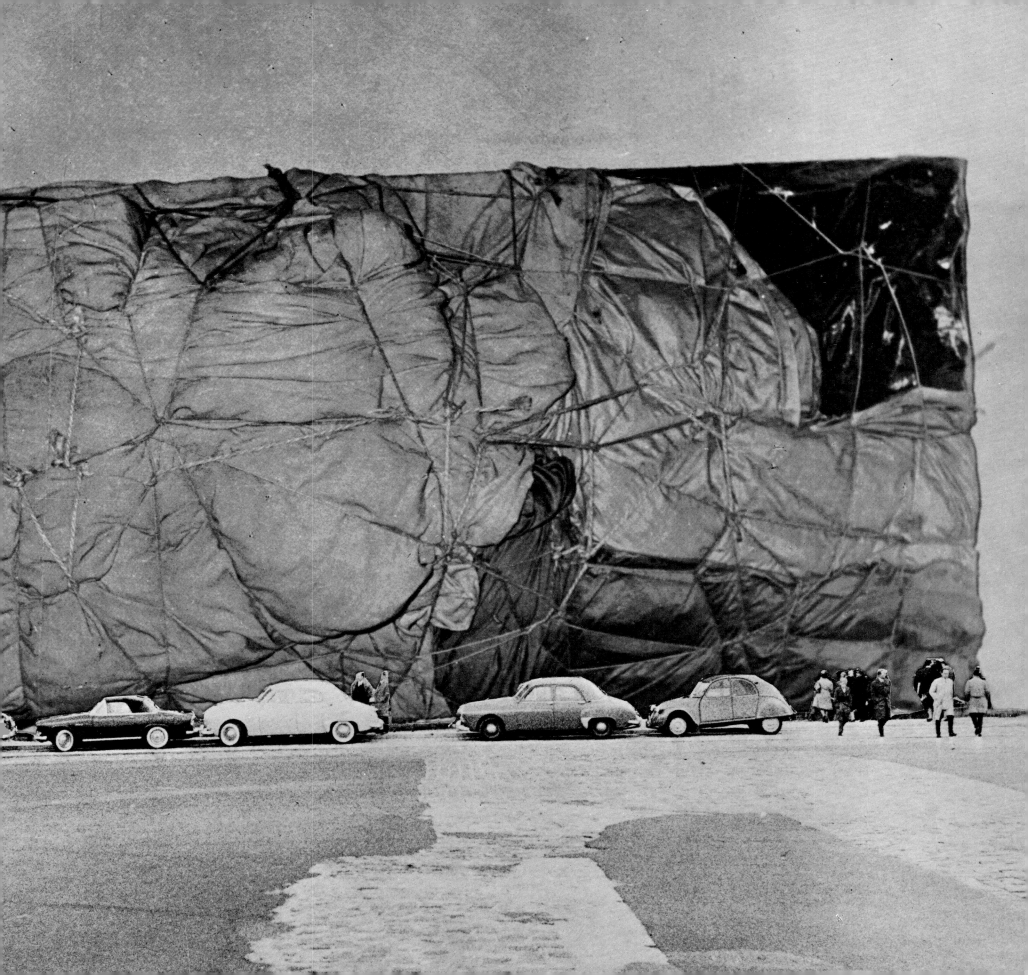

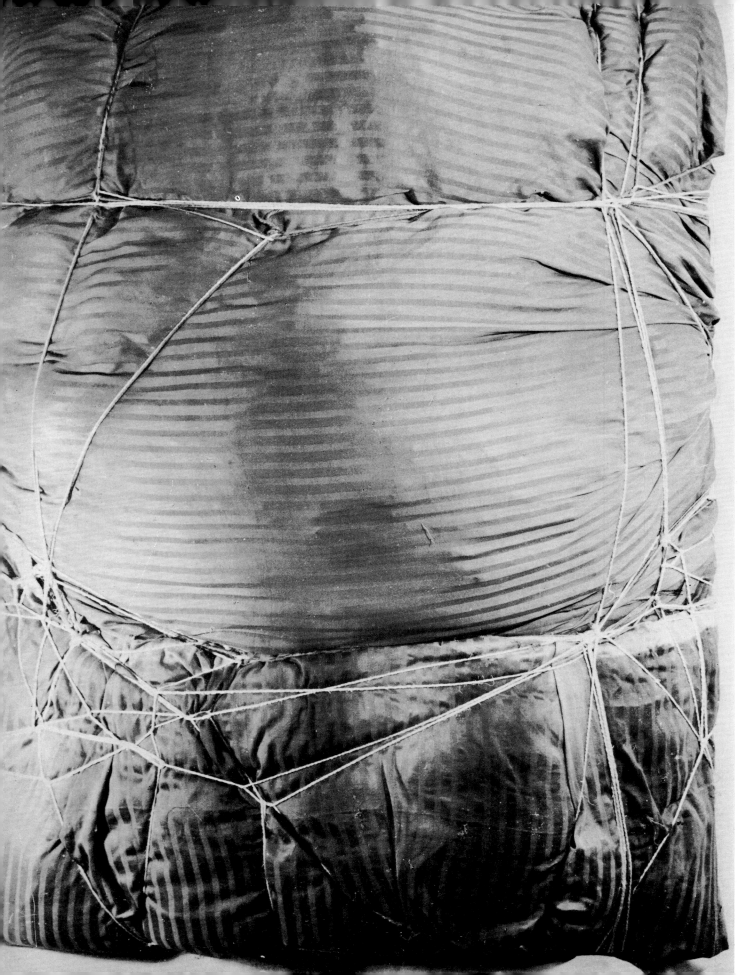

16. *Package*. 1961. Fabric and rope, 32×24×12 in.

17. *Package*. 1961. Fabric and rope, 36½×26×12 in. Private collection, Antwerp

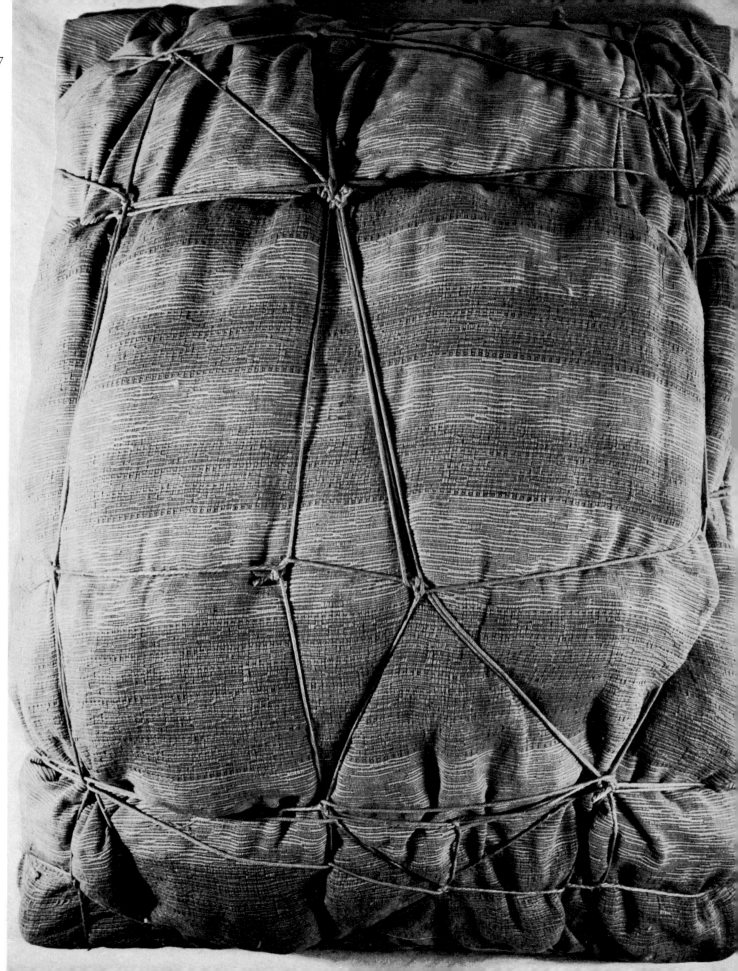

18. *Package*. 1961. Linen and rope, 60 × 96 × 13 in. Collection Mr. and Mrs. Martin Visser, Bergeyk, The Netherlands
19. *Two Chairs Packed*. 1961. Wooden chairs, jute, and rope, $35\frac{1}{2} \times 17 \times 18\frac{1}{2}$ in. Collection Laufs-Krefeld, Kaiser Wilhelm Museum, Krefeld, West Germany

18

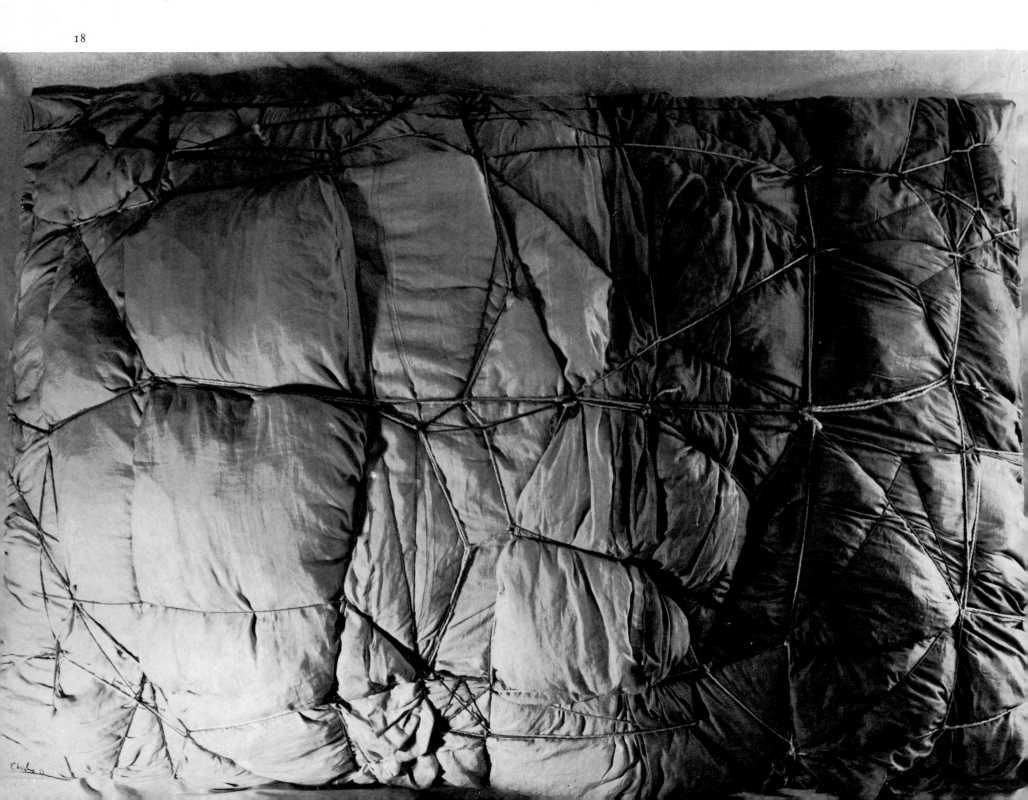

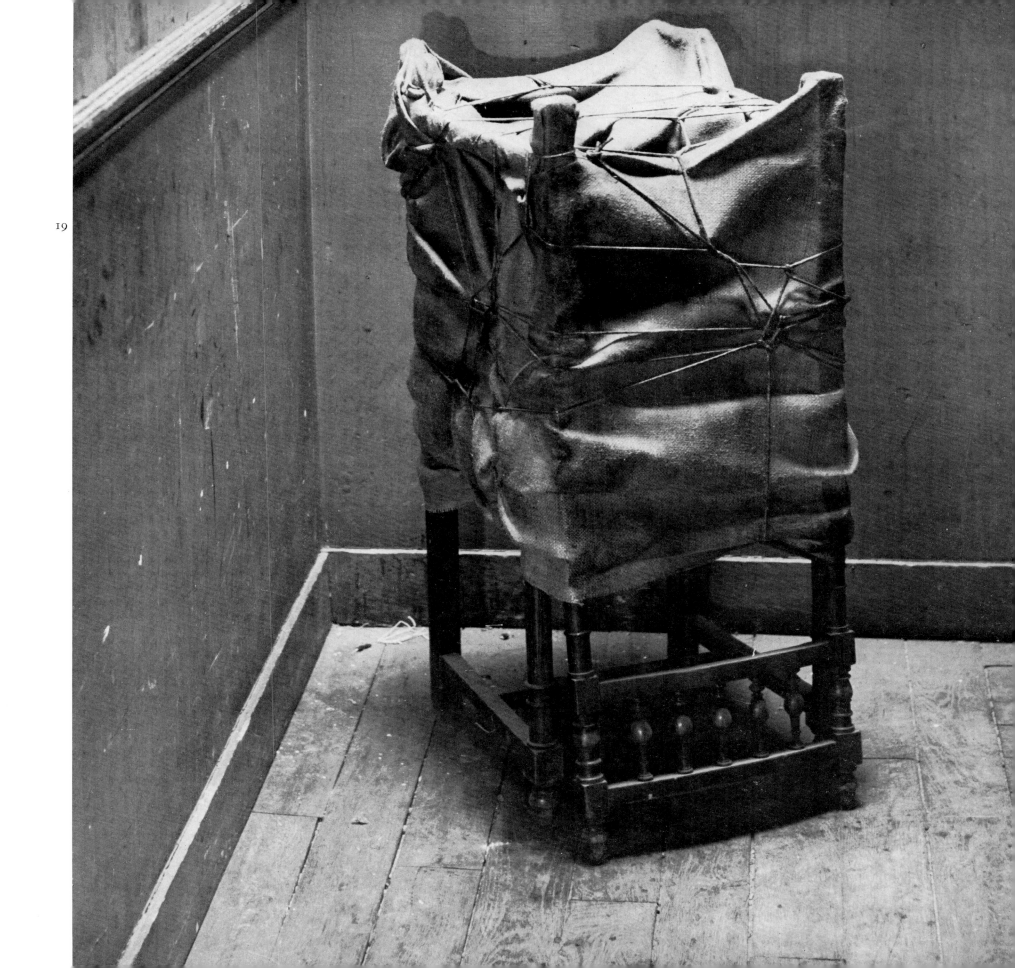
19

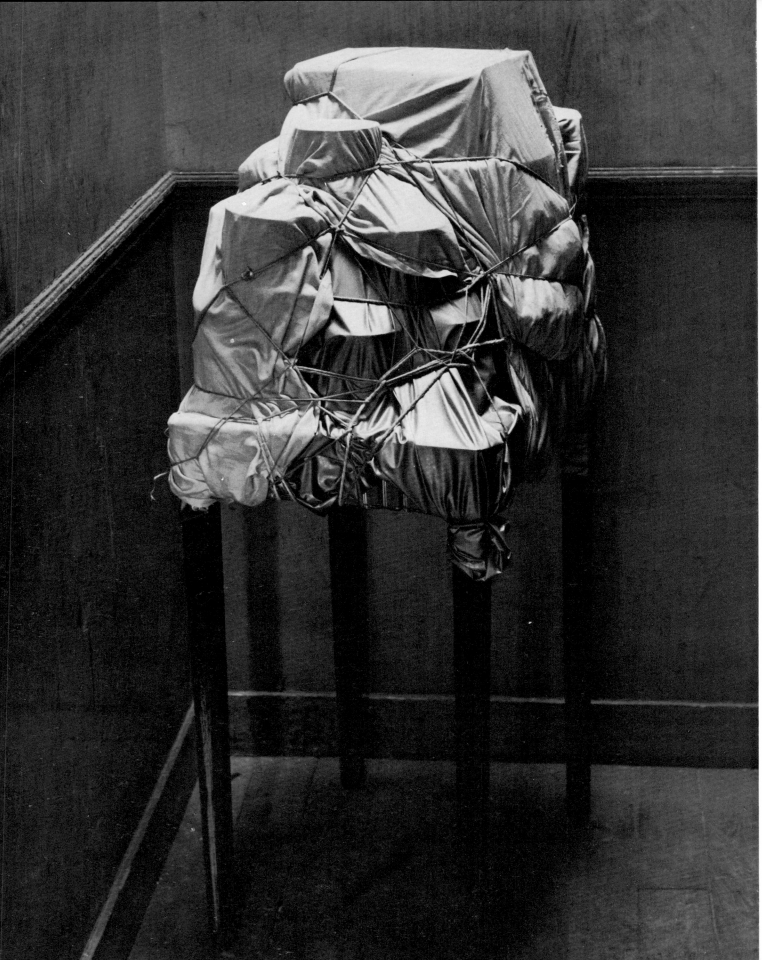

20. *Packed Table*. 1962. Mirrored table, linen, plastic, and twine, $48 \times 21\frac{3}{4} \times 16\frac{1}{2}$ in.
21. *Packed Table*. 1961. Table, linen, and twine, $54 \times 16\frac{1}{2} \times 16\frac{1}{2}$ in. Collection Daniel Varenne, Paris

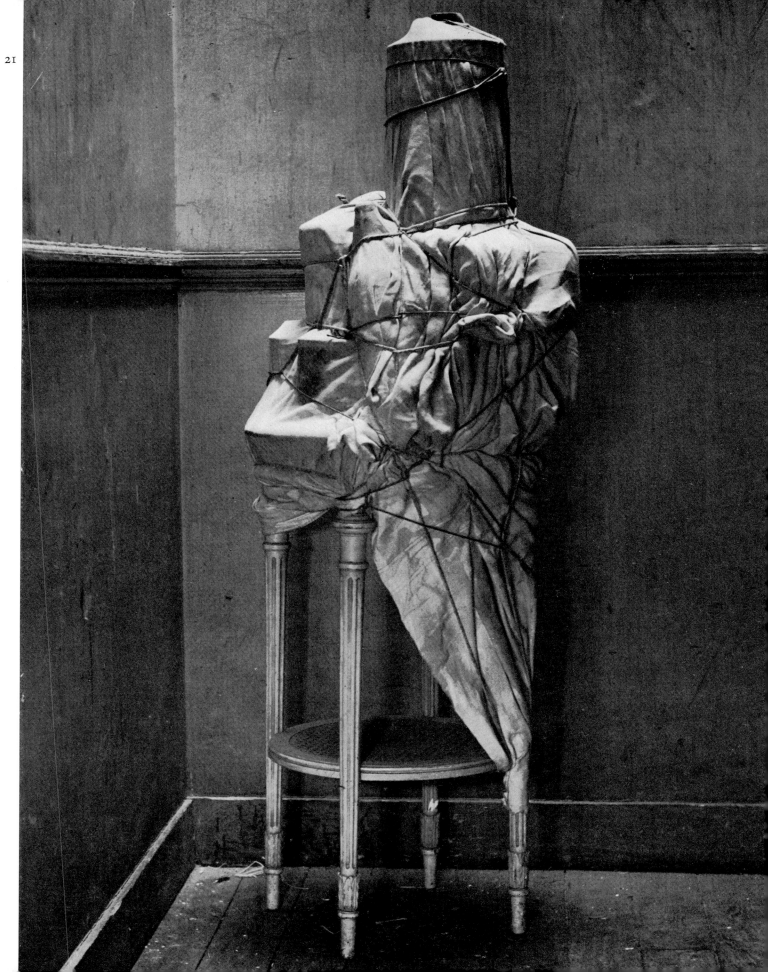

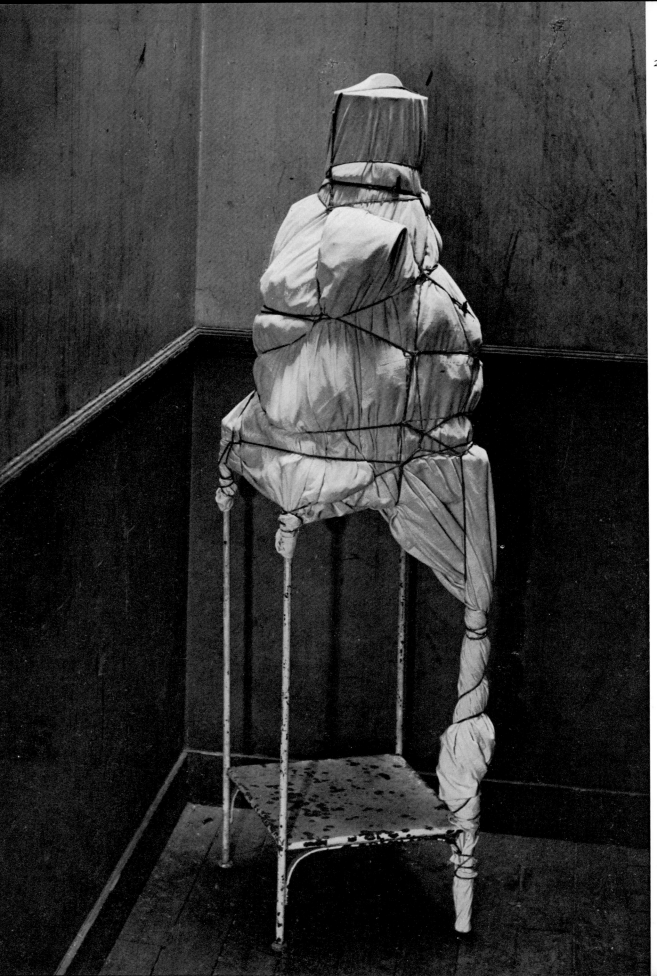

22. *Packed Table with Package*. 1961. Metal, table, fabric, and twine, 57×15×15 in. Galleria Apollinaire, Milan

23. *Packed Table*. 1961. Wooden table, linen, canvas, cans, and twine, $47\frac{1}{4}$×32×15 in. Collection Jeanne-Claude Christo, New York City

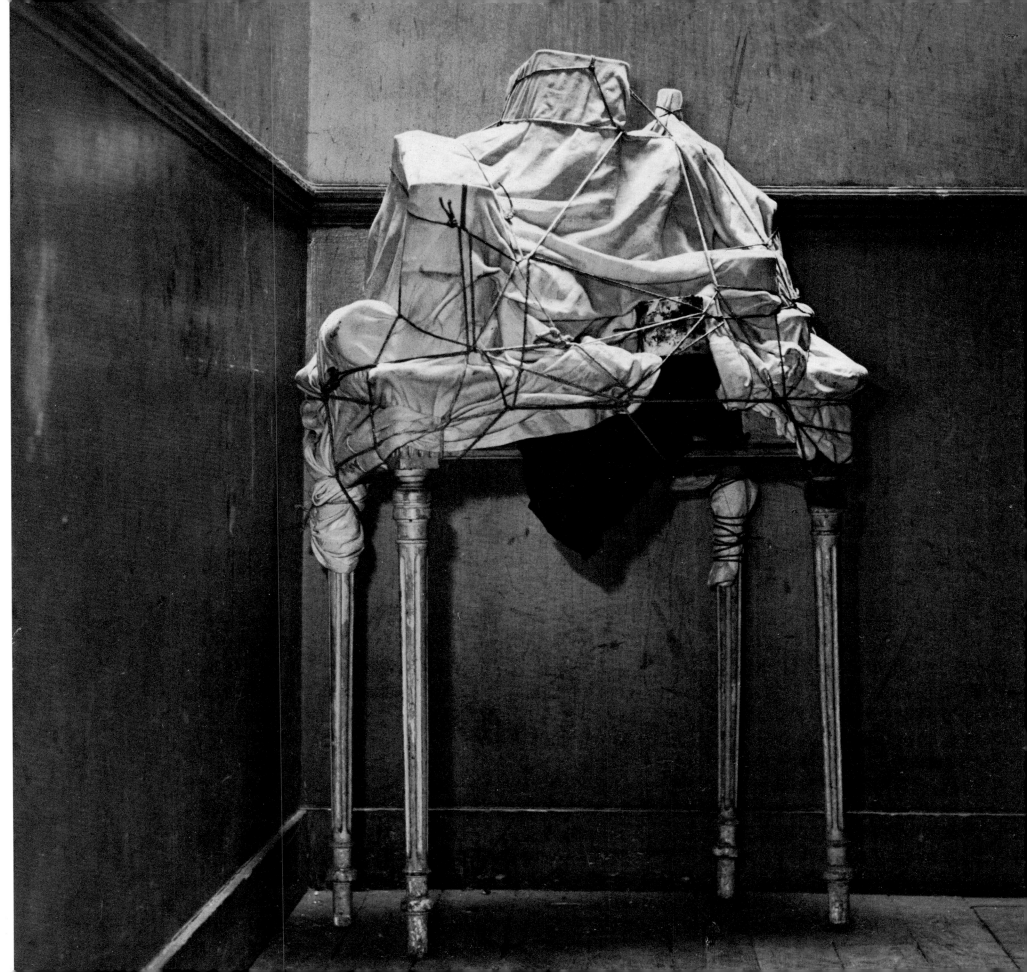

PROJECT FOR THE WRAPPING OF THE ECOLE MILITAIRE

The Ecole Militaire is situated between the Avenue de la Motte Picquet, the Avenue Duquesne, the Avenue de Lowendal, and the Avenue de Suffren. The main facade fronts upon the Avenue de la Motte Picquet and faces toward the Champ-de-Mars by the Avenue Anatole France and the Avenue Pierre Loti, coming out on the Quai d'Orsay near the Eiffel Tower.

I. *The Wrapping*

The wrapping of the main building of the Ecole Militaire involves covering the building with tarpaulins, steel cables, and strong Manila rope. The steel cables will obviate the need for a scaffolding to help the workers. Where the steel cables cross, we will have the strong points that will secure the wrapping.

II. *This Project Can Be Used As:*

1) Protection during maintenance work, the cleaning or repairing of the walls.
2) Monumental presentation for a *son-et-lumière* spectacle.
3) Scaffolding, resembling a package, during an eventual demolition of the building, preserving the normal traffic of passers-by and cars.

CHRISTO
Paris, September–October, 1961

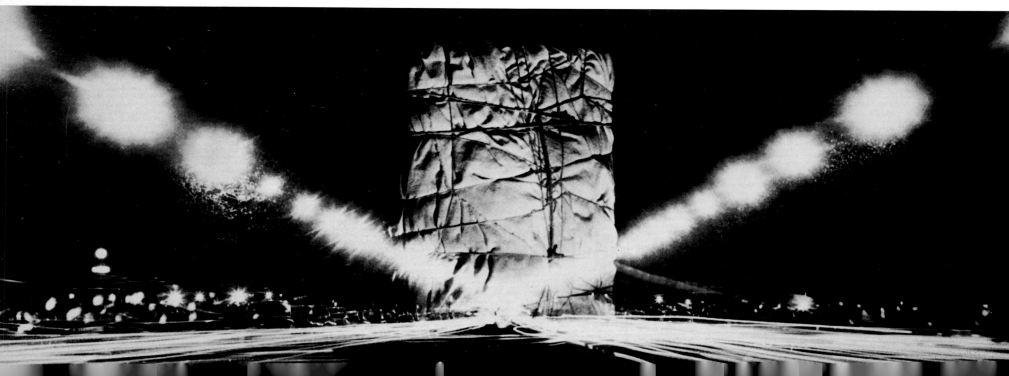

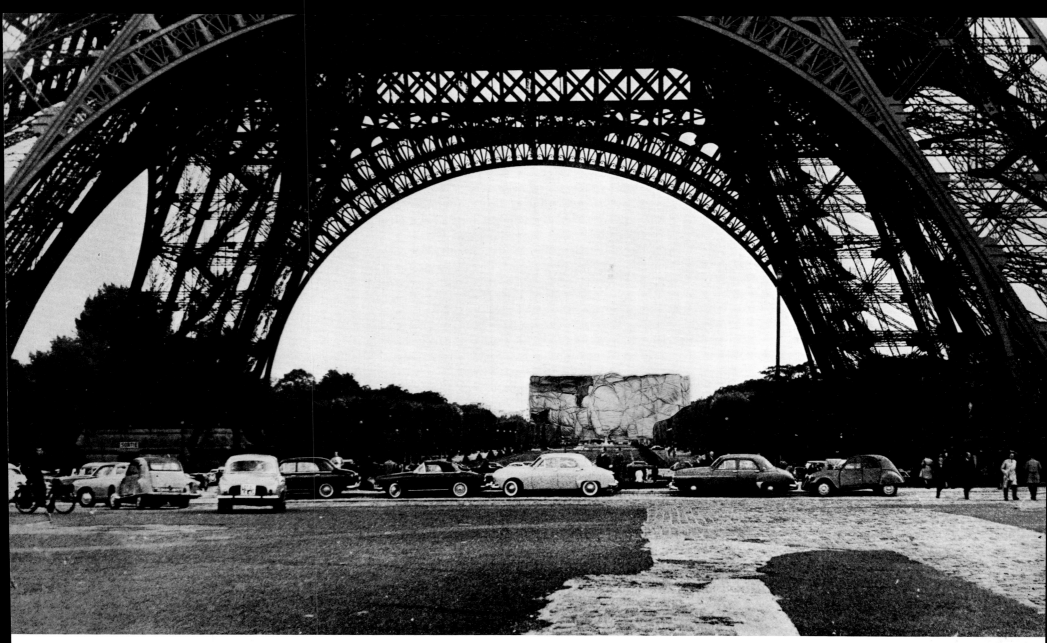

24. *Packaged Building*. Project. 1963. Photomontage, 13×36 in. Collection
 Jeanne-Claude Christo, New York City
25. *Packaged Building*. Project. 1961. Collaged photographs, 7×9½ in.

PROJECT FOR A TEMPORARY WALL OF METAL DRUMS
(Rue Visconti, Paris)

Between the Rue Bonaparte and the Rue de Seine is the Rue Visconti, a one-way street 592 ft. long, with an average width of 12 ft. The street ends at number 25 on the left side and at 26 on the right. There are few shops: a bookstore, a modern art gallery, an antique shop, an electrical supply shop, a grocery store.

The wall will stand between numbers 1 and 2, completely closing the street to traffic, and will cut all communication between the Rue Bonaparte and the Rue de Seine.

Constructed solely with metal drums used for transporting gasoline and oil (labeled with various brand names: Esso, Total, Shell, BP, and with a capacity of either 13 or 52 gals.), the wall will be 12 ft. high and 12 ft. wide. Eight 13-gal. drums, or five 52-gal. drums, laid on their sides, will constitute the base. One hundred and fifty 13-gal. drums or eighty 52-gal. drums are necessary for the erection of the wall.

This "iron curtain" can be used as a barrier during a period of public work in the street, or to transform the street into a dead end. Finally, its principle can be extended to a whole quarter, eventually to an entire city.

CHRISTO
Paris, October, 1961

26

27

26. Aerial view of Paris, showing location of Rue Visconti. 1961
27. View of Rue Visconti
28. *Wall of Oil Drums.* Erected in the Rue Visconti, Paris, June 27, 1962. Oil drums, 13 ft. 8 in. ×13 ft. 3 in. ×5 ft. 4 in.
29. *Wall of Oil Drums.* Installation view in Galerie J, Paris. 1962. Oil drums, 10 ft. ×18 ft. 9 in. ×36 in.
30. *Wall of Oil Drums.* Detail. Oil drums, diameter 14 in. (each)
31. *Stacked Oil Drums.* Detail. 1962. Oil drums, height 48 in. (each). Gentilly, France
32. *Barrel Column.* 1961. 15 ft. ×2 ft. 6 in. ×2 ft. 6 in. Gentilly, France
33–34. *Stacked Oil Drums.* 1962. 12 ×55 ×39 ft. Gentilly, France

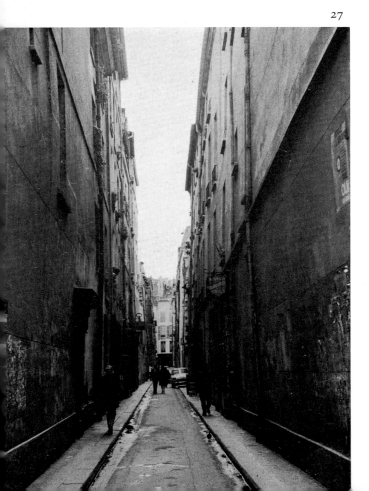

28 ▶

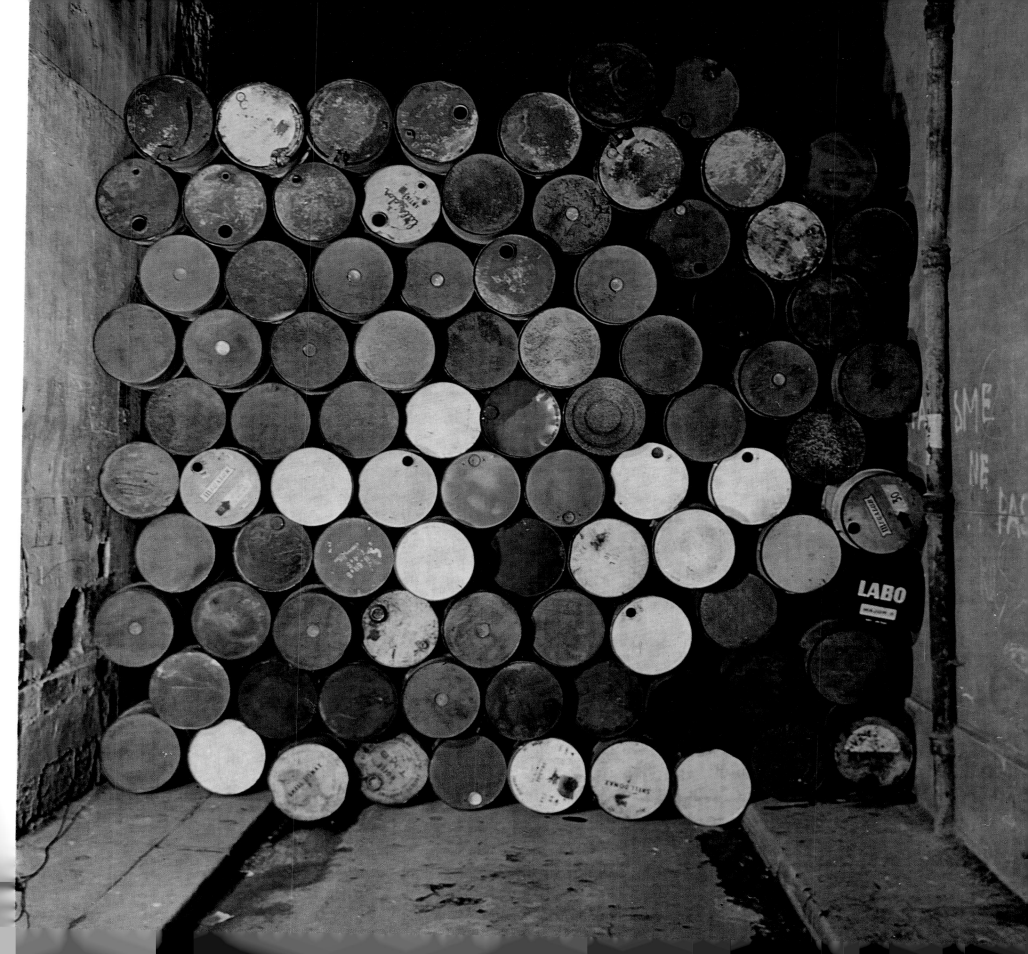

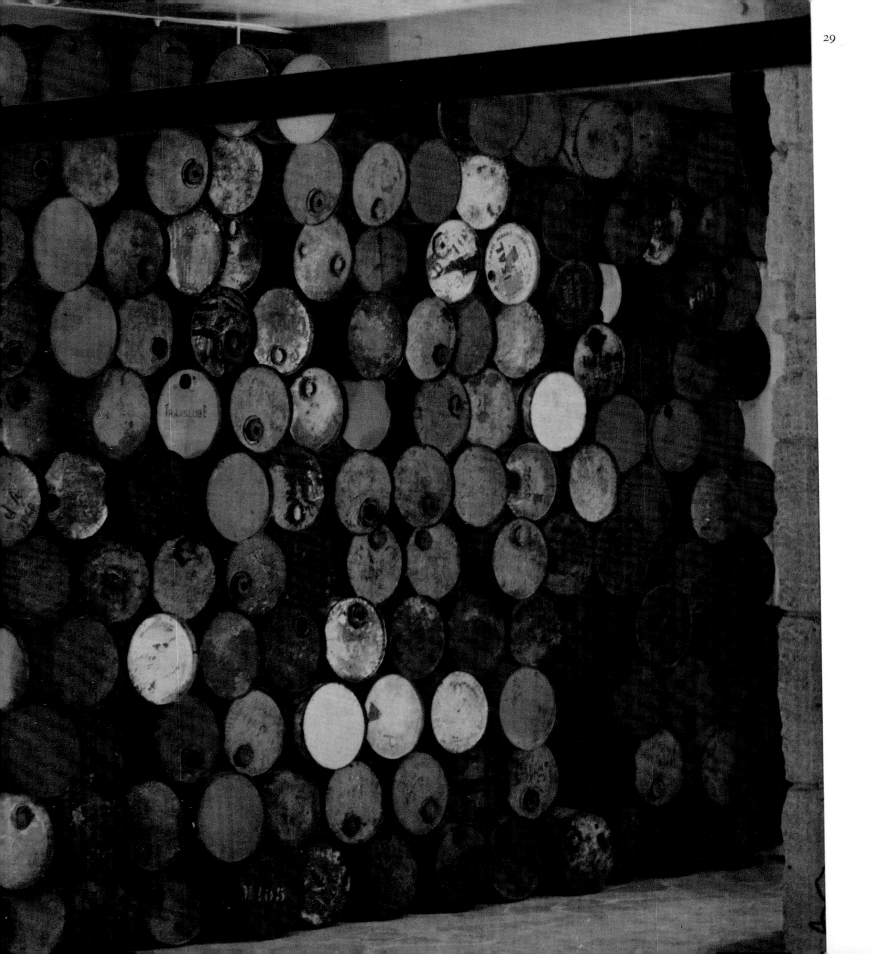

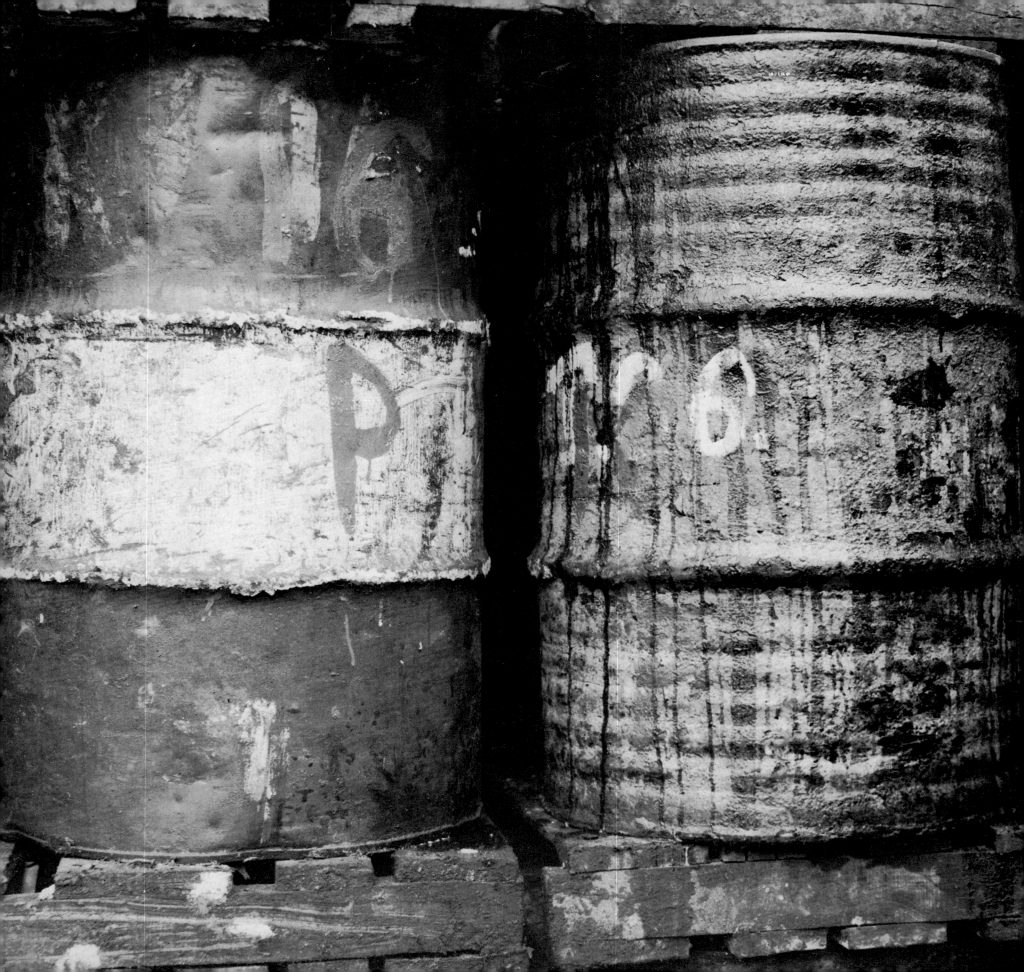

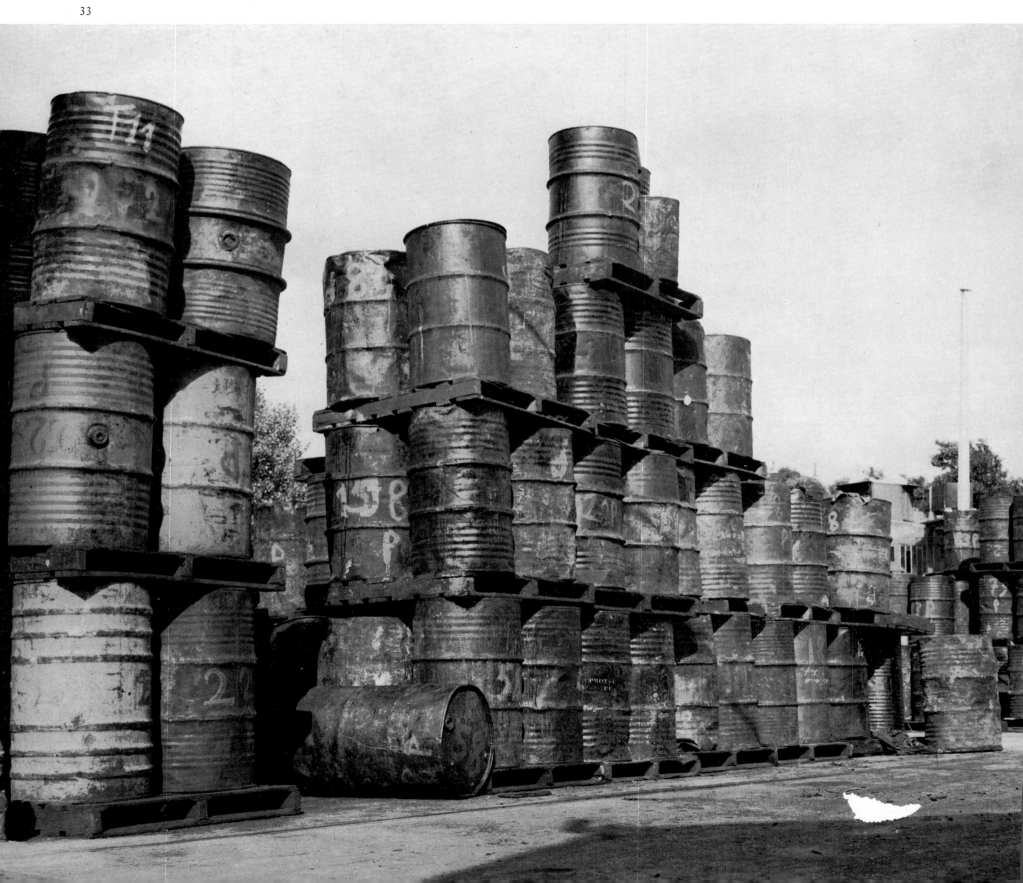

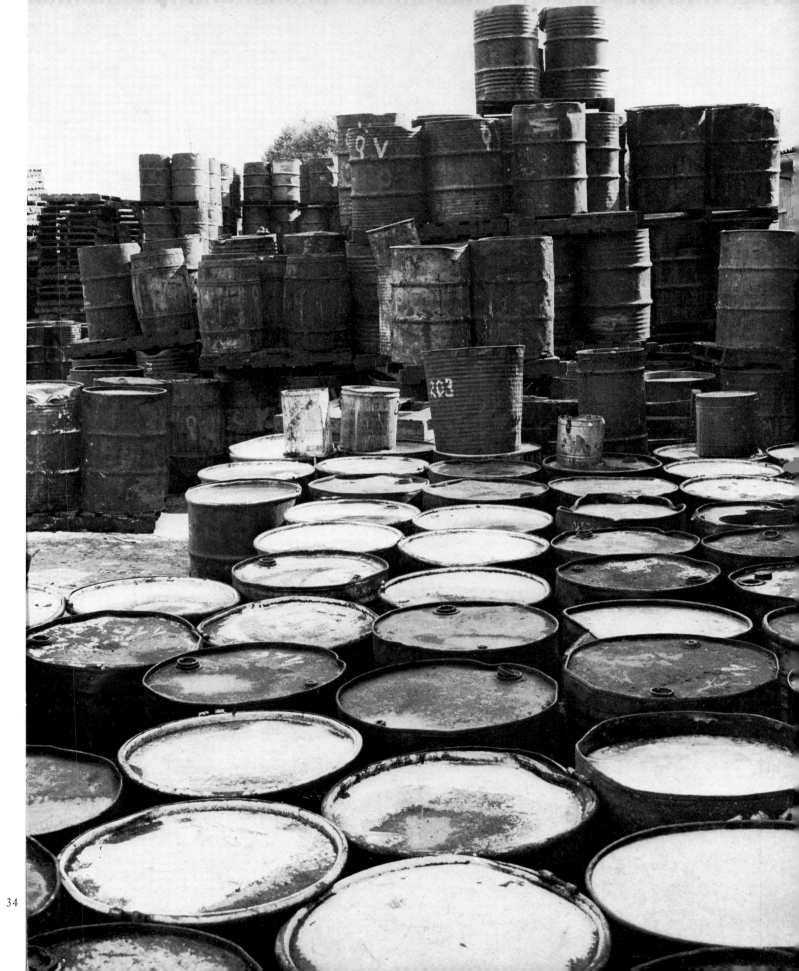

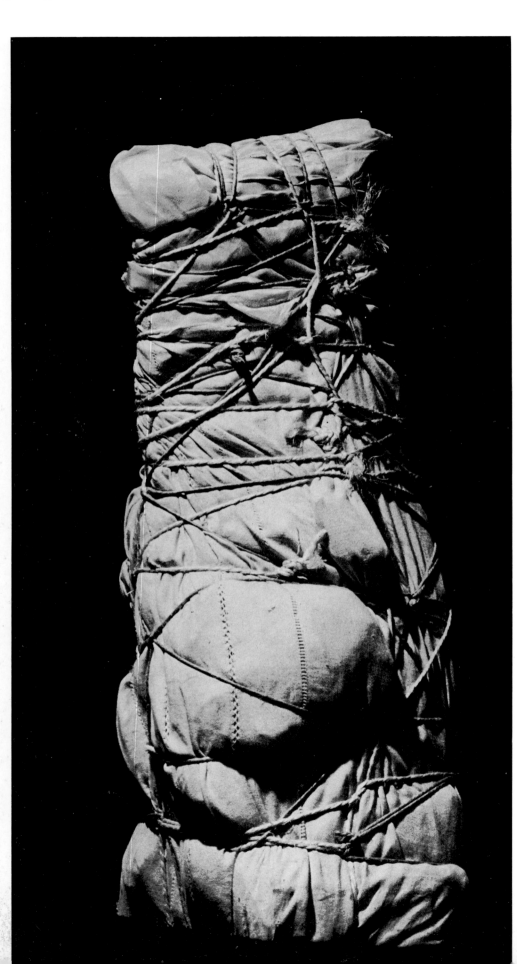

35. *Package*. 1961. Embroidered tablecloth and cord, 19×10×10 in. Collection Cyril Christo, New York City
36. *Package*. 1961. Fabric and twine, 40×96×11 in. Wide White Space Gallery, Antwerp
37. *Packed Road Sign*. 1963. Wood, metal, jute, rope, and electric light, 67×24½×21¼ in.
38. *Packed Road Sign*. 1963. Wood, metal, jute, and rope, height 65 in.

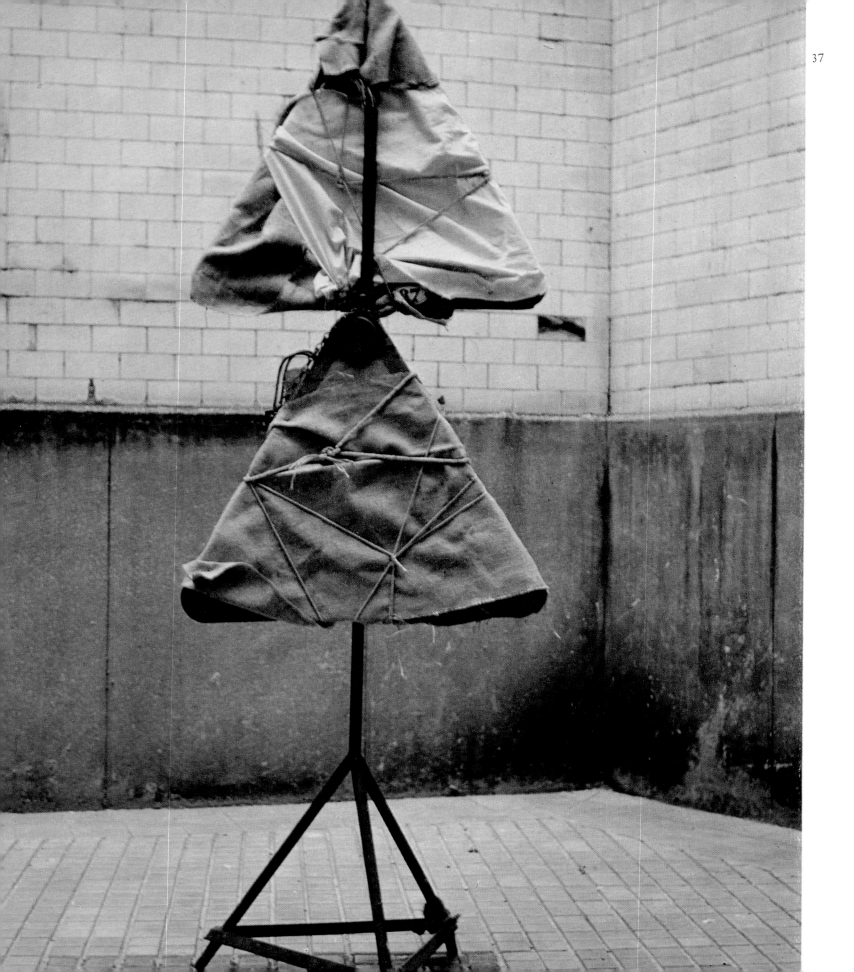

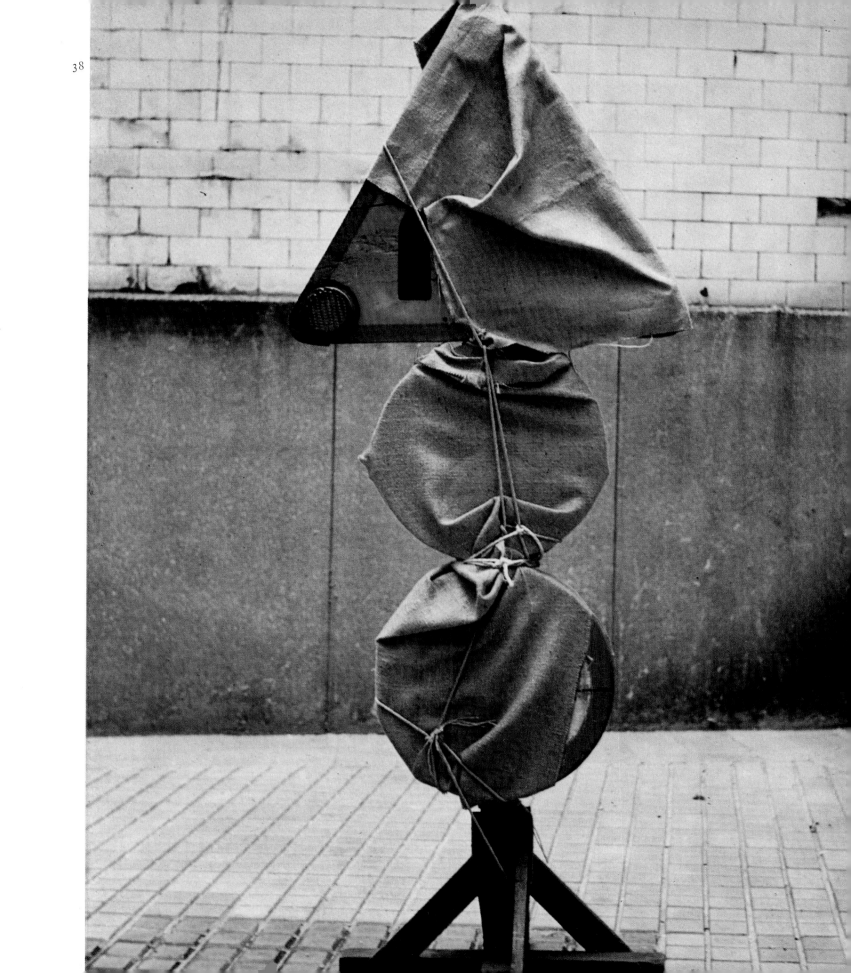

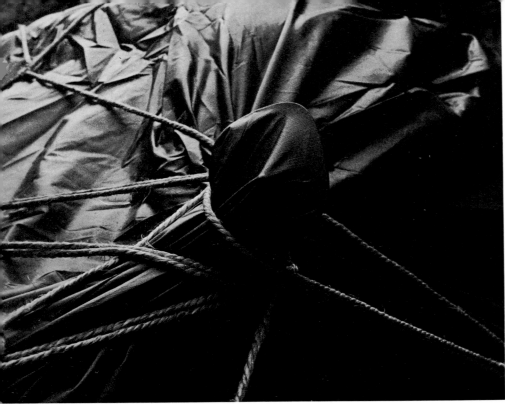

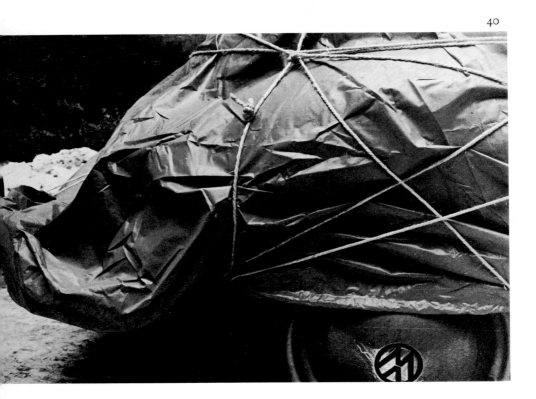

39. *Packed Car (Volkswagen)*. Detail. 1963. Automobile, rubberized tarpaulin, and rope
40. *Packed Car (Volkswagen)*. Detail
41. *Packed Car (Volkswagen)*. 1963. 5 ft. ×5 ft. 3 in. ×13 ft. 5 in.

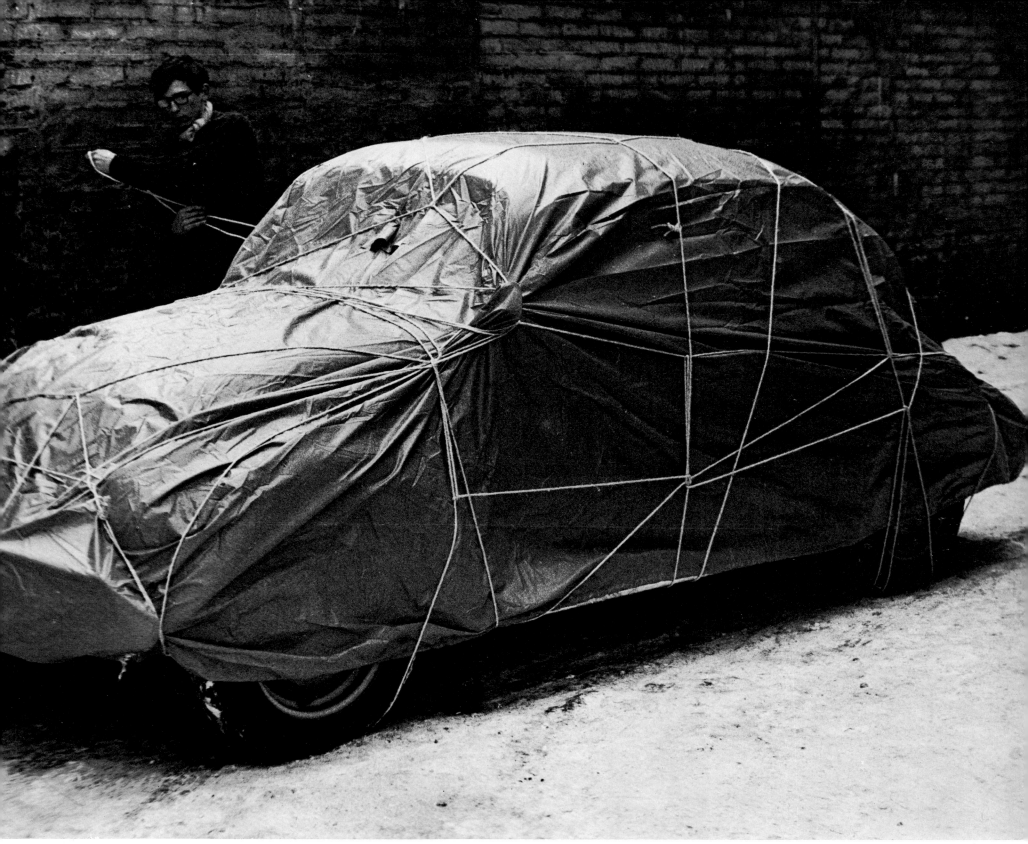

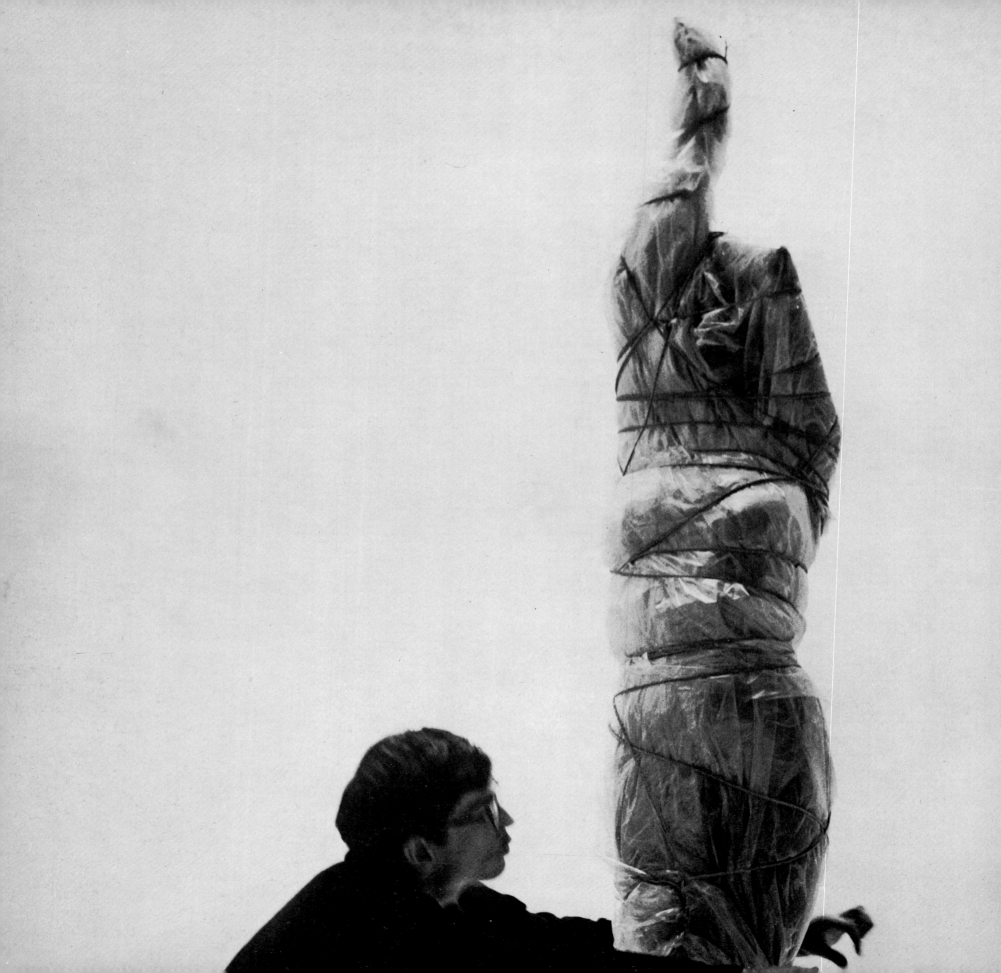

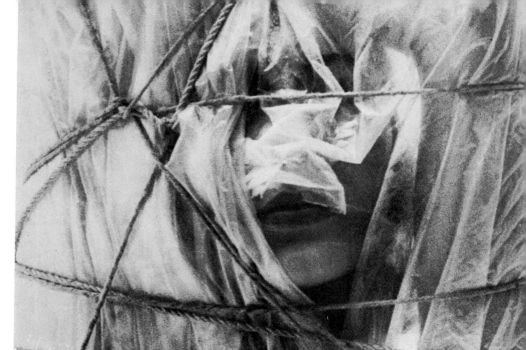

43

44

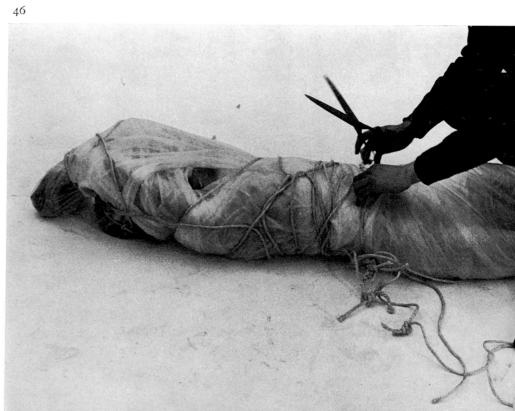

◀ 42 42–46. *Packaged Girls.* 1963

45 46

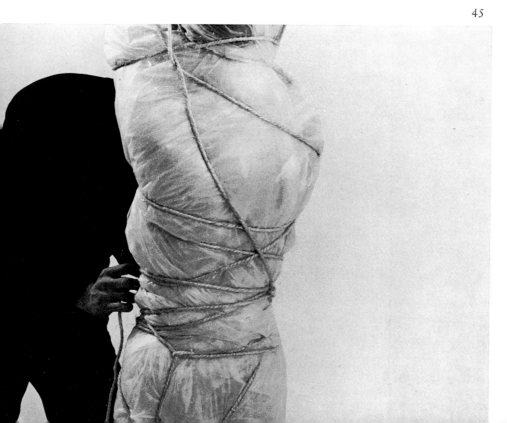

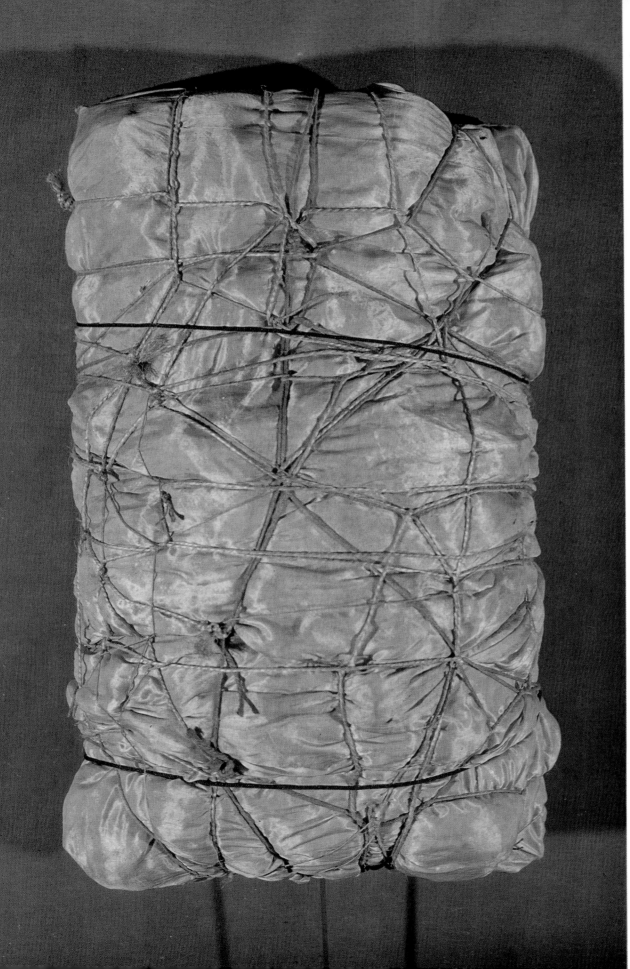

47. *Package*. 1961. Fabric and cord, 30×24×6 in. Private collection, Paris
48. *Package*. 1961. Cotton fabric and cord, 23×39×8 in.

49. *Package*. 1961. Linen and cord, 32×84×14 in. Collection Jeanne-Claude Christo, New York City
50. *Packed Postcard Stand*. 1963. Metal, postcards, plastic, and cord, 39×10 ×10 in. Private collection, Rome

49

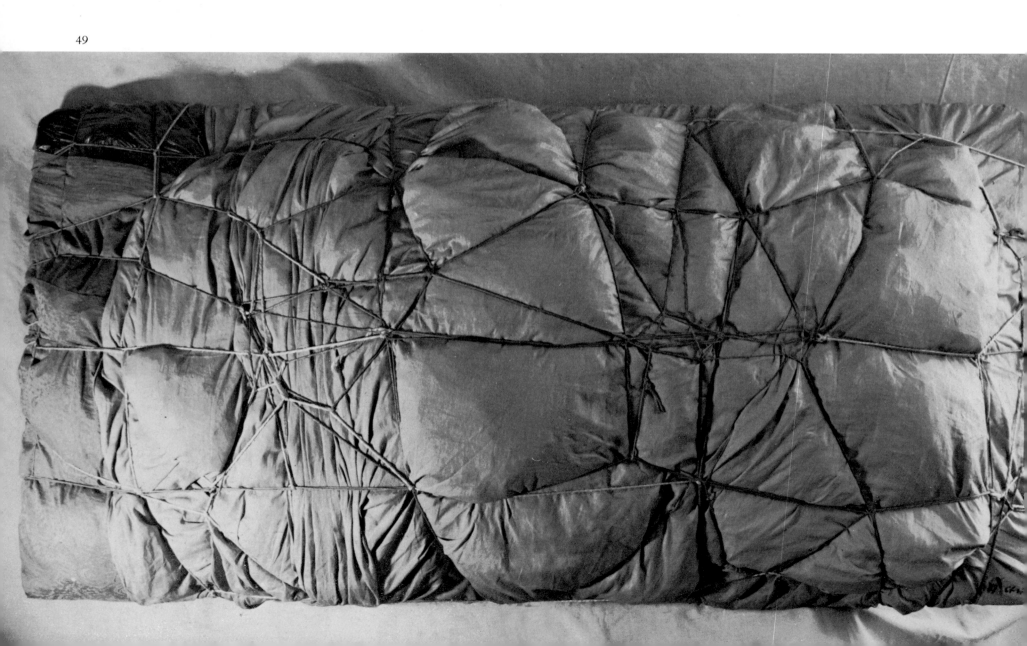

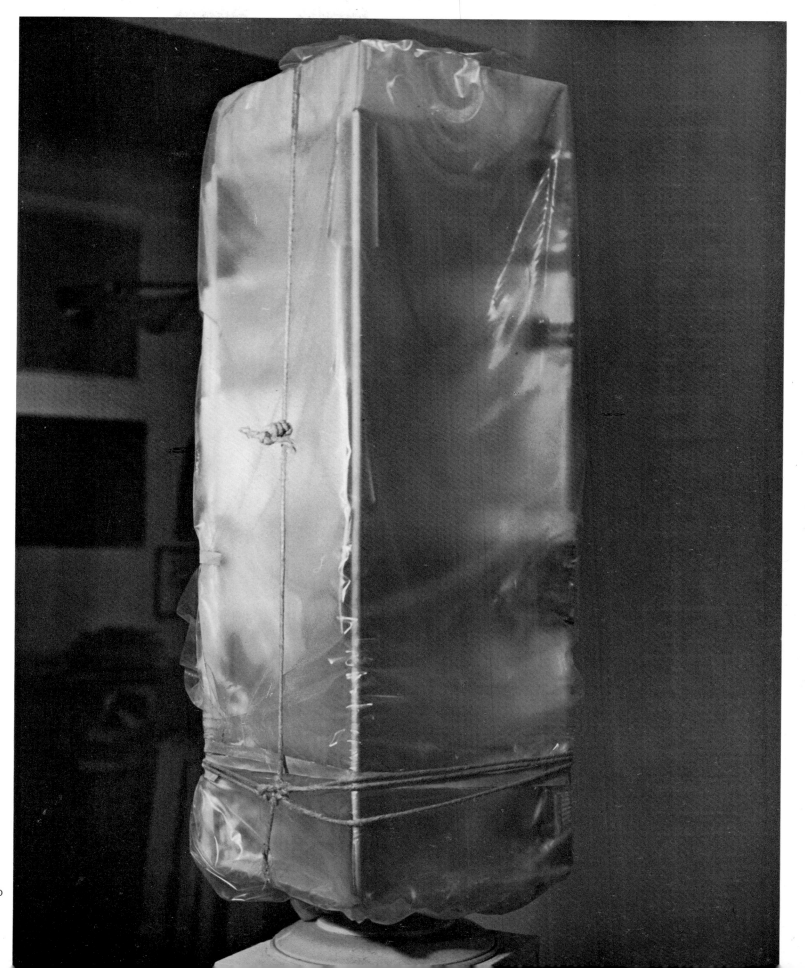

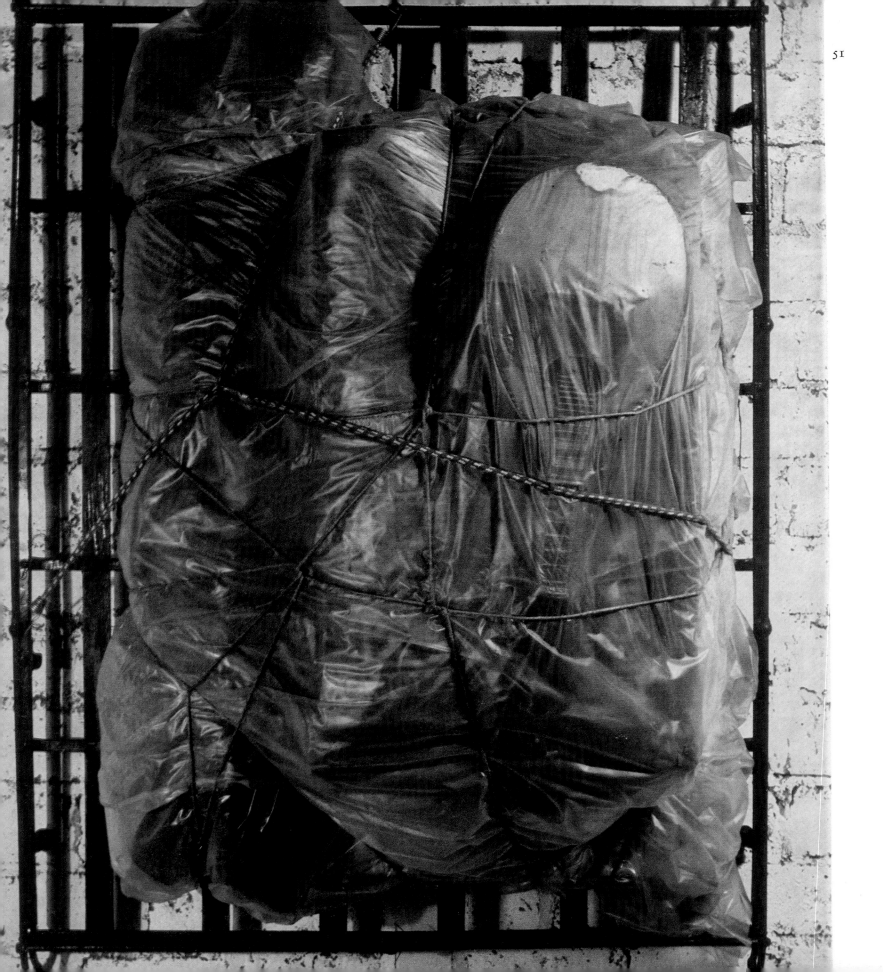

51. *Package on Luggage Rack*. 1962. Metal, wood, fabric, plastic, elastic, rubber cord, and rope, 72×42×18 in.
52. *Package on Luggage Rack*. 1963. Metal, plastic, elastic, rubber cord, and rope, 16×67×36 in. The Harry N. Abrams Family Collection, New York City
53. *Packed Supermarket Cart*. 1963. Metal, plastic, and rope, 37×30×17 in. Galerie Schmela, Düsseldorf
54. *Packed Perambulator*. 1962. Metal, plastic, and rope, $37\frac{1}{2}×35×23\frac{3}{4}$ in. Collection Gerd-Jan Visser, Antwerp

52

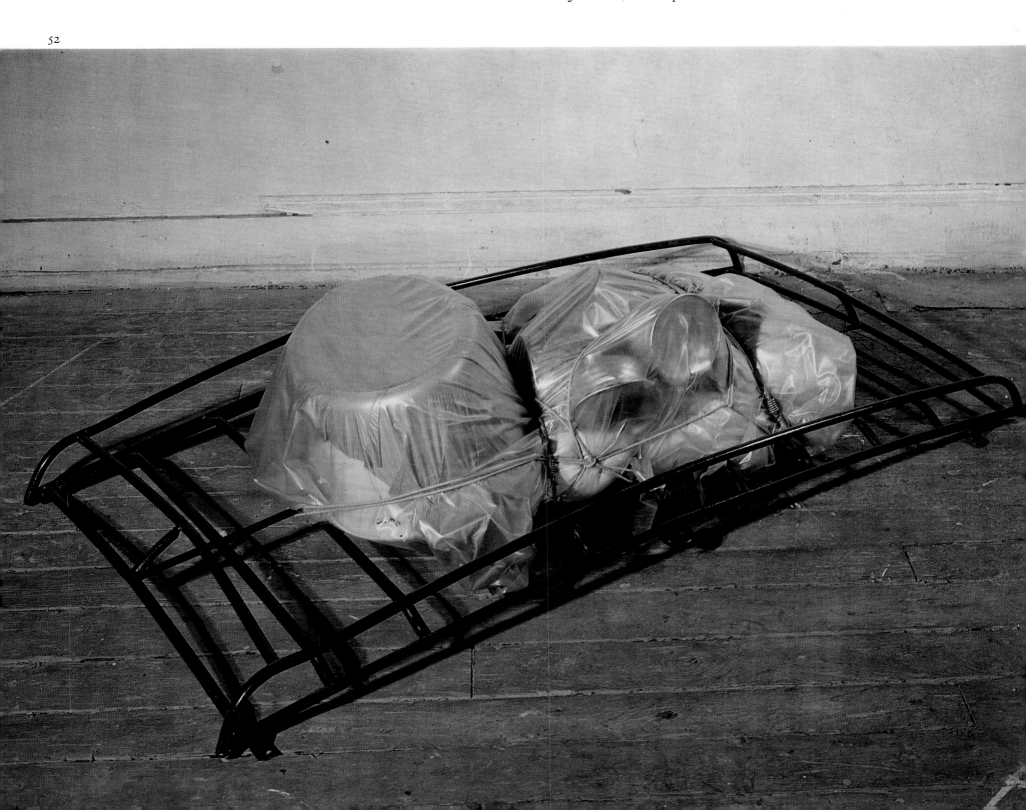

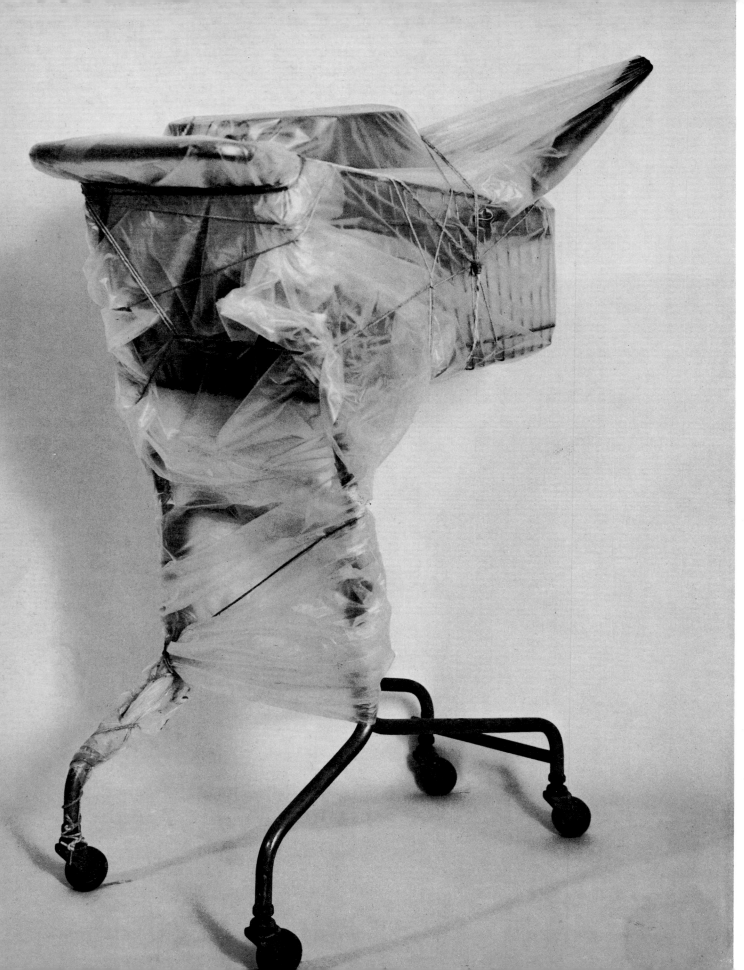

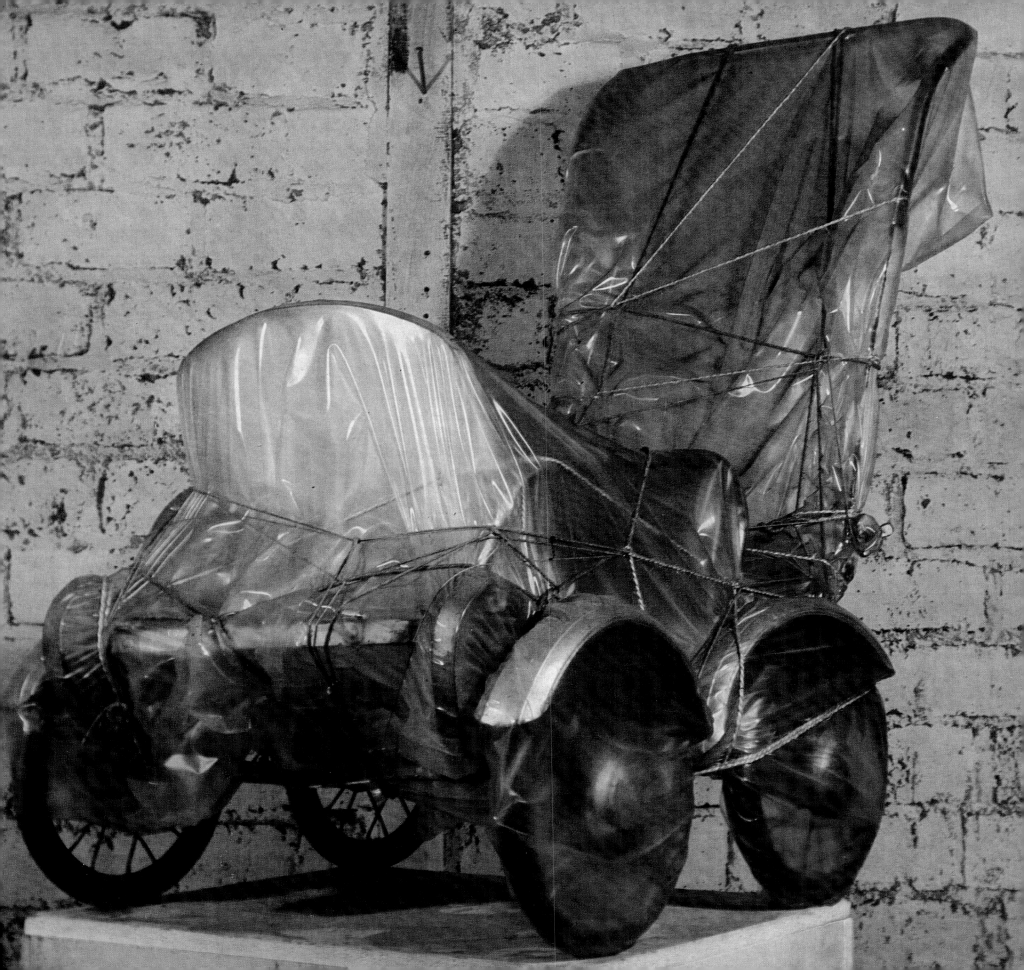

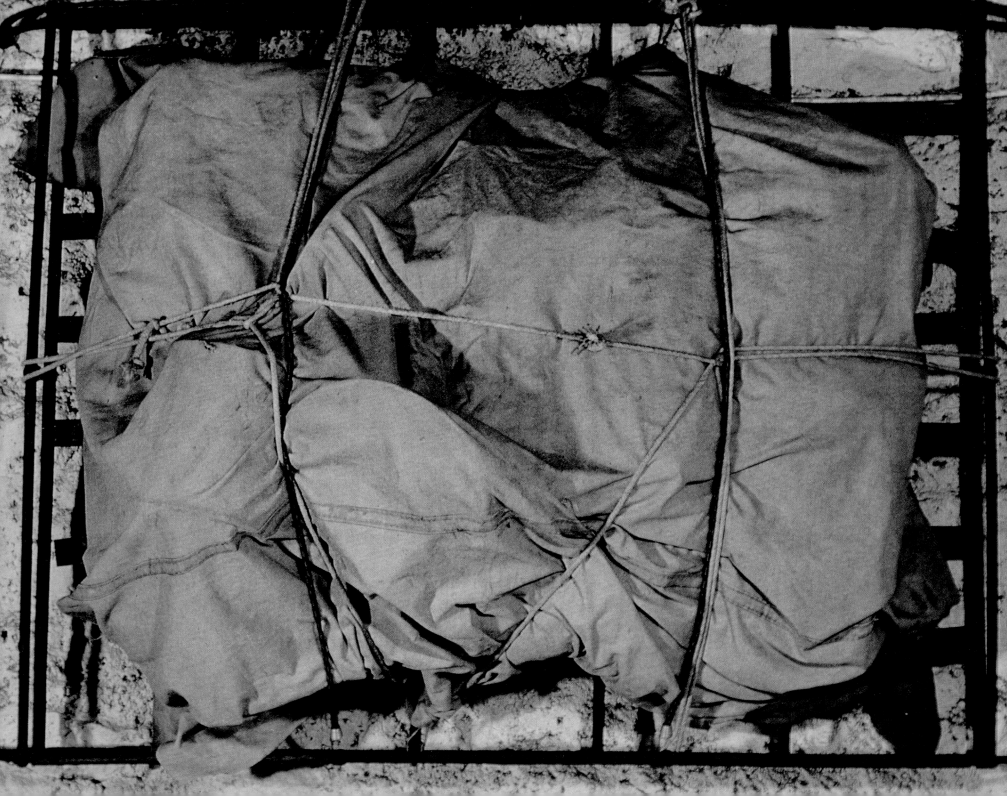

55. *Package on Luggage Rack*. 1962. Metal, tarpaulin, rubberized cord, and rope, 72×42×18 in.
56. *Package on Luggage Rack*. 1962. Metal, stroller, fabric, plastic, rope, and rubberized cord, 25×53½×37½ in. Collection Mr. and Mrs. Martin Visser, Bergeyk, The Netherlands

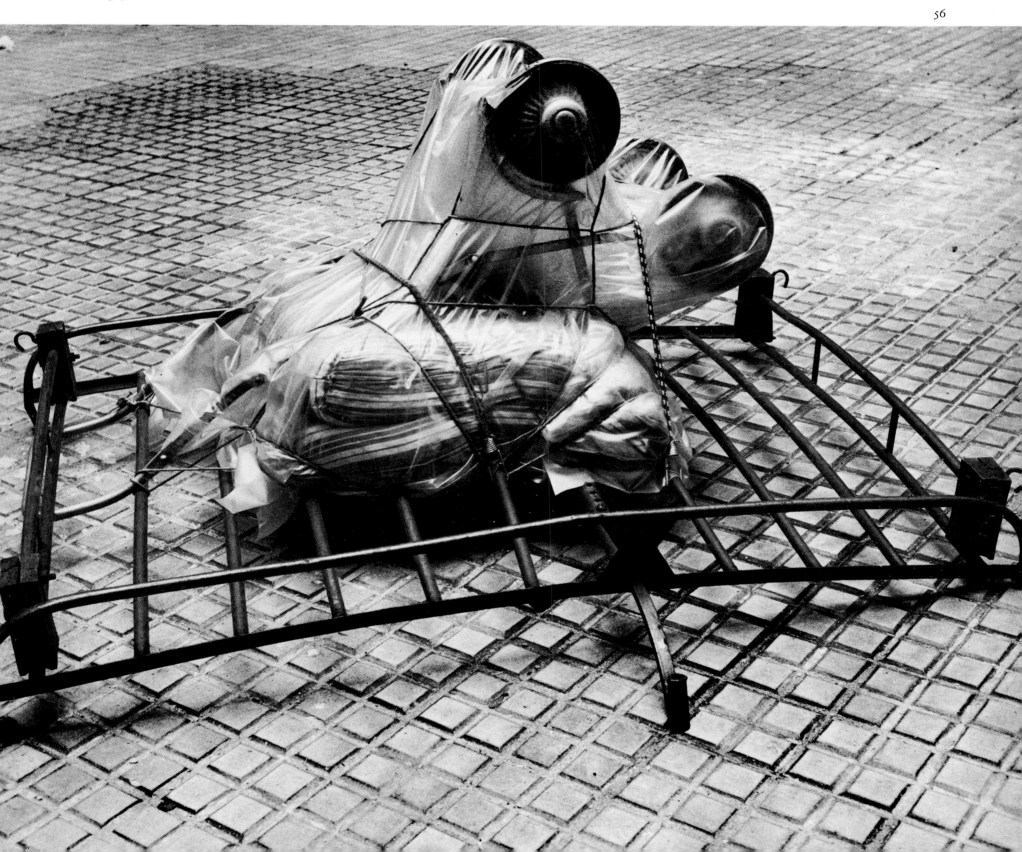

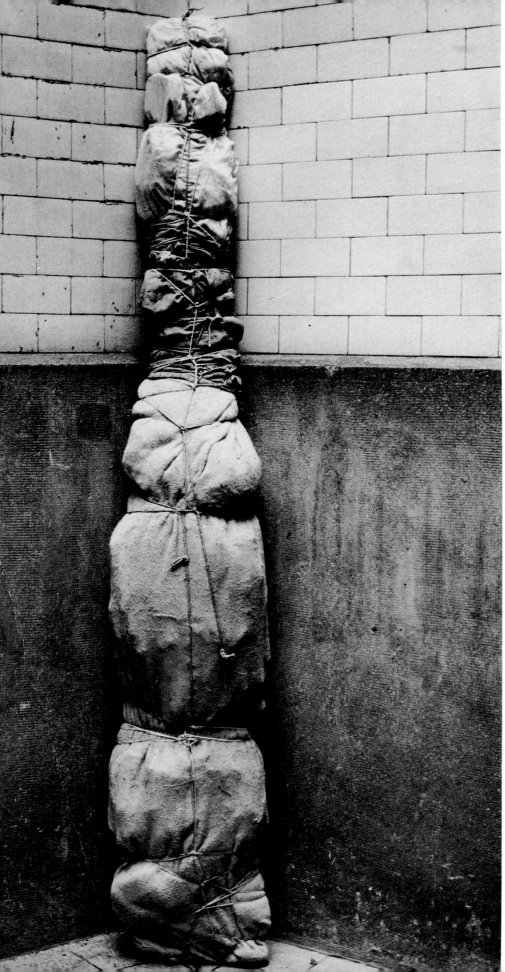

57. *Package*. 1960. Fabric and cord, height 72 in., width 14 in. at base. Galleria Apollinaire, Milan

58. *Packed Camera (Rolleiflex)*. 1963. Camera, tripod, plastic, and cord, height 56 in. Collection Charles Wilp, Düsseldorf

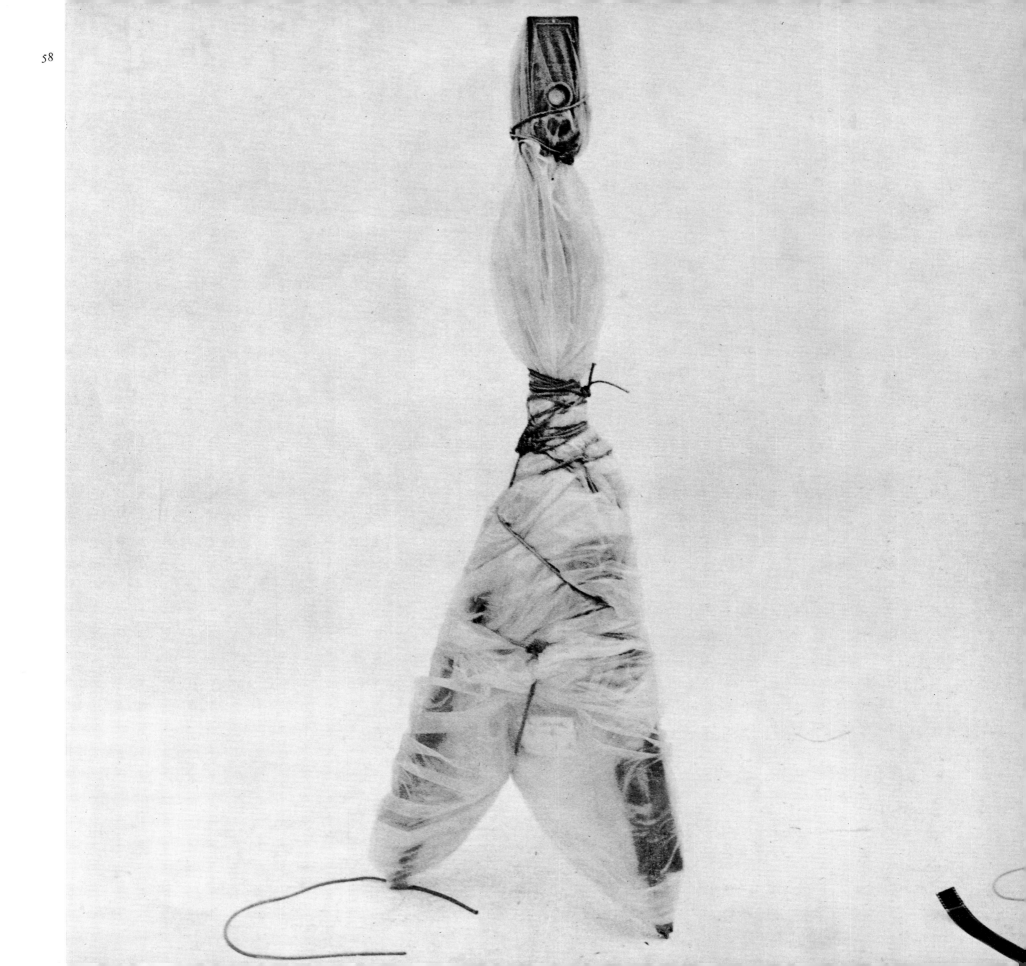

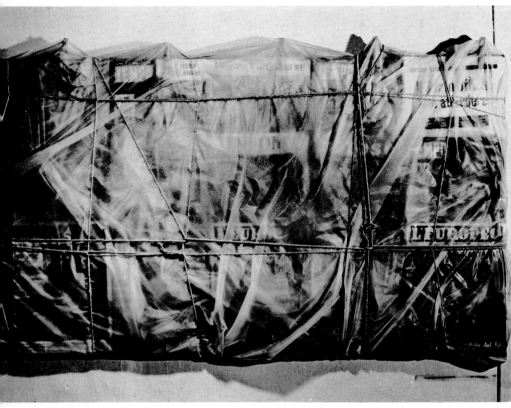

59. *Packed Magazines*. 1963. Magazines, plastic, wooden clasps, and cord, $38 \times 65 \times 3$ in. Collection Mr. and Mrs. Attilio Codgnato, Venice

60. *Packed Adding Machine*. 1963. Adding machine, plastic, and cord, $8 \times 16 \times 11$ in. Galerie Schmela, Düsseldorf

61. *Packed Printing Machine*. 1963. Printing machine, plastic, and twine, $20 \times 12 \times 12$ in. Collection Hans Müller, Düsseldorf

59

60

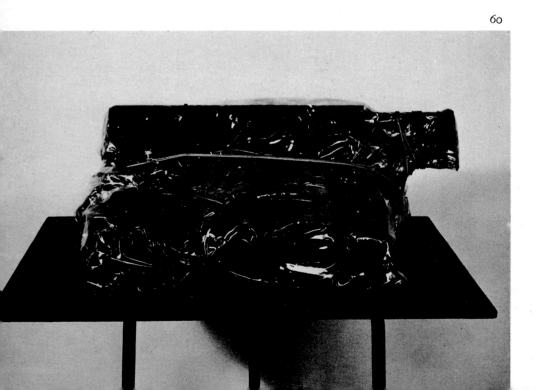

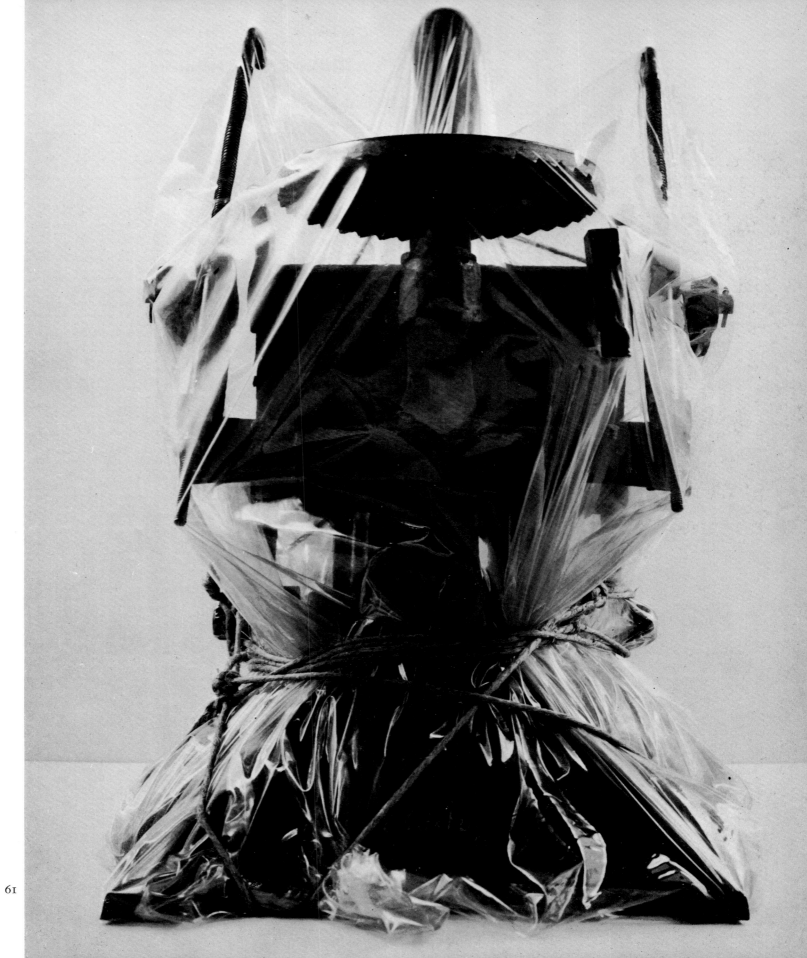

62. *Packed Table and Packed Chair*. 1963. Wooden console table and chair, crystal candelabra, plastic, and twine, 42×60×16 in. Galleria del Leone, Venice
63. *Packed Flowers*. 1966. Plastic flowers, plastic, and twine, length 19 in., width 7 in. Collection Raymond Thomas, Munich
64. *Packed Horse*. Scale model. 1963. Toy horse, canvas, and rope, 16×20 ×5 in. Collection Mr. and Mrs. Jan van der Marck, Chicago

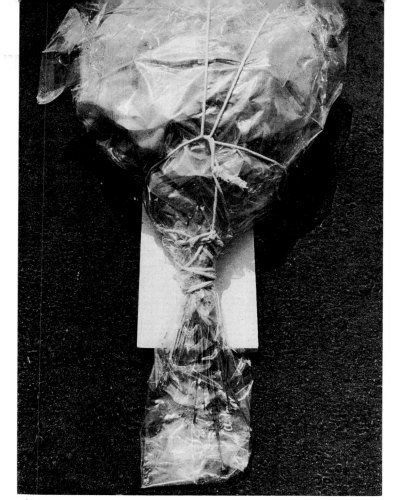

63

64

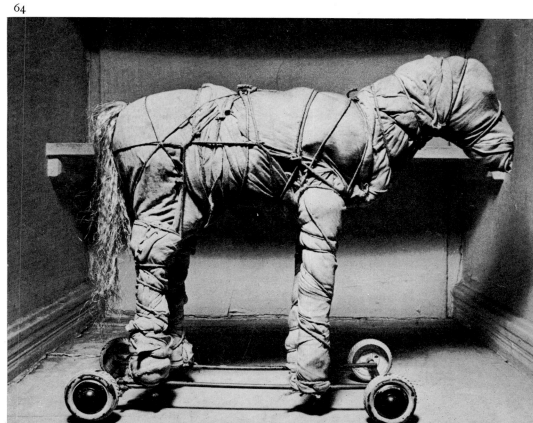

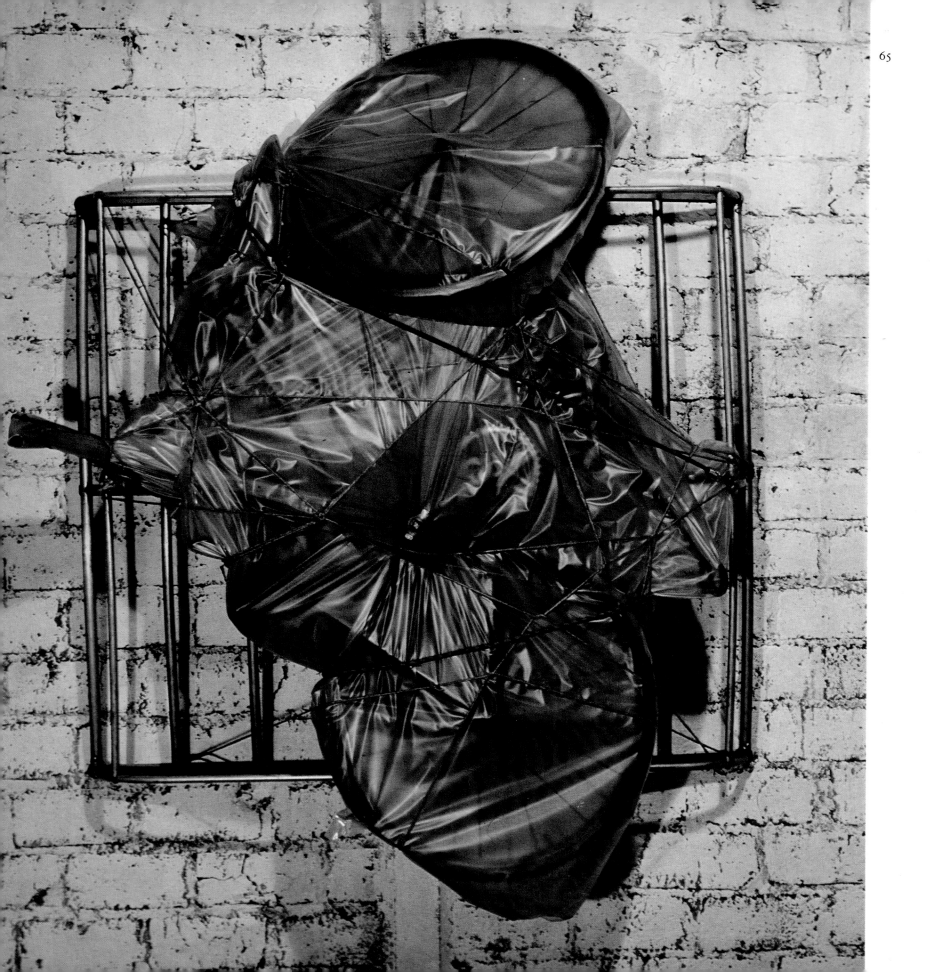

65. *Packed Bicycle on Luggage Rack*. 1962. Bicycle, metal rack, plastic, rubberized cord, and rope, $60 \times 40\frac{1}{4} \times 12\frac{1}{4}$ in. Collection Mr. and Mrs. Fritz Becht, Hilversum, The Netherlands
66. *Package on Wheelbarrow*. 1963. Cloth, rope, wood, and metal, $35 \times 60 \times 23$ in. The Museum of Modern Art, New York City

66

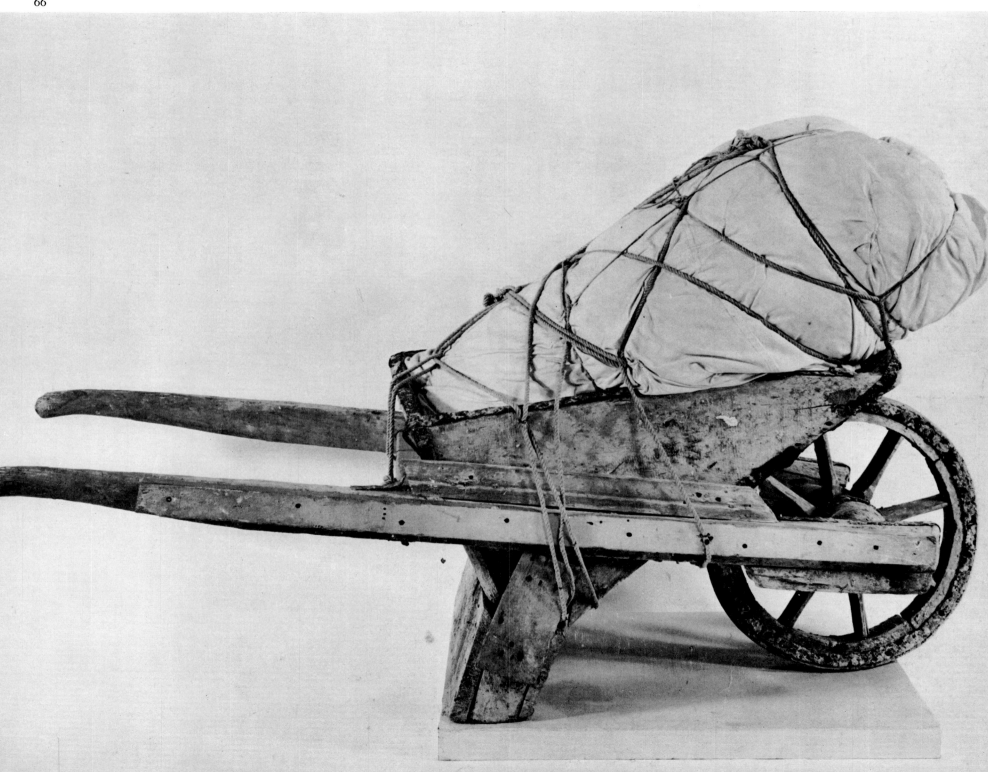

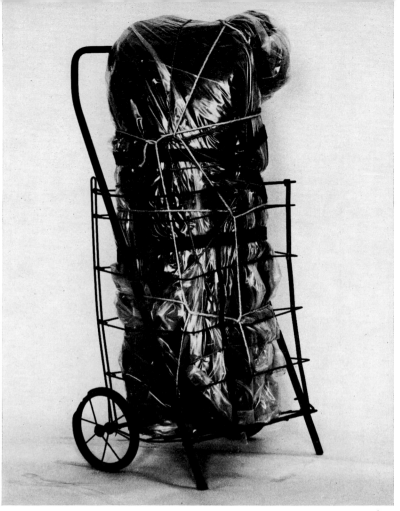

67

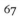

67. *Package in Shopping Cart*. 1964. Metal, polyethylene, string, plastic, and canvas, 40×18×15 in. Galleria Gian Enzo Sperone, Turin

68–69. *Packed Motorcycle*. 1962. Motorcycle, plastic, steel, rubber, and rope, $30\frac{1}{4}\times76\times$ 16 in. Collection Mr. and Mrs. Philippe Durand-Ruel, Paris

70. *Package*. 1963. Fabric and twine, 15×12×5 in. Collection Mr. and Mrs. Martin Visser, Bergeyk, The Netherlands

71. *Package*. 1963. Canvas and rope, $42\frac{1}{2}\times33\times12$ in. Collection Mr. and Mrs. Martin Visser, Bergeyk, The Netherlands

68

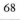

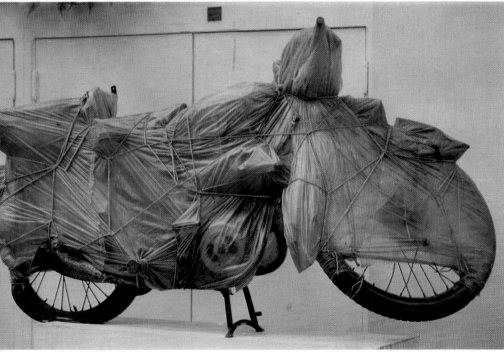

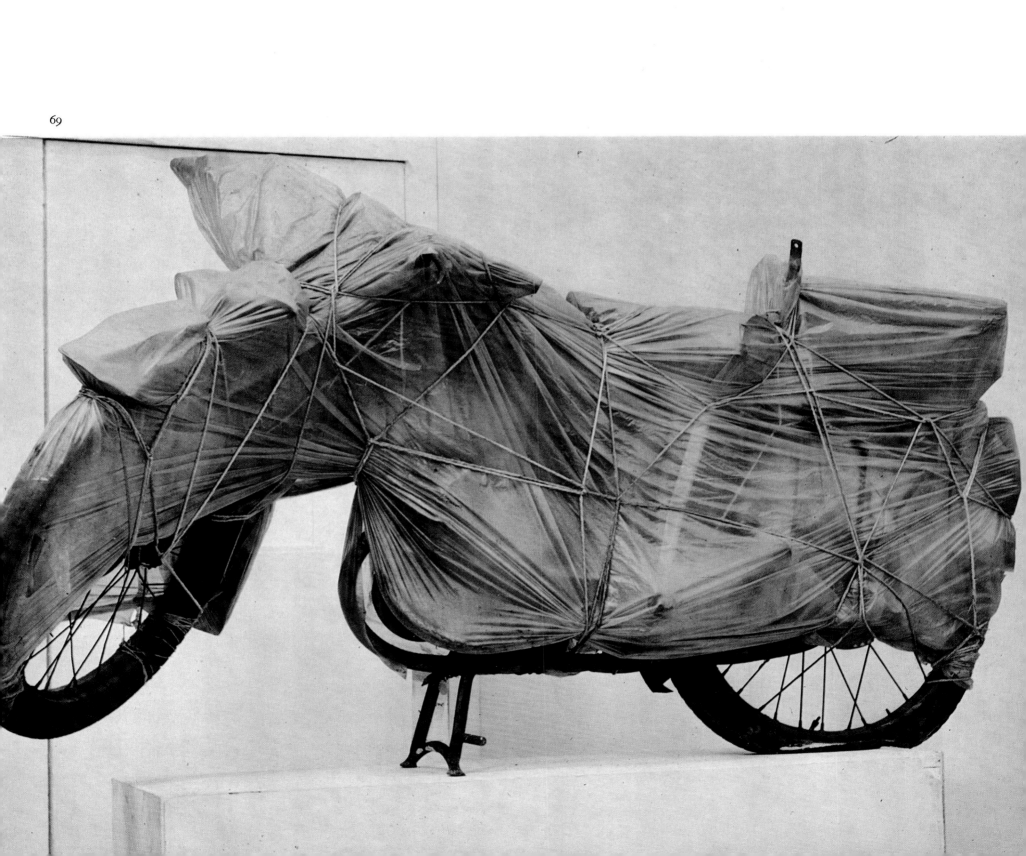

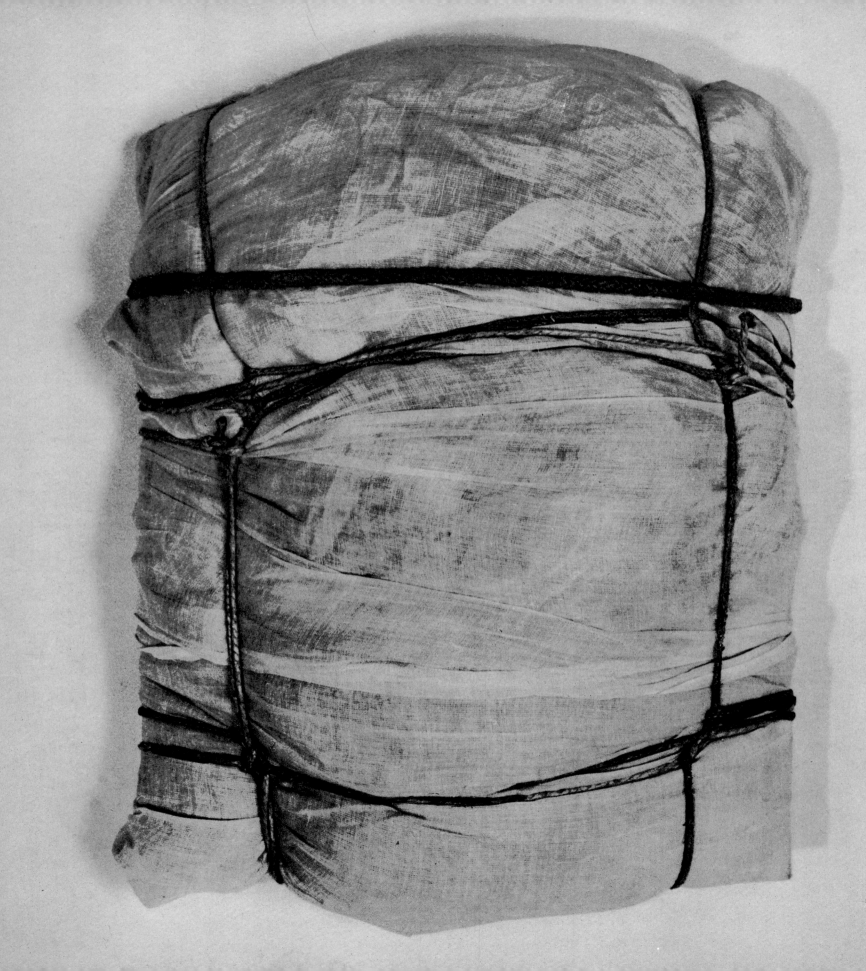

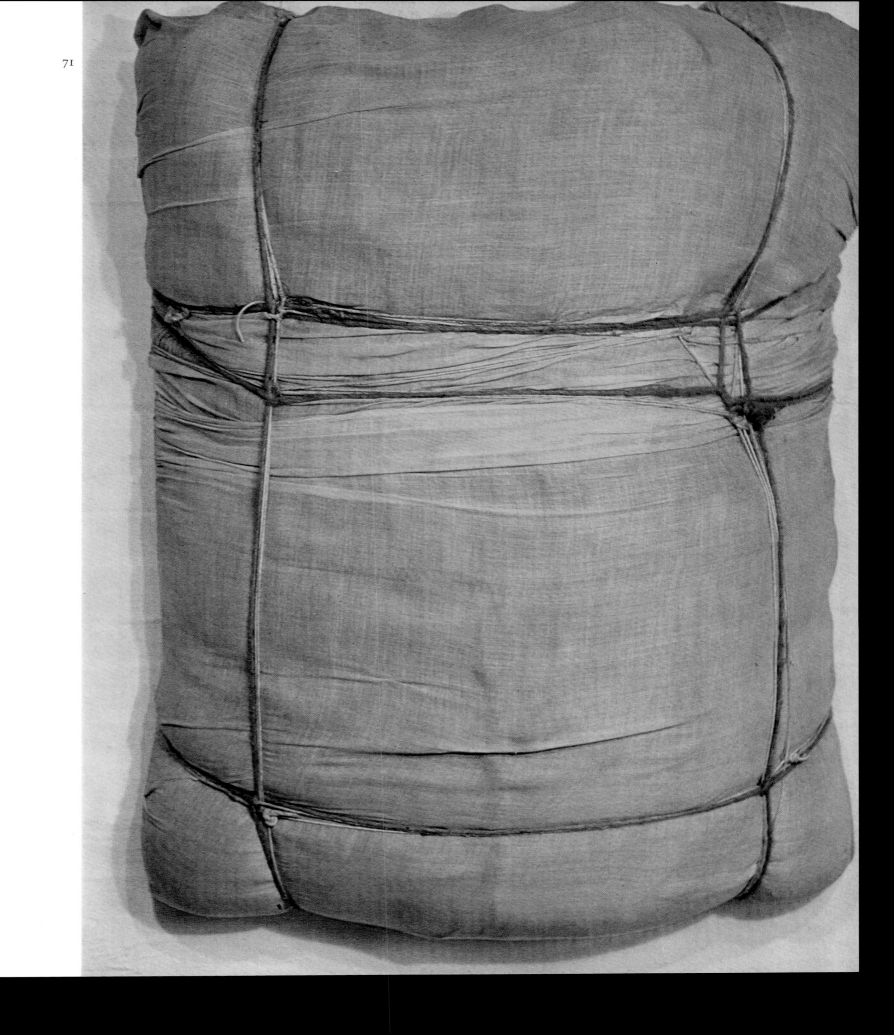

72. *Showcase*. 1963. Plastic, wrapping paper, satin, and neon light, $30 \times 20 \times 8$ in.

73. *Showcase*. 1963. Glass, stainless steel, wrapping paper, satin, and electric light, $47\frac{1}{4} \times 31\frac{1}{2} \times 10$ in. Collection Mr. and Mrs. Martin Visser, Bergeyk, The Netherlands

74. *Store Front*. 1964. Wood, glass, cloth, paper, and electric light, $92\frac{1}{2} \times 86\frac{1}{2} \times 14$ in.

75. *Store Front*. 1964. Wood, glass, cotton, paper, aluminum, plastic, cord, and neon light, $10 \times 9 \times 3$ ft.

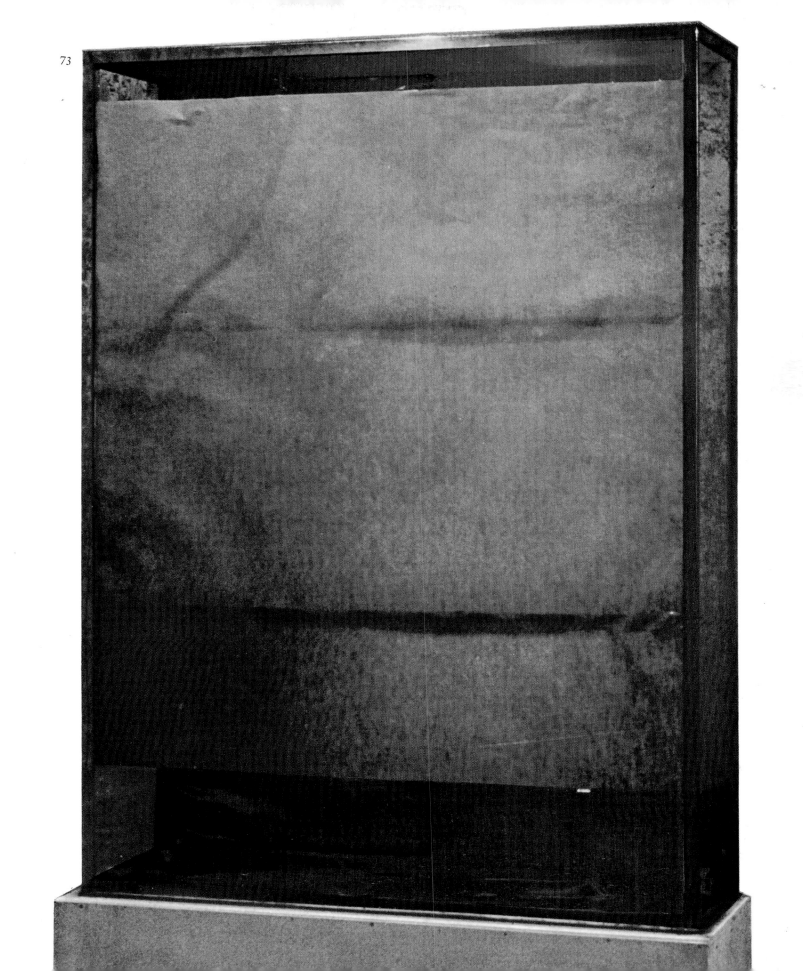

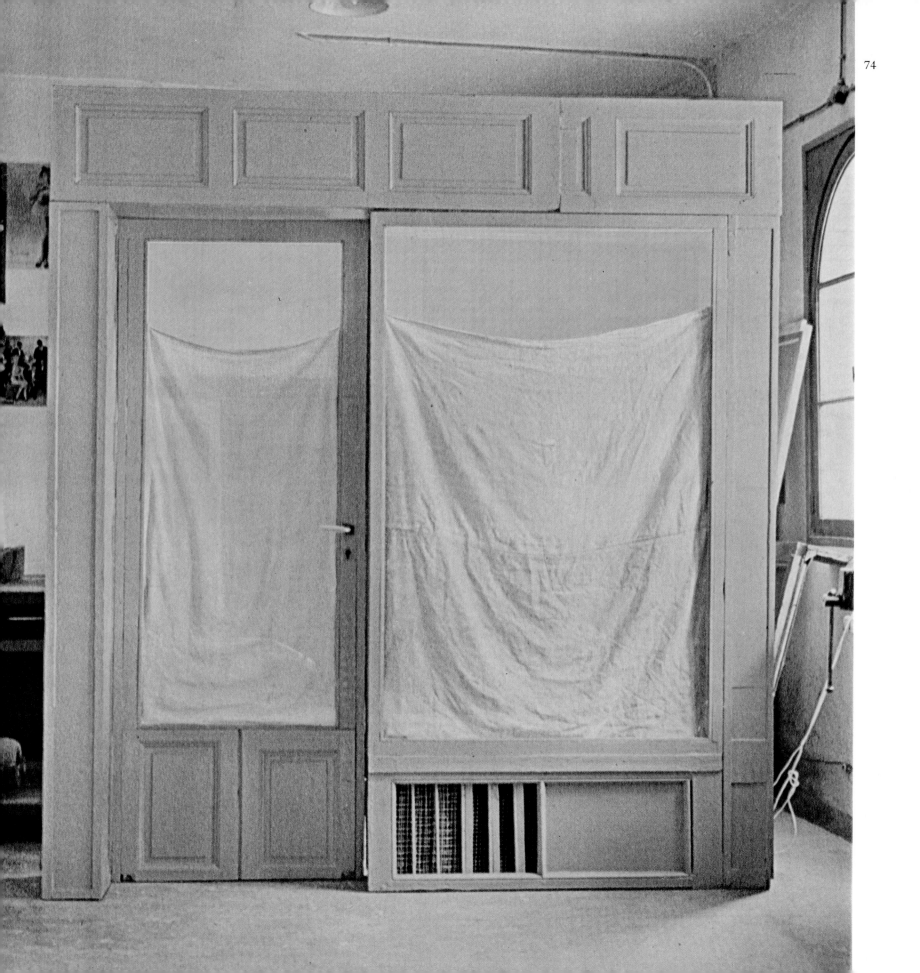

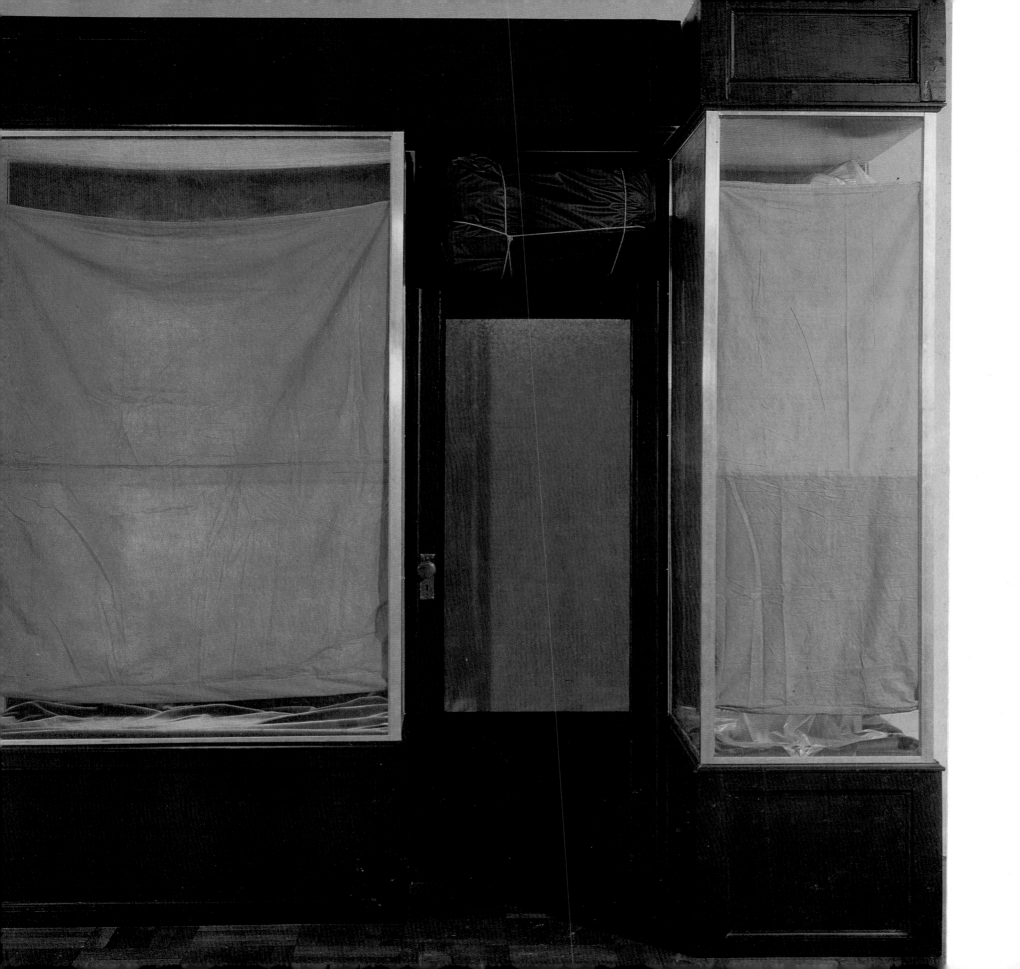

76. *Double Store Front*. Project. 1964. Wood, Plexiglas, cloth, paper, and electric light, $34\frac{3}{4} \times 26\frac{1}{2} \times 3$ in. Collection Mr. and Mrs. Burton Tremaine, New York City

77. *Store Front*. Project. 1965. Wood, Plexiglas, cloth, and electric light, $33\frac{1}{2} \times 48 \times 3$ in. Collection Dr. and Mrs. Judd Marmor, Los Angeles

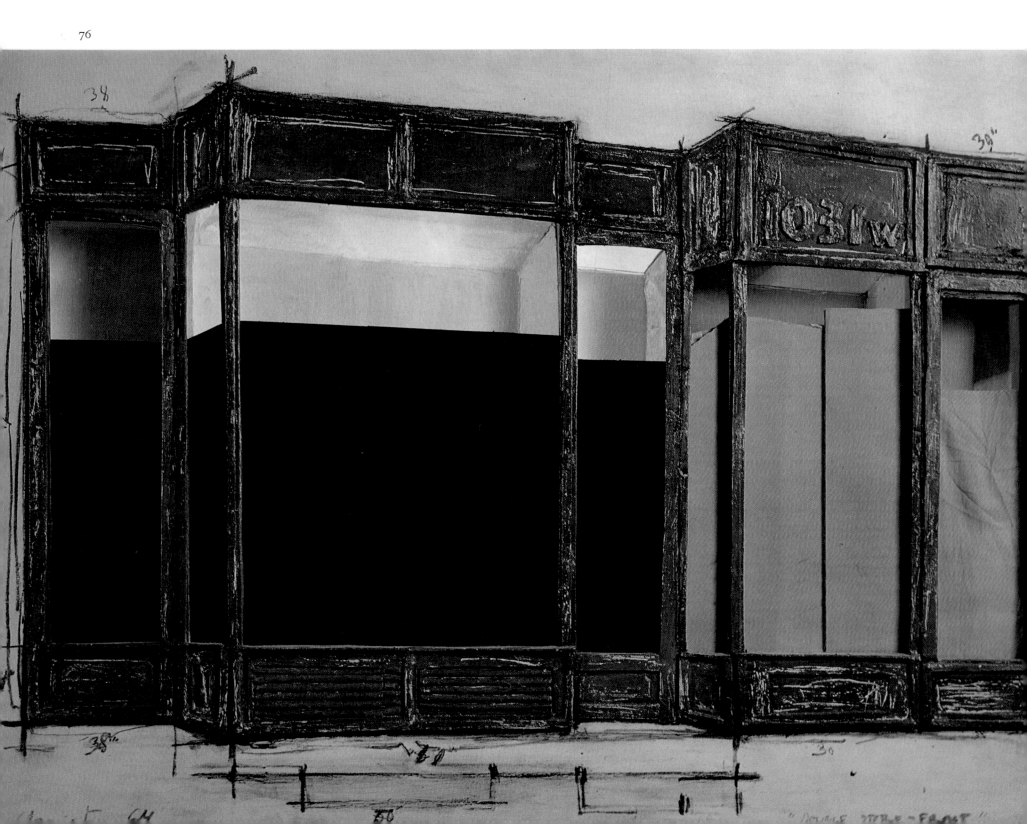

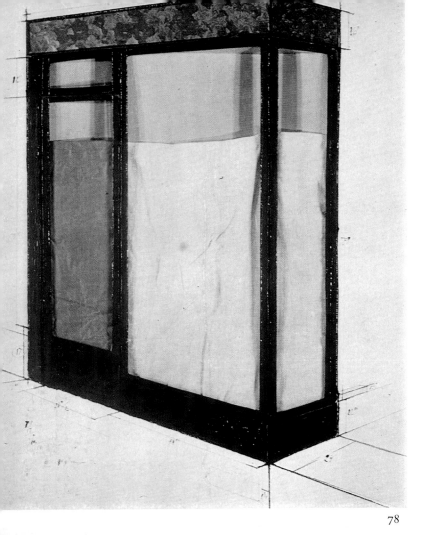

78. *Store Front*. Project. 1964. Wood, Plexiglas, paper, and electric light, 48×33×3 in. Collection William Copley, New York City
79. *Double Store Front*. Project. 1964–65. Wood, Plexiglas, cloth, and paper, 24×48×3 in. The Harry N. Abrams Family Collection, New York City
80. *Orange Store Front*. 1964–65. Wood, Plexiglas, galvanized metal, pegboard, cloth, and electric light, 9 ft. 4 in.×8 ft. 5 in.×2 ft. Collection Dr. and Mrs. Erving Forman, Chicago
81. *Yellow Store Front*. 1965. Wood, Plexiglas, fabric, paper, galvanized metal, pegboard, and electric light, 98×88¼×16 in. Collection Mr. and Mrs. Horace H. Solomon, New York City
82. *Store Front*. Project. 1964. Wood, Plexiglas, paper, cloth, and electric light, 33×24×3 in. Collection Mr. and Mrs. John Powers, New York City
83. *Double Store Front*. Project. 1964–65. Paper, tracing paper, canvas, and pencil on cardboard, 29×29×2 in. Collection Hubert Graf, New York City
84. *Yellow Store Front*. Project. 1965. Cardboard, cloth, Plexiglas, paper, and metal, 22×28×2 in. Collection Rosalind Constable, New York City
85. *Double Store Front*. Project. 1964–65. Wood, Plexiglas, cloth, metal, paper, and electric light, 24×38¼×2 in. Collection David Bourdon, New York City

78

79

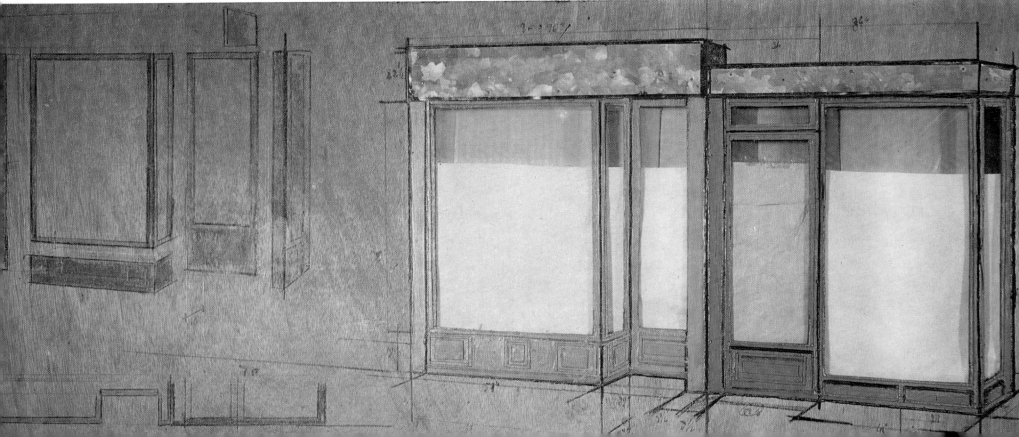

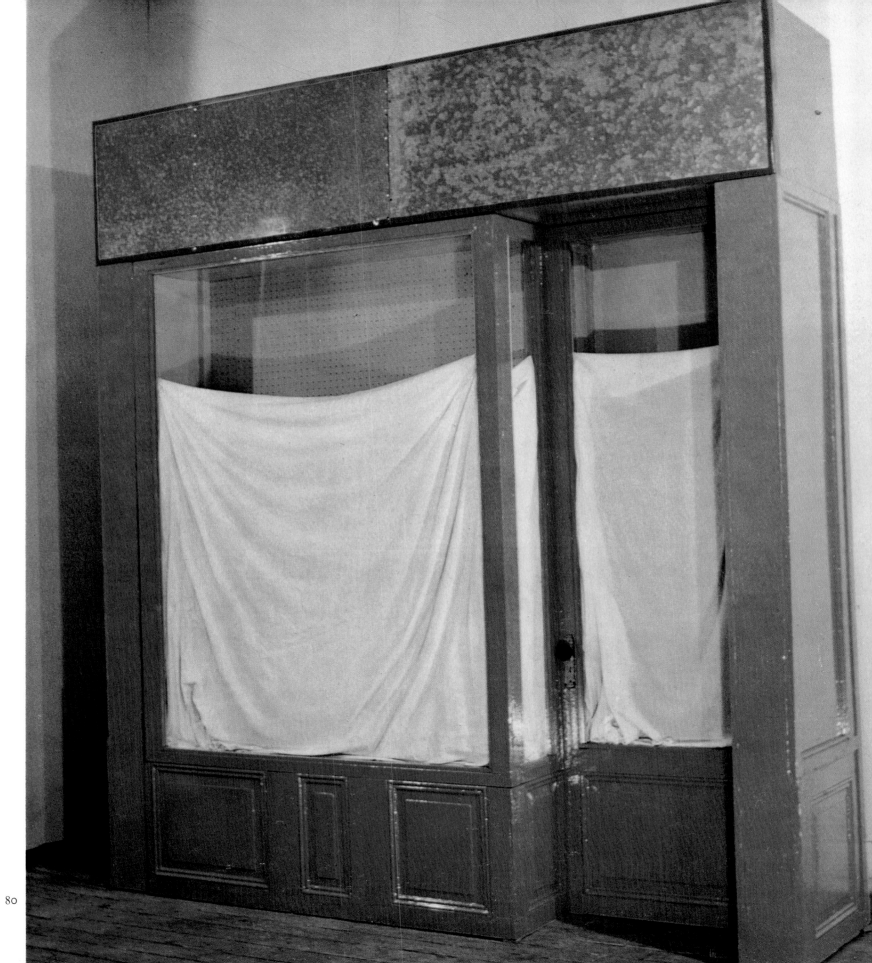

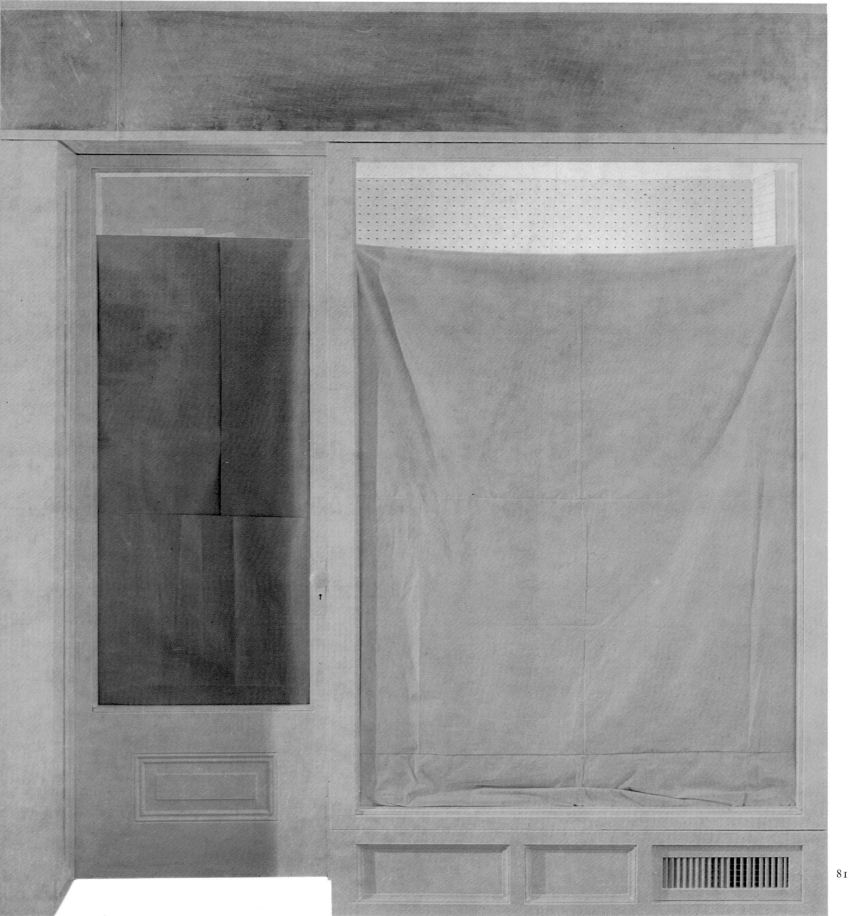

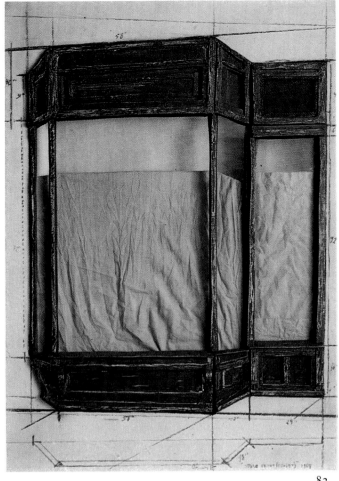

82

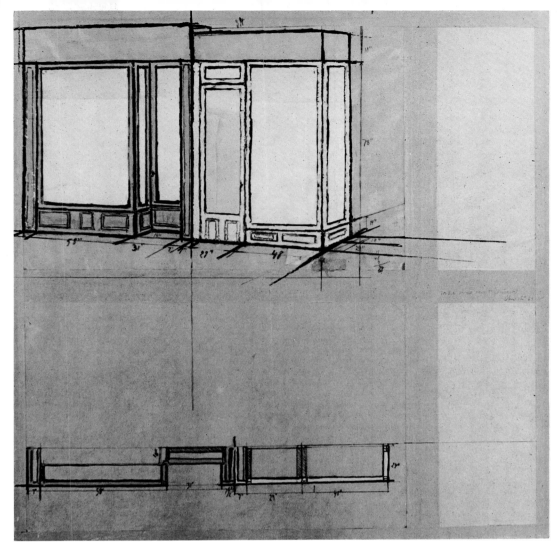

83

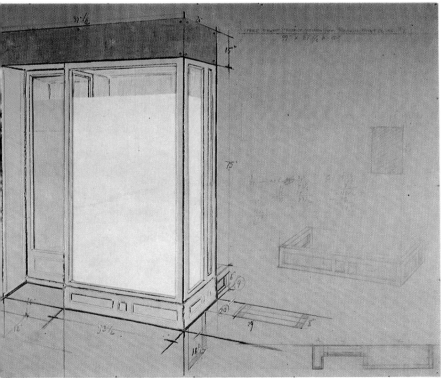

84

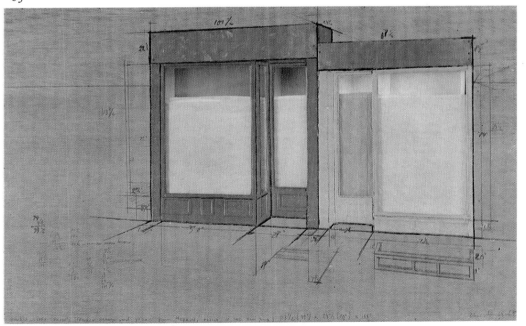

85

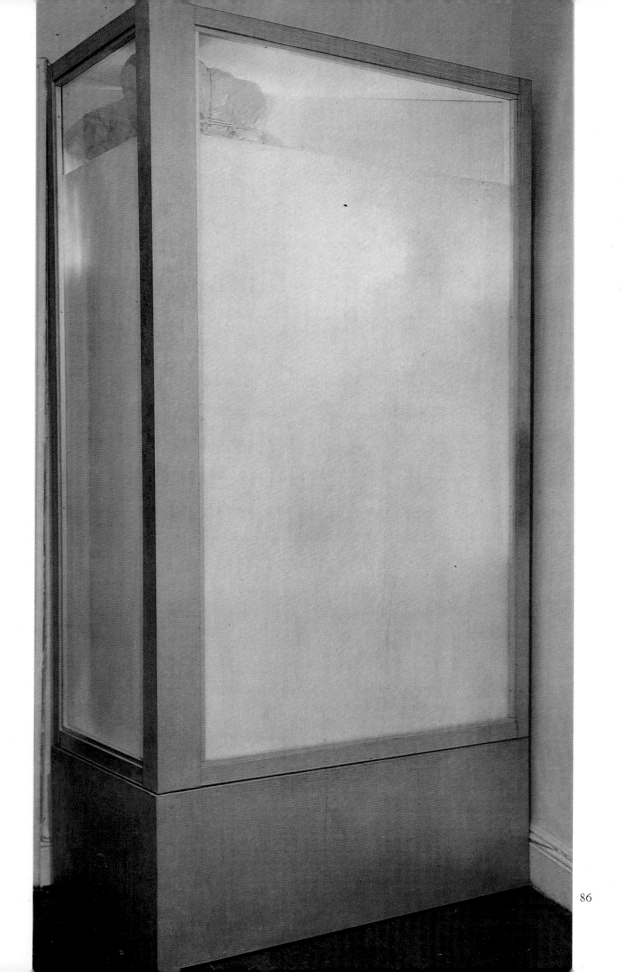

86. *Store Front Corner*. 1965. Galvanized metal, Plexiglas, paint, plastic, rope, and electric light, $87\frac{1}{2}\times59\times23$ in. Collection Harrison Rivera, New York City

87. *Double Show Window*. 1965. Aluminum, Plexiglas, and paint, $30\frac{3}{4}\times49\frac{1}{2}\times2\frac{1}{4}$ in.

86

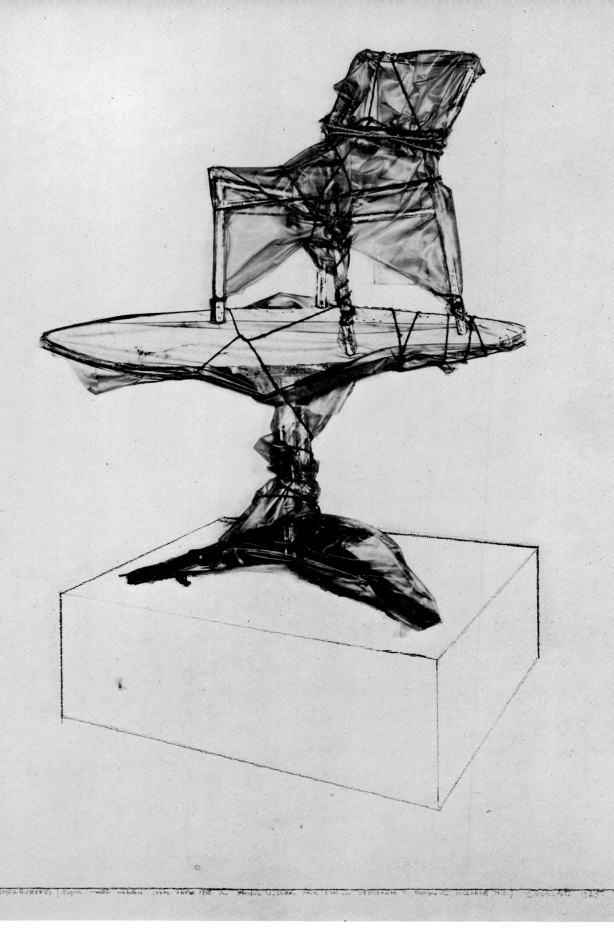

88. *Packed Table and Chair*. Project. 1965. Masonite, plastic, and twine, 48×29 in. Collection Dr. and Mrs. Hans Hunstein, Kassel, West Germany

89. *Packed Table and Two Chairs*. Project. 1964–65. Cardboard, plastic, twine, and pencil on Masonite, 29×24 in. Collection René de Montaigue, Paris

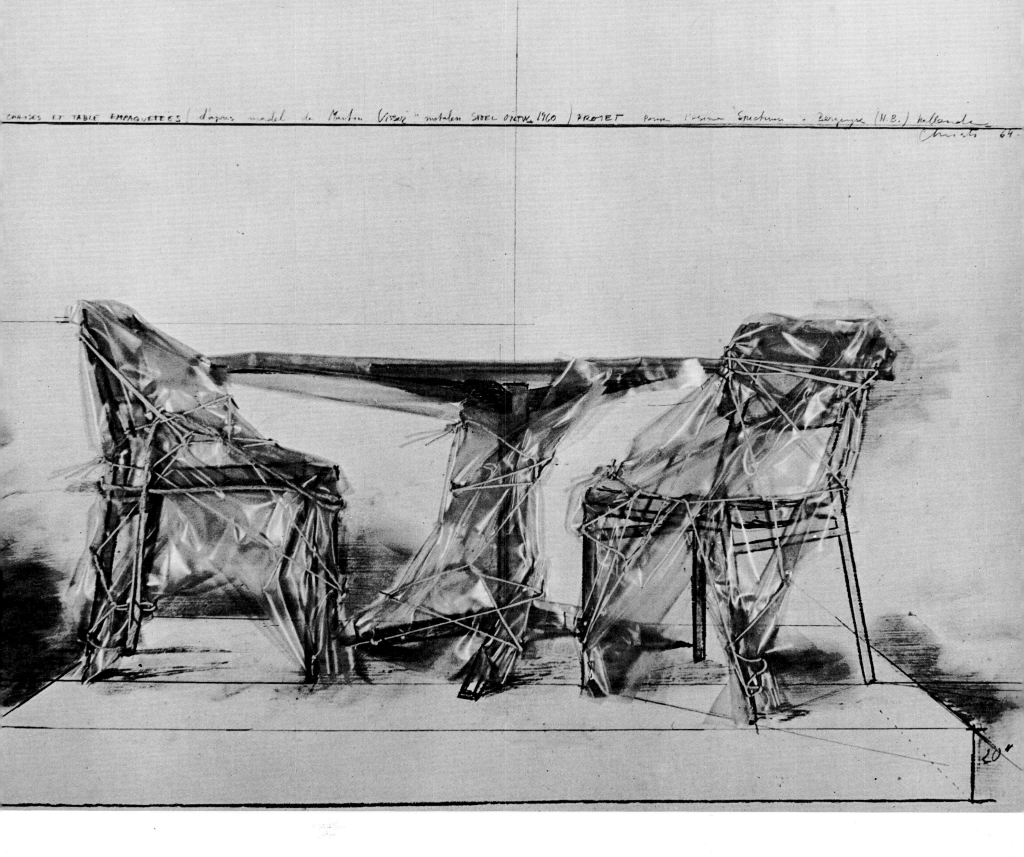

CHAISES ET TABLE EMPAQUETEES (d'après model de Martin Visser " notalen STOEL ONTW 1960) PROJET pour l'usine Spectrum . Bergeyr (N.B.) Hollande
Christo 64

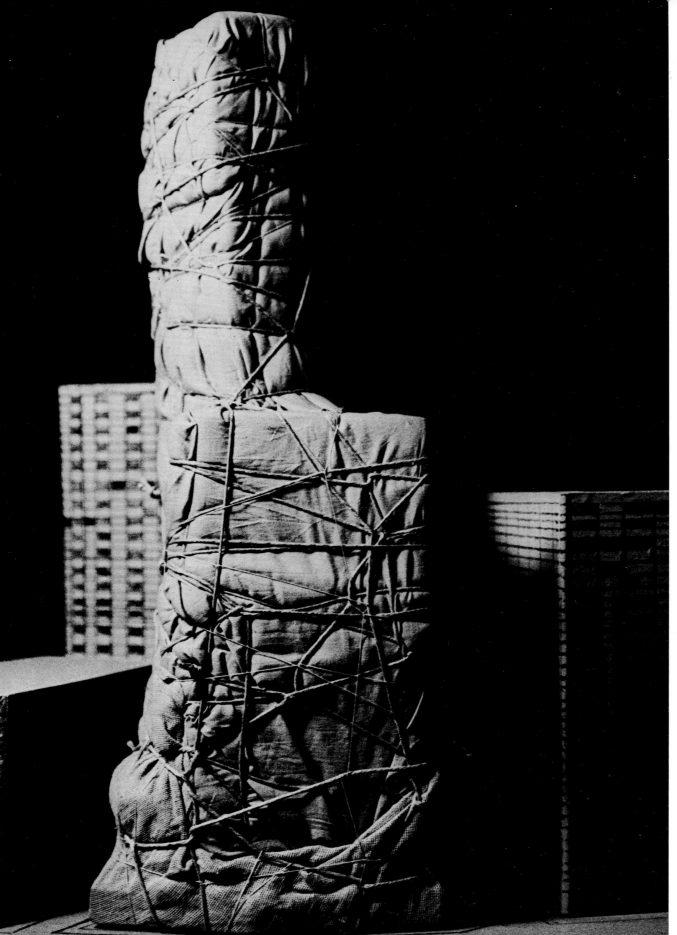

90. *Lower Manhattan Packed Building*. Scale model. 1964. Wood, canvas, and twine, 29×20×22 in. Collection Stephen Shore, New York City
91. *Lower Manhattan Packed Buildings*. Project. 1964–66. Collaged photographs and paper, $20\frac{1}{2}×29\frac{1}{2}$ in. Collection Mr. and Mrs. Horace H. Solomon, New York City
92. *Nine Packed Bottles*. 1965. Cardboard, bottles, plastic, and twine, $13\frac{1}{4}×14×11$ in. Collection Harrison Rivera, New York City
93. *Packed Telephone*. 1964. Telephone, plastic, and twine, 5×5×9 in. Collection William Dorr, New York City

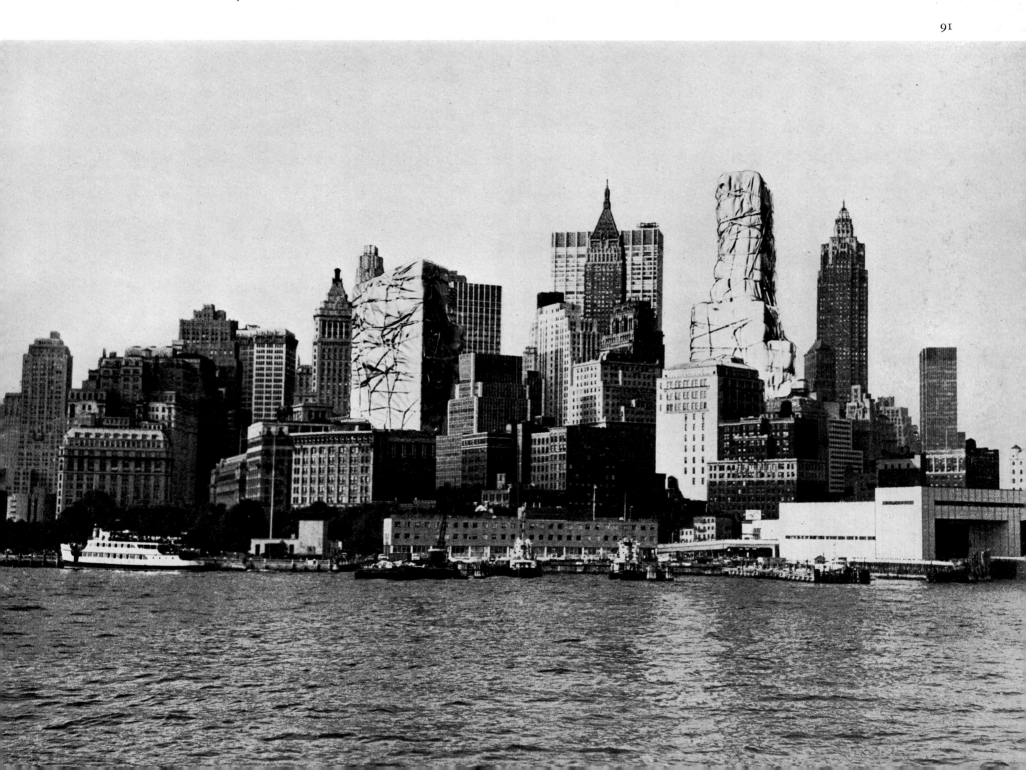

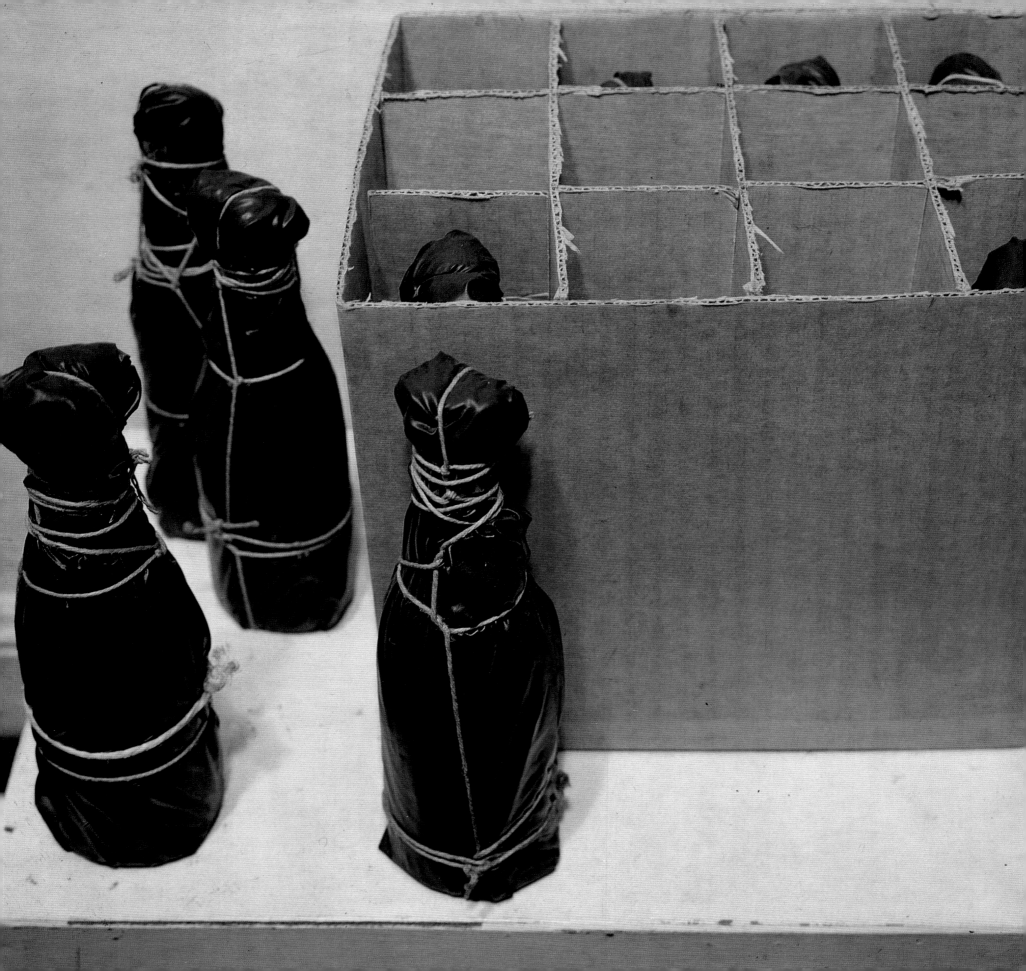

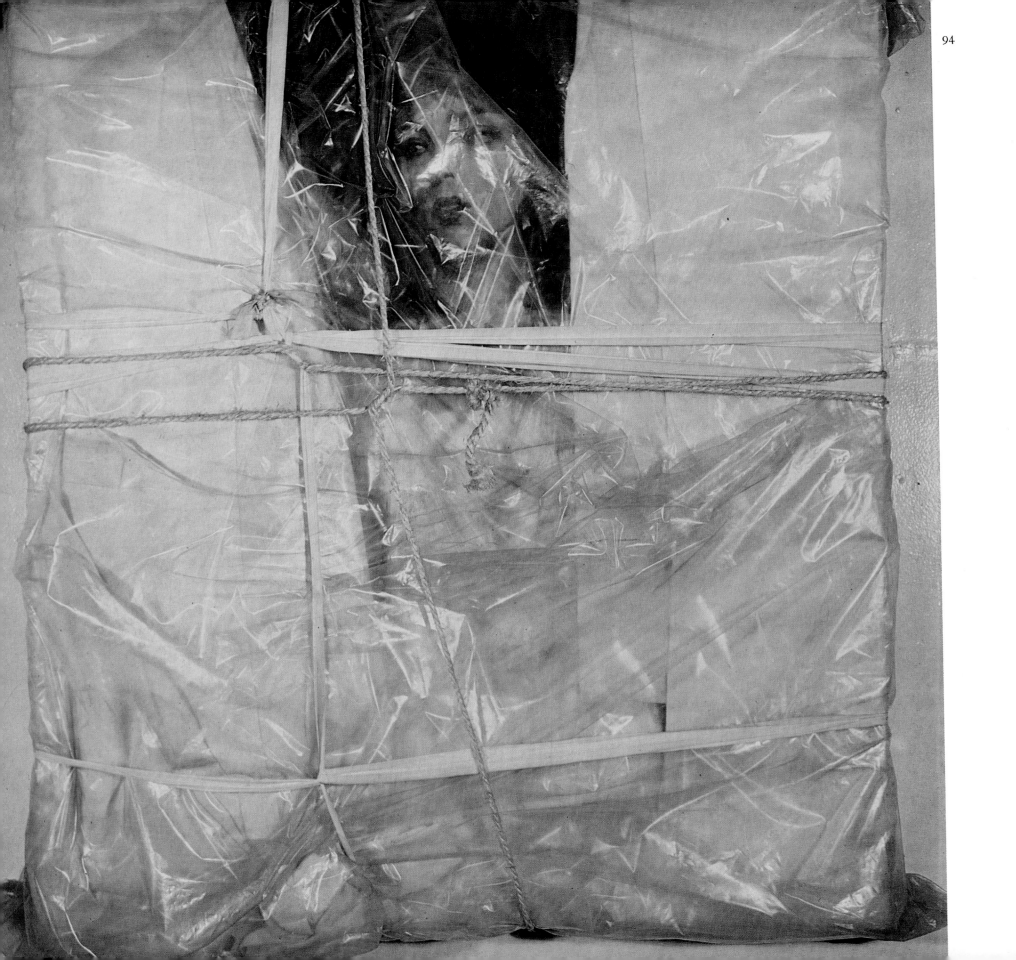

94. *Packed Portrait of Jeanne-Claude.* 1966. Oil on canvas covered with fabric, plastic, rope, and cord, 39 × 33 × 2½ in.

95. *Packed Magazines.* 1964. Magazines, plastic, and twine, 12 × 10 × 6 in. Collection Richard Bellamy, New York City

96. *Dolly.* 1964. Wooden box, tarpaulin, plastic, ropes, and girth, 72 × 40 × 24 in.

97. *Packed Armchair.* 1964–65. Armchair, plastic, cloth, polyethylene, and rope, 38 × 31¼ × 32 in. Stedelijk van Abbemuseum, Eindhoven, The Netherlands

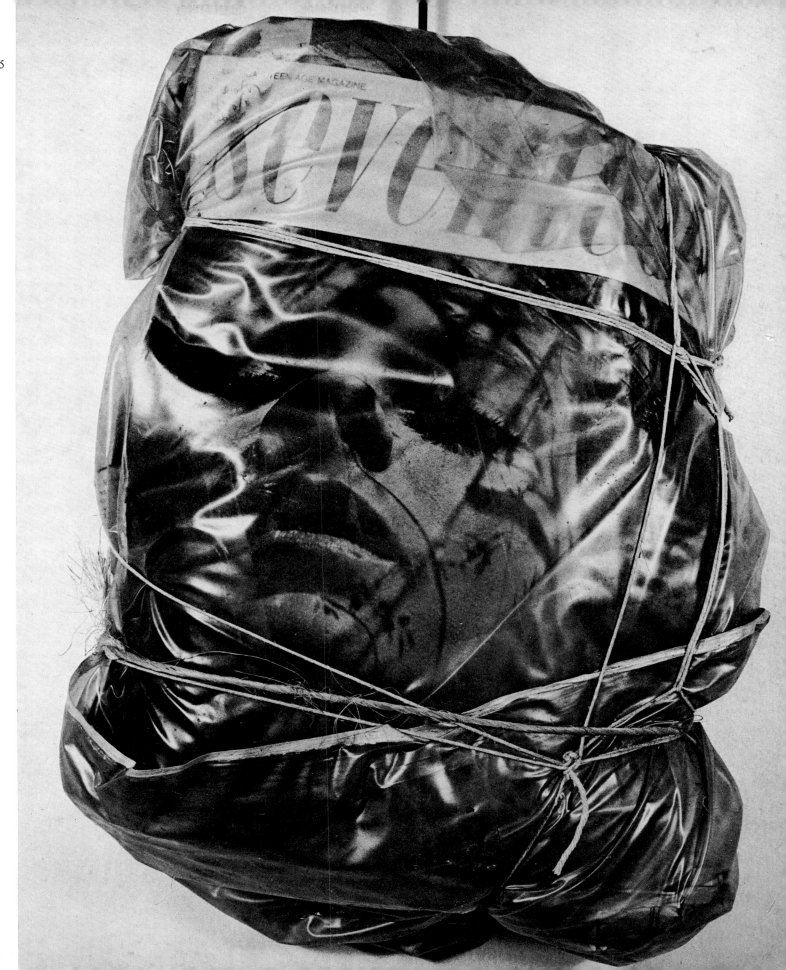

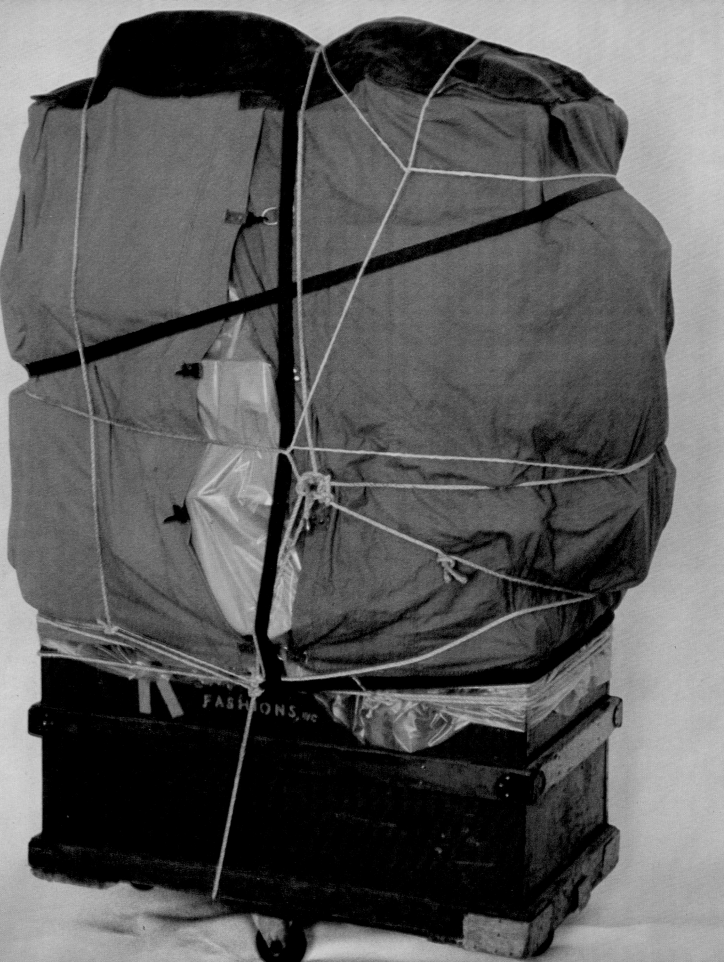

98

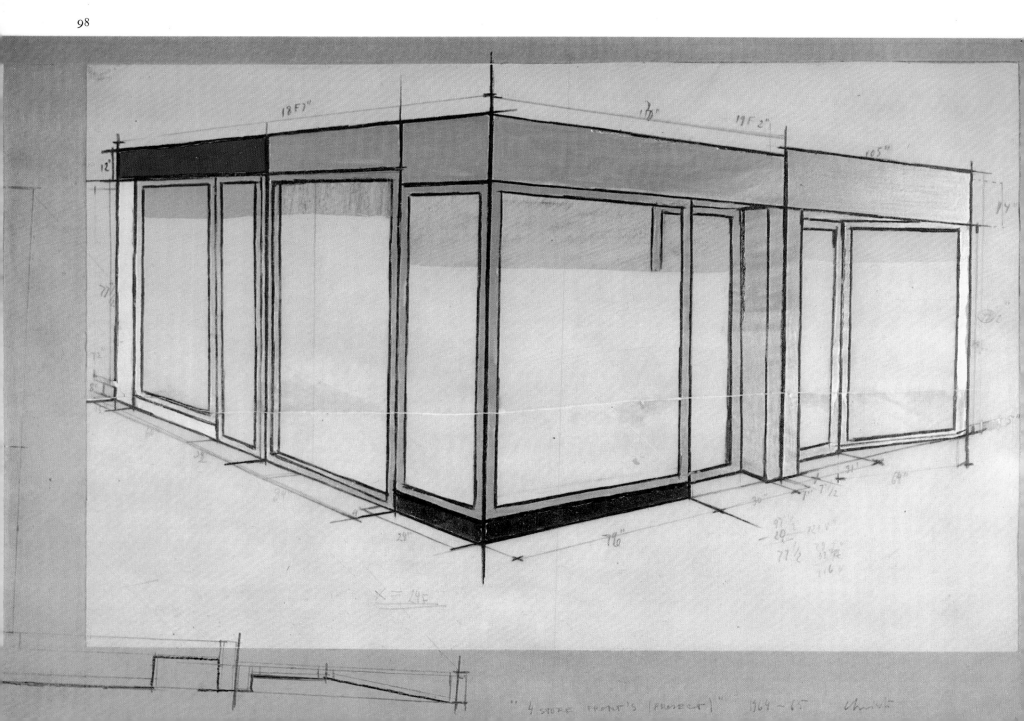

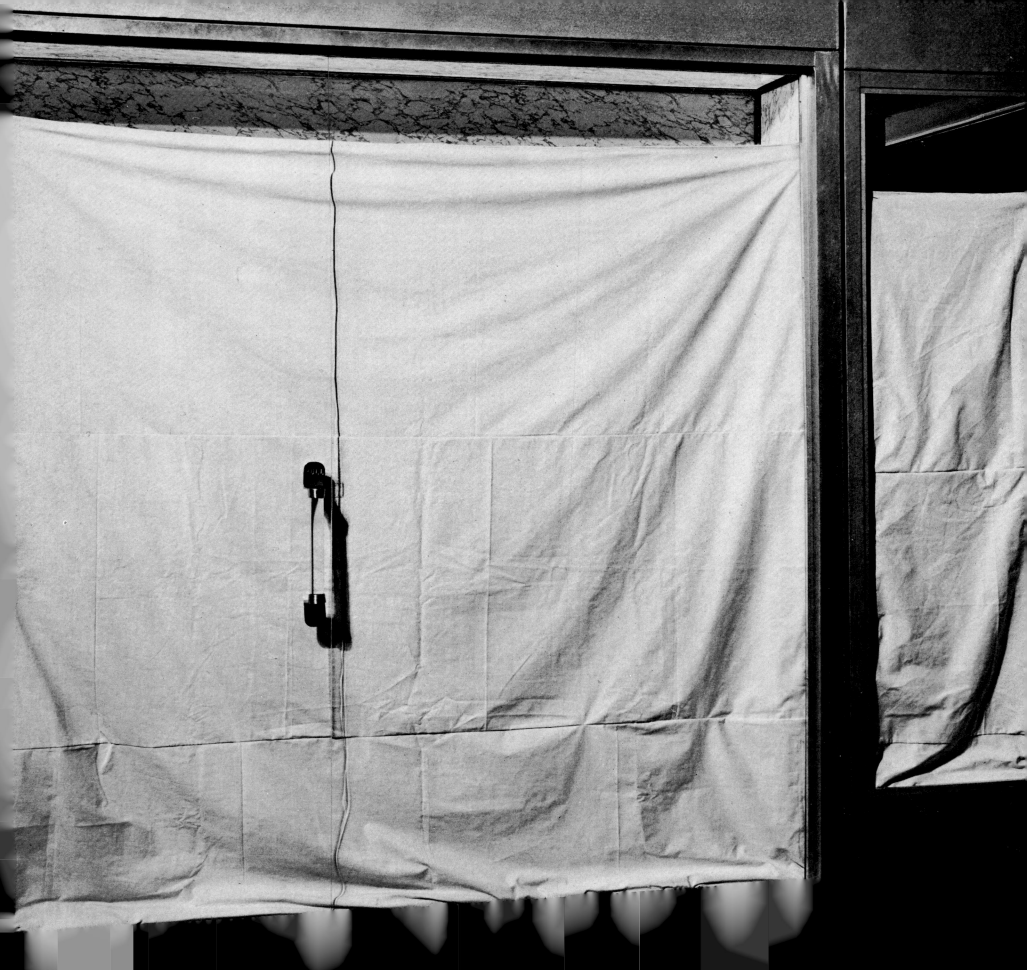

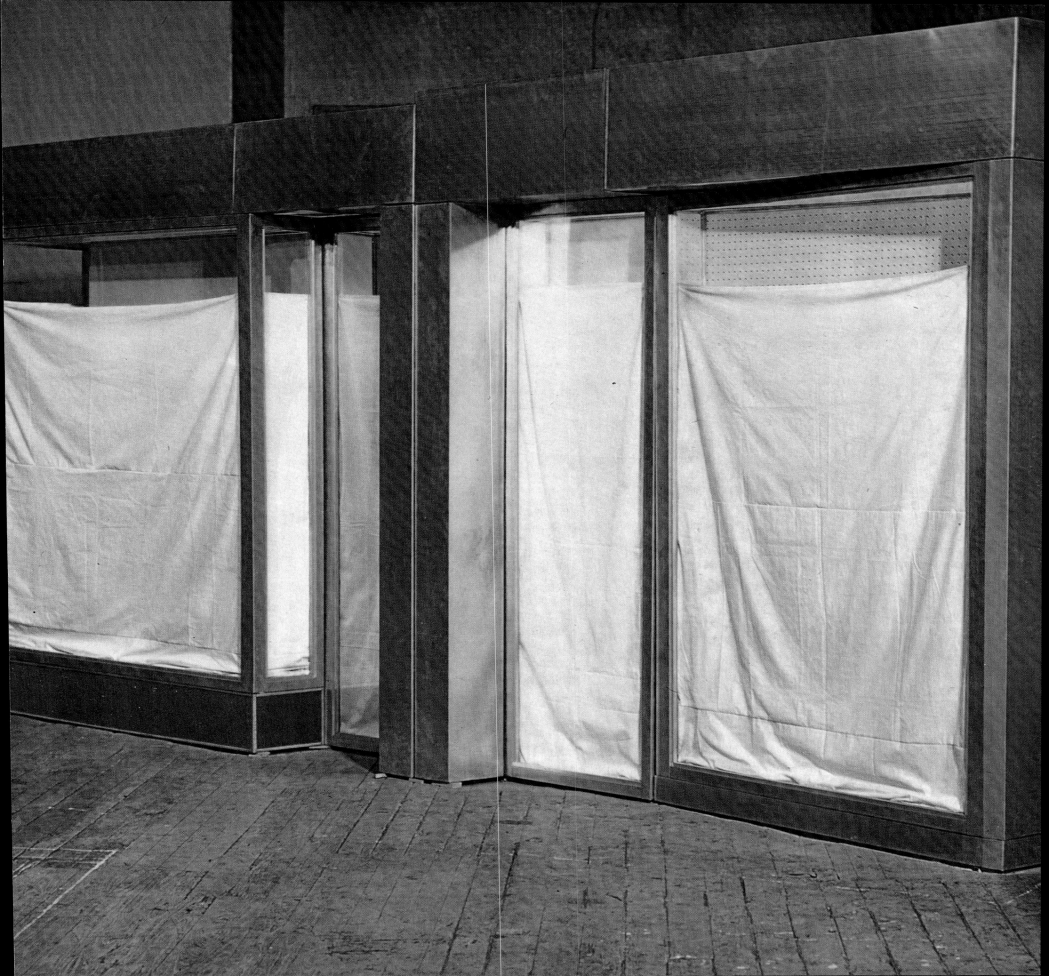

102. *Four Store Fronts.* Parts 4 and 3. 1964–65. Galvanized metal, clear and colored Plexiglas, Masonite, canvas, paper, and electric light, 8 ft. 1½ in. × 17 ft. 6 in. × 1 ft. 5 in.
103. *Four Store Fronts.* Project. 1964. Wood, Plexiglas, fabric, paper, and colored Plexiglas, 33 × 48 × 3 in. The Harry N. Abrams Family Collection, New York City
104. *Packed Tree.* 1966. White birch, jute, plastic, and rope, length 33 ft., diameter 25 in. Collection Christophe Vowinckel, Cologne

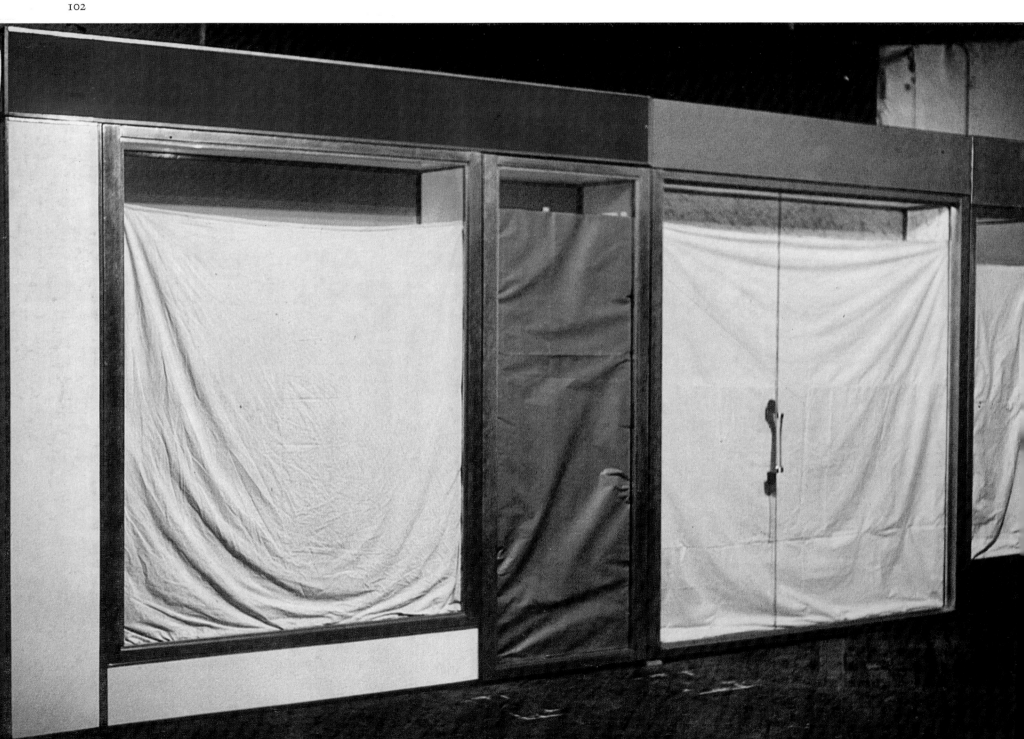

104 (overleaf) ▶

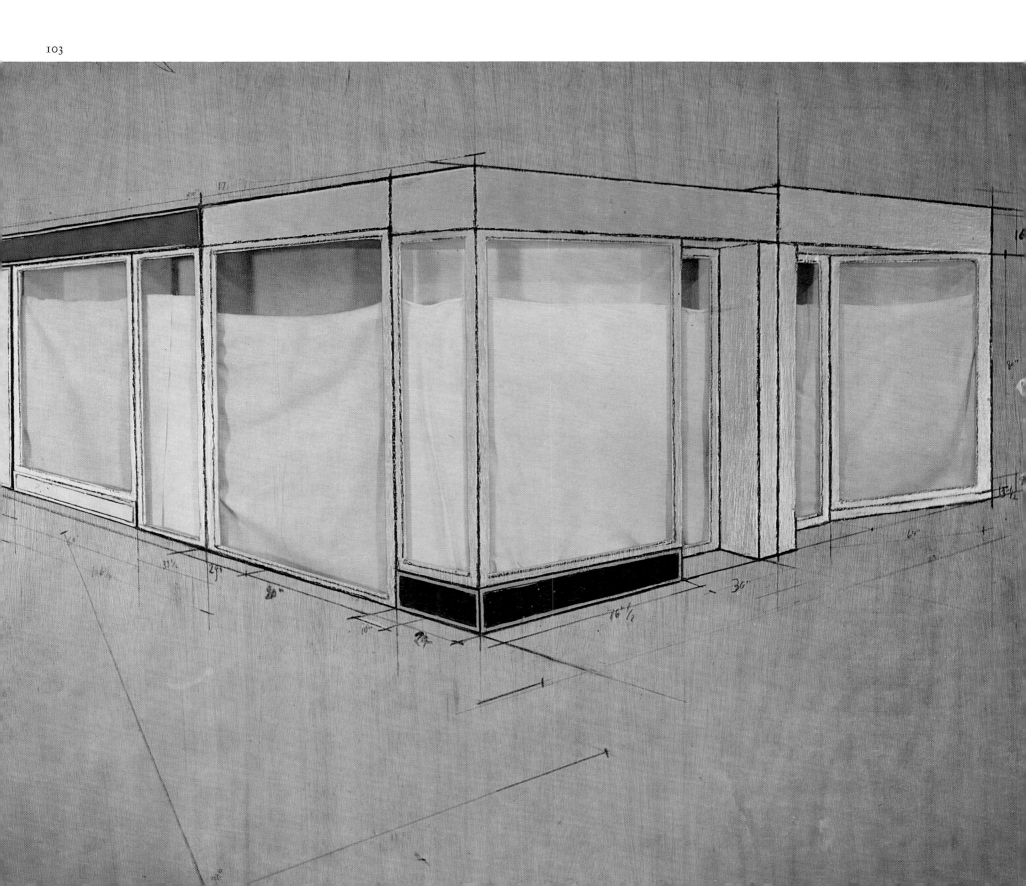

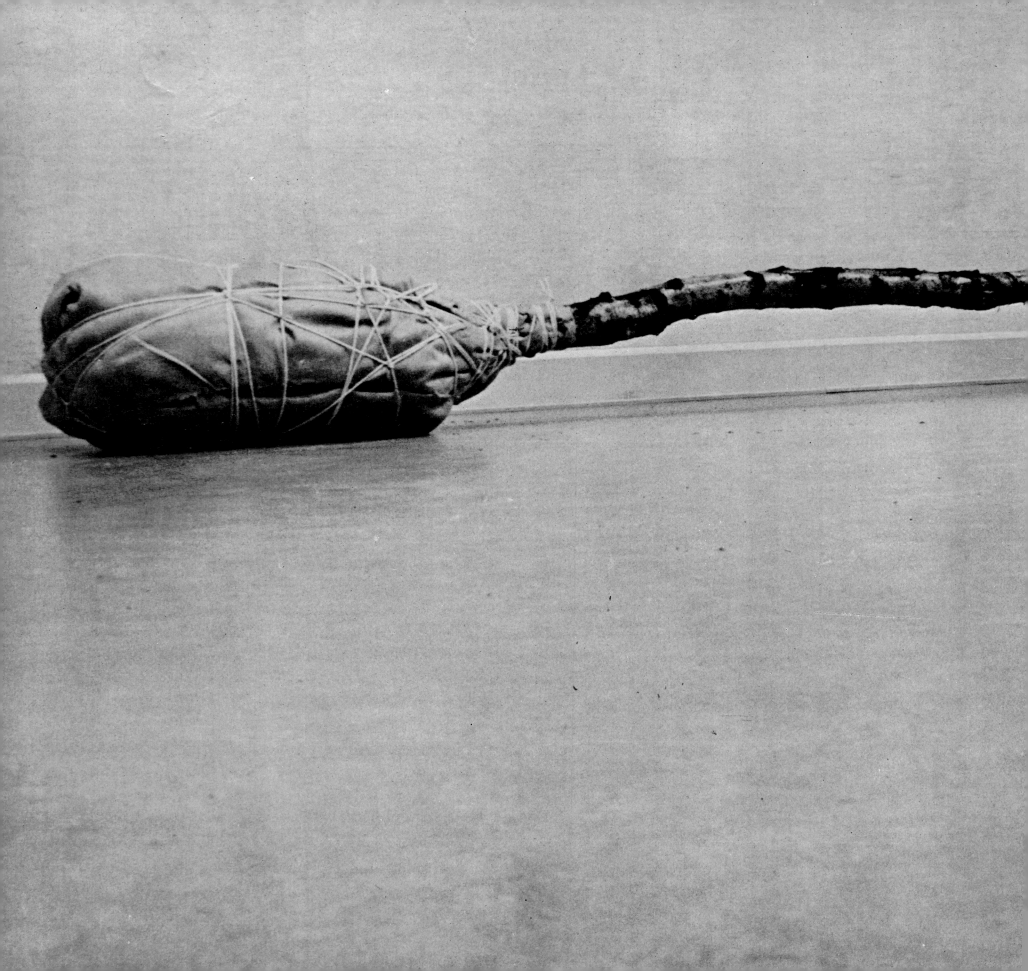

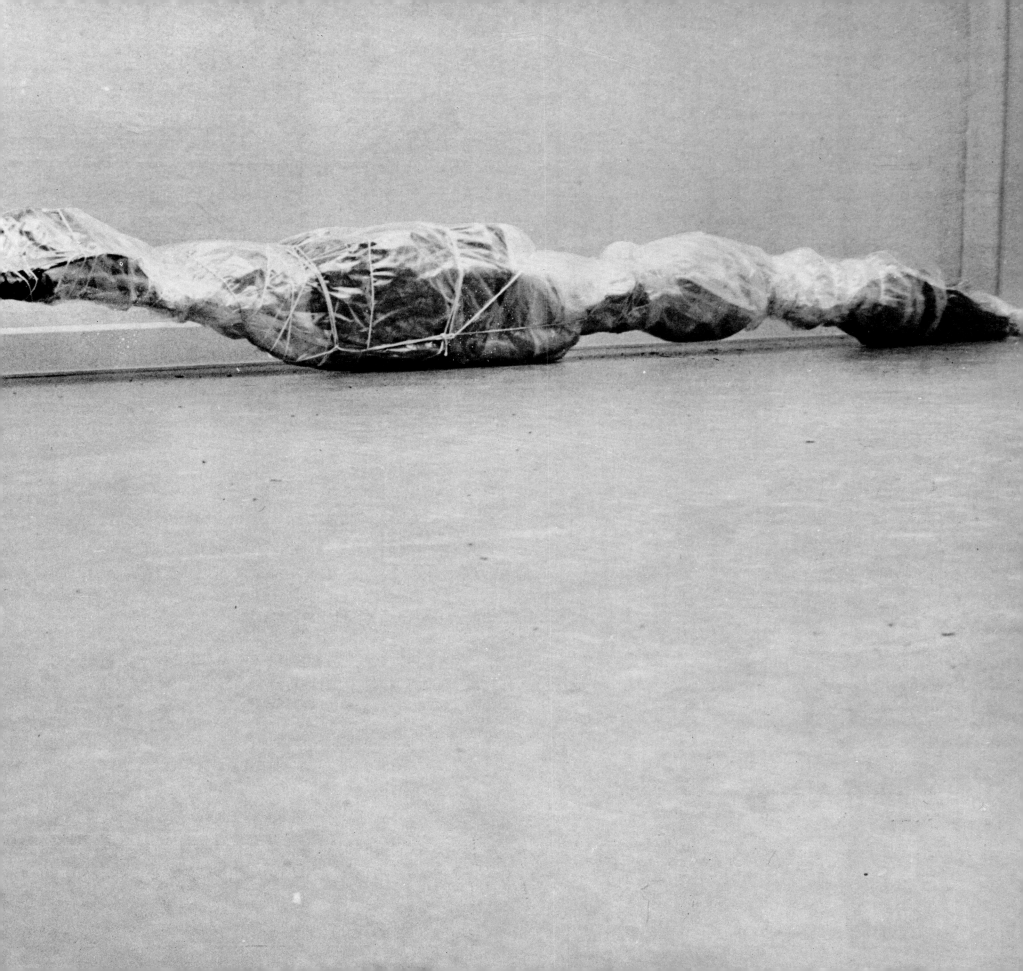

105. *Packed Trees*. Project for Forest Park, St. Louis, Missouri. 1966. Polyethylene, twine, and wood, $14\frac{1}{4} \times 30 \times 33\frac{1}{4}$ in.
106. *Air Package*. 1966. Air, polyethylene, rubberized canvas, and rope, suspended by steel cables, diameter 17 ft. Eindhoven, The Netherlands

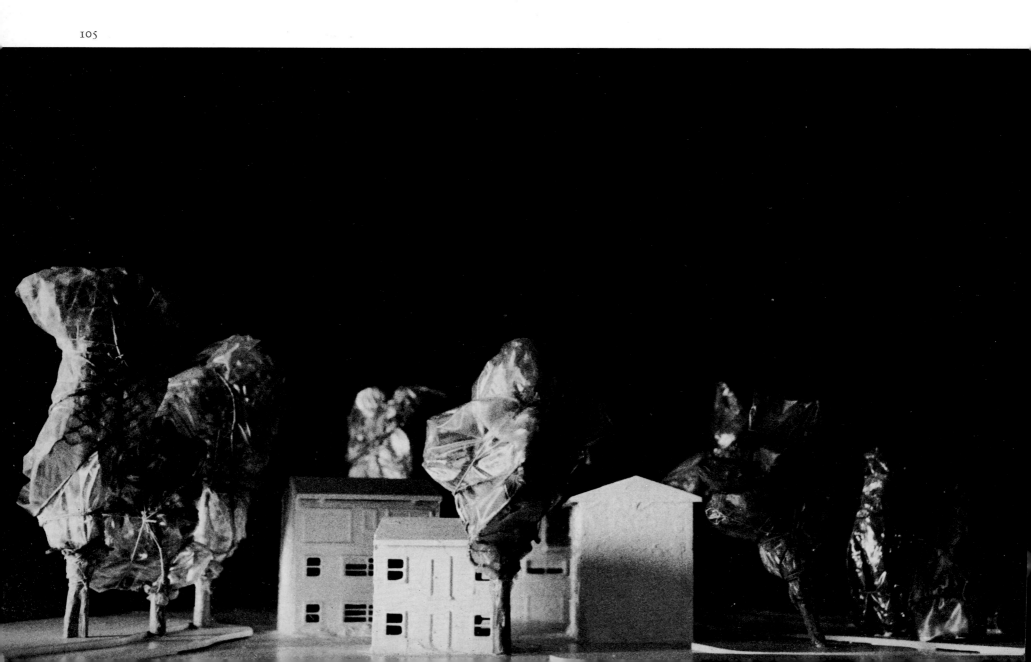

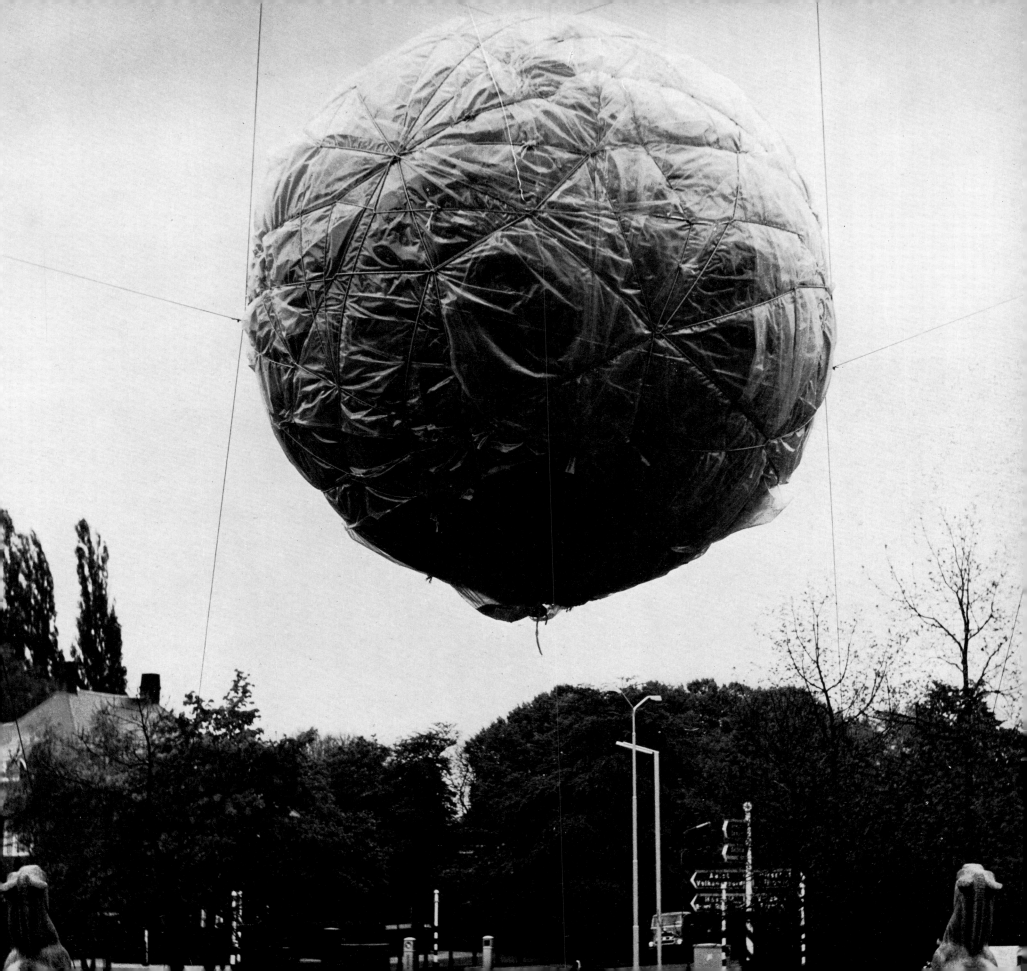

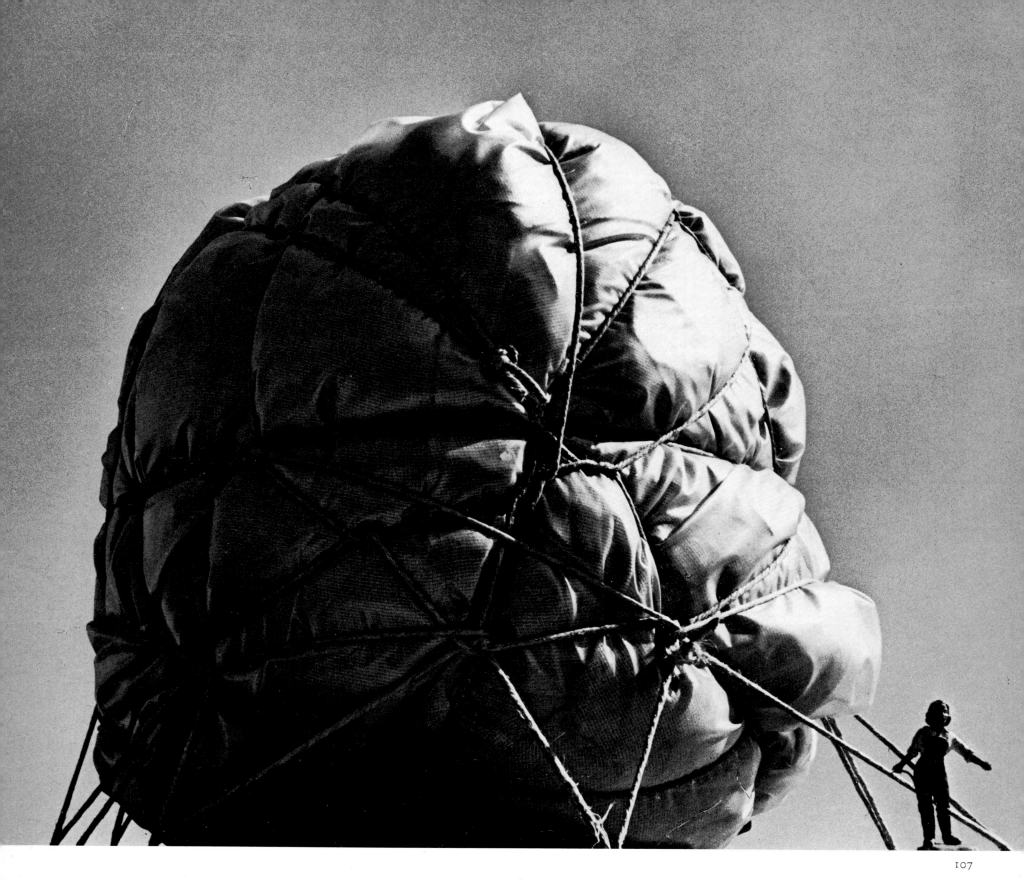

107

107. *42,390 Cubic Feet Package*. Scale model. 1966. Plastic, wood, and rope, 15 × 30 ×
 30 in. Collection Mr. and Mrs. Armand Bartos, New York City
108. *42,390 Cubic Feet Package*. Under construction. 1966

108

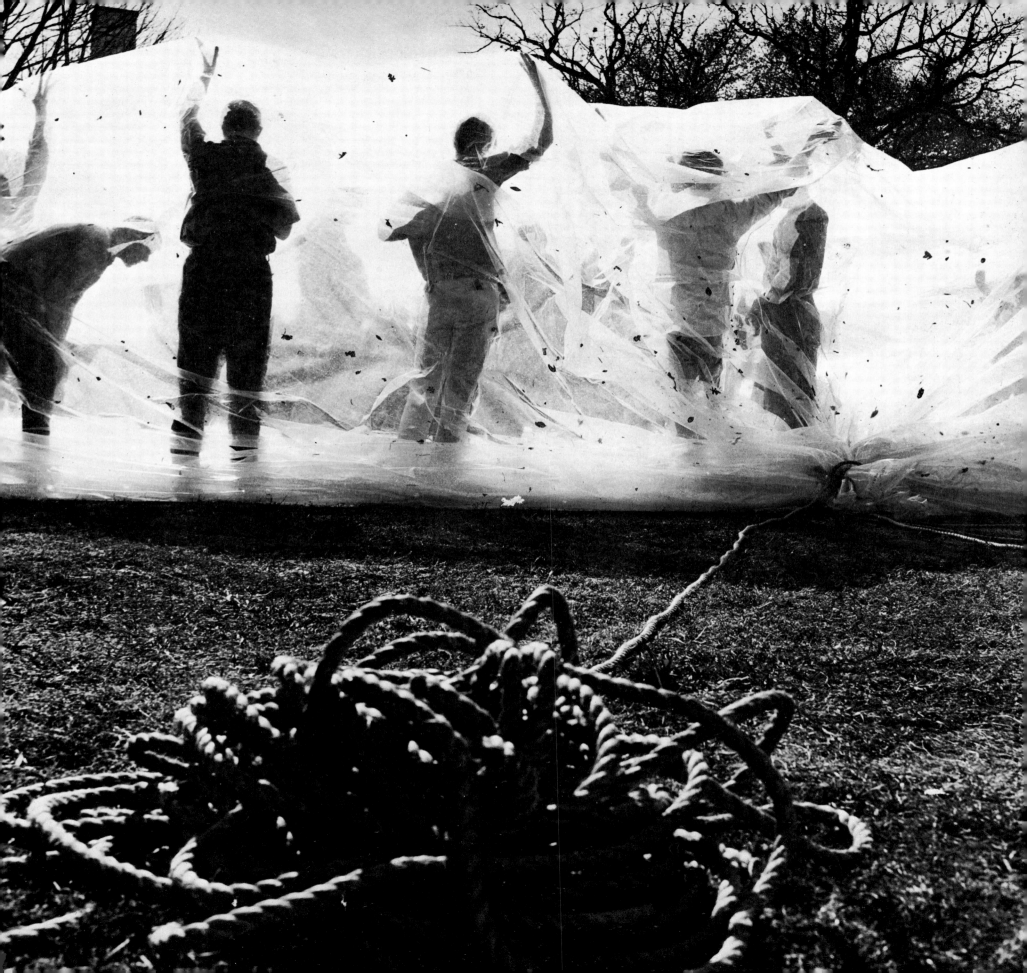

109. *42,390 Cubic Feet Package.* 1966. Length 60 ft., diameter 21 ft. The package is comprised of four United States high-altitude research balloons, sheathed in 8,000 sq. ft. of translucent polyethylene and wrapped with 3,000 ft. of rope. The giant balloon, inflated by two air blowers, contains 2,800 small colored balloons. The work was constructed at the Minneapolis School of Art with the aid of 147 student assistants

110–12. *42,390 Cubic Feet Package.* Being airlifted by helicopter

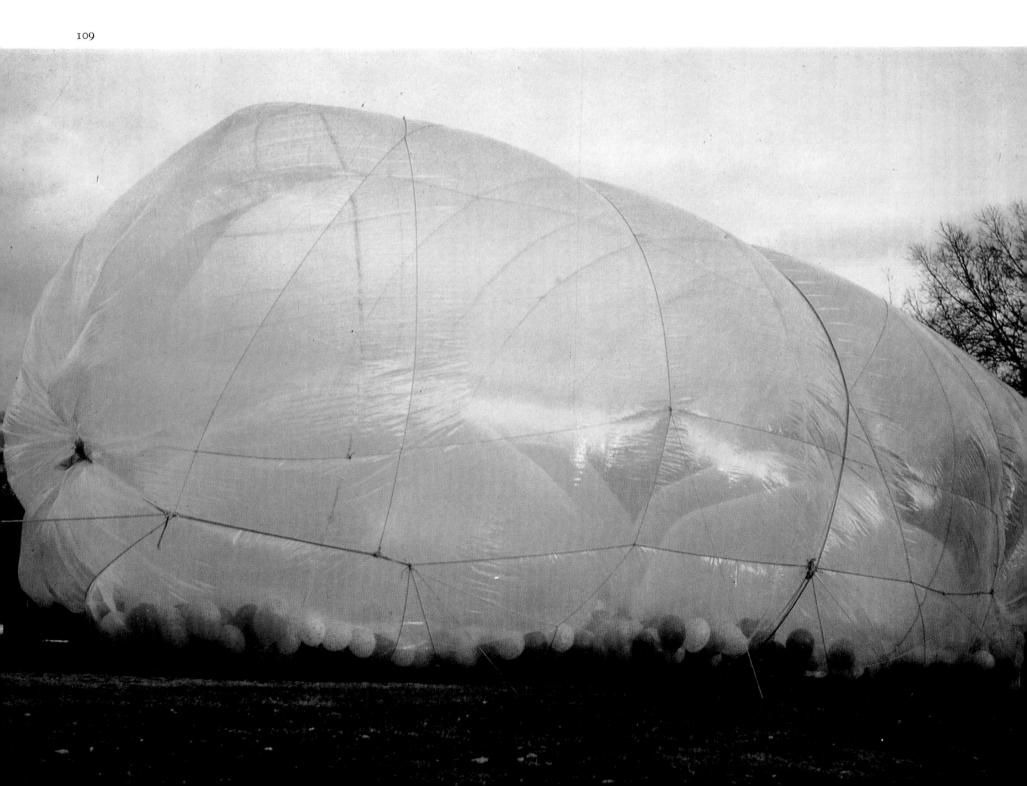

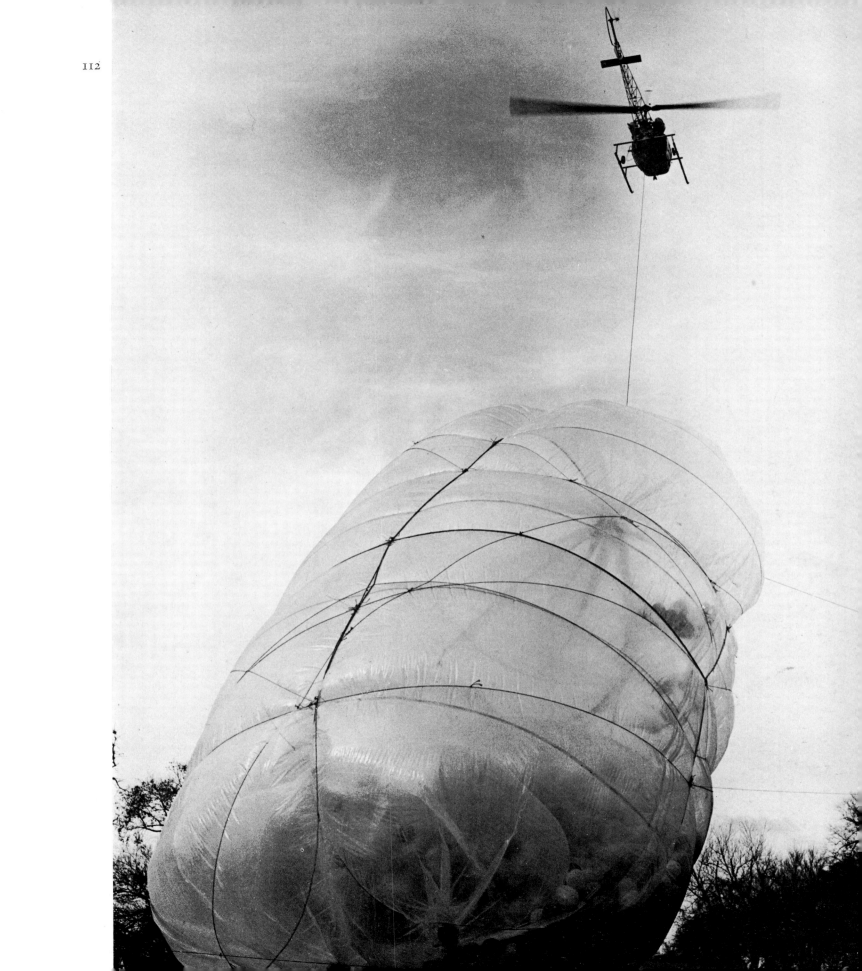

113. *Show Window*. 1965. Galvanized metal, lacquered Masonite, Plexiglas, and wrapping paper, $84 \times 48 \times 3\frac{3}{4}$ in.

114. *Double Show Window*. 1965–66. Galvanized metal, Plexiglas, and fabric, $84 \times 96 \times 3\frac{3}{4}$ in. Collection Mr. and Mrs. Martin Visser, Bergeyk, The Netherlands

115. *Three Store Fronts*. Project. 1965–66. Wood, Plexiglas, fabric, and electric light, 33×48×2 in. Collection Simone Swan, New York City
116. *Study for Three Store Fronts*. 1965–66. Ink drawing superimposed on photograph of the artist's New York studio

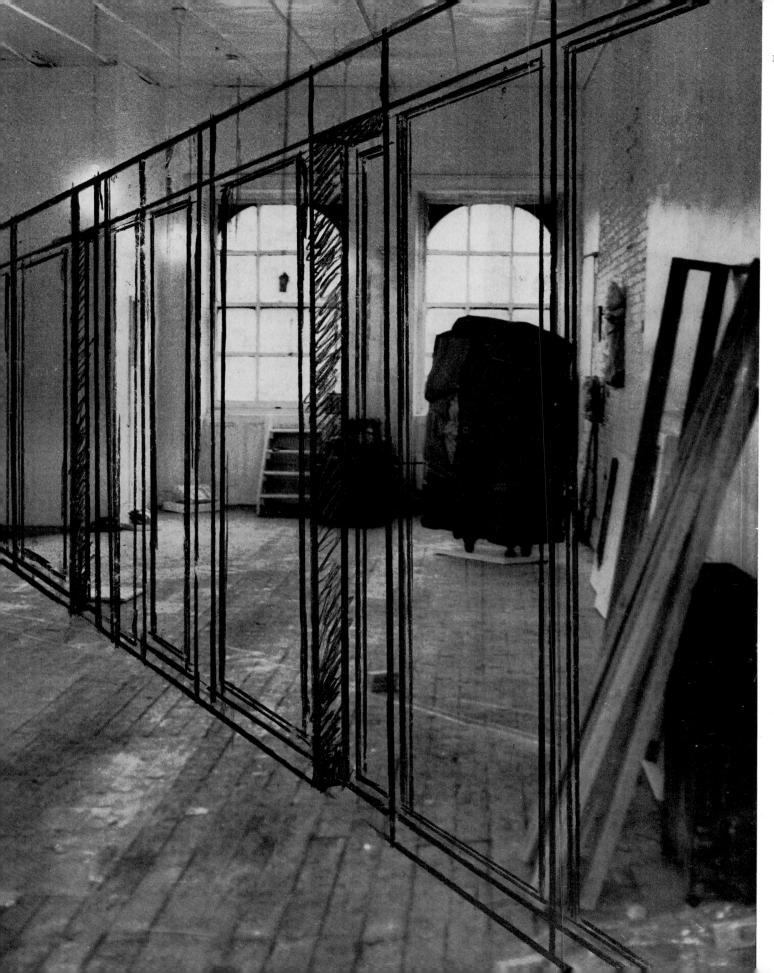

117. *Three Store Fronts*. Detail. 1965–66
118. *Three Store Fronts*. 1965–66. Galvanized metal, Plexiglas, Masonite,
fabric, and electric light, 8 ft. × 46 ft. × 1 ft. 5 in.

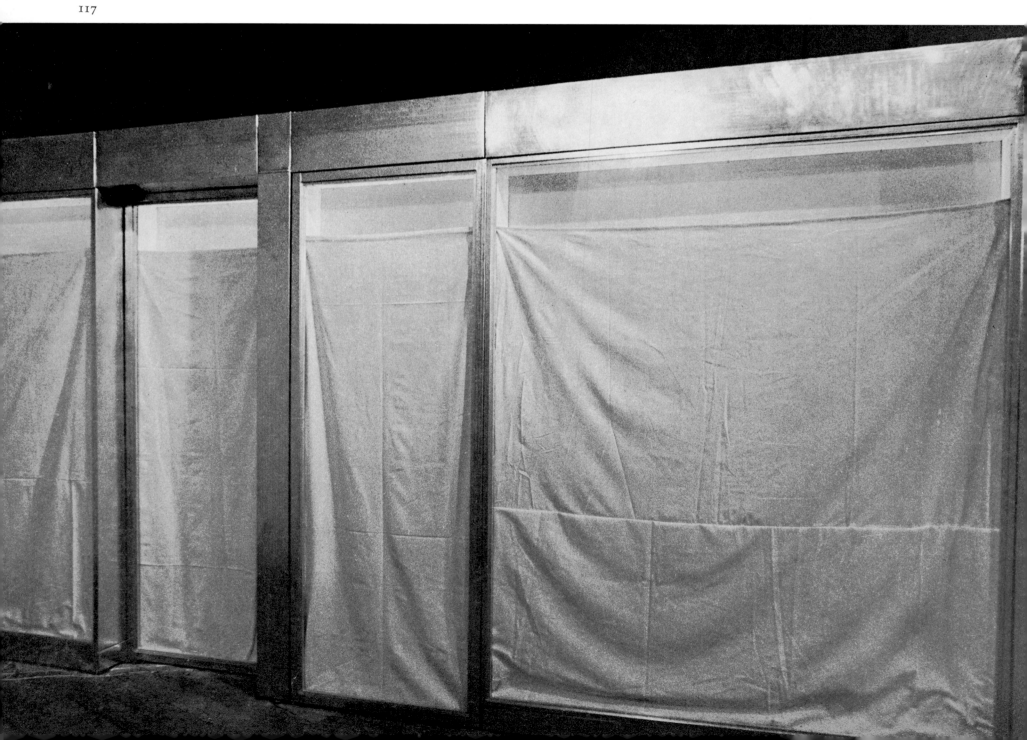

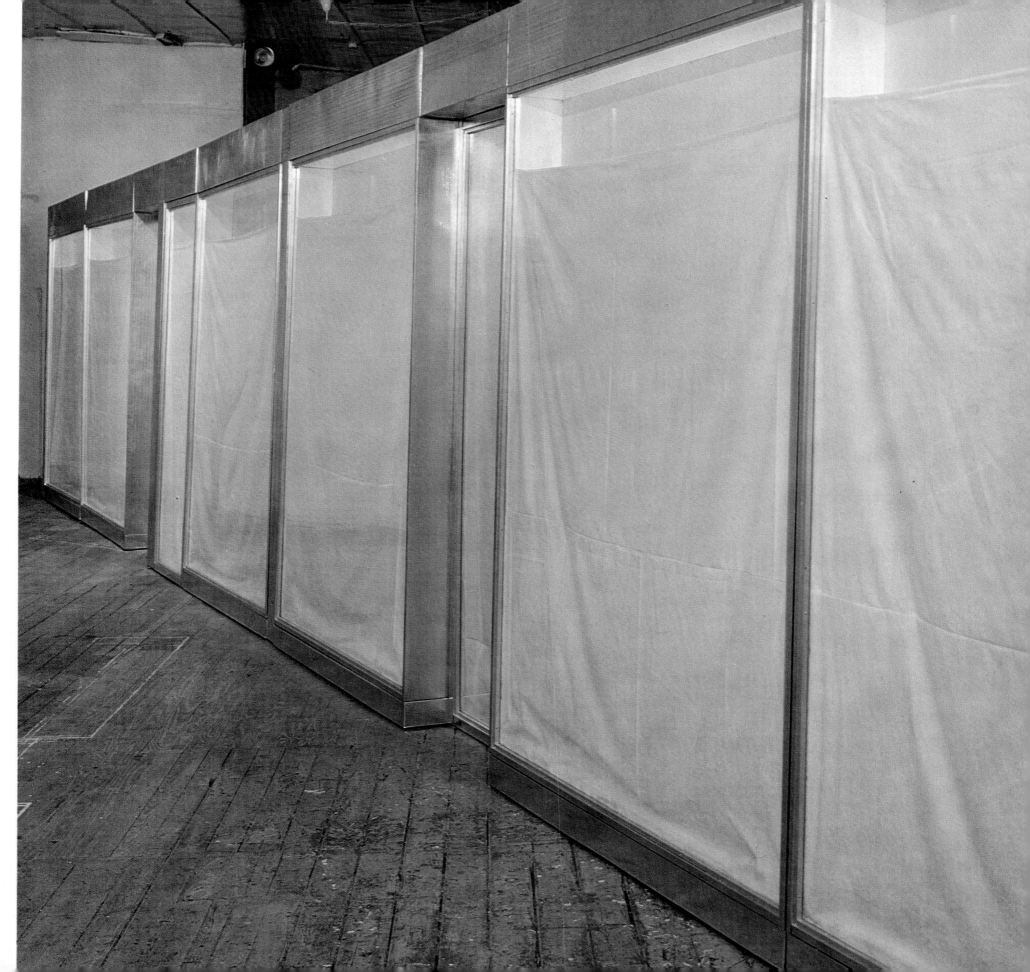

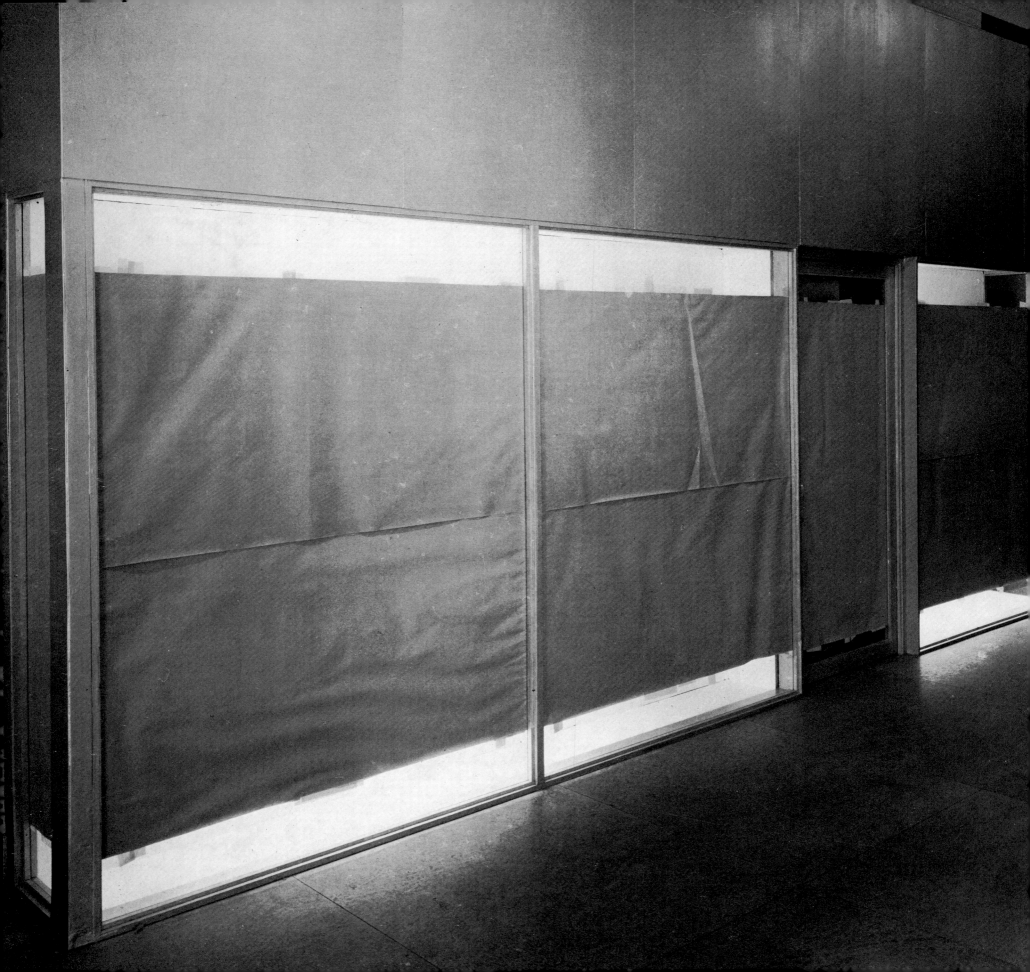

119. *Store Front*. 1967. Painted wood, Plexiglas, paper, and electric light, 14×24×2 ft. Young Men's and Young Women's Hebrew Association, on extended loan to the Philadelphia Museum of Art

120. *Store Front*. Project. 1967. Wood, Plexiglas, and paper, 29×24 in. Collection Dr. and Mrs. William Wolgin, Philadelphia

121. *Corridor—Store Front*. Project. 1967–68. Plexiglas and cardboard, 28× 22 in. Collection Mr. and Mrs. John Powers, New York City

120 121

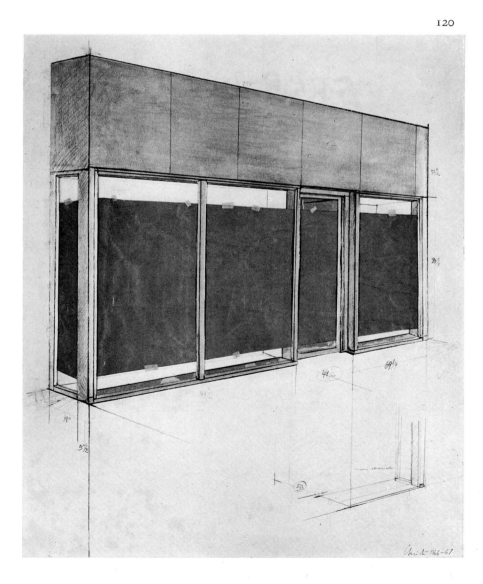

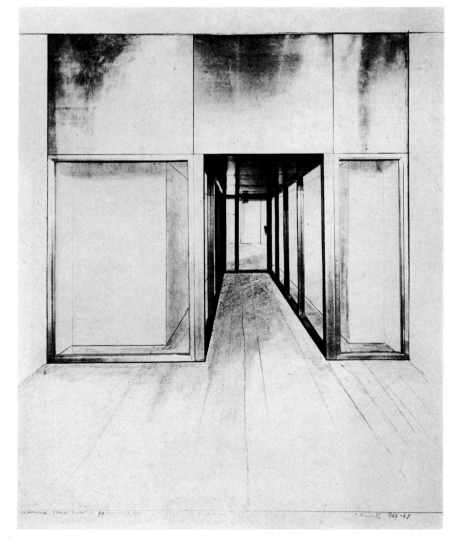

122. *Corridor—Store Front.* Scale model. 1967. Wood, Plexiglas, and electric light, 20×36×30 in. The Harry N. Abrams Family Collection, New York City
123. *Corridor—Store Front.* Scale model. 1968. Wood, Plexiglas, and glass, 20×24× 48 in. Collection Mr. and Mrs. John de Menil, Houston, Texas

122

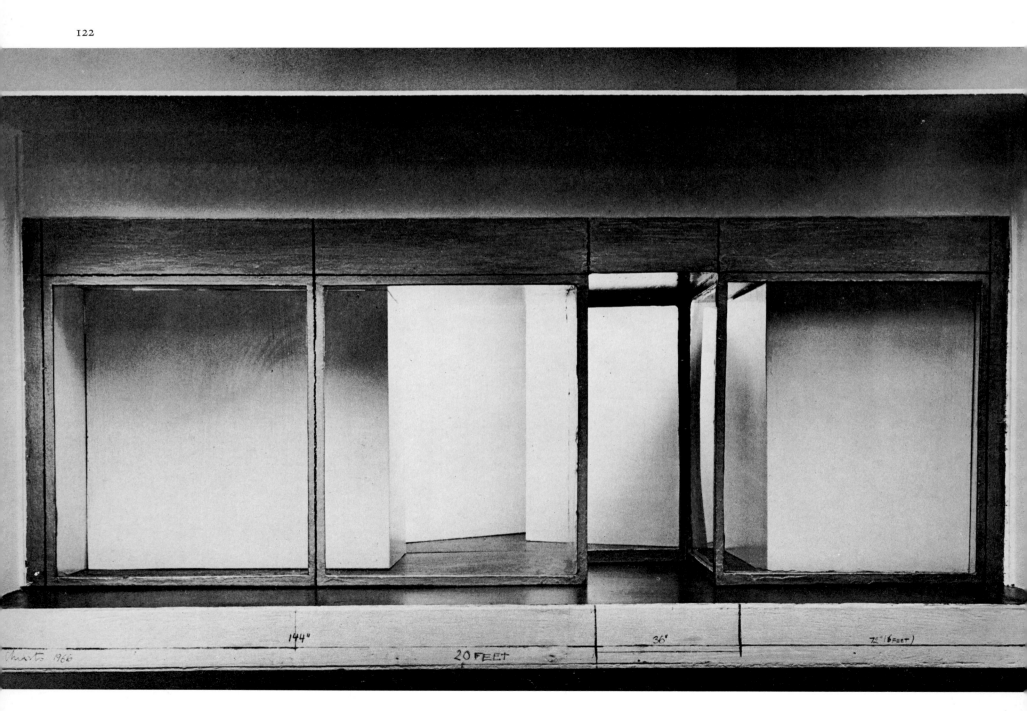

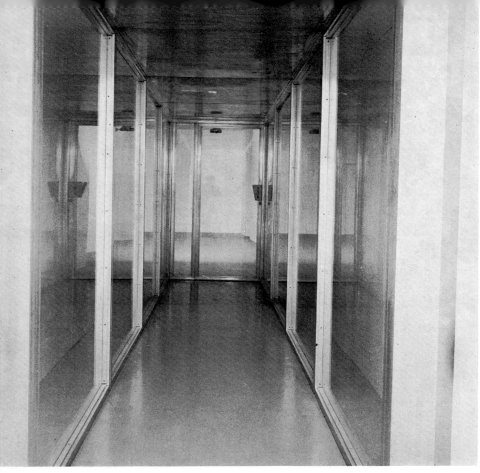

124

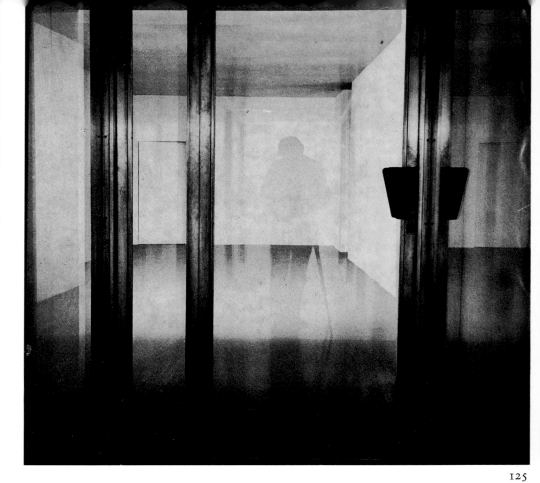

125

124–25. *Corridor—Store Front*. 1967–68. Aluminum, wood, Plexiglas, and electric light;
the entire work covers an area of 1,513 sq. ft. Private collection, Antwerp

126. *Corridor—Store Front*. Floor plan. 1967–68. Tracing paper and pencil

127. *Corridor—Store Front*. 1967–68. The facade in the foreground is 12×12 ft.

127 ▶

126

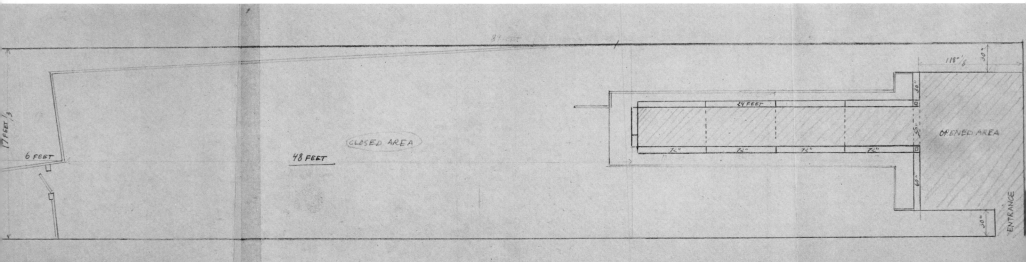

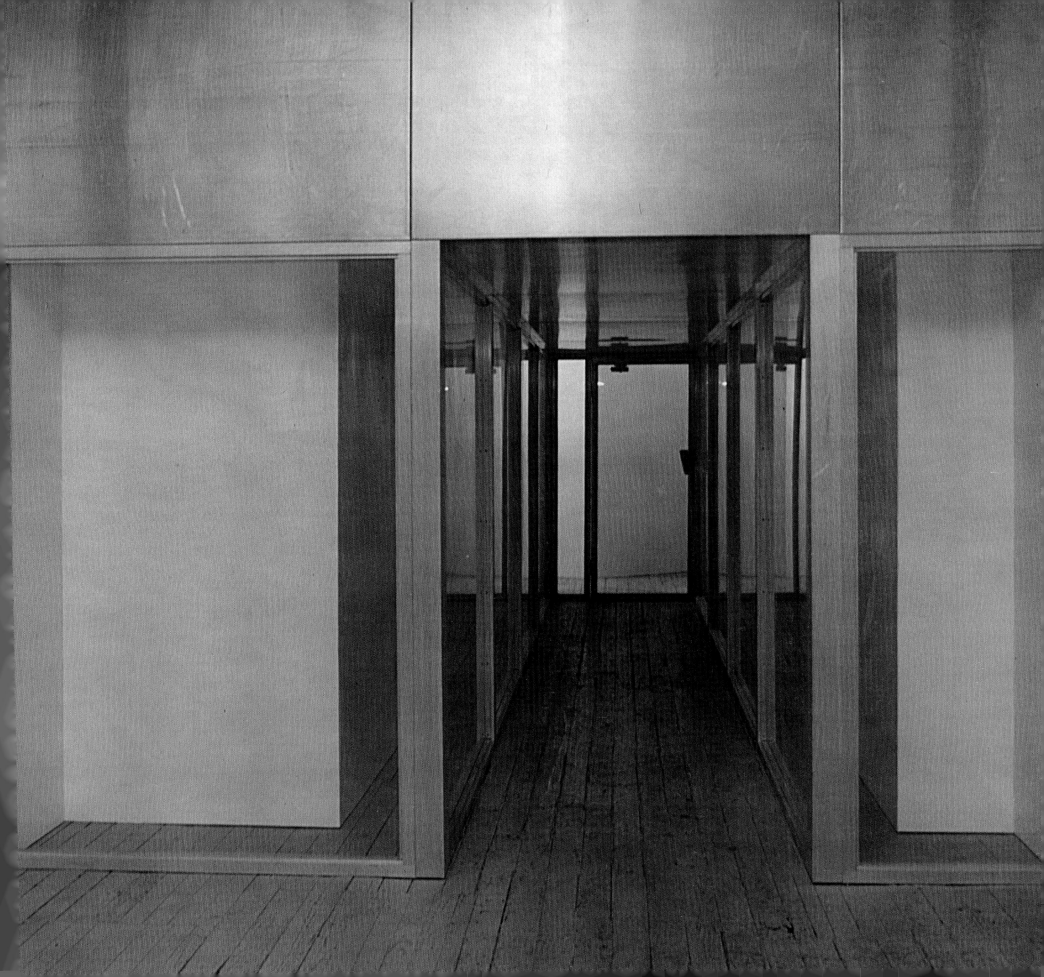

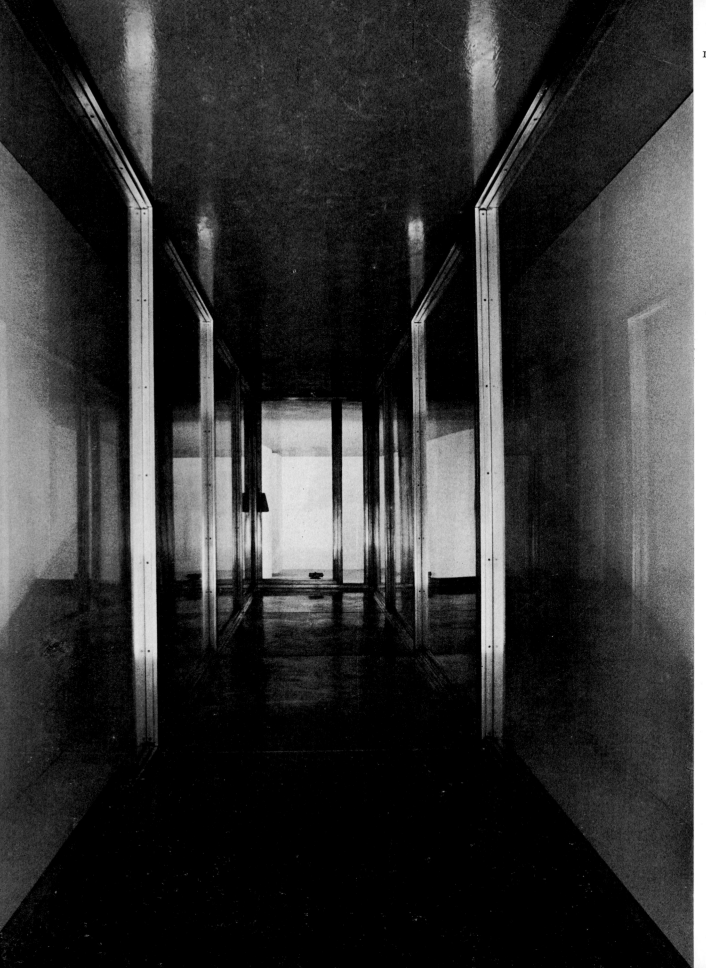

128. *Corridor—Store Front.* Detail of corridor. 1967–68. 8 ft. × 4 ft. 10 in. × 24 ft.

129. *Corridor—Store Front.* View through glass door of sealed back room. 1967–68. Aluminum, Plexiglas, wood, brick wall, and electric light, 10 × 17 × 48 ft.

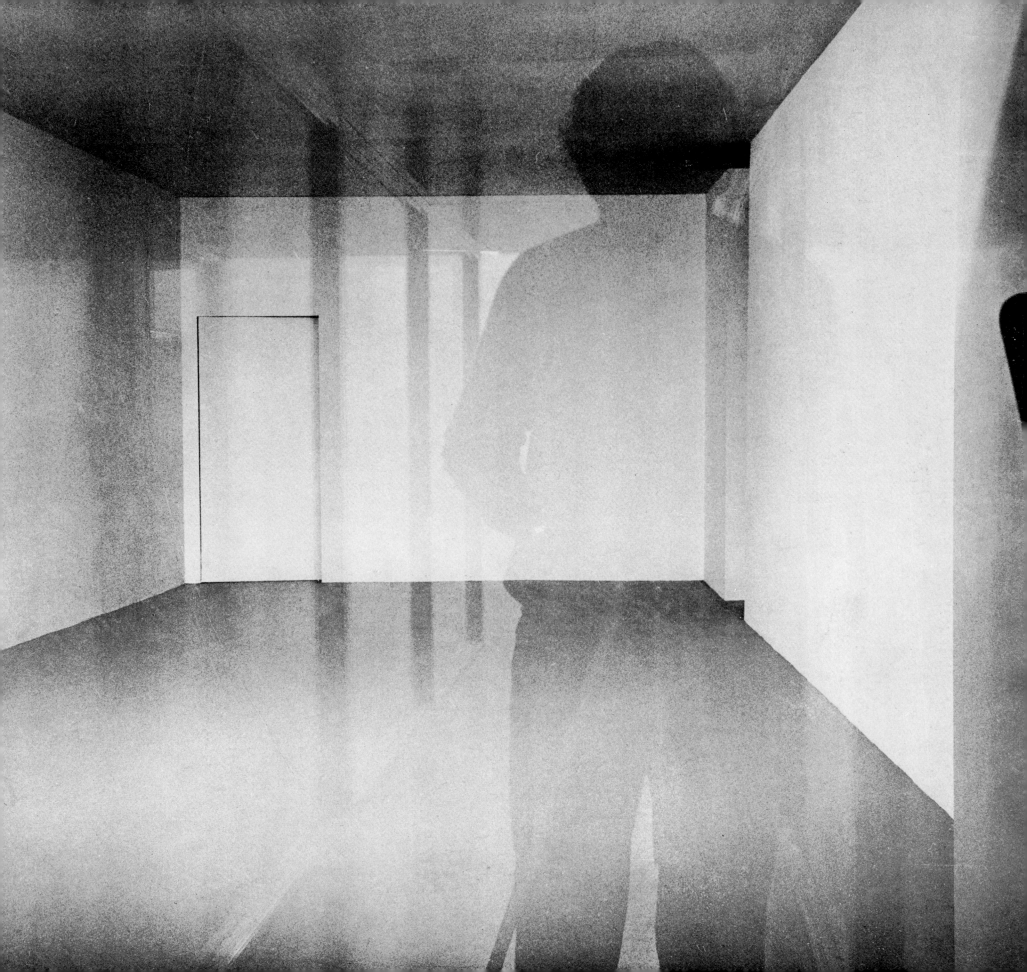

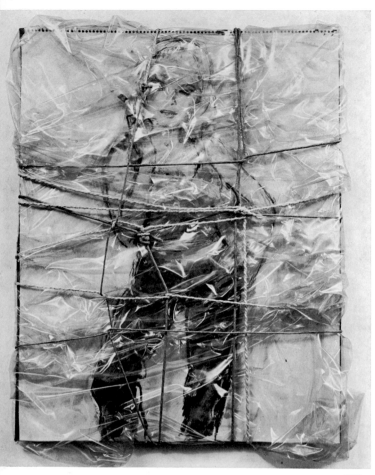

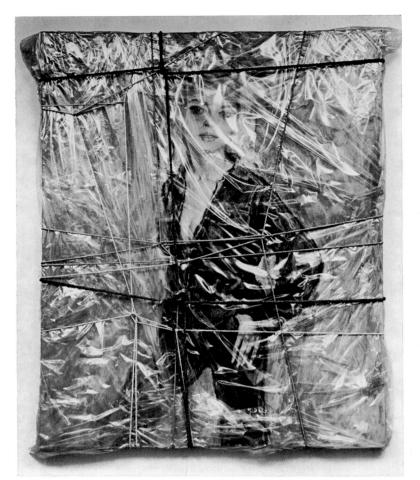

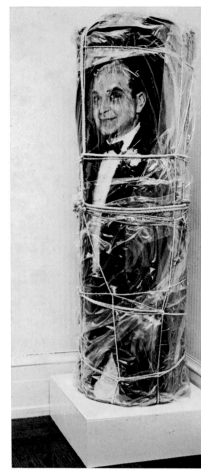

130

131 132

133

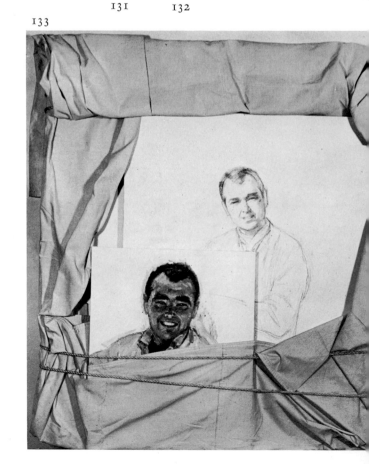

130. *Wrapped Portrait—Holly*. Study. 1966–67. Oil on paper, wrapped in plastic and twine, 20×12×1 in. Collection Mr. and Mrs. Horace H. Solomon, New York City

131. *Wrapped Portrait—Holly*. 1966–67. Oil on canvas, polyethylene, and twine, 52×33×2 in. Collection Mr. and Mrs. Horace H. Solomon, New York City

132. *Wrapped Portrait—Horace*. 1967. Oil on canvas (rolled), plastic, and rope, height 45 in., diameter 20 in. Collection Mr. and Mrs. Horace H. Solomon, New York City

133. *Wrapped Portrait—Ray*. Revealed view. 1968. Pencil and oil on canvas, tarpaulin, and rope, 48×33×4 in. Collection Mr. and Mrs. Ray Kaufmann, New York City

134. *Wrapped Portrait—Ray*. Concealed view

135. *Packed Magazines*. 1965. Magazines, plastic, and twine, 10×14×12 in.

136. *Packed Magazines*. 1966. Magazines, plastic, and twine, 16×11×5½ in. Collection David Bourdon, New York City

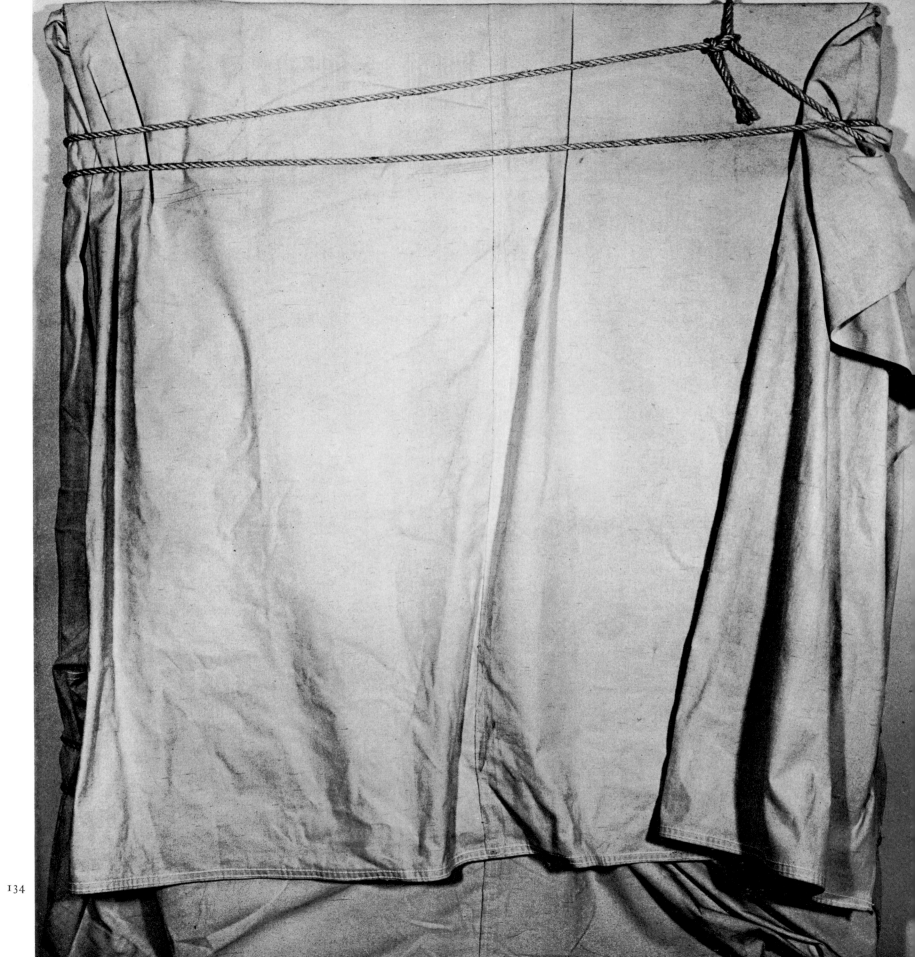

137

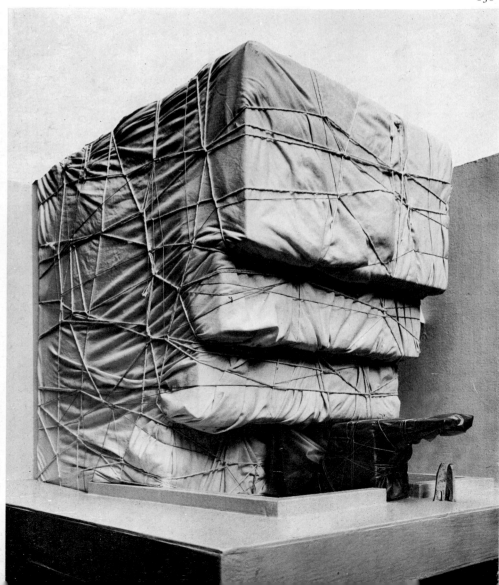

138

137. *National Gallery of Modern Art, Rome—Packed.* Scale model. 1967. Canvas, string, and wood, $10 \times 48 \times 24$ in. Collection Mr. and Mrs. John de Menil, Houston, Texas

138. *Whitney Museum of American Art, New York—Packed.* Scale model. 1967. Canvas and twine, $20 \times 19\frac{1}{2} \times 22$ in. Collection Mr. and Mrs. N. Richard Miller, New York City

139. *Museum of Modern Art, New York—Packed.* Scale model. 1968. Wood, canvas, and twine, $14 \times 48 \times 24$ in. The Museum of Modern Art, New York City. Gift of Mr. and Mrs. John de Menil

140. *Barrel Wall on West Fifty-third Street.* Project. 1968. Enamel paint on photostat, 22×28 in. The Museum of Modern Art, New York City. Gift of Louise Ferrari

141. *Museum of Modern Art, New York—Packed (View from the Garden).* Project. 1968. Collaged photographs, $12 \times 8\frac{1}{4}$ in.

142. *Museum of Modern Art, New York—Packed Sculpture Garden.* Project. 1968. Pencil on paper, 28×22 in. Richard Feigen Gallery, Chicago

143. *Museum of Modern Art, New York—Packed.* Project. 1968. Collaged photographs. The Museum of Modern Art, New York City. Gift of Mr. and Mrs. John de Menil

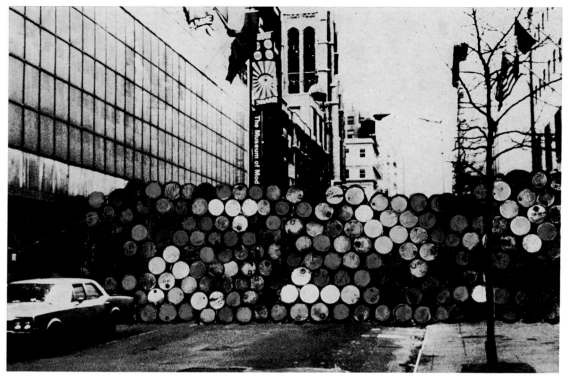

140

141

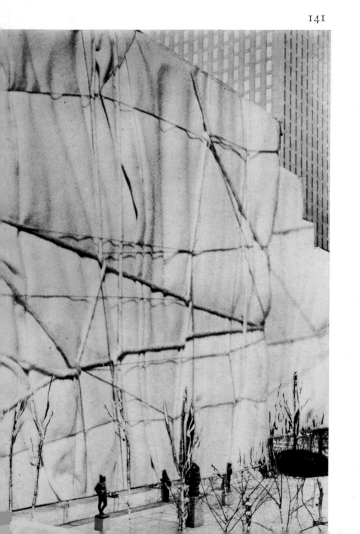

142

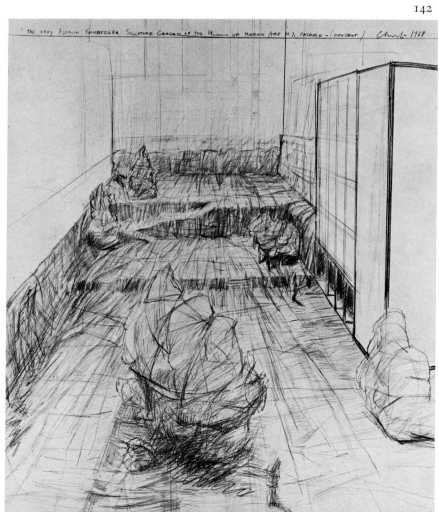

143

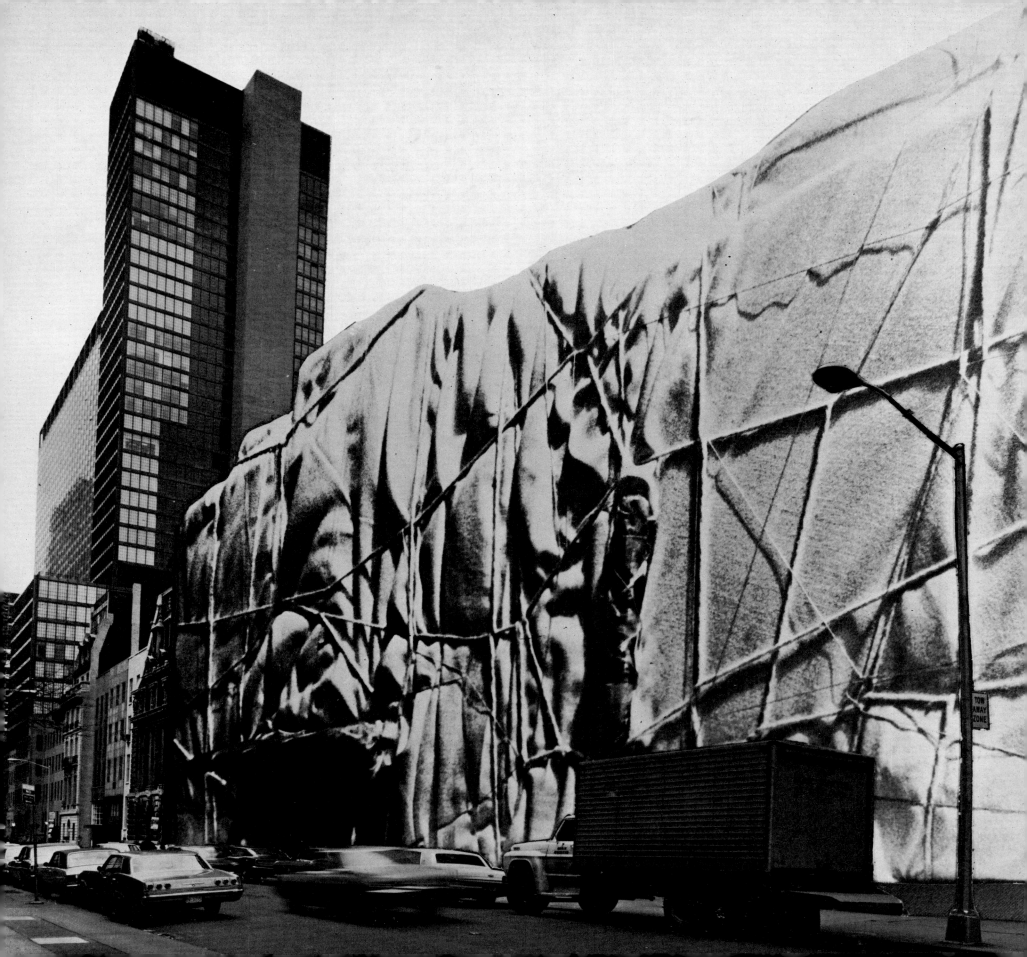

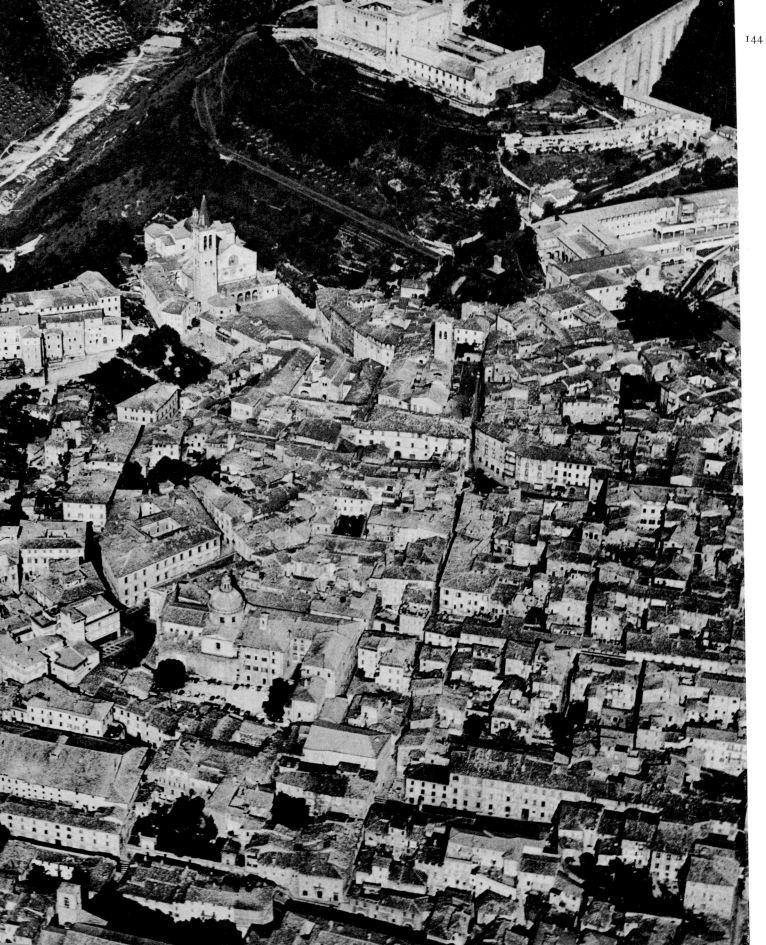

144. Aerial view of Spoleto, Italy
145. Map of Spoleto, Italy
146–48. *Packed Tower (Spoleto)*. 1968
Woven polypropylene and nylon
rope, 82×24×24 ft. The medieval
tower is adjacent to an arched
Roman viaduct

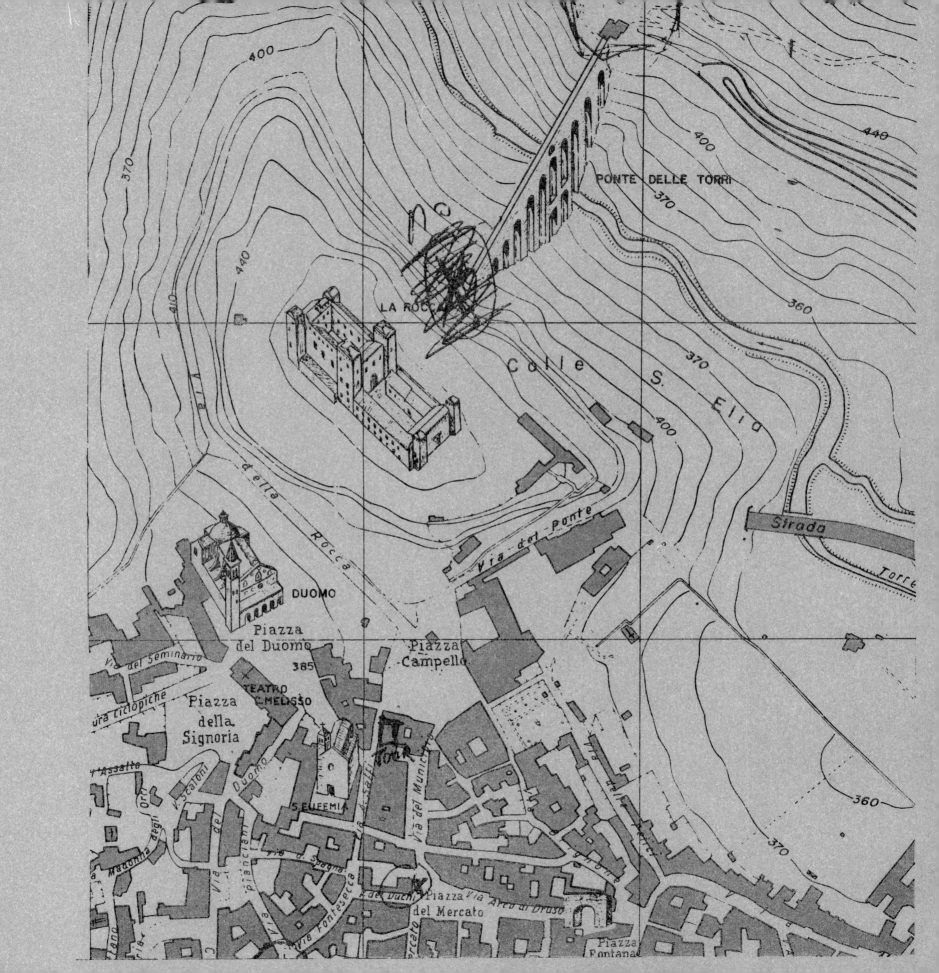

PONTE DELLE TORRI

LA ROCCA

Calle S. Elia

Via della Rocca

Via del Ponte

Strada

Torre

DUOMO

Piazza del Duomo

Piazza Campello

Via del Seminario

TEATRO C.MELISSO

385

Piazza della Signoria

ura ciclopiche

Via del Duomo

S.EUFEMIA

Via del Municipio

Piazza del Mercato

Piazza Fontana

400

370

440

370

440

400

400

440

360

370

400

360

370

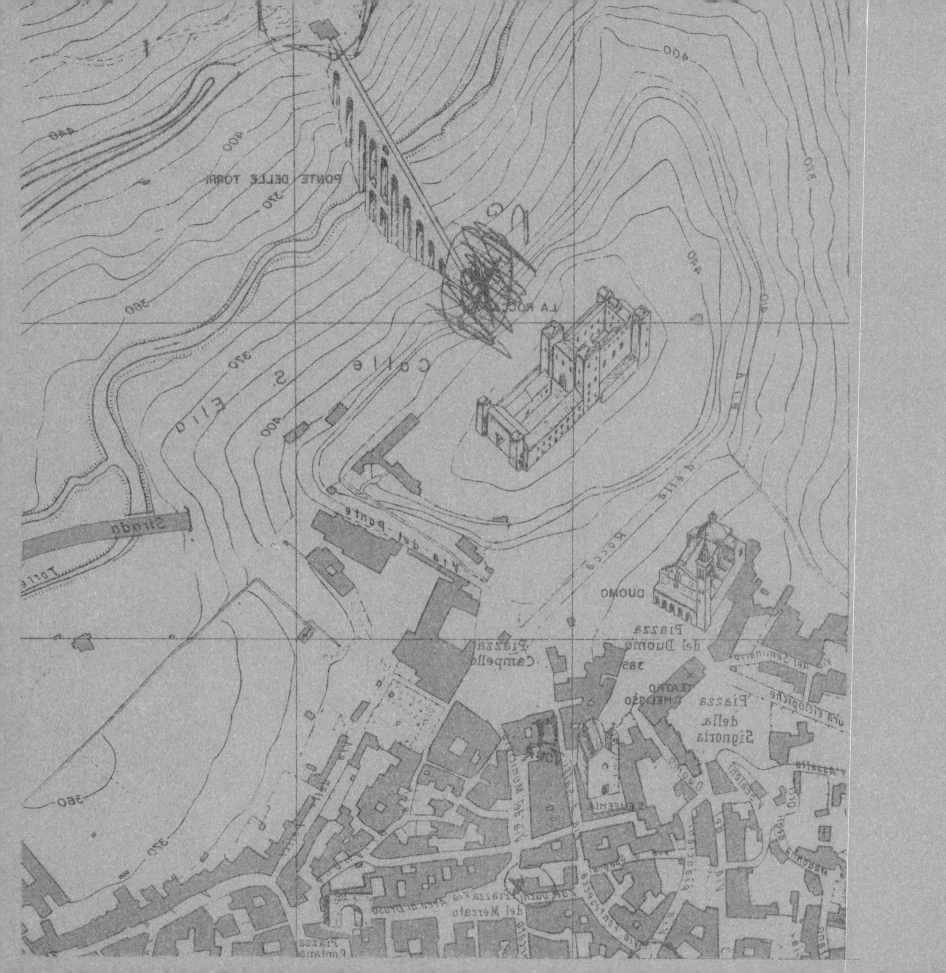

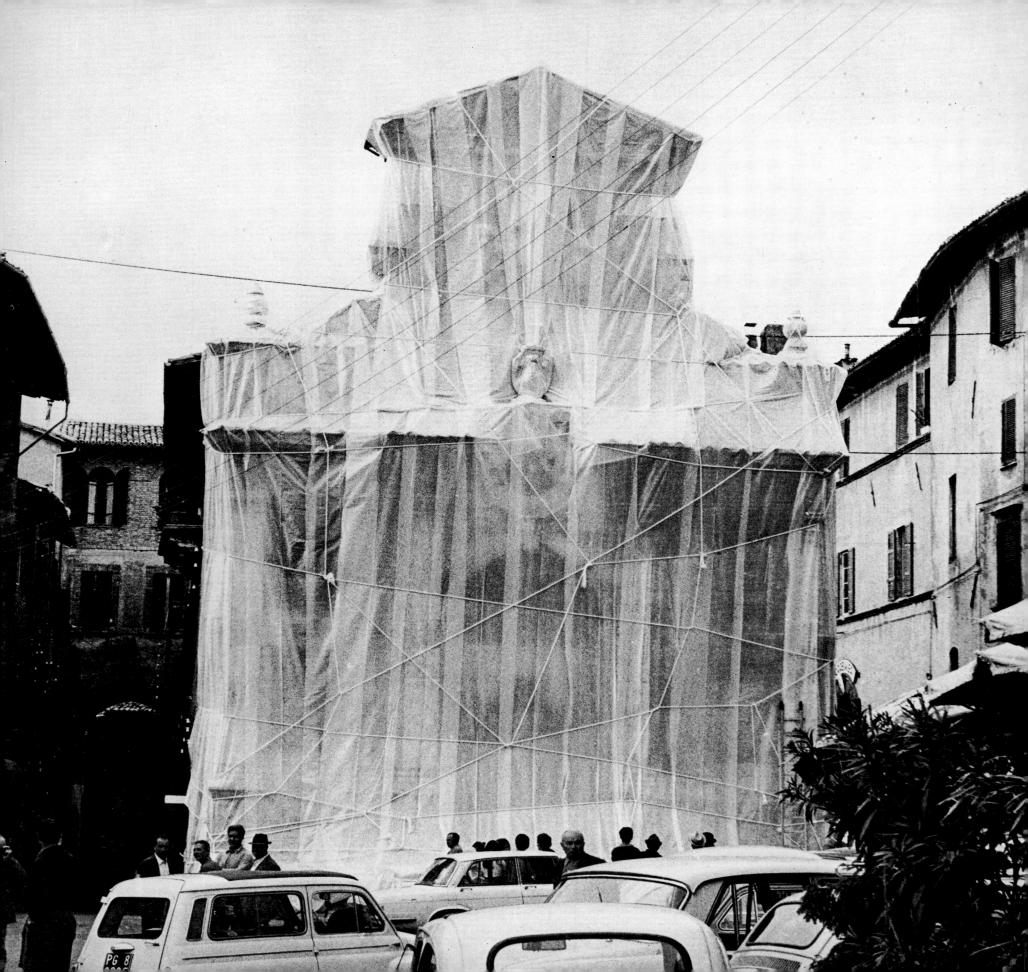

149. *Packed Fountain (Spoleto)*. 1968. Woven polypropylene and nylon rope, height 46 ft.
150. *Packed Fountain*. Detail

150

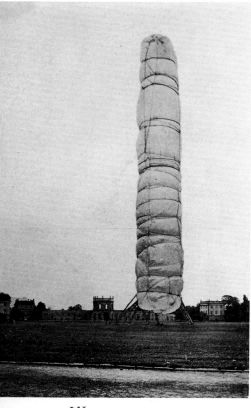

151

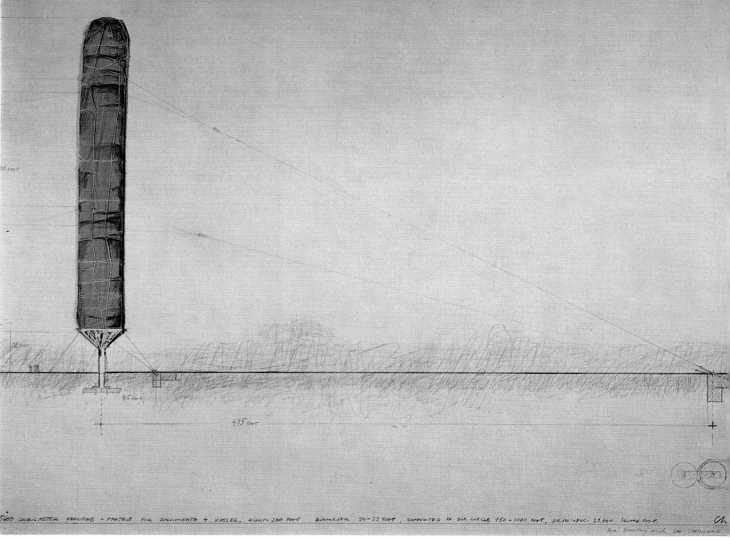

152

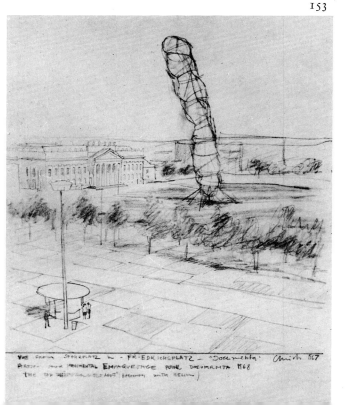

153

151. *5,600 Cubic Meter Package*. Project. 1968. Collaged photograph, 28 × 22 in.

152. *5,600 Cubic Meter Package*. Project. 1967–68. Cardboard, fabric, and string, 22 × 28 in. Collection Mr. and Mrs. Leo Steinberg, New York City

153. *5,600 Cubic Meter Package*. Project. 1967. Pencil on paper, 14 × 10 in. Collection Mr. and Mrs. John Powers, New York City

154. Map of the Karlswiese (Karl's Meadow). Auepark, Kassel, West Germany

155. View of the Karlswiese, site of the *5,600 Cubic Meter Package*

5,600 CUBIC METER PACKAGE. Plates 151–87.

Christo made the world's tallest inflated sculpture—a 280-foot-high air package—for Documenta 4, the 1968 international art show in Kassel, West Germany. The package consisted of a synthetic fabric skin, which was inserted in a network of ropes and kept inflated by air blowers. Resting on a cradle-like steel base, the package was kept upright by guy wires, strung out in six directions, which were attached to steel belts that girdled the sculpture at various heights. The project was Christo's most ambitious technical undertaking, requiring the assistance of a mechanical engineer, professional riggers, and dozens of skilled laborers. After three unsuccessful attempts to raise the package, it was finally erected, with the aid of five cranes, on August 3. It remained in place for three months.

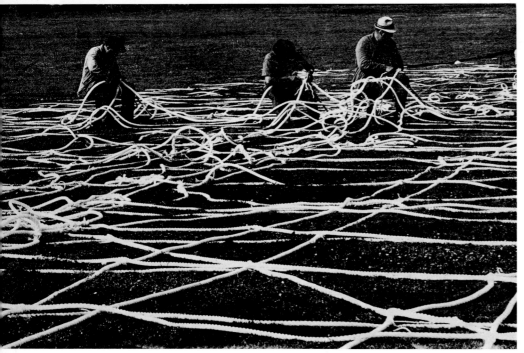

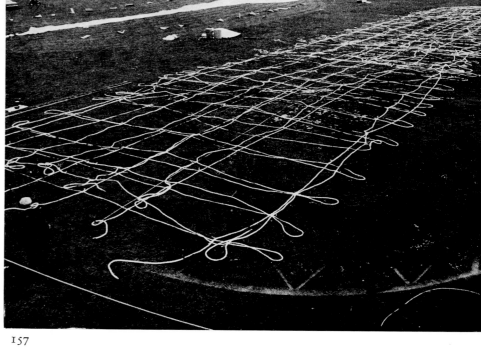

156

157

156. Professional riggers tying some of the 1,200 knots
157. Network of knotted ropes spread out, awaiting insertion of polyethylene skin (in background)
158. Inserting polyethylene skin in network of ropes
159. A concrete foundation, one of twelve securing the guy wires. The six inner guy wires required 10-ton concrete foundations, while the six outer guy wires required 18-ton concrete foundations
160. Polyethylene skin spread out inside network of ropes

158

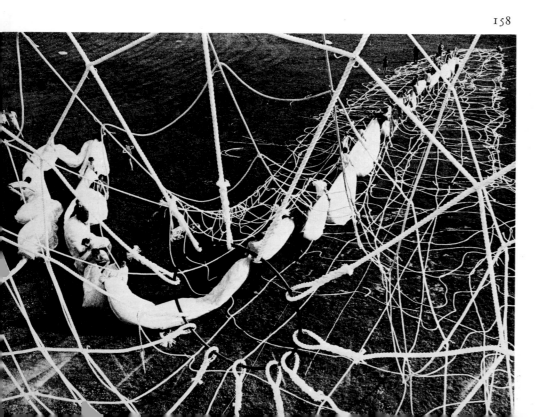

159

160

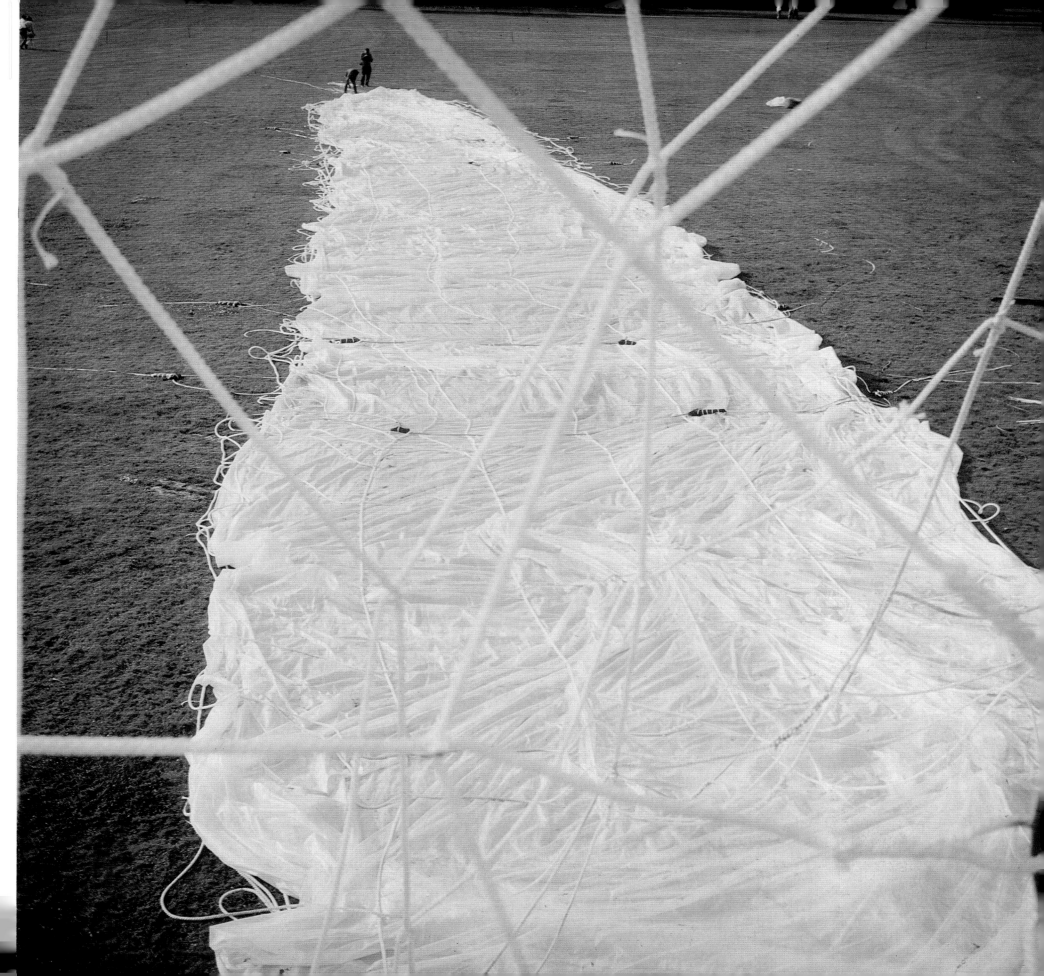

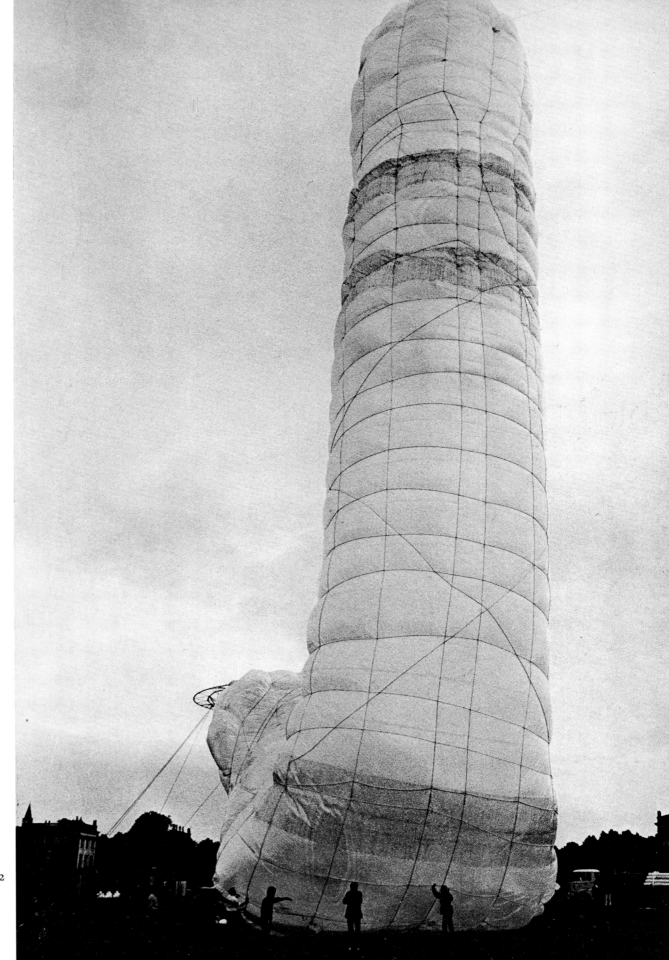

161. The first erection occurred at 7:00 A.M., June 26, 1968. The air structure contained, in an "internal balloon," 40,000 cu. ft. of helium, comprising one-fifth of the total air contents

162. The air structure remained erect for ten minutes, before buckling to the ground in high wind

163. Second skin of Trevira fabric spread out inside the rope network

164. Detail of steel cradle, diameter 36 ft., elevated 36 ft. above the ground, and weighing 3½ tons. The steel cradle was hinged on a central steel column, anchored in 1-ton concrete foundation

163–164 (overleaf) ▶

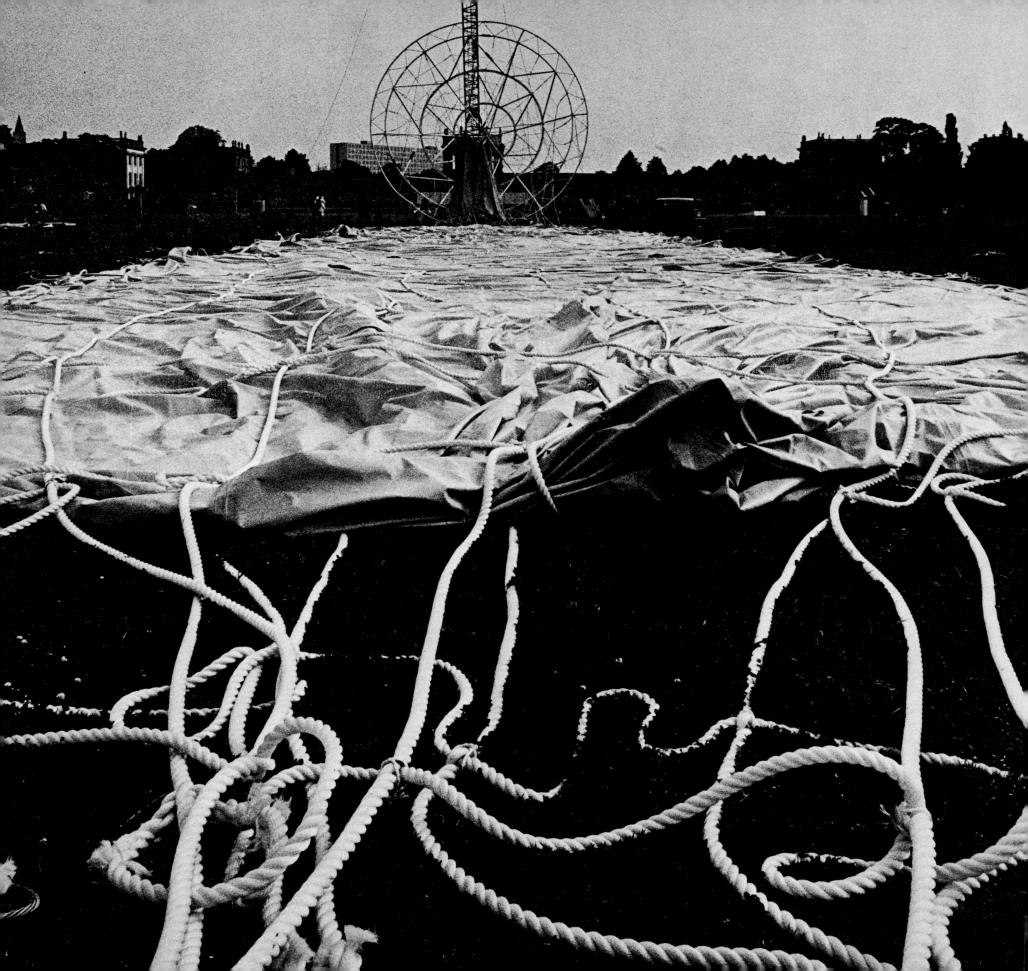

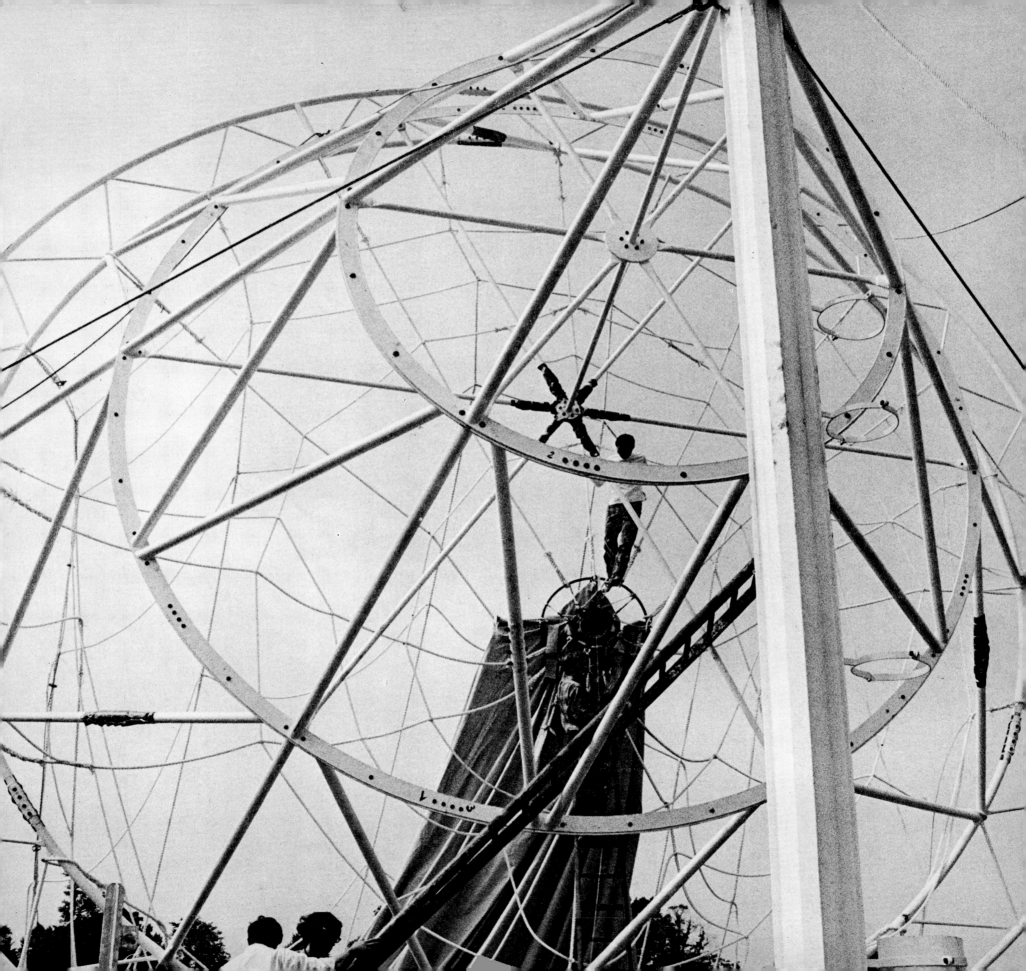

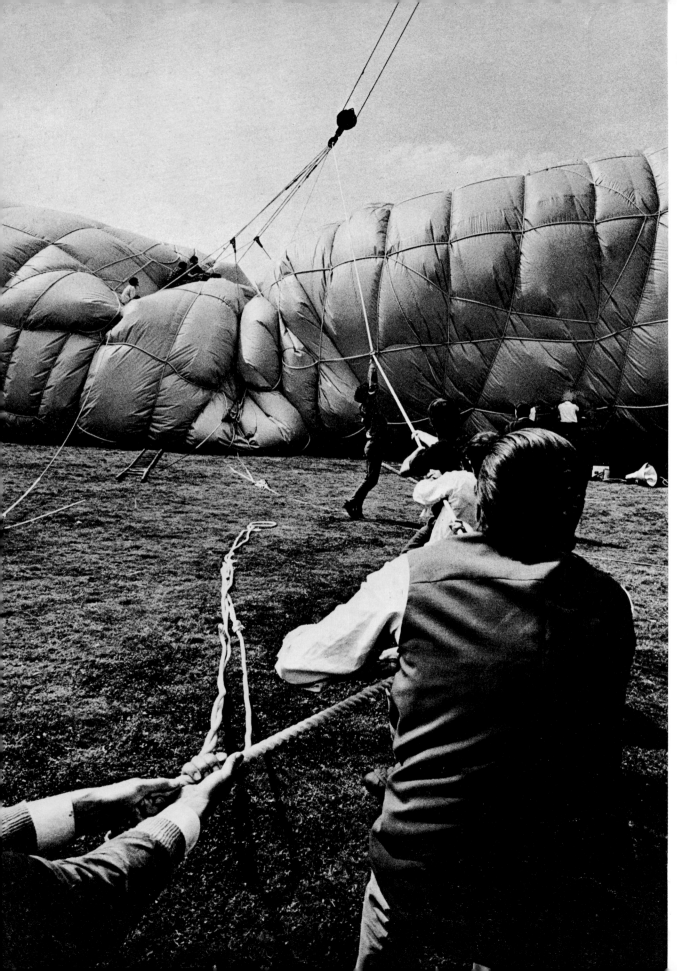

165. Students help the crane to lift the network of ropes so that the skin will inflate more readily. The guy wire, lying on the ground at left, is attached to one of two steel cable belts, each covered with polypropylene

166–69. Inflation period. The copper wire threaded through the ropes and connected to both steel cable belts serves as a lightning rod. Each belt has six brackets for guy wires

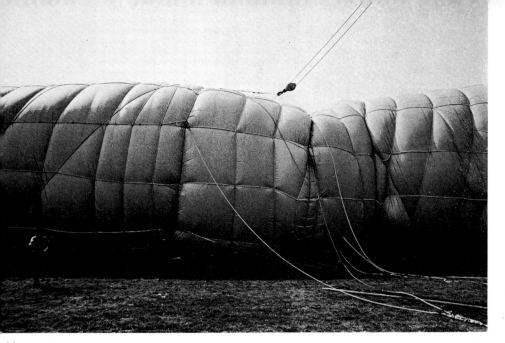

66

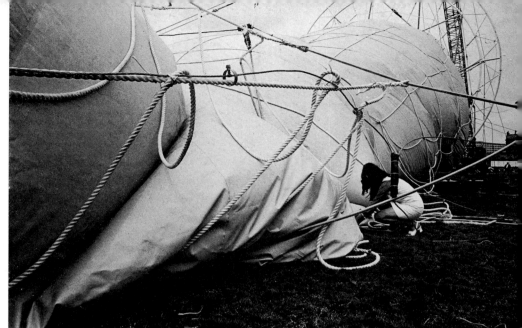

167

68

169

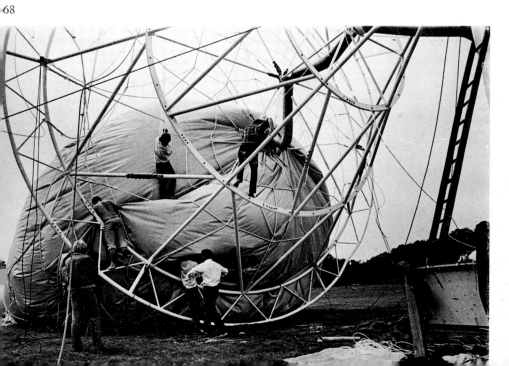

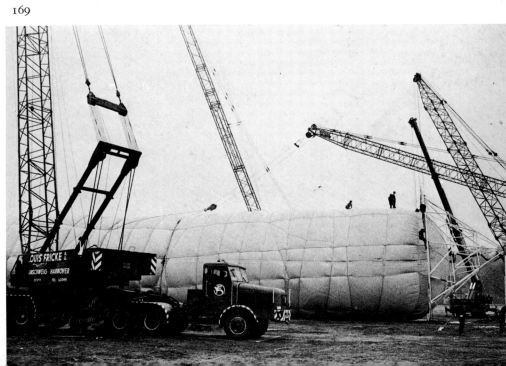

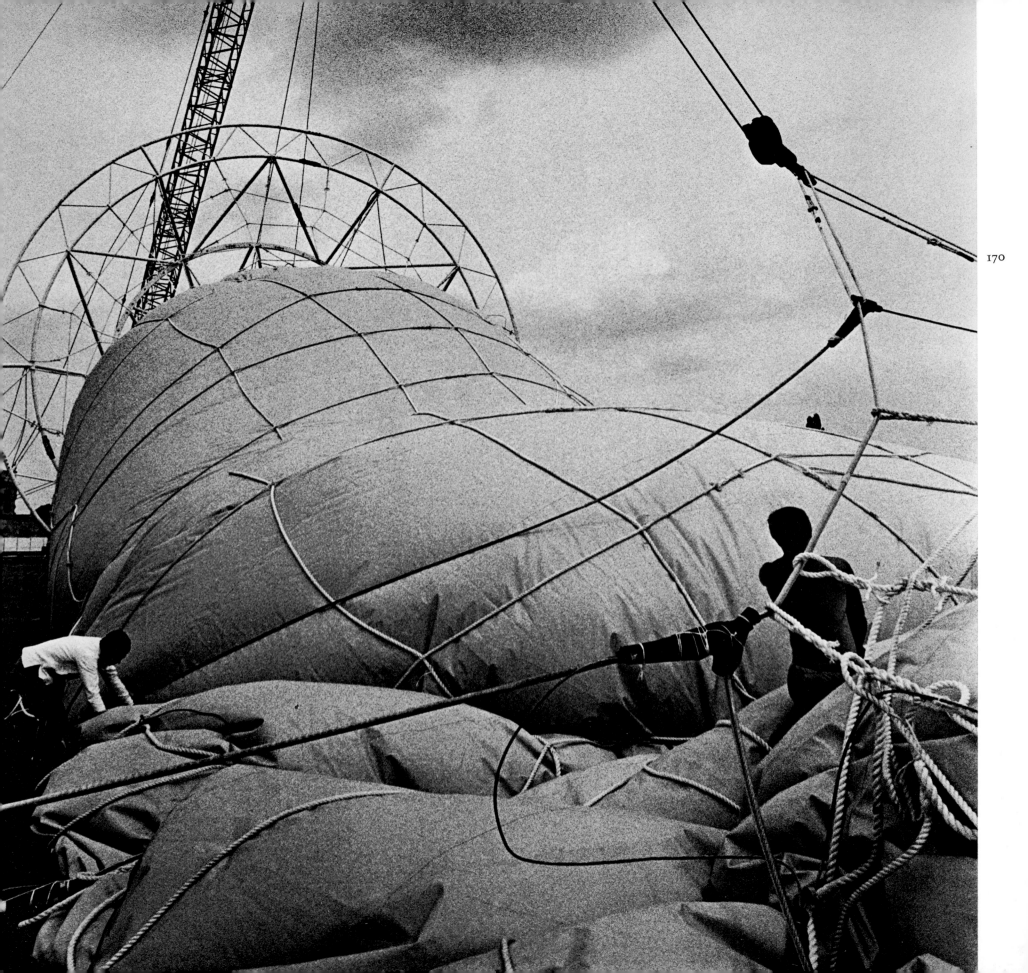

170. Partially inflated balloon with crane lifting net. Air pressure was maintained by a centrifugal blower run by a variable-speed electric motor. A gasoline generator stood by in case of power failure
171. Securing the ropes on the balloon. The crane pulley, attached to the belt, remains in place from a previous attempt at erection
172. Steel cables from the crane are attached to the belt and cradle

172 (overleaf) ▶

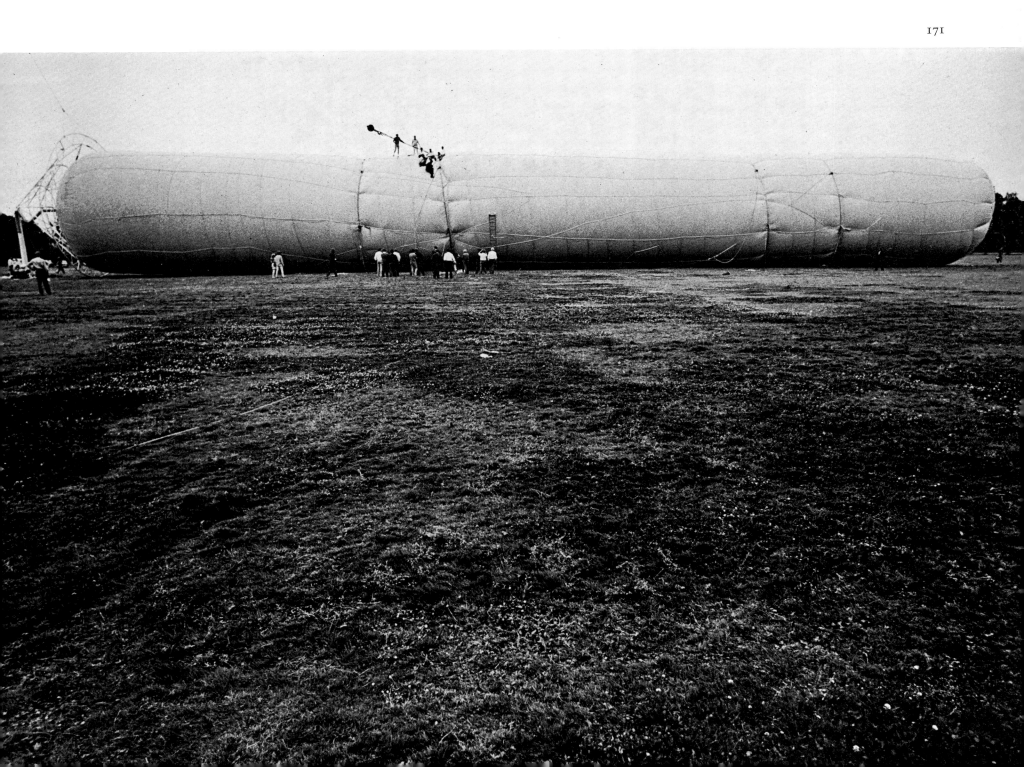

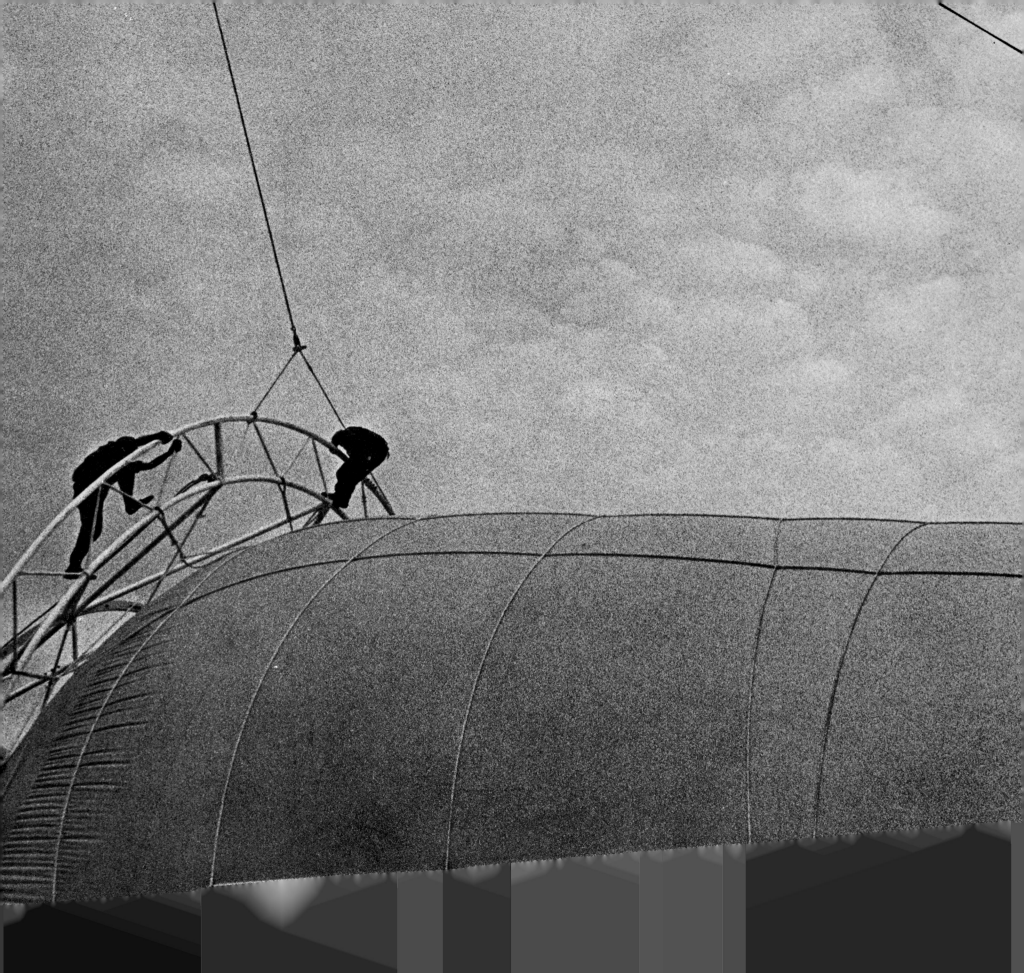

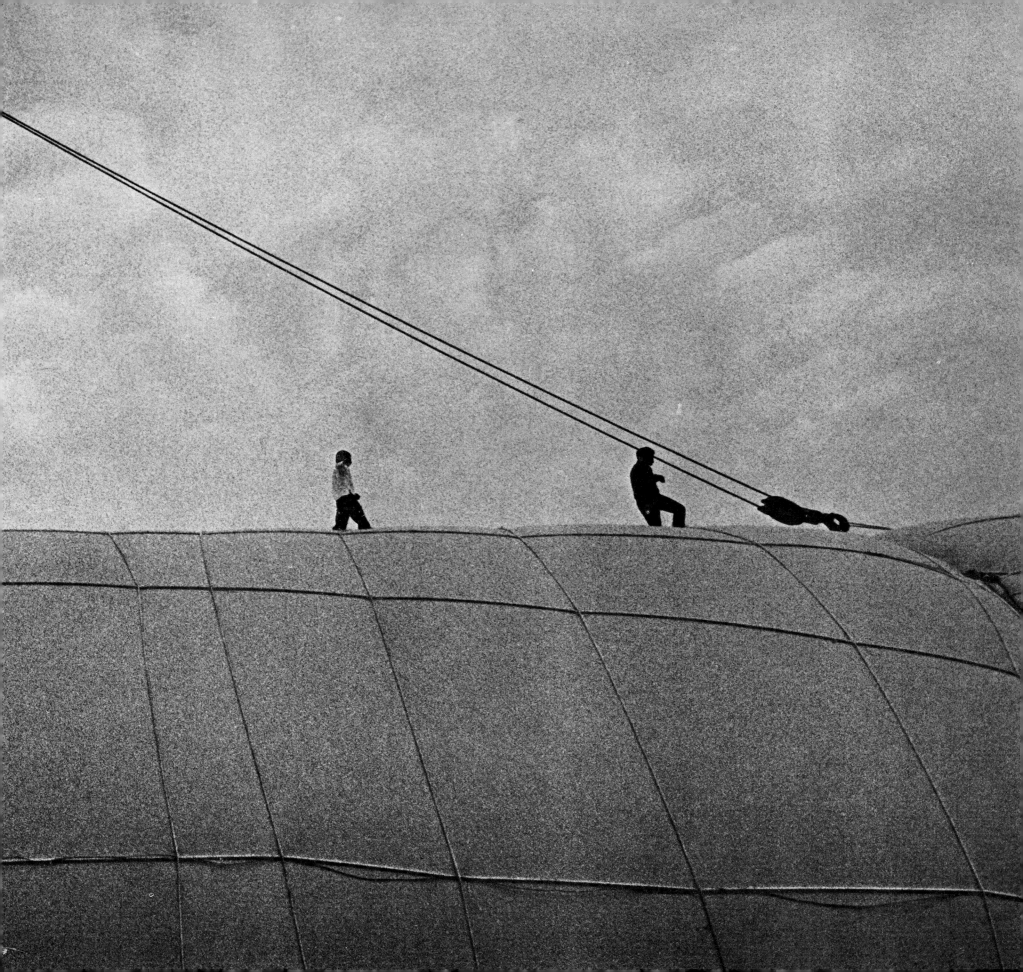

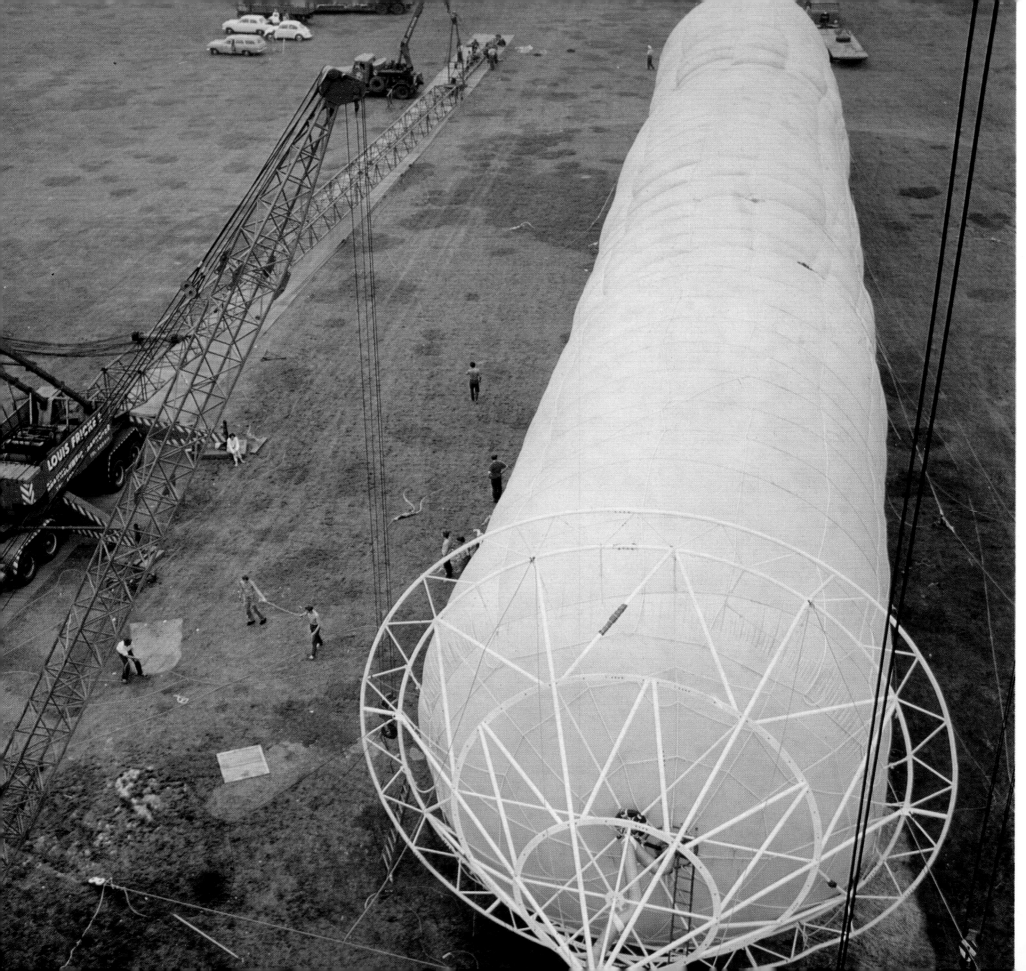

173. A 230-ft. crane being assembled on metal ground
 mats to prevent sinking
74–76. Five cranes lifting the balloon. Erection began at
 5:00 A.M., August 3, 1968, and took nine hours to
 complete

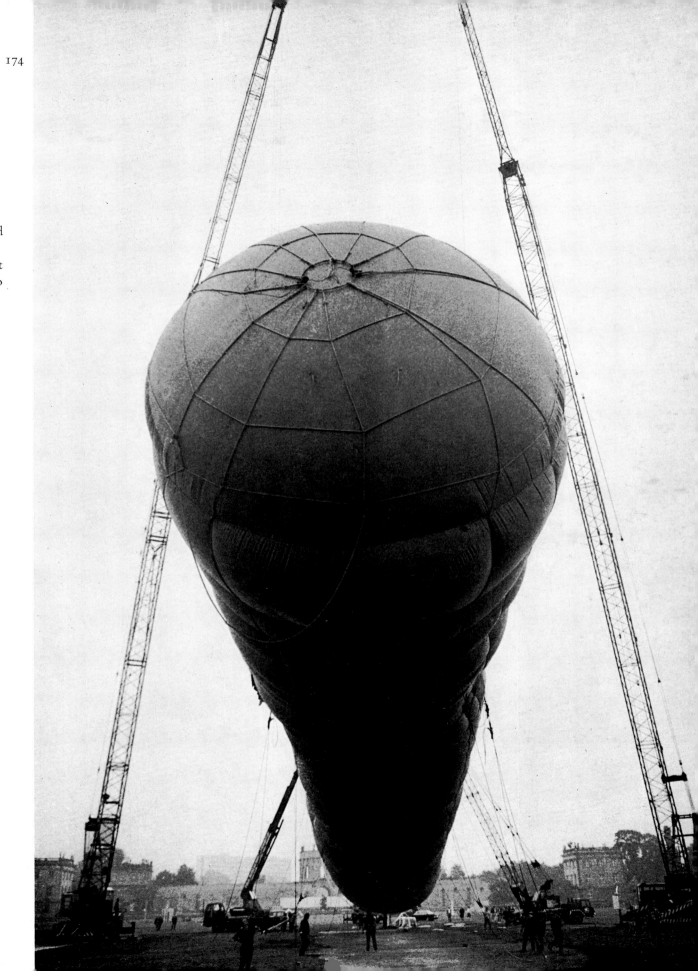

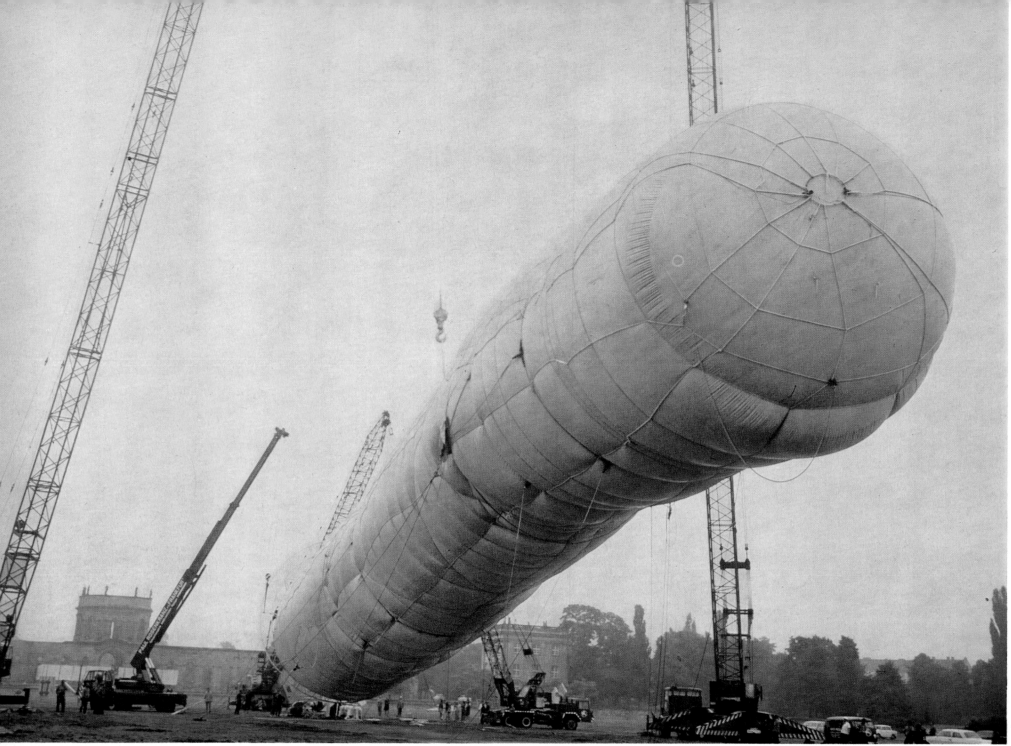

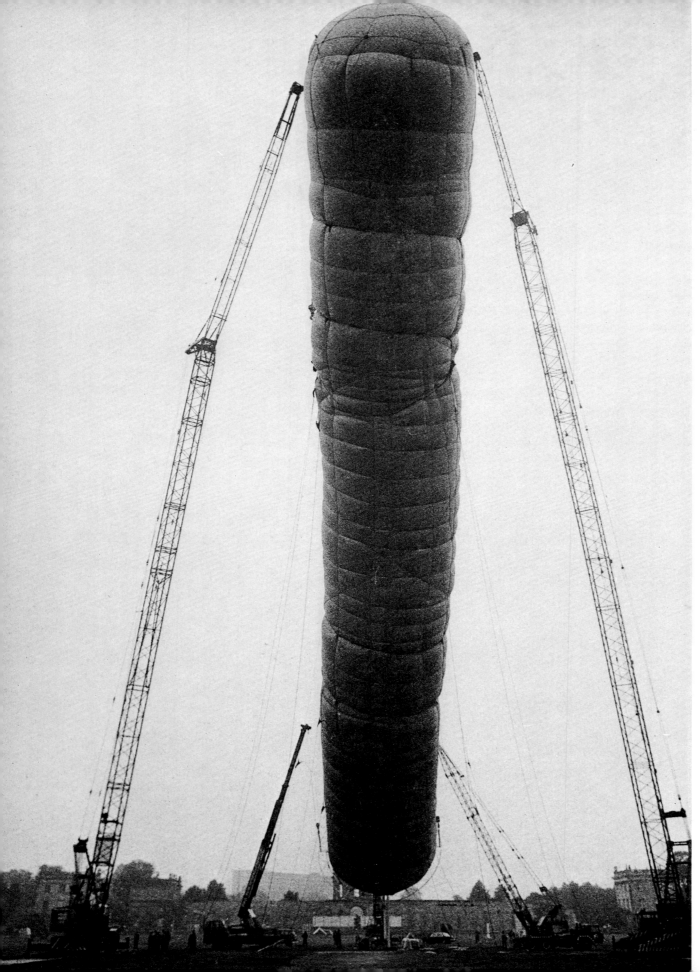

77–80. Cranes holding balloon in place, awaiting attachment of guy wires, which were strung out in six directions and anchored in concrete foundations

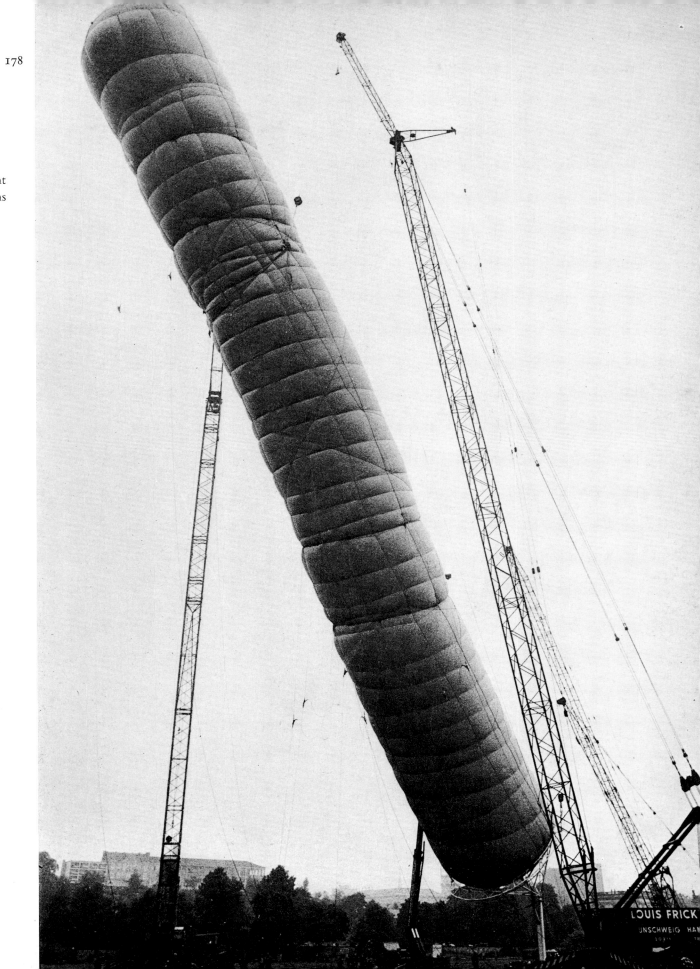

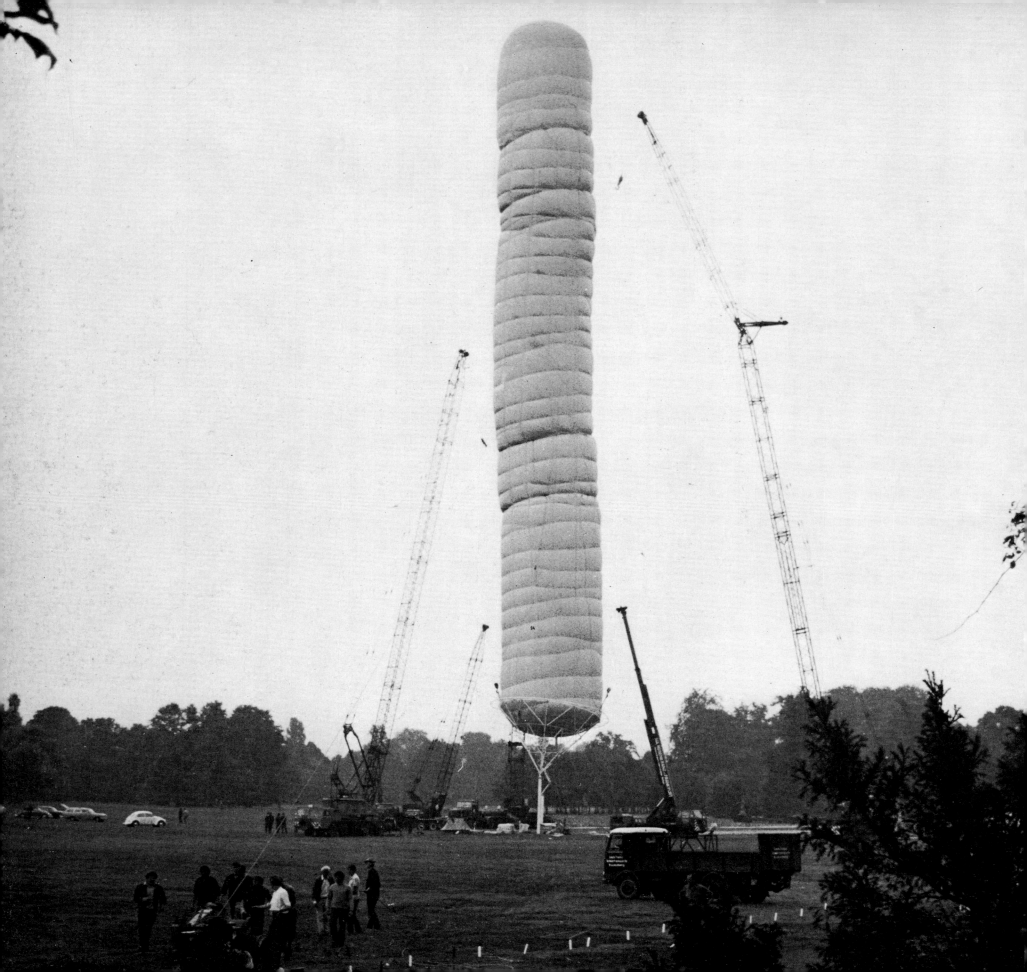

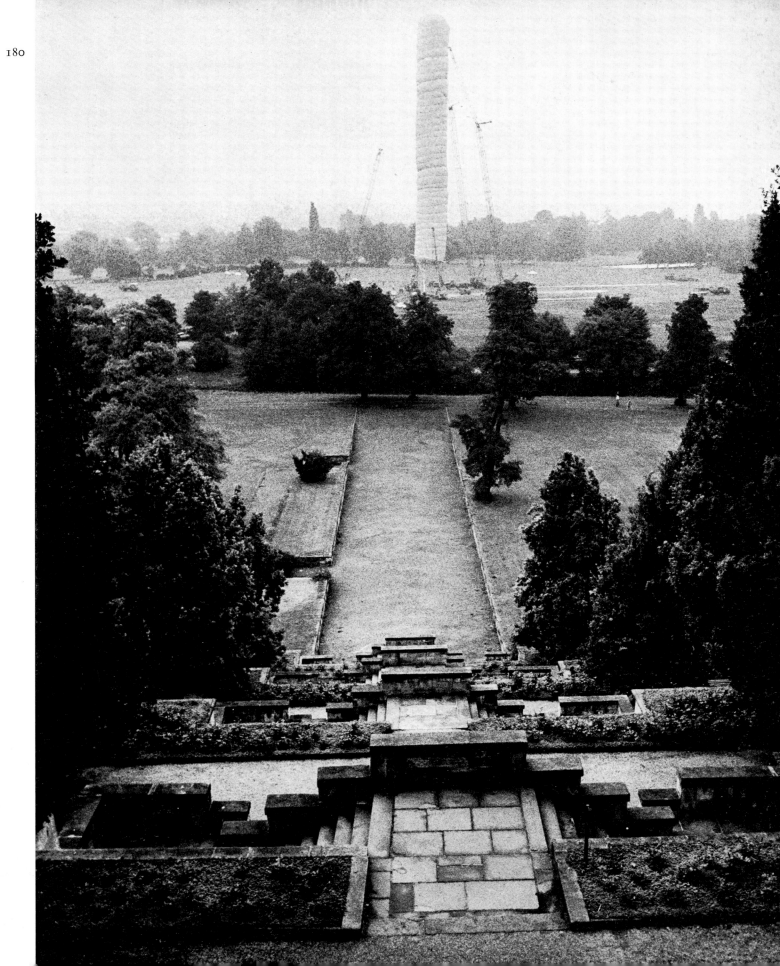

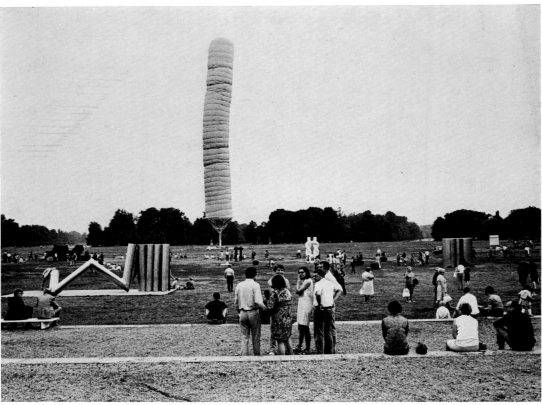

181

182

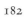

181–87. Views of final installation. The total height of structure is 280 ft. The air-inflated Trevira envel is 240 ft. high and 33 ft. in diameter. The pack consists of 22,000 sq. ft. of Trevira fabric, 12,00 of polyethylene ropes, and weighs 14,000 lbs.

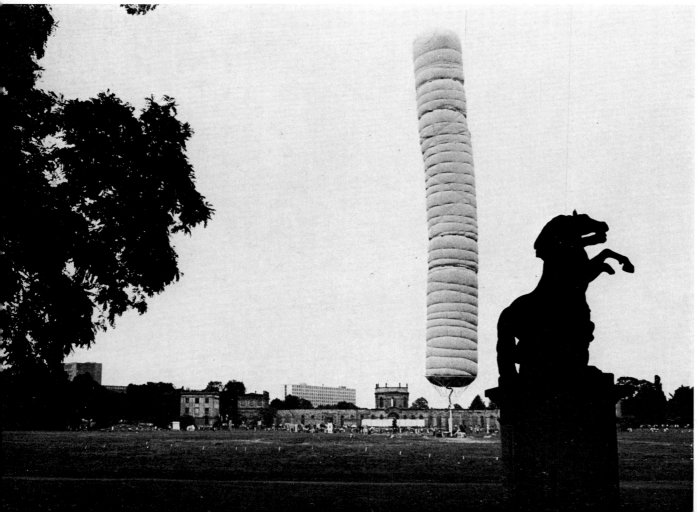

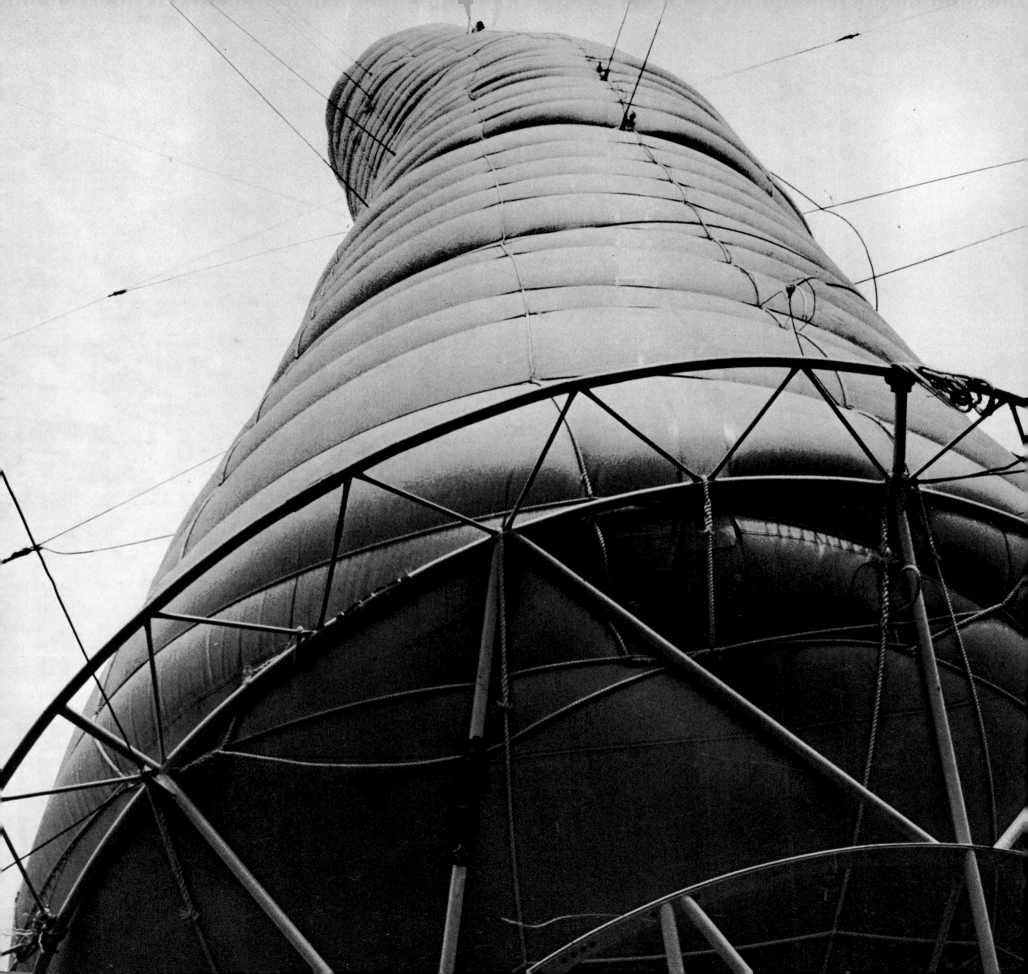

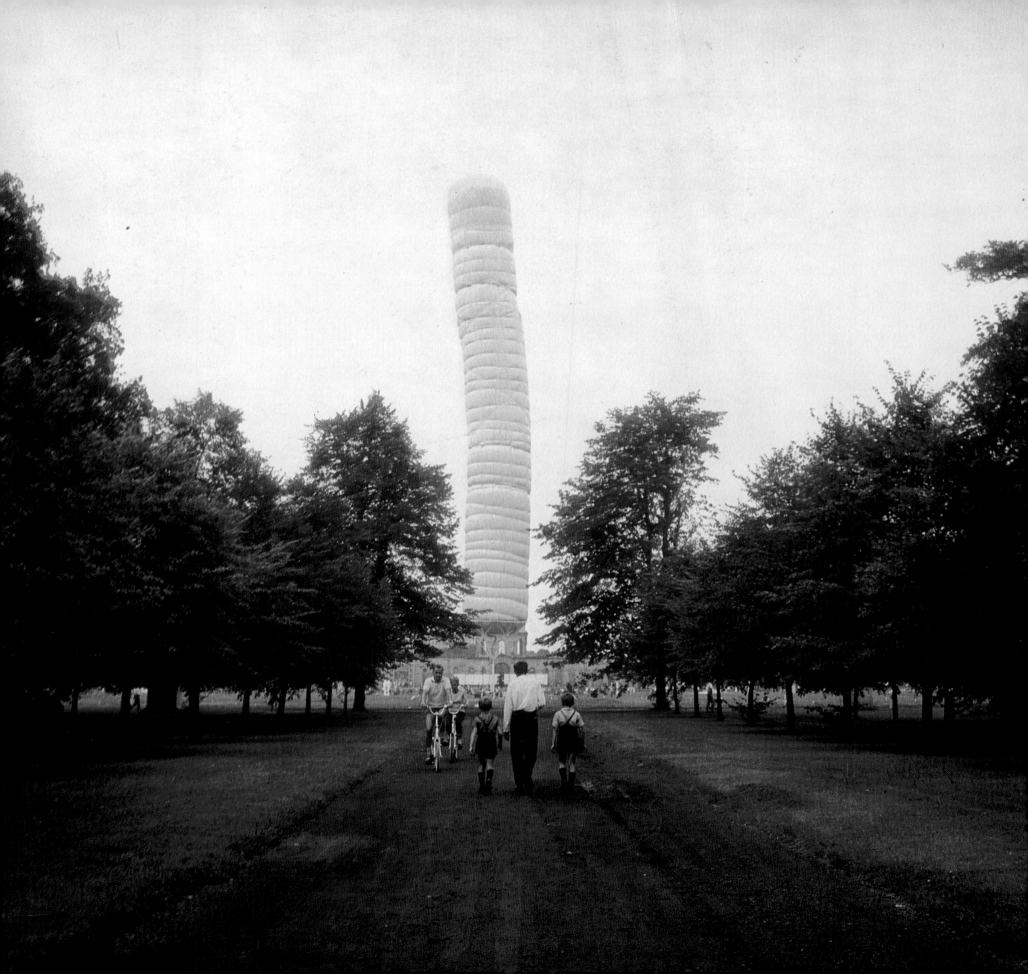

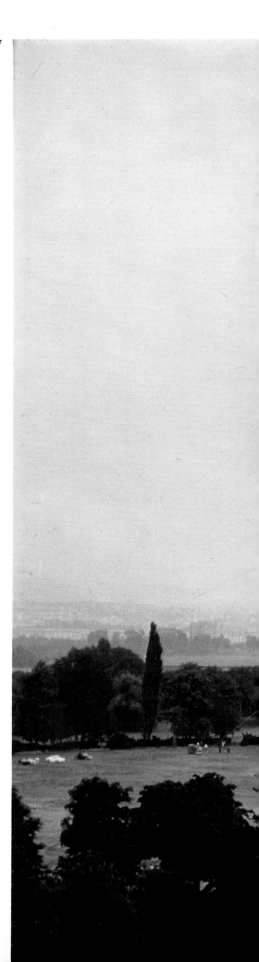

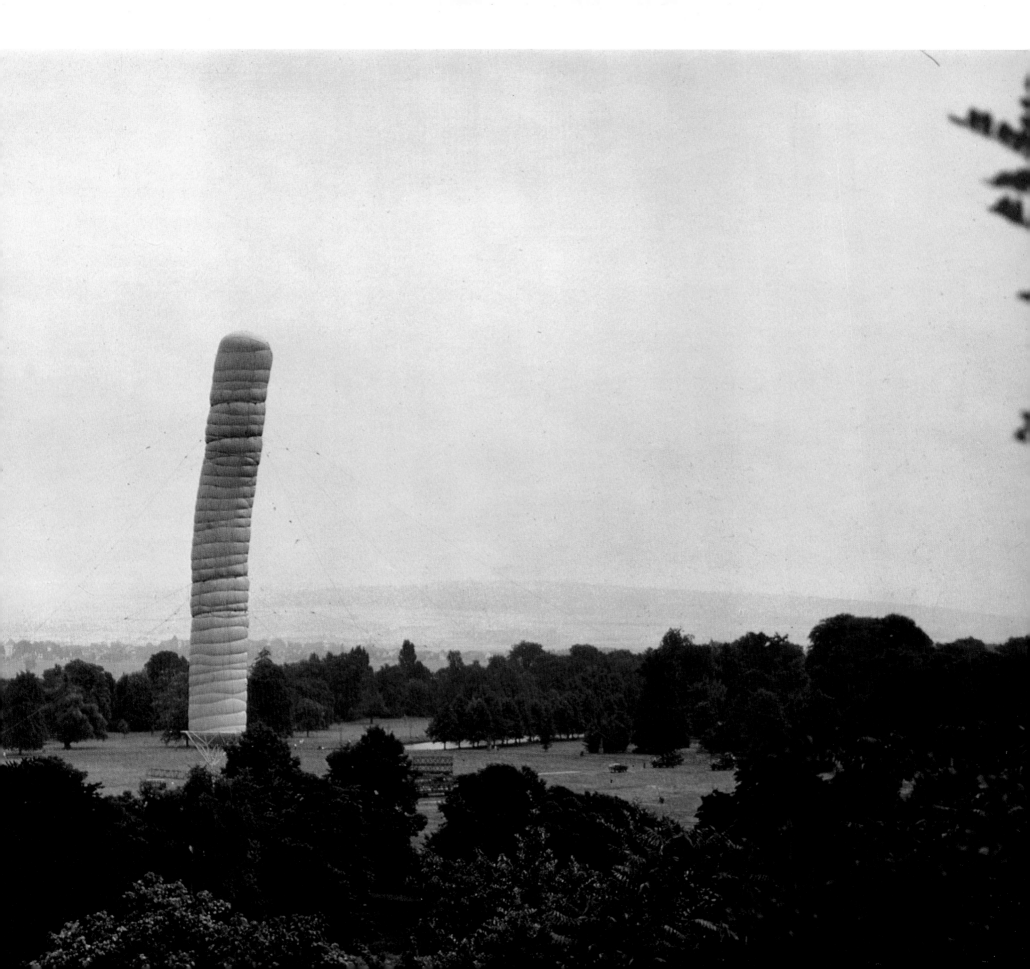

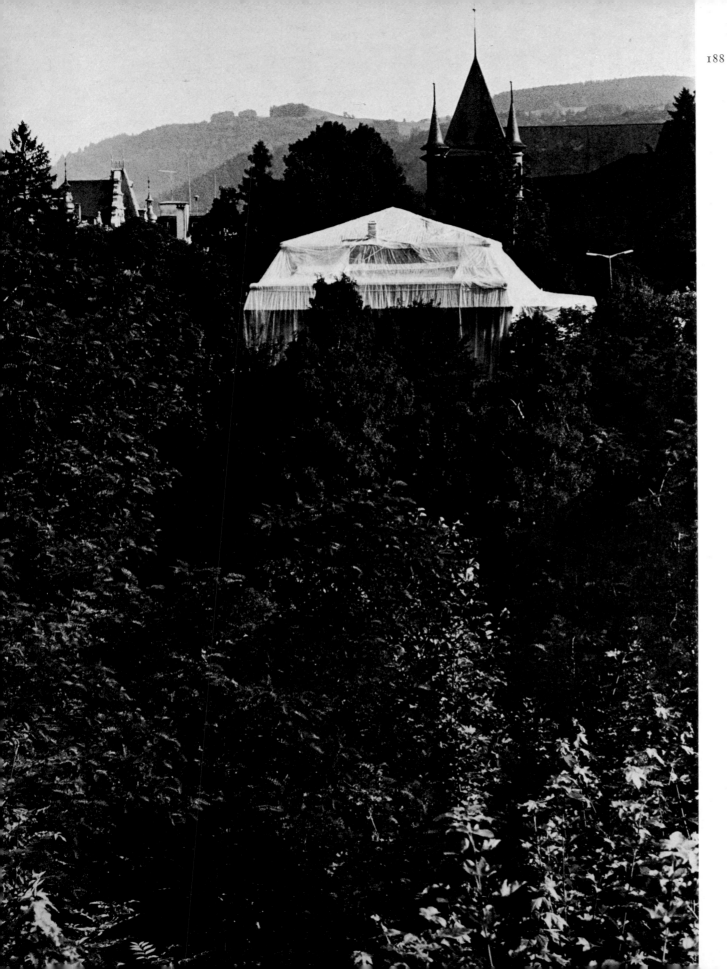

188. *Packed Kunsthalle (Bern, Switzerland).* 1968. 27,000 sq. ft. of reinforced polyethylene and nylon rope
189. *Packed Kunsthalle.* Detail
190–91. *Packed Kunsthalle*
192. *Packed Kunsthalle.* Opening day of exhibition

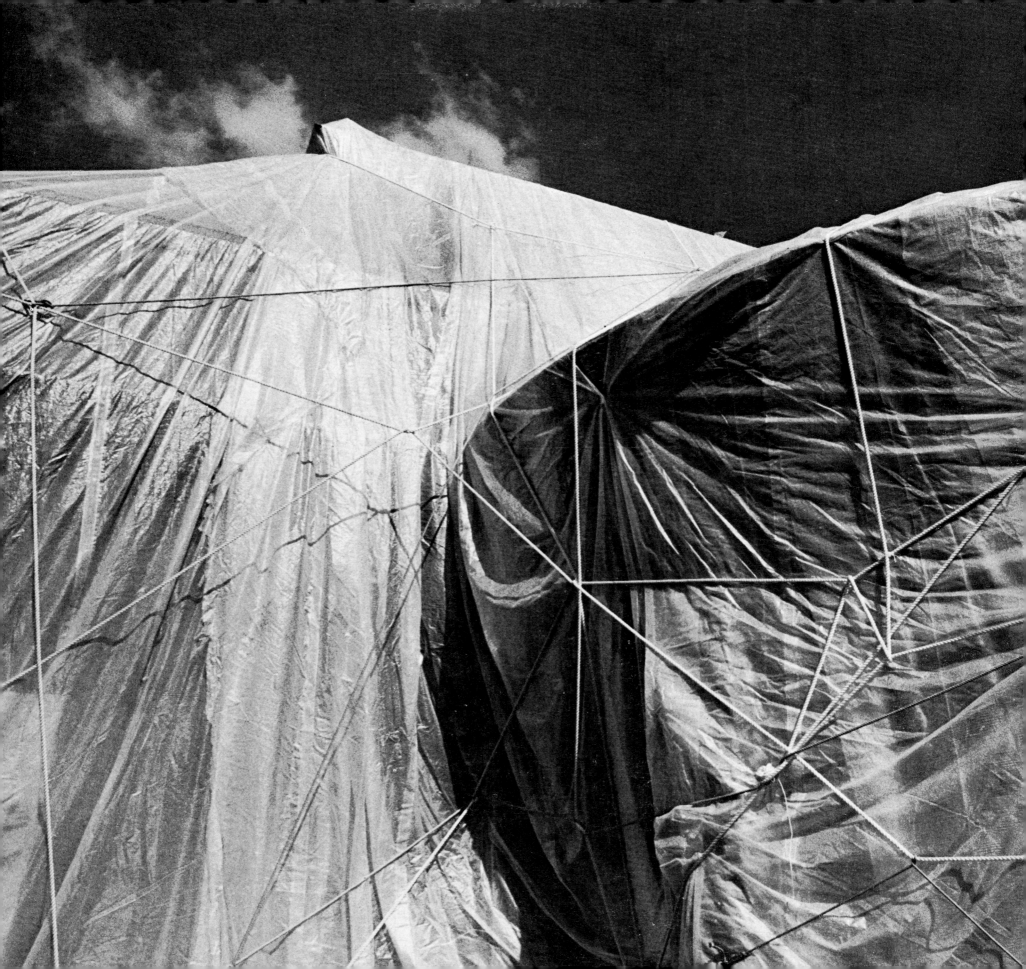

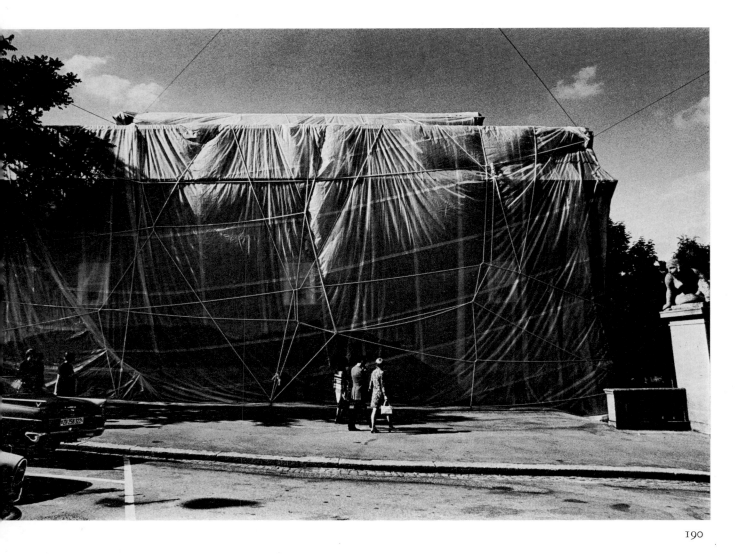

190

191

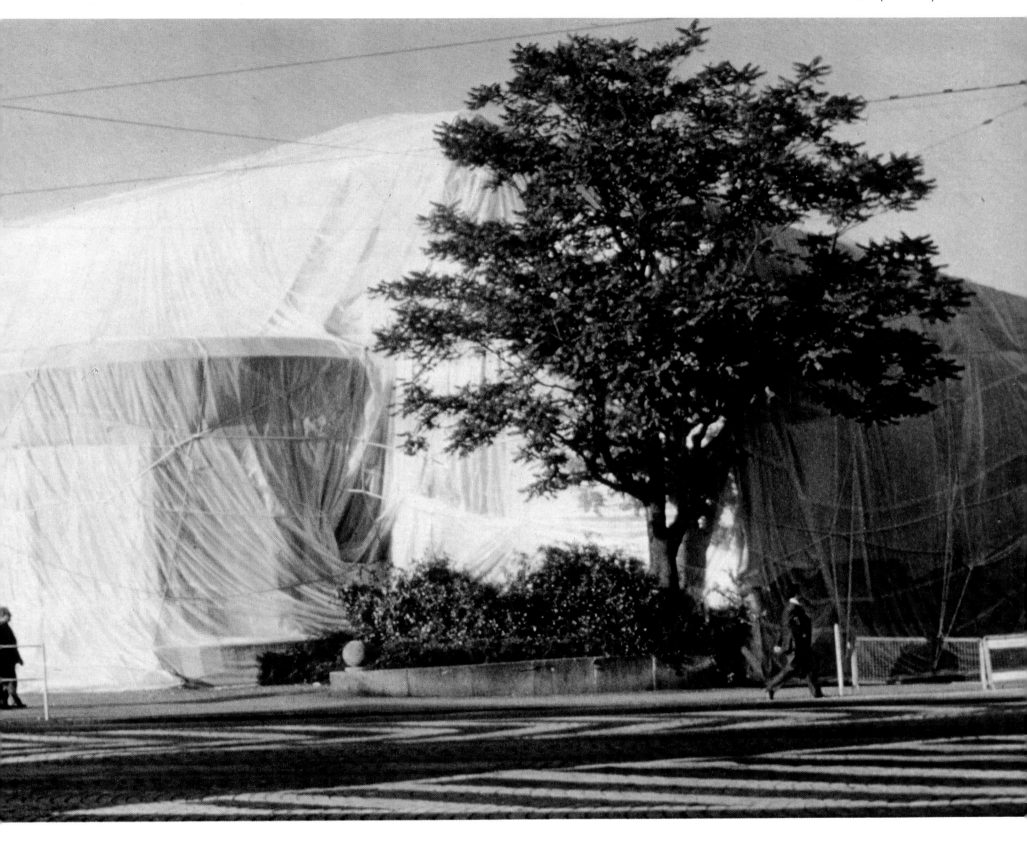

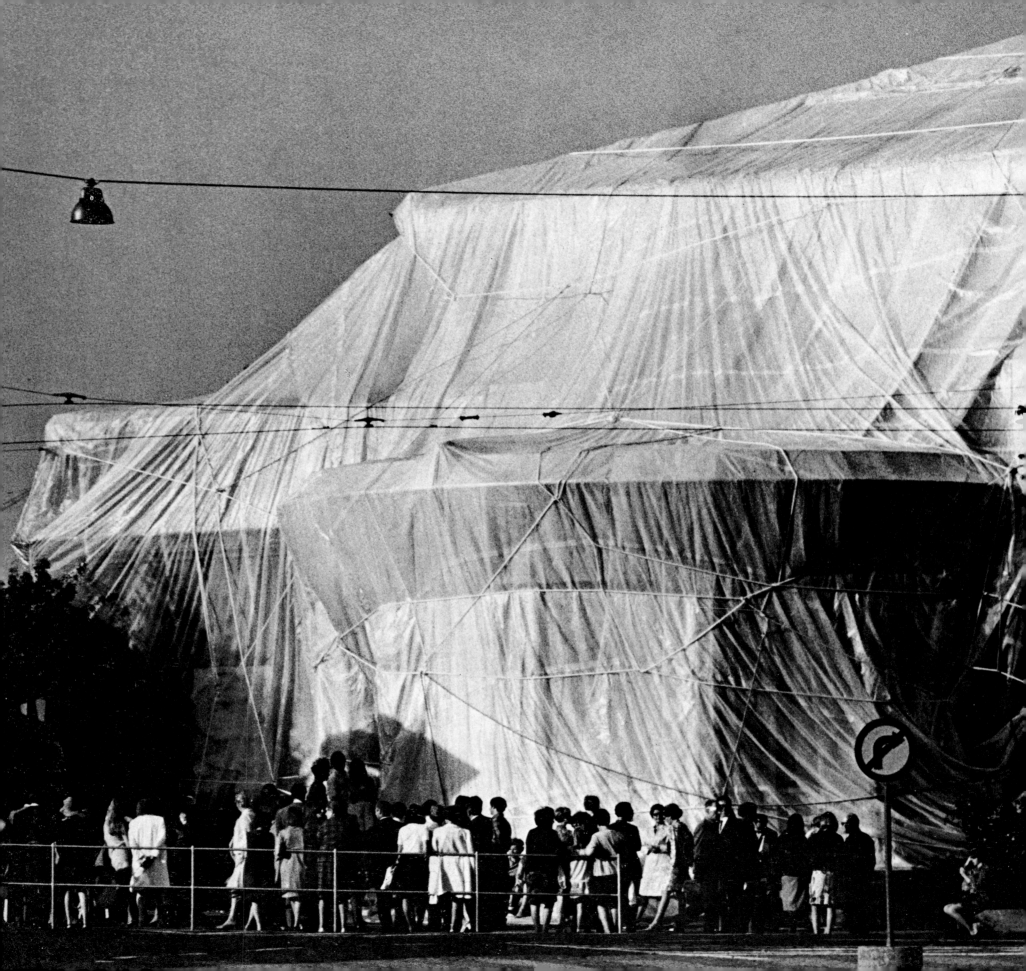

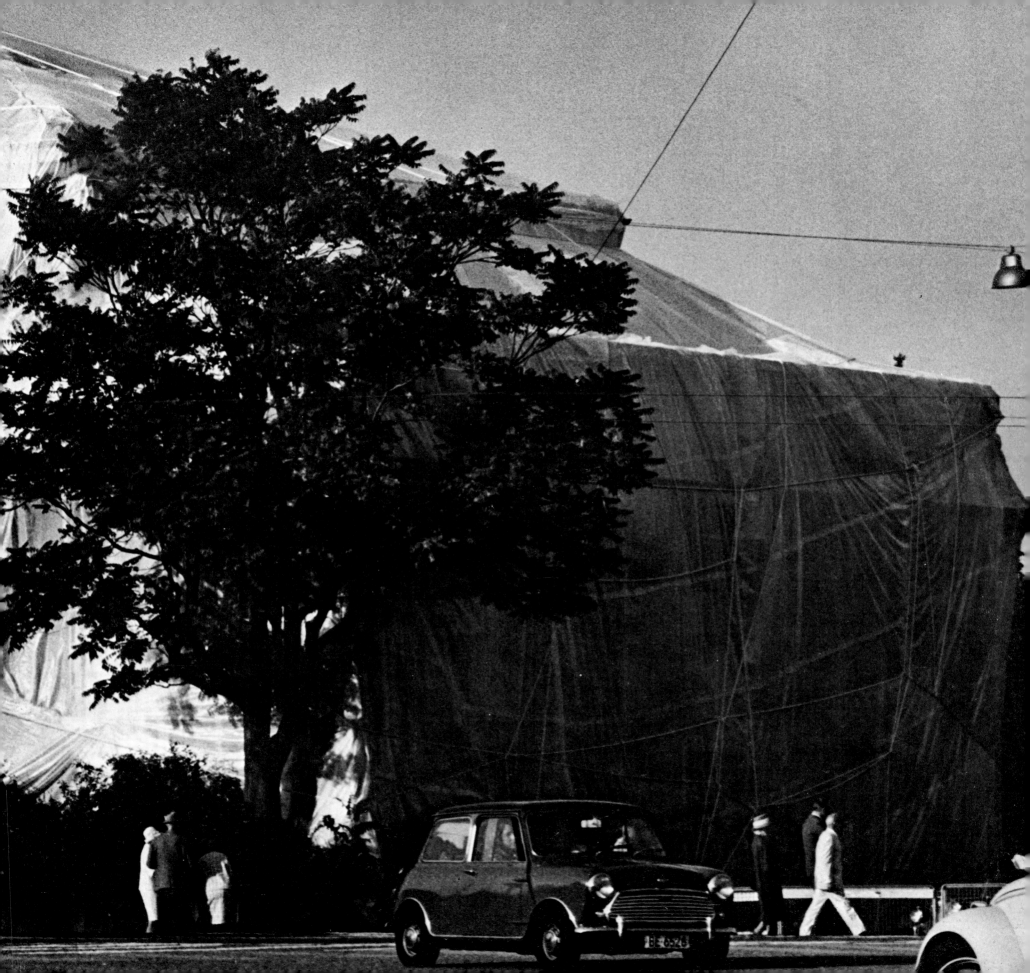

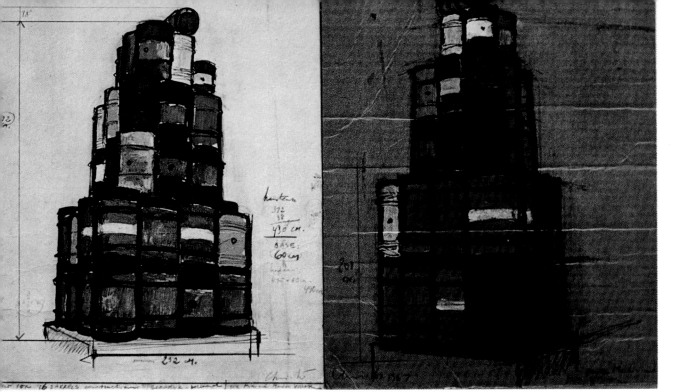

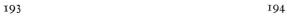

193 194

193. *56 Barrels*. Project. 1966. Pencil and enamel paint on paper, $27\frac{1}{2} \times 19$ in. Collection Mr. and Mrs. Martin Visser, Bergeyk, The Netherlands

194. *56 Barrels*. Project. 1966. Pencil and enamel paint on cardboard, $27\frac{1}{2} \times 19$ in. Collection Mr. and Mrs. Martin Visser, Bergeyk, The Netherlands

195. *Four Barrels*. 1966. Oil drums, $98 \times 48 \times 24$ in. Collection Mr. and Mrs. Martin Visser, Bergeyk, The Netherlands

196. *56 Barrels*. 1966–68. Oil drums, $15\frac{1}{2} \times 8 \times 8$ ft. Collection Mr. and Mrs. Martin Visser, Bergeyk, The Netherlands

195

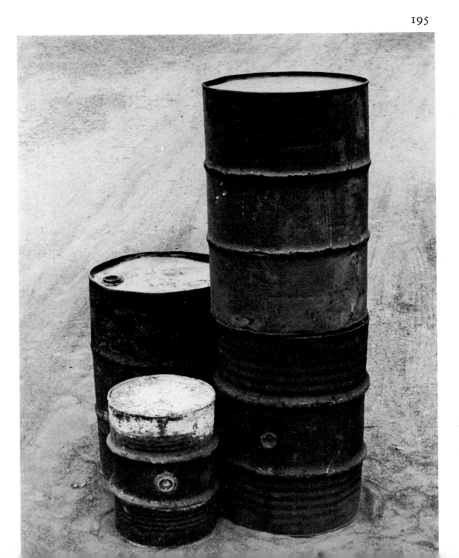

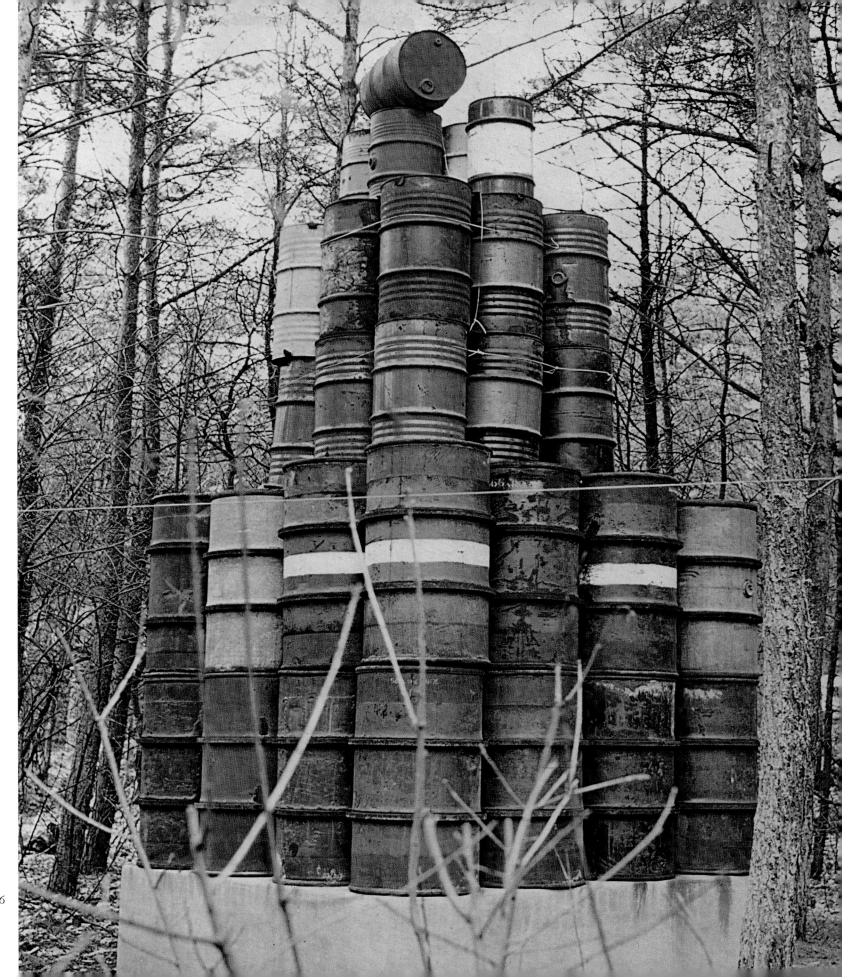

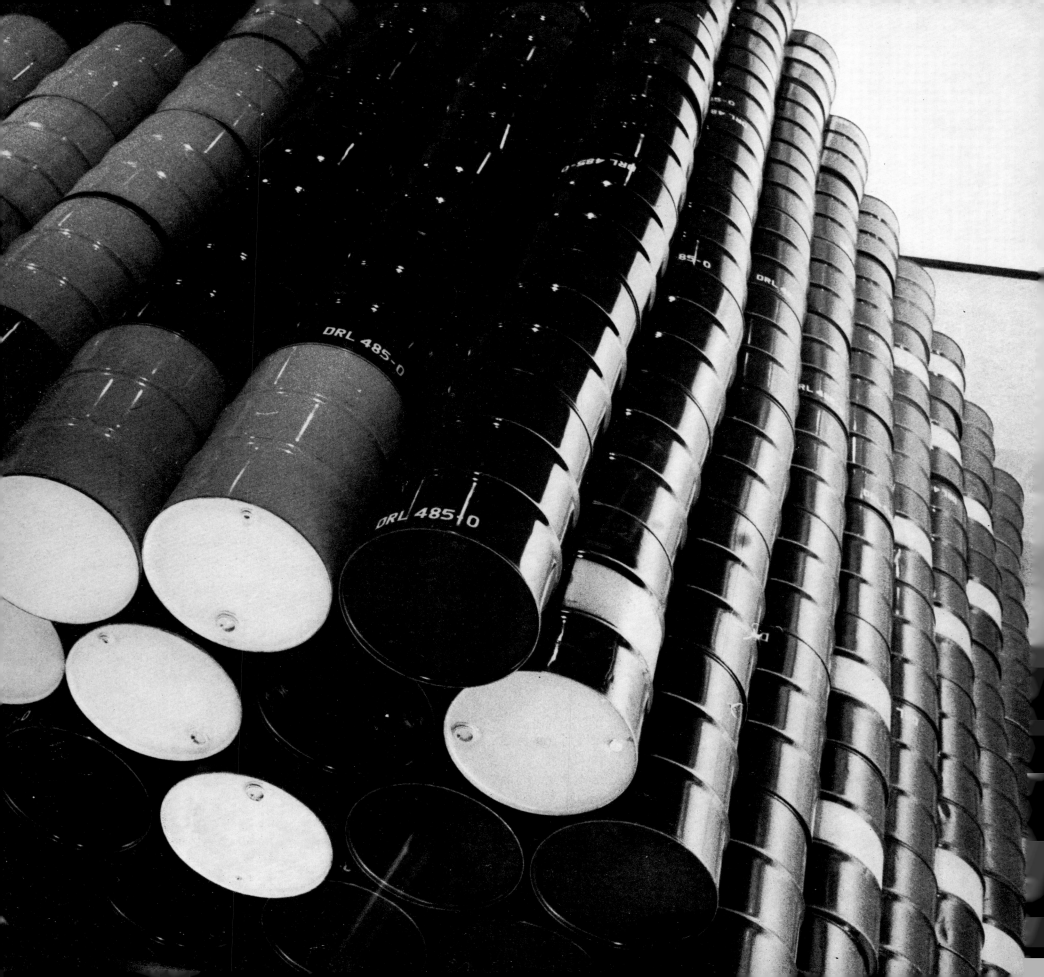

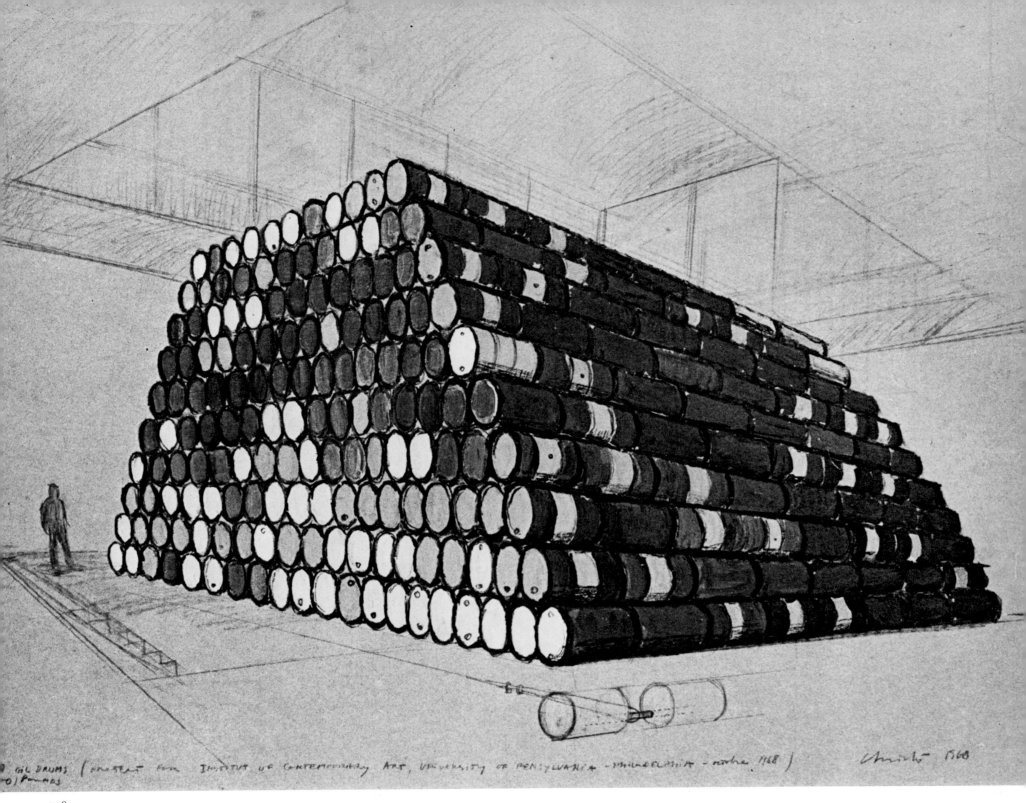

197. *1,240 Oil Drums*. Detail of installation at The Institute of Contemporary Art, Philadelphia. 1968. Oil drums, 21×30×40 ft.
198. *1,240 Oil Drums*. Project for The Institute of Contemporary Art, Philadelphia. 1968. Enamel paint on cardboard, 22×28 in.
199–200. *1,240 Oil Drums*. Details.

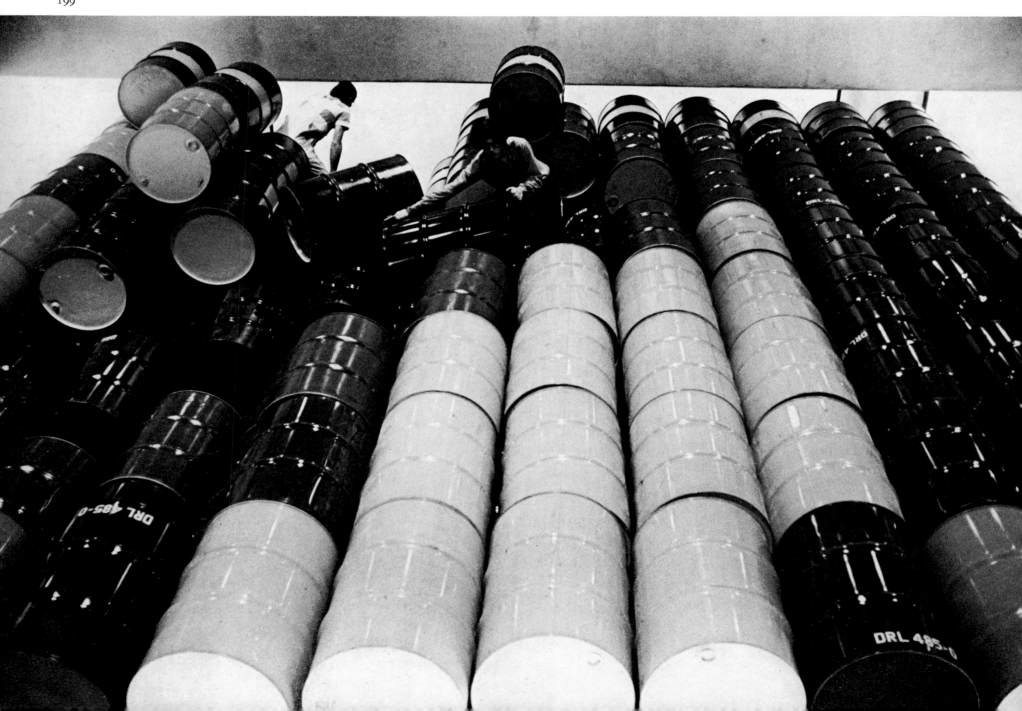

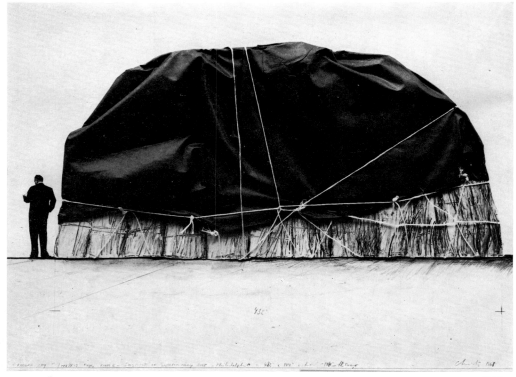

201

201. *Packed Hay*. Project. 1968. Rubberized canvas, twine, photograph, and paint on cardboard, 22×28 in. Galerie Yvon Lambert, Paris
202. *Packed Nude Girl*. Project. 1968. Plastic, twine, and pencil on cardboard, 22×28 in. Collection William S. Rubin, New York City
203. *Packed Hay*. Installation view at The Institute of Contemporary Art, Philadelphia. 1968. Hay, tarpaulin, and rope, 8×12×20 ft.

202

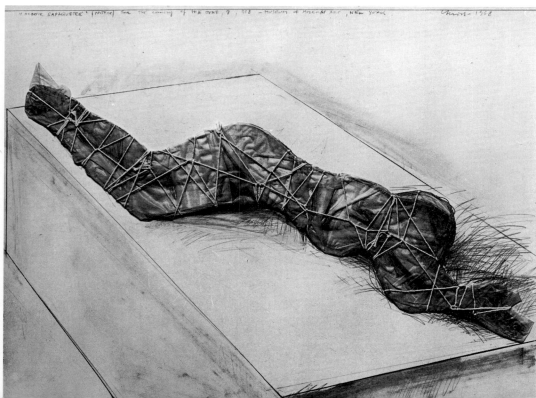

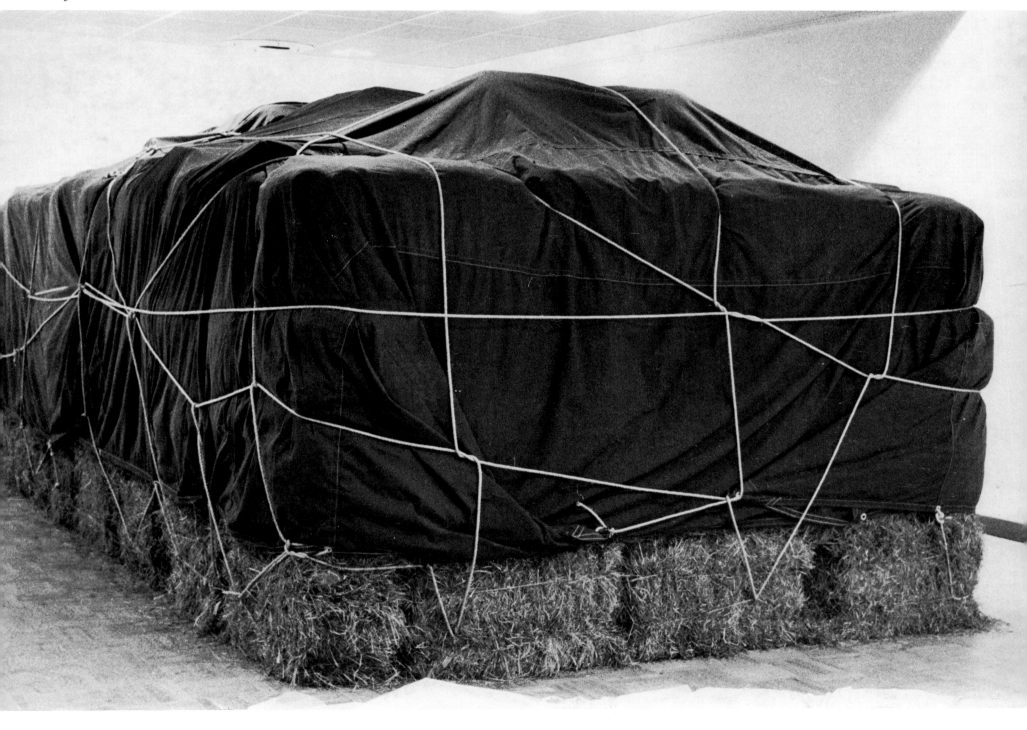

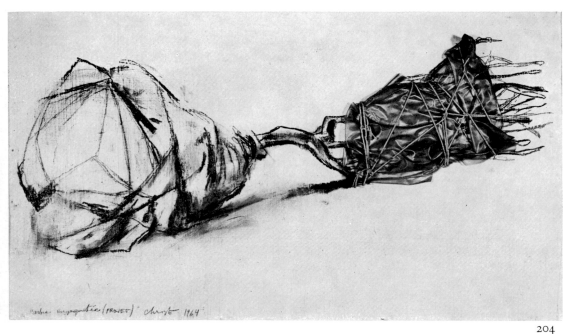

204. *Packed Tree*. Project. 1964. Plastic, cardboard, twine, and pencil on wood, 24×29 in. Collection Harrison Rivera, New York City

205. *Packed Trees*. Project. 1967. Cardboard, plastic, and canvas on wood, 24×29 in. The Harry N. Abrams Family Collection, New York City

206. *Packed Tree*. 1968. Oak tree, rubberized canvas, plastic, and rope, length 58 ft. Collection Mr. and Mrs. Albert A. List, Byram, Connecticut

207. *Wrapped Painting*. 1968. Rubberized canvas and twine, $41\frac{1}{2} \times 27\frac{1}{2} \times 5\frac{1}{2}$ in. Collection David Bourdon, New York City

208. *Wrapped Painting*. 1968. Tarpaulin and rope, $31 \times 29 \times 3$ in. Collection Gian Enzo Sperone, Turin

204
205

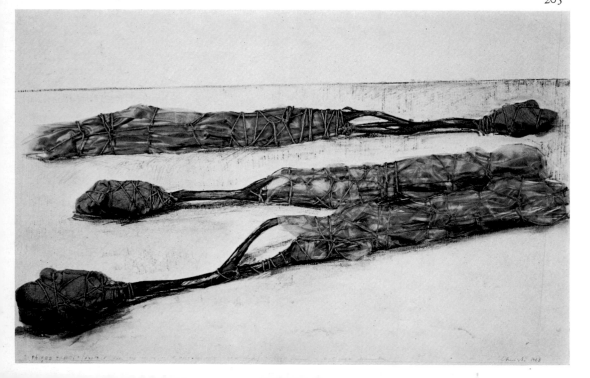

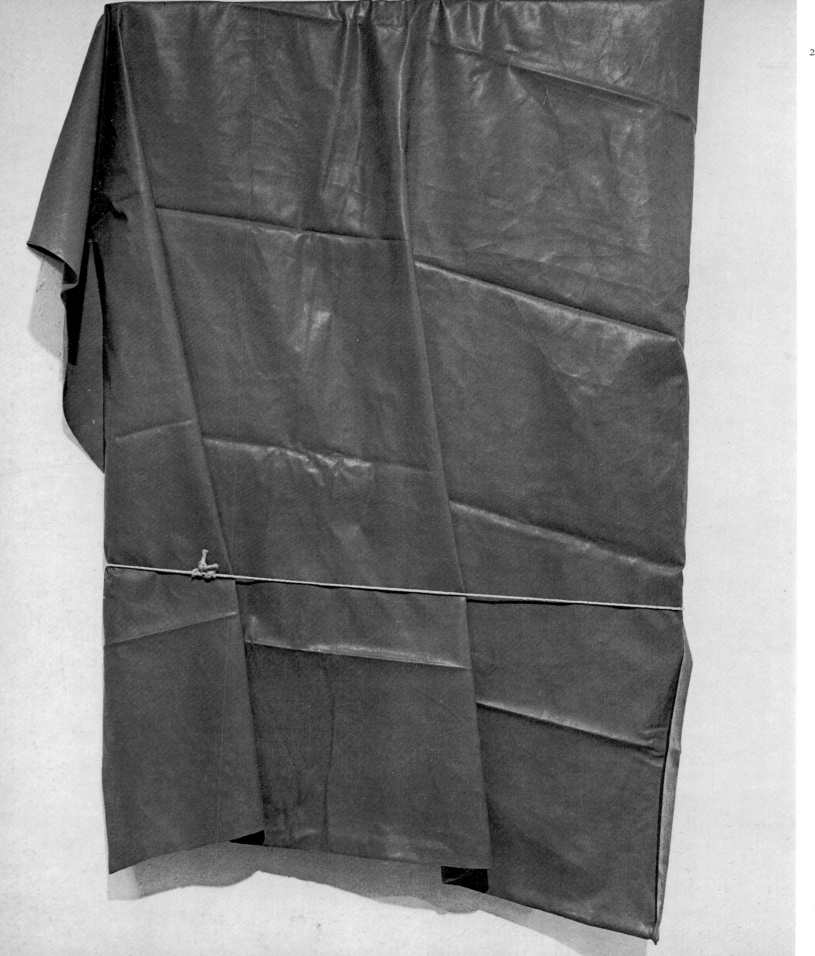

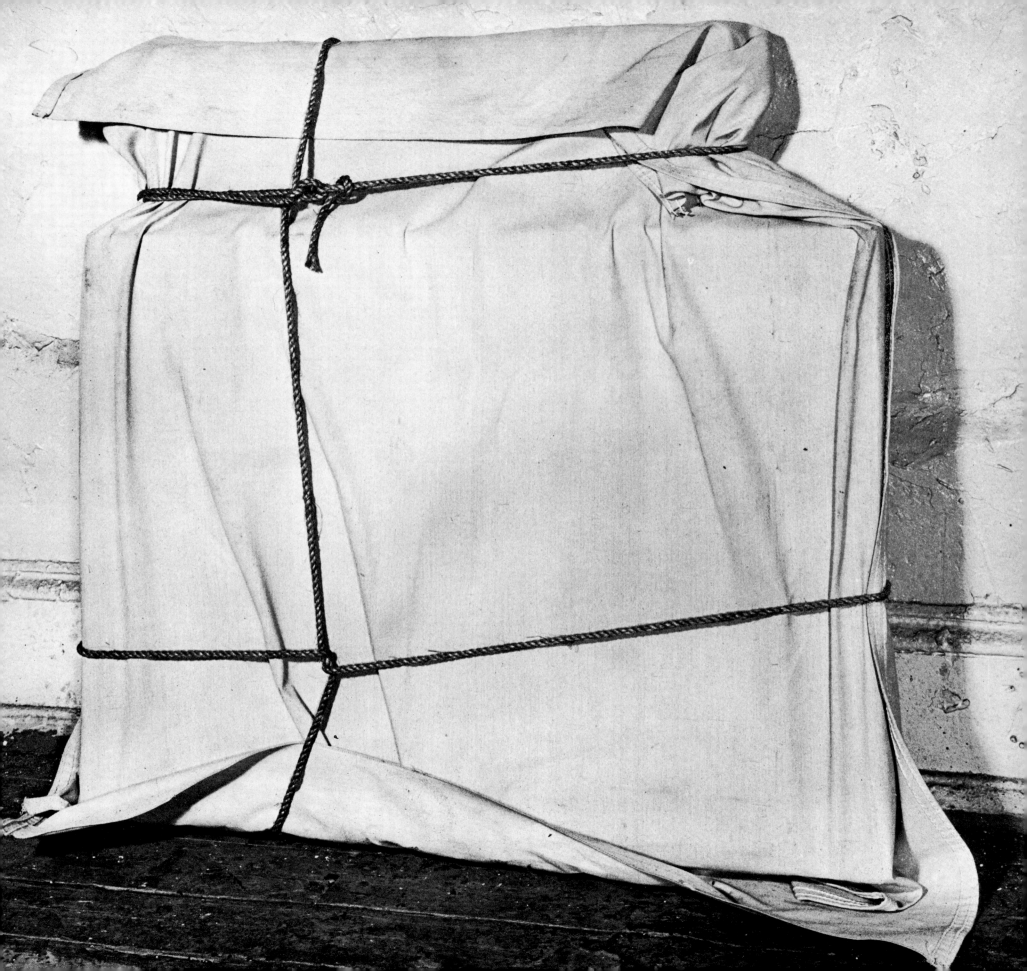

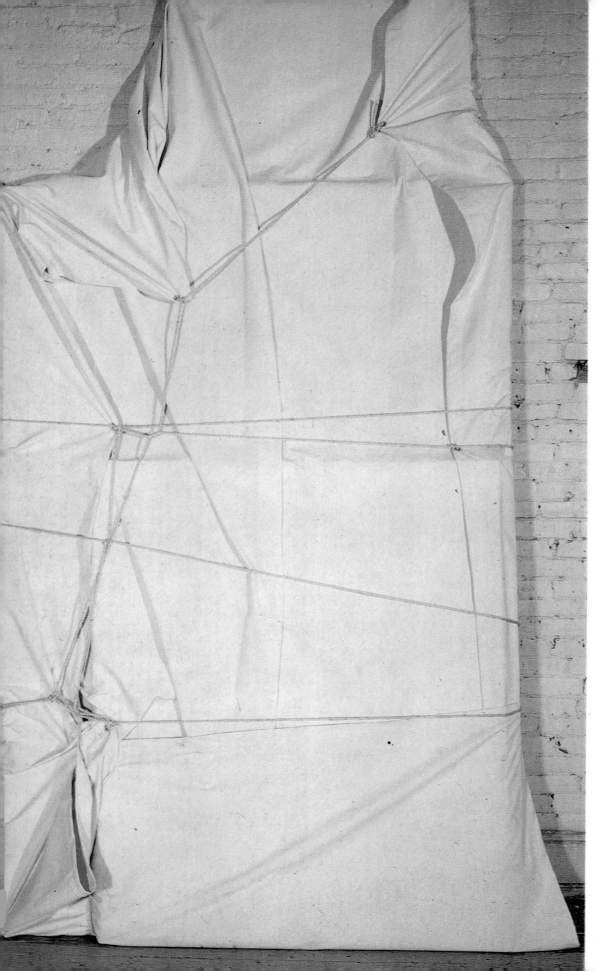

209. *Wrapped Painting*. 1968. Tarpaulin and rope, 10 ft. 7 in. × 5 ft. 4 in. × 7 in. Collection Gian Enzo Sperone, Turin

210. *Wrapped Painting*. 1968. Tarpaulin and rope, 96 × 72 × 8 in. Collection Gian Enzo Sperone, Turin

211. *Packed Flowers*. 1966. Plastic roses, plastic, and twine, $5\frac{1}{2} \times 12 \times 4$ in. Collection Wolfgang H. Buggenhagen, Berlin
212. *Packed Road Lamp*. 1966. Lamp, plastic, and twine, $8 \times 12 \times 4$ in. Locksley Shea Gallery, Minneapolis, Minnesota
213. *Yellow Package*. 1968. Rubberized tarpaulin and rope, $16 \times 45 \times 48$ in.
214. *Brown Paper Package*. 1968. Wrapping paper and tape, $12 \times 21 \times 15$ in.
215. *Package*. 1968. Rubberized canvas and twine, $10 \times 16 \times 12$ in. Collection Bernar Venet, New York City

211

212

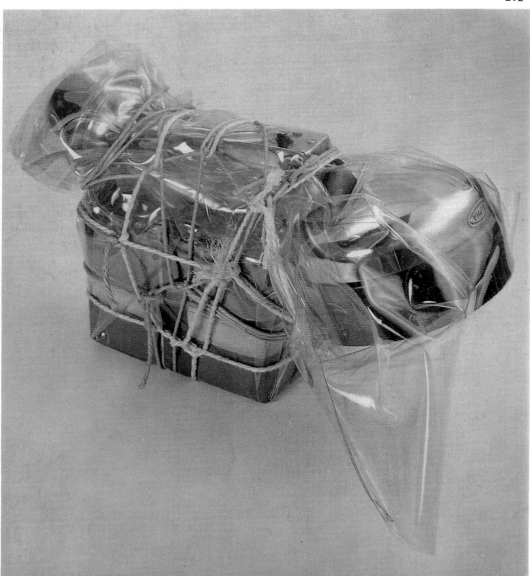

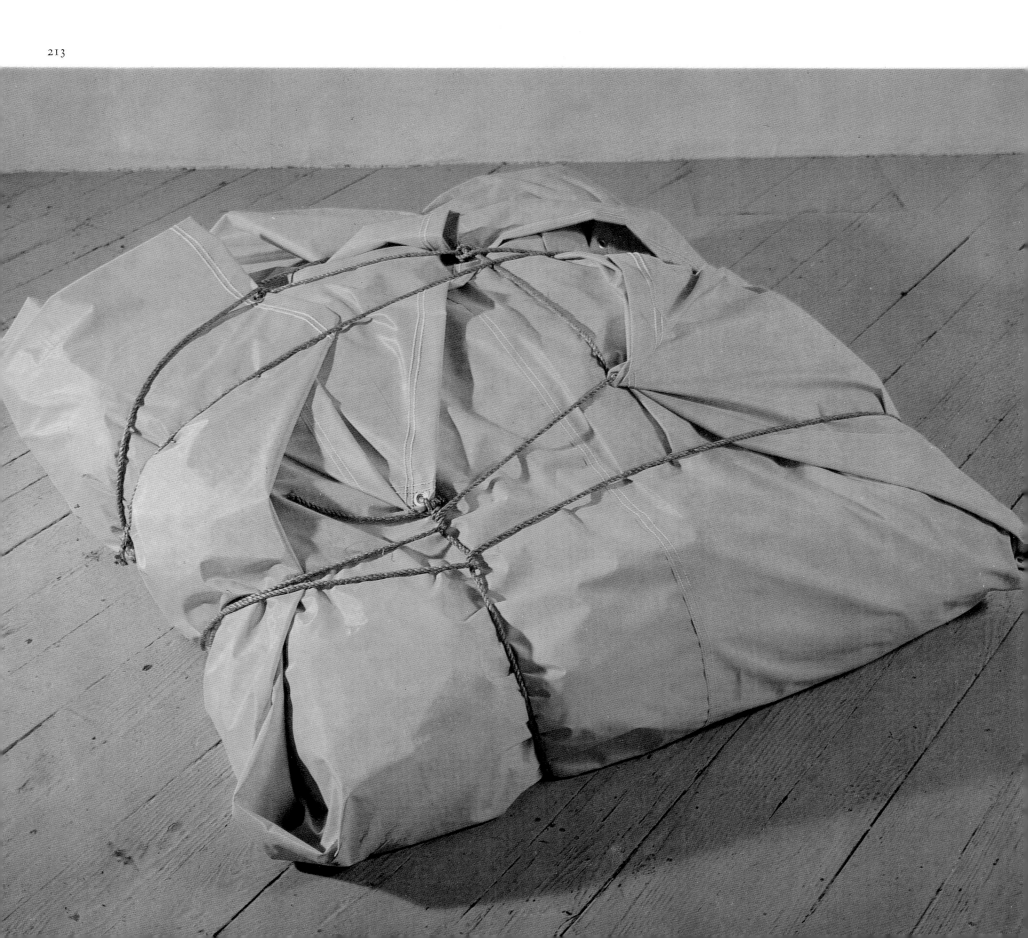

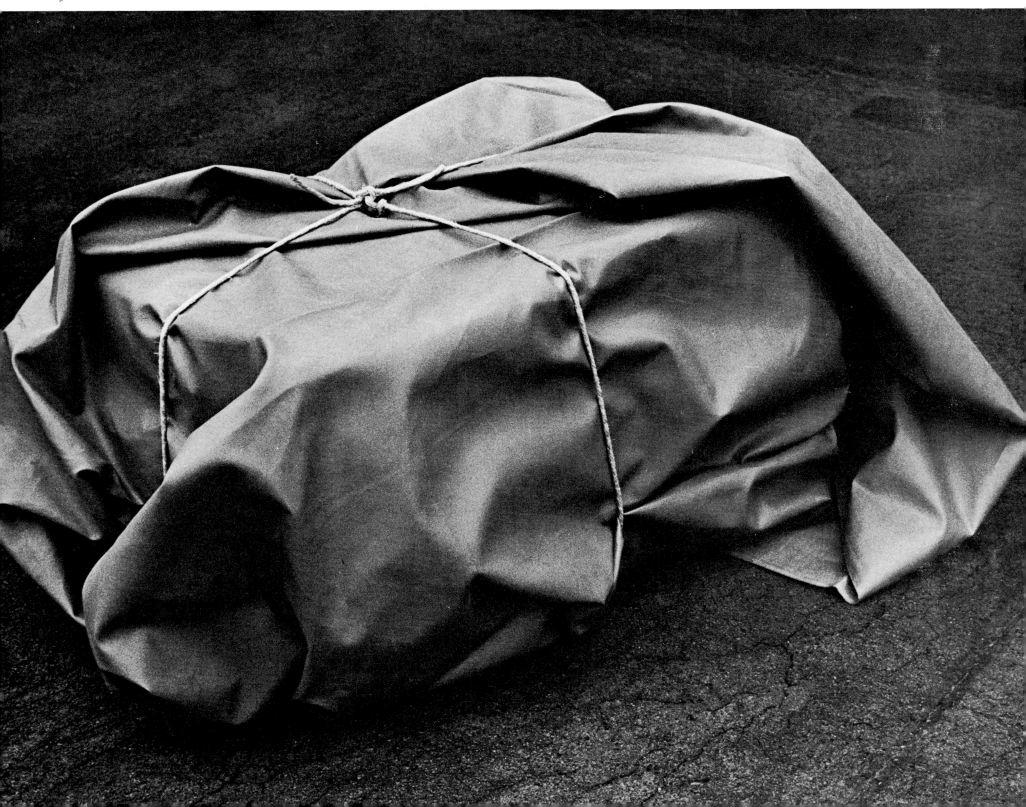

216. *Package*. 1969. Tarpaulin and rope,
5 ft. 9 in.×10 ft.×5 ft. 10 in.

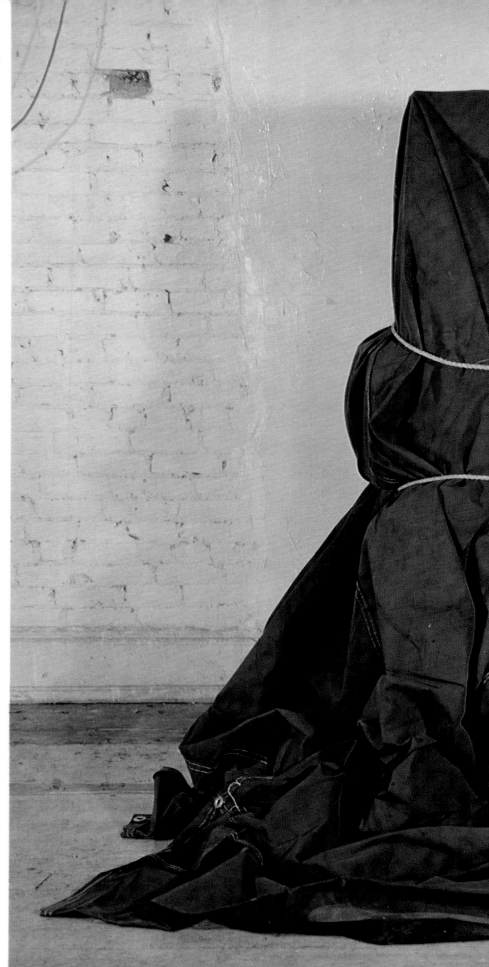

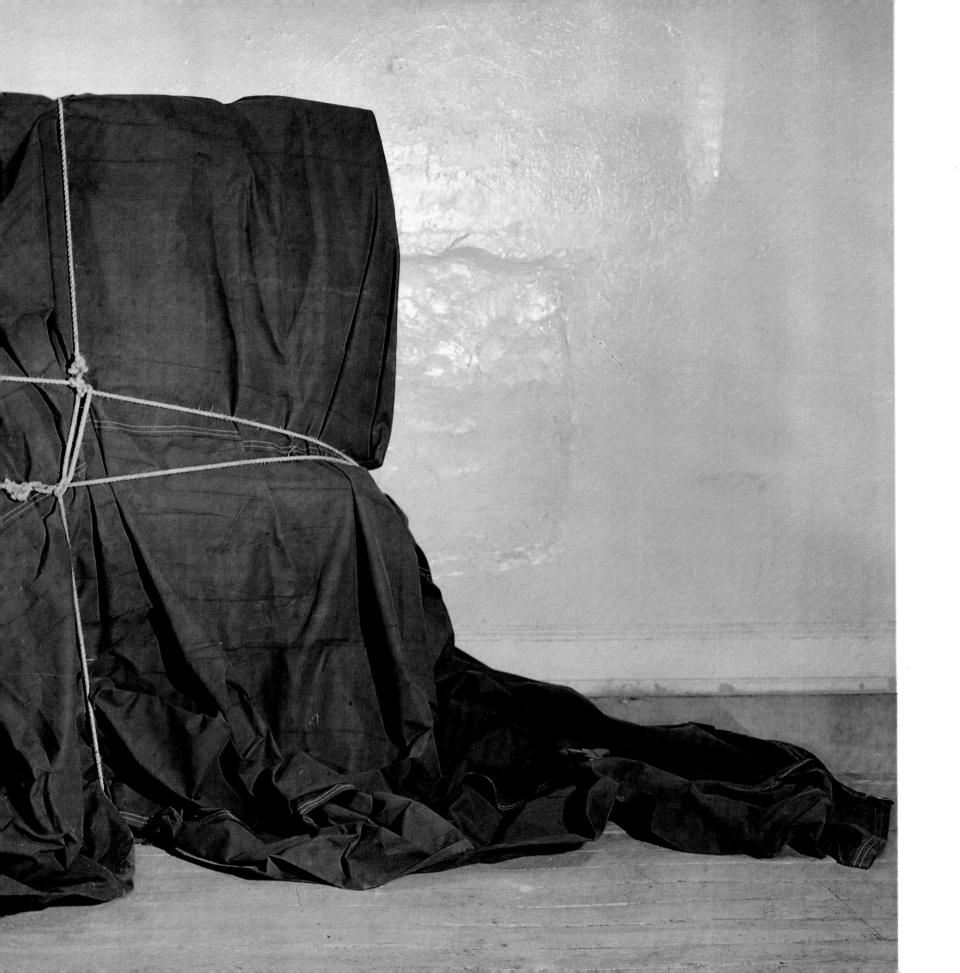

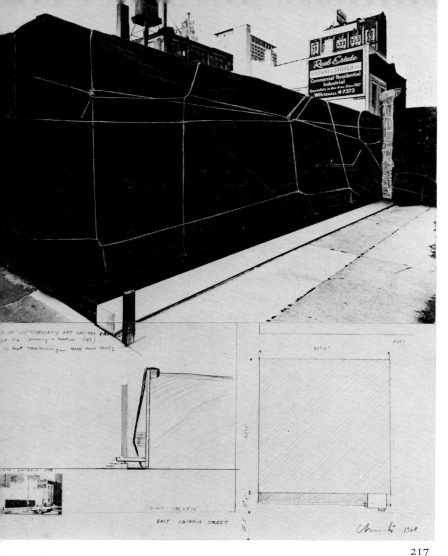

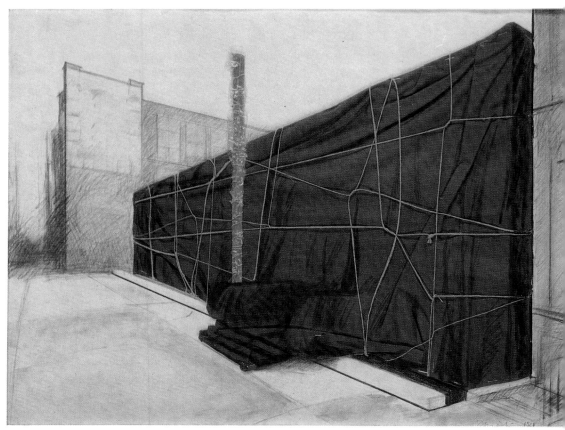

217 218

MUSEUM OF CONTEMPORARY ART, CHICAGO—PACKED.

Plates 217–42. Christo made a package of monumental proportions when he wrapped his first public building in the United States in 1969. The occasion was Christo's one-man exhibition, entitled *Wrap In Wrap Out*, at Chicago's Museum of Contemporary Art. Using 10,000 square feet of heavy tarpaulin and 3,600 feet of Manila rope, Christo and his helpers shrouded the exterior of the building within forty-eight hours. He also created a complementary work for the interior—a wrapped floor in the museum's lower gallery. Using 2,500 square feet of used painters' dropcloths, he carefully arranged the wrinkled fabric to create a visually pleasing and sensuously tactile floorpiece. The building and the floor remained wrapped for six weeks.

217. *Museum of Contemporary Art, Chicago—Packed.* Project. 1968. Canvas, twine, and photostats, 22×28 in. Galerie Yvon Lambert, Paris
218. *Museum of Contemporary Art, Chicago—Packed.* Project. 1968. Canvas, twine, and pencil on paper, 22×28 in. Collection Mr. and Mrs. Edwin A. Bergman, Chicago
219. Museum of Contemporary Art, Chicago, on the first day of packaging, January 13, 1969. The complete wrap-up required 10,000 sq. ft. of tarpaulin, 3,600 ft. of Manila rope, and the aid of student assistants from the school of the Art Institute and the Institute of Design
220. About 30 canvas tarpaulins were needed to cover the three sides of the building (the fourth was inaccessible, being joined to a neighboring building). The tarpaulins were secured to 2×4 lumber laid out along the edge of the roof and along the ground
221. *Museum of Contemporary Art, Chicago—Packed.* Detail
222. The artist and a workman inspecting the tarpaulins on the rear of the building
223–24. The artist tying his package
225–26. Installing the tarpaulin on the side and the rear of the building
227–28. *Museum of Contemporary Art, Chicago—Packed.* Rear view

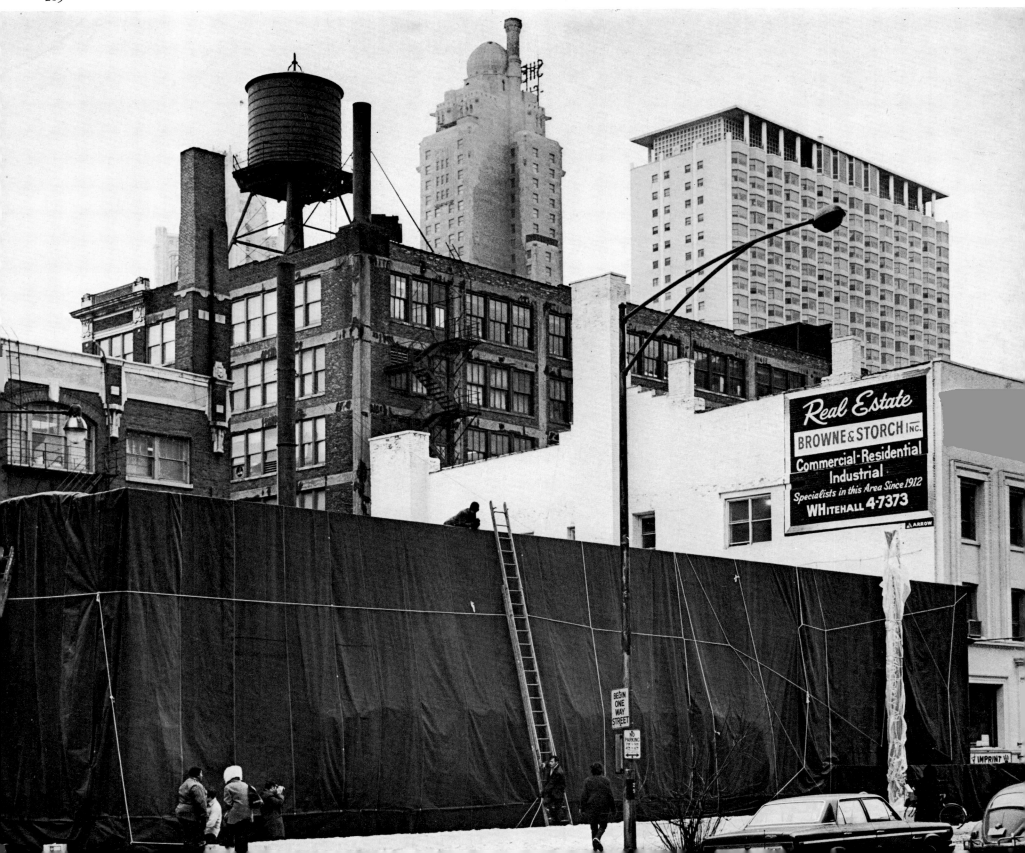

Real Estate
BROWNE & STORCH Inc.
Commercial-Residential
Industrial
Specialists in this Area Since 1912
WHitehall 4-7373

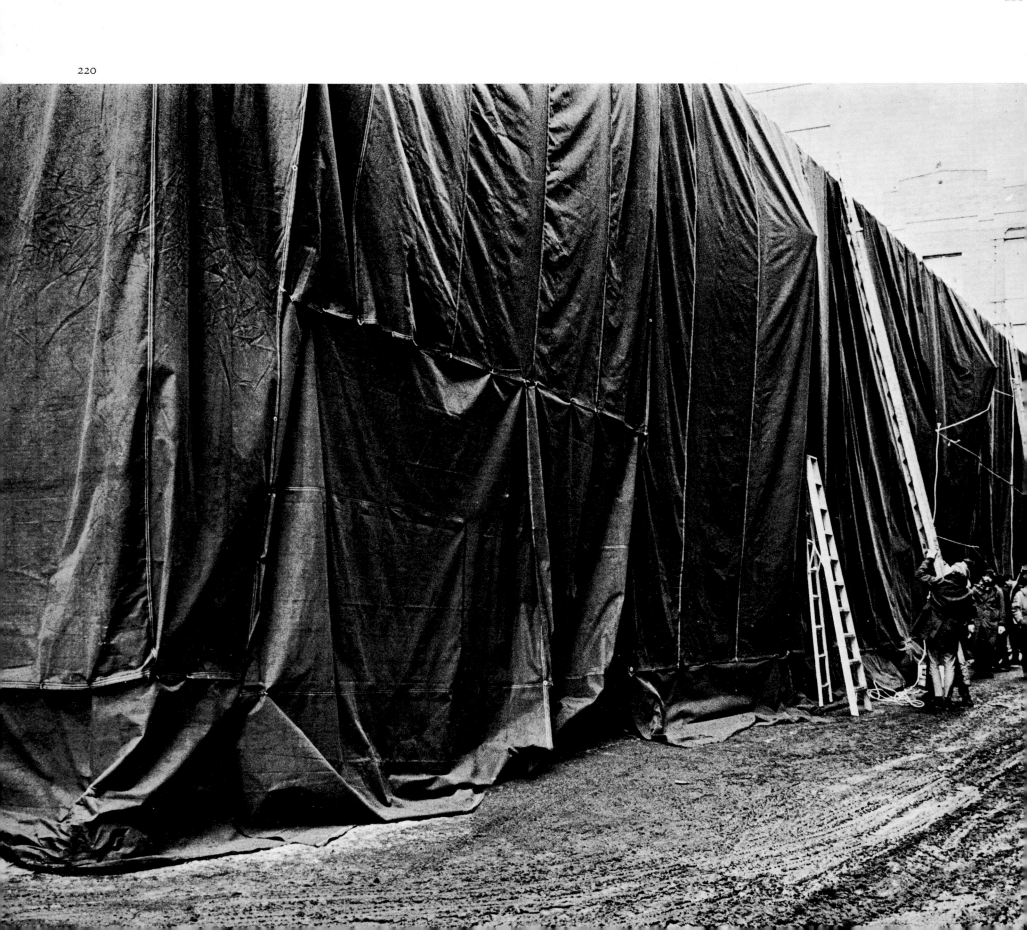

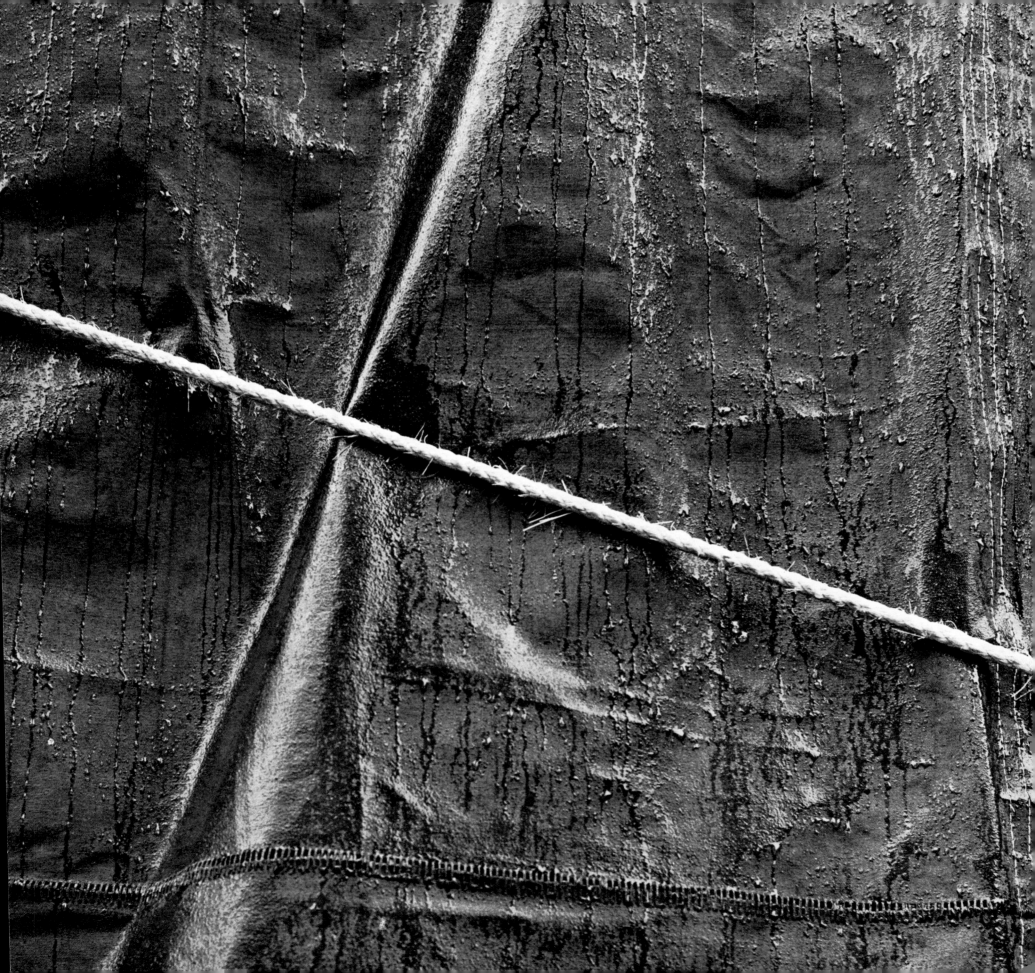

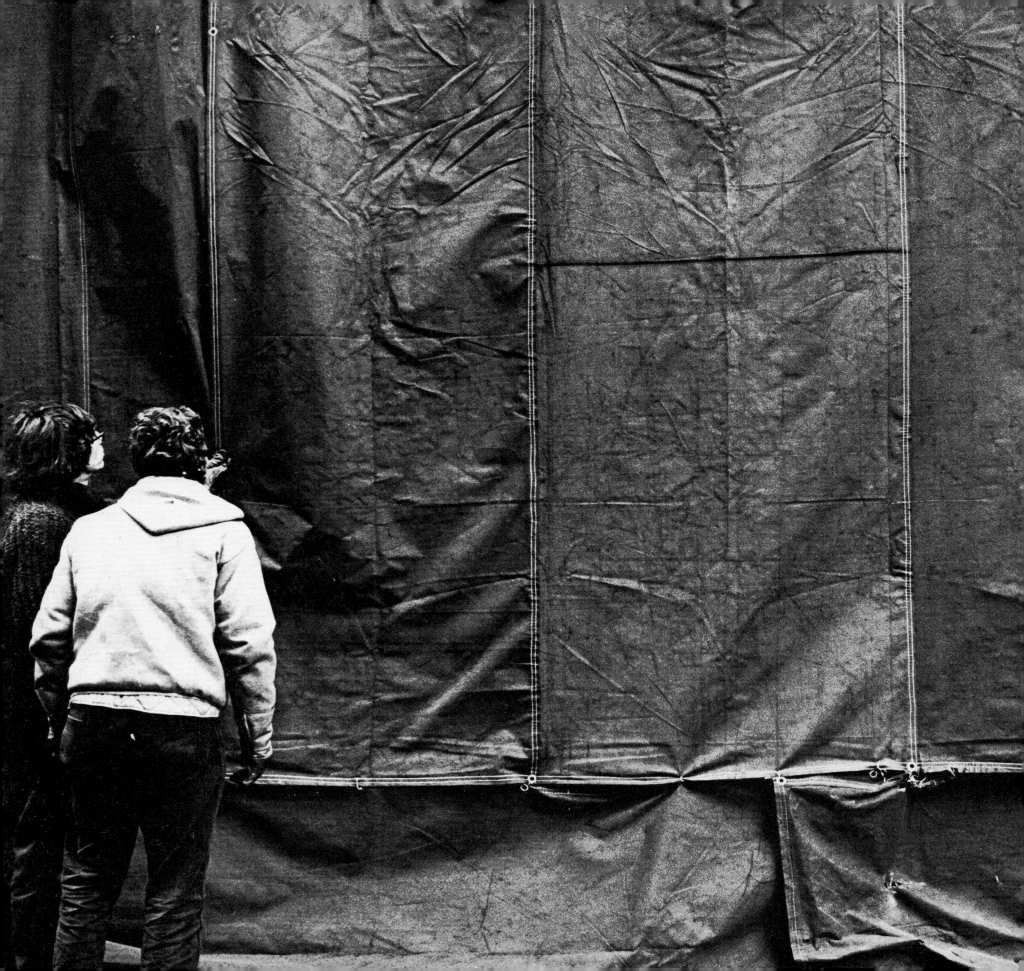

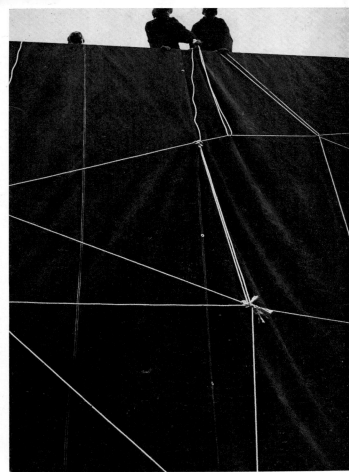

223

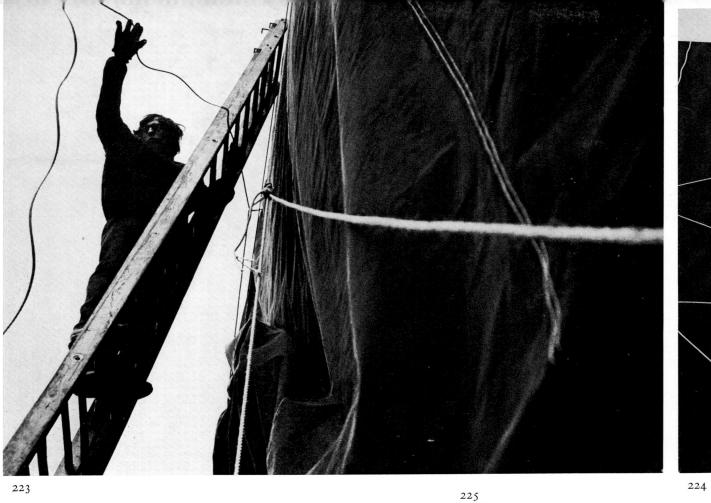

224

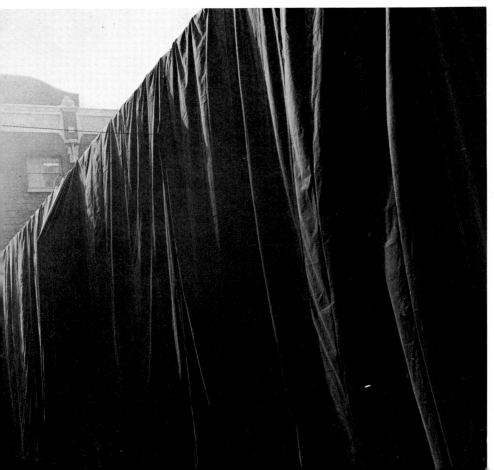

225

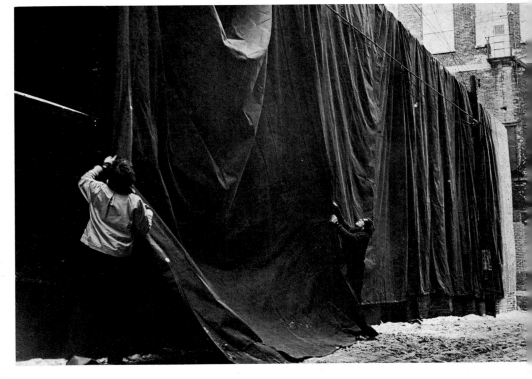

226

227-228 (overleaf) ▶

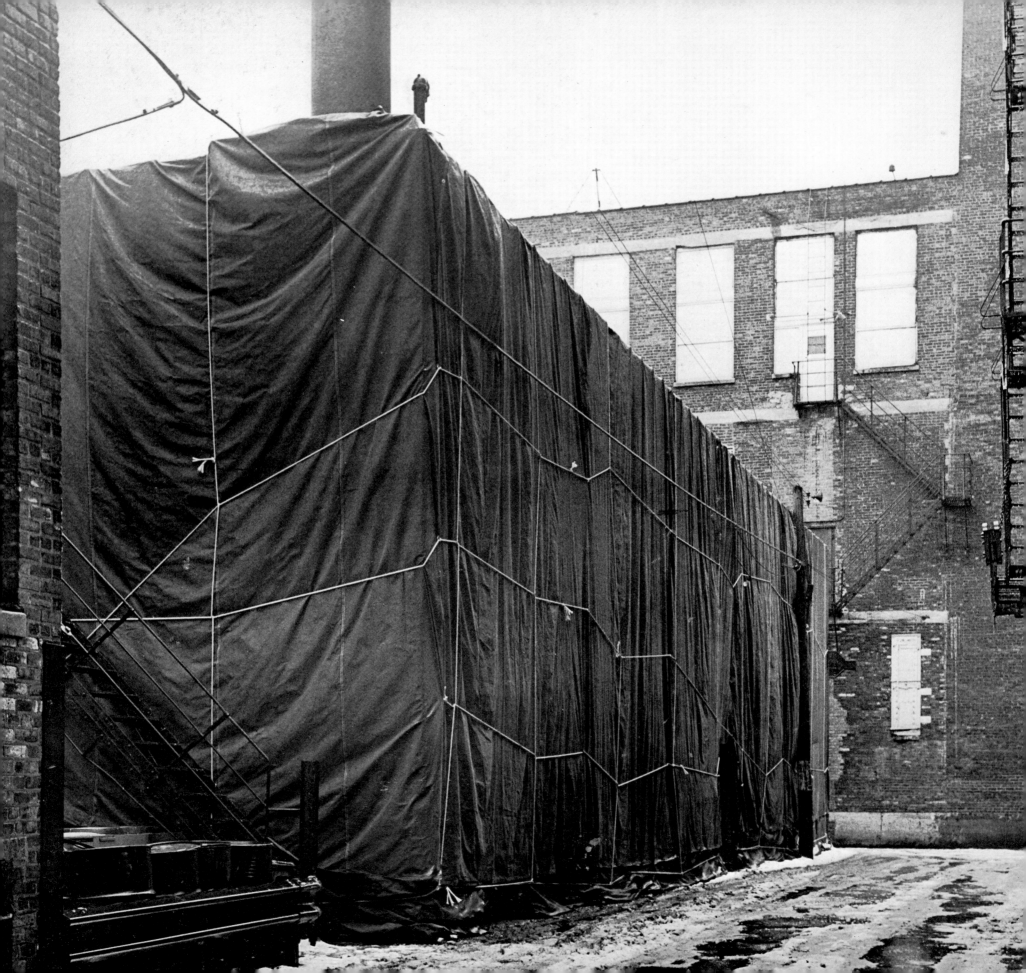

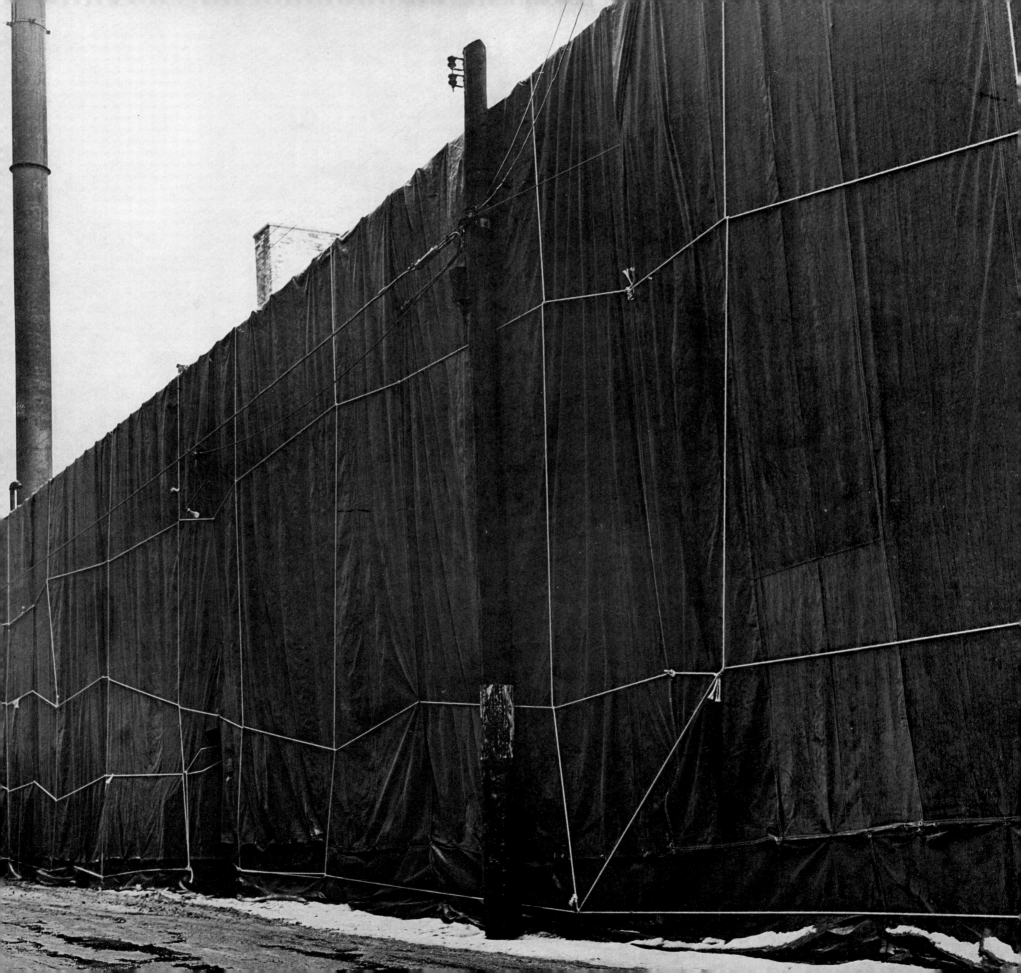

229. *Museum of Contemporary Art, Chicago—Packed.*
 Corner view, showing side and front of building
230. *Museum of Contemporary Art, Chicago—Packed.*
 Corner view, showing rear and side of building
231. *Museum of Contemporary Art, Chicago—Packed.*
 Front view, showing the museum's vertical signpost
 shrouded in translucent polyethylene

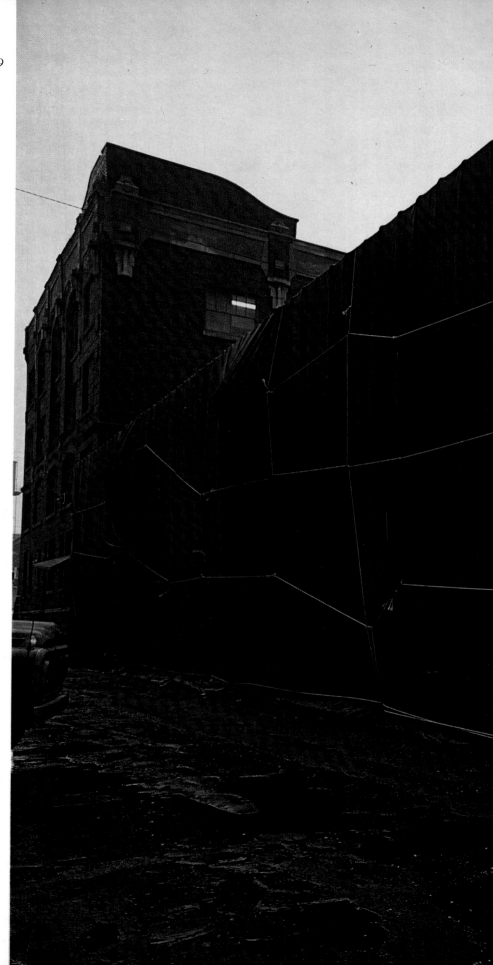

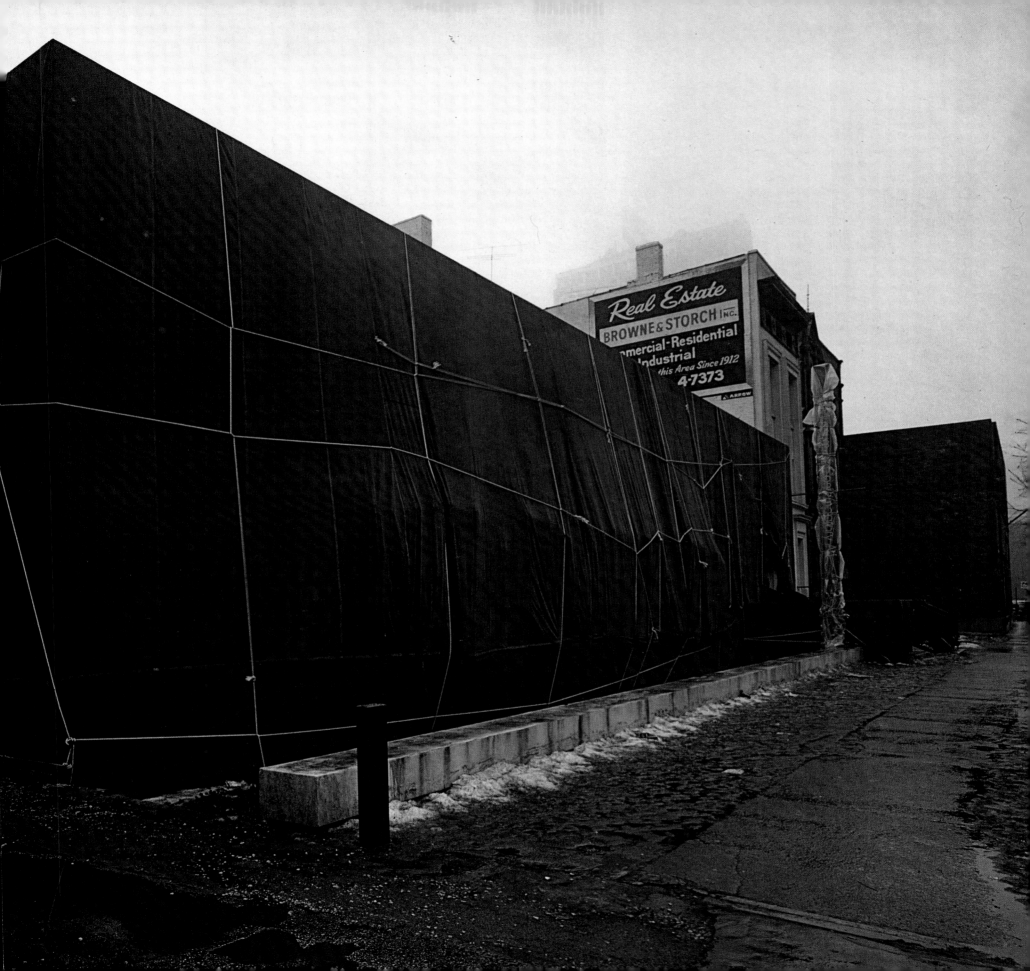

Real Estate
BROWNE & STORCH INC.
ommercial-Residential
Industrial
this Area Since 1912
4-7373
ARROW

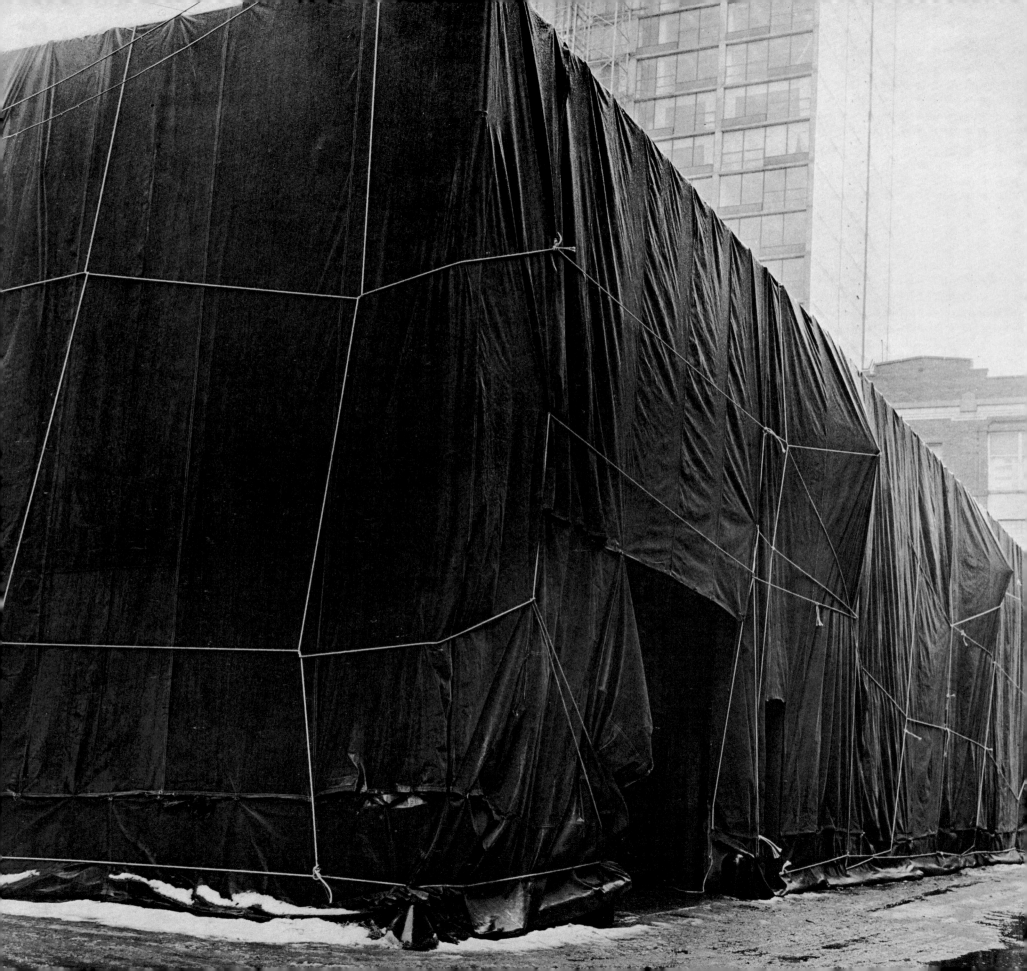

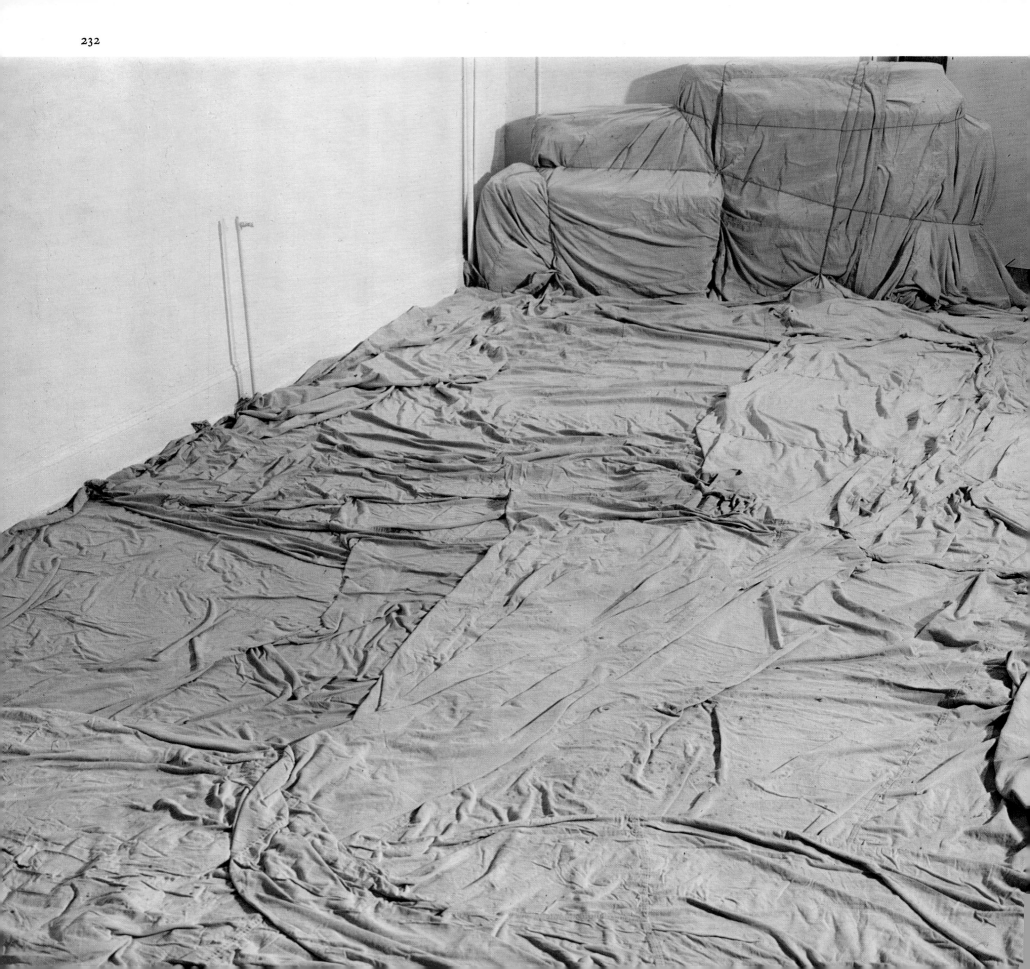

232. *Wrapped Floor.* Installation view in the artist's New York studio. 1969. Dropcloths and rope, 33×18 ft.

233. *Wrapped Floor.* Project. 1968. Canvas and pencil on paper, 22×28 in. Galerie Yvon Lambert, Paris

234. *Wrapped Floor.* Installation view at Museum of Contemporary Art, Chicago. 1969. 2,800 sq. ft. of dropcloths and rope

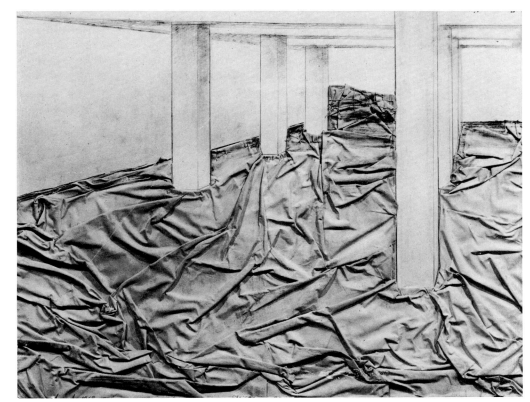

233

234

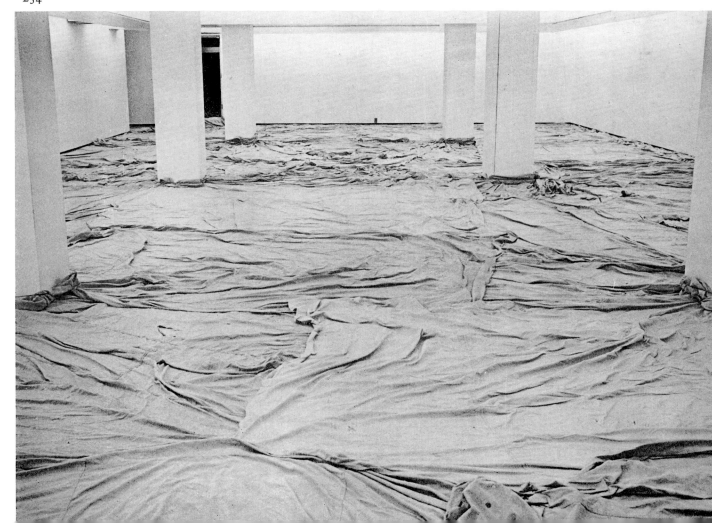

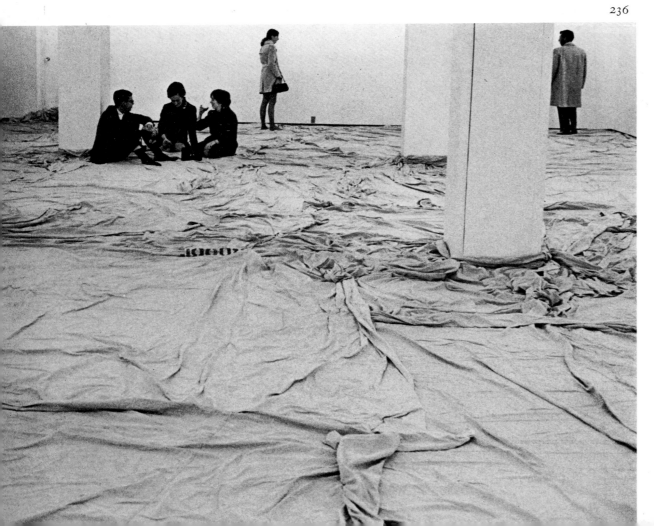

235–36. *Wrapped Floor.* Opening day of exhibition
 237. *Wrapped Floor.* Detail of stairway
 238. *Wrapped Floor.* View from upper floor, looking down at staircase and portion of lower floor
239–40. *Wrapped Floor.* Installation views
 241. *Wrapped Floor.* Detail of dropcloths roped to pillars
 242. *Wrapped Floor.* Installation view showing wall package containing pedestals and other museum equipment

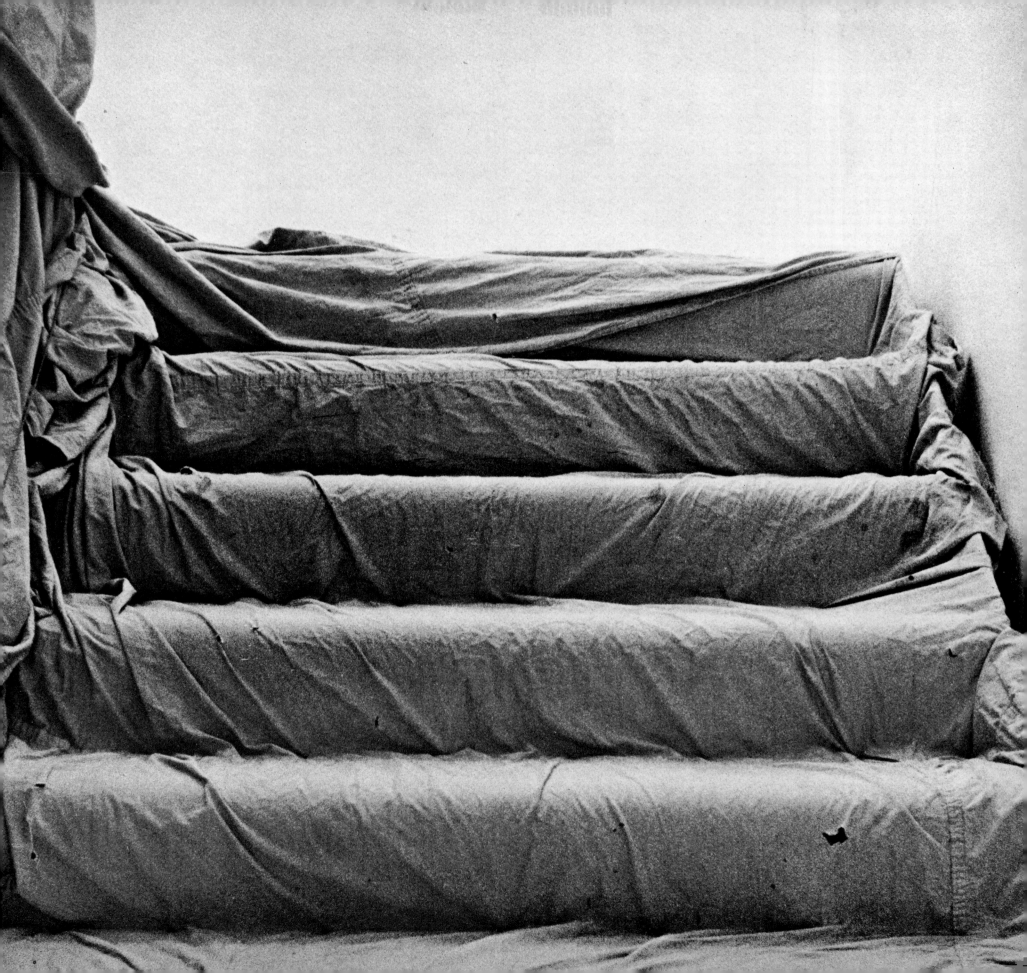

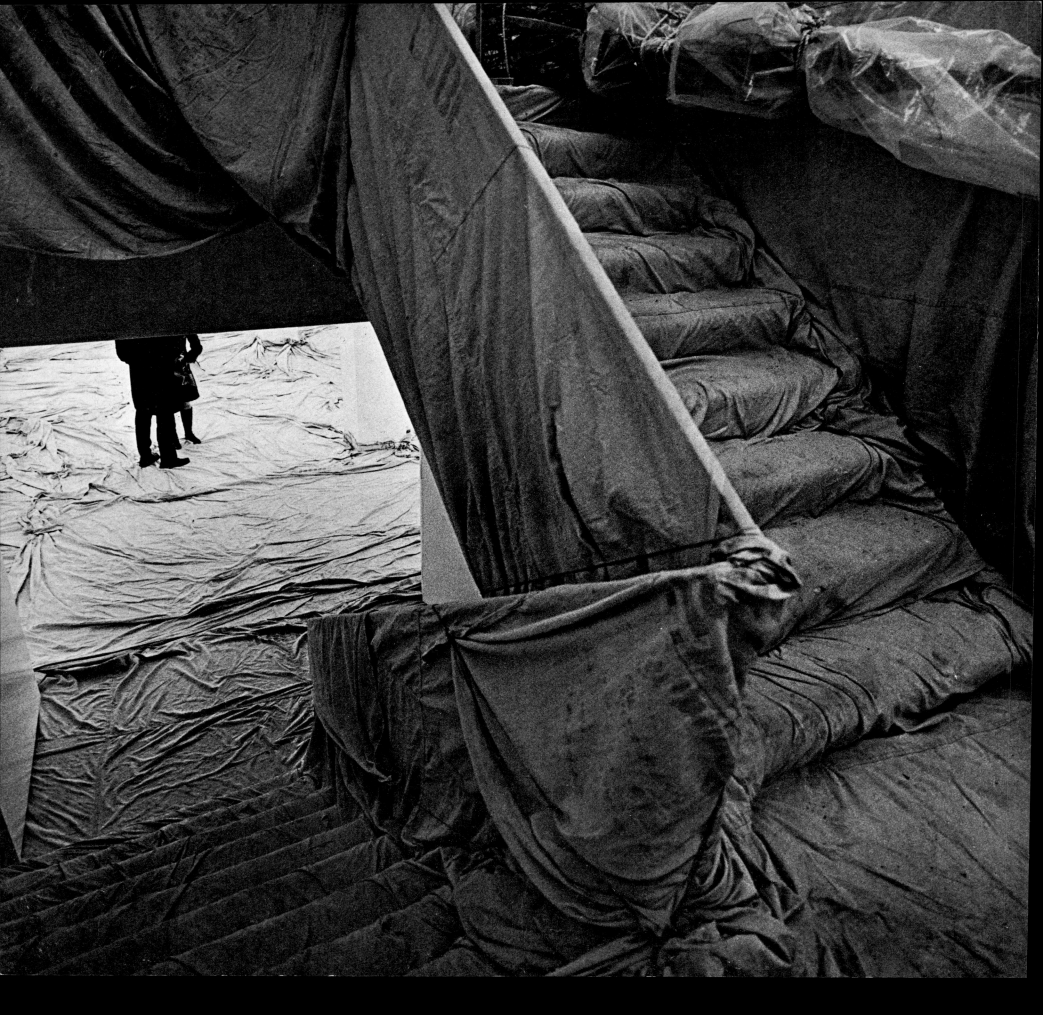

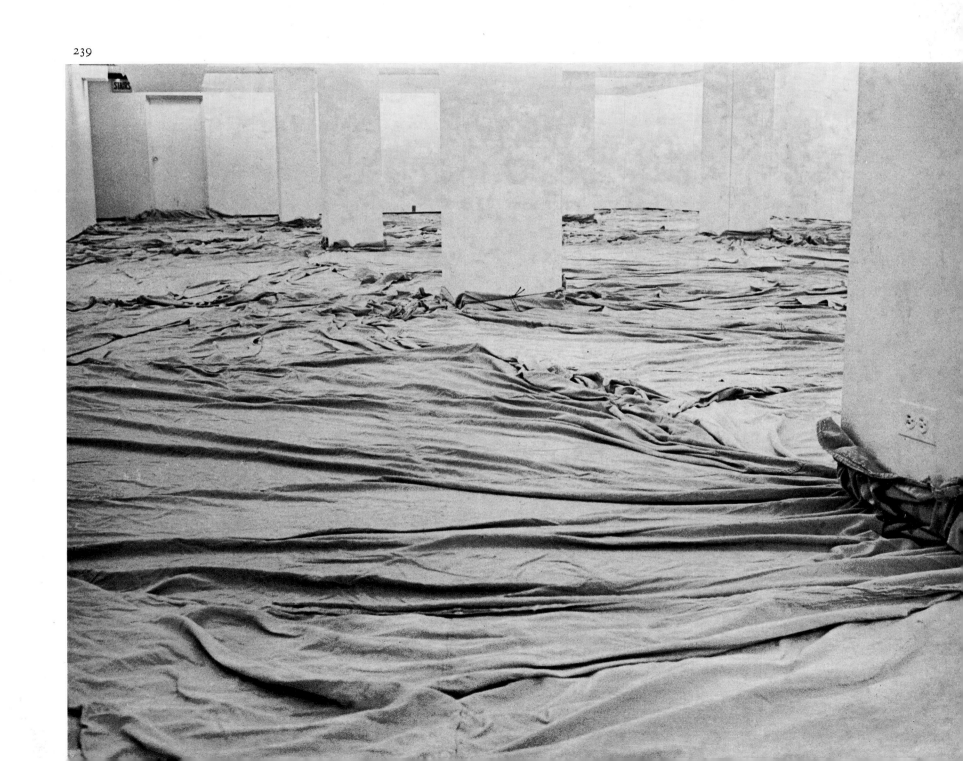

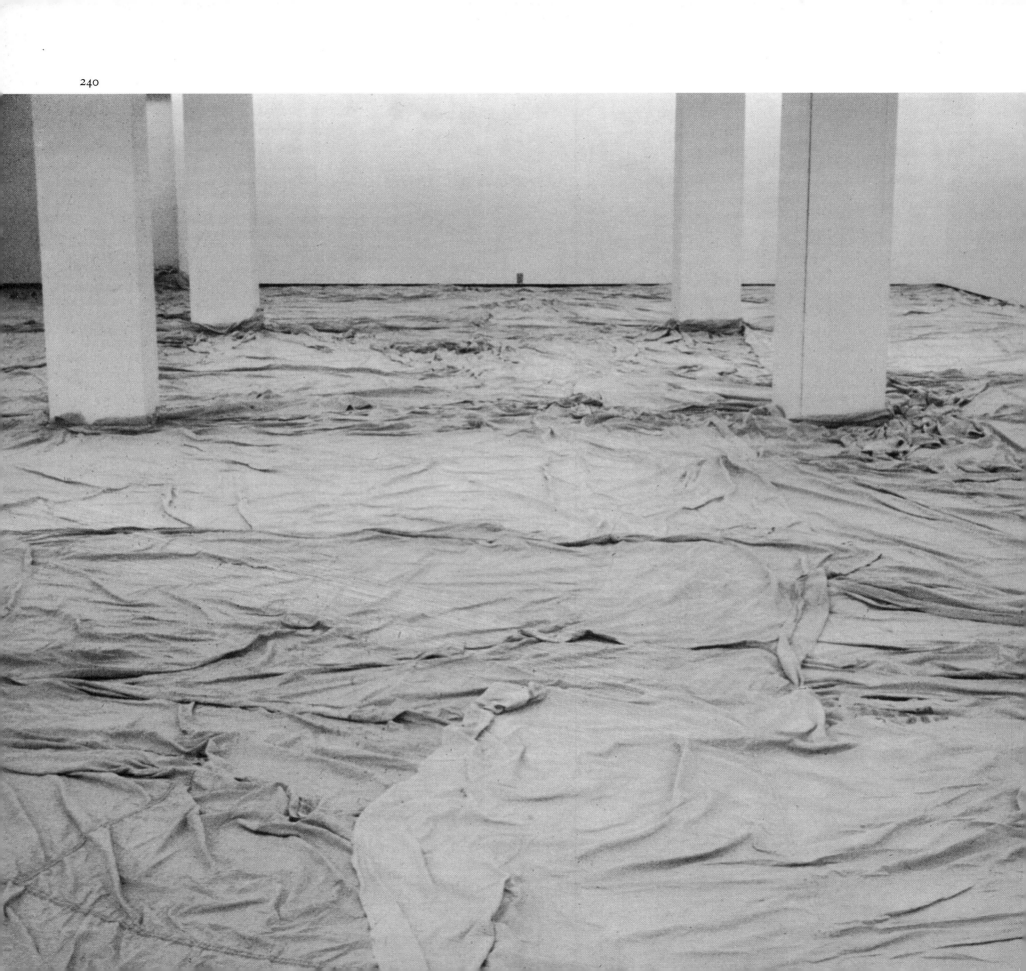

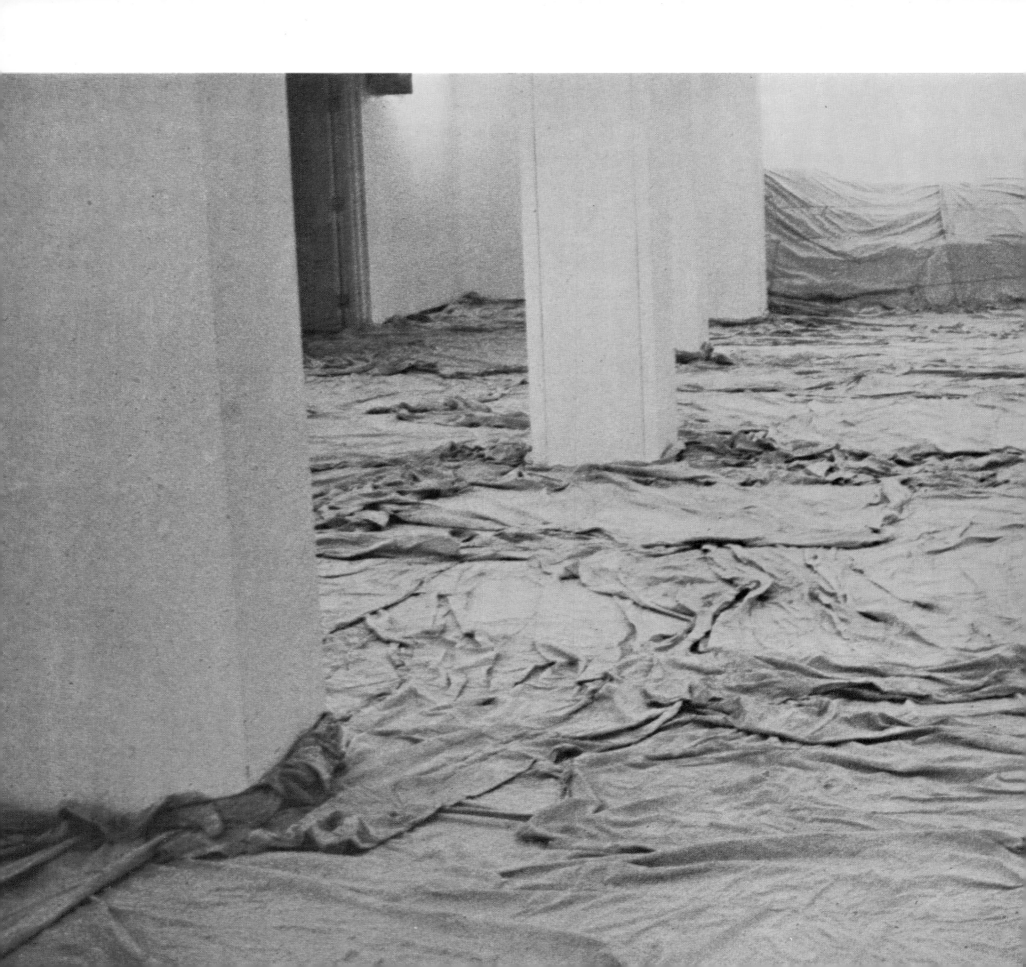

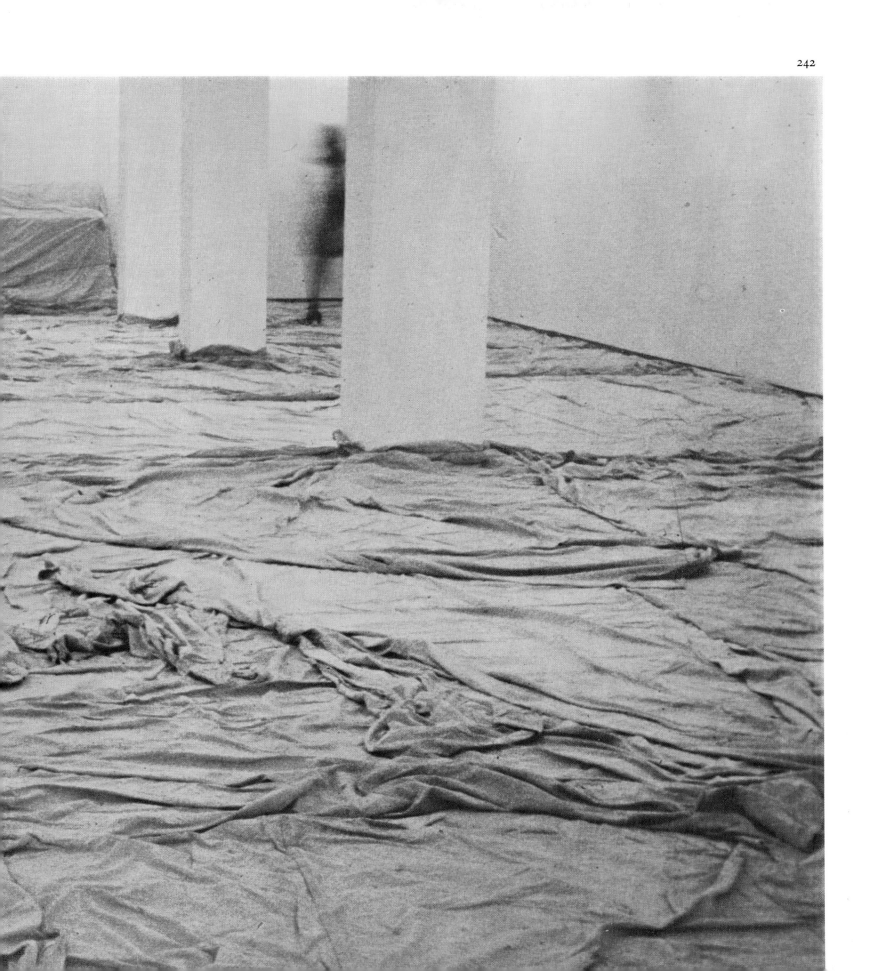

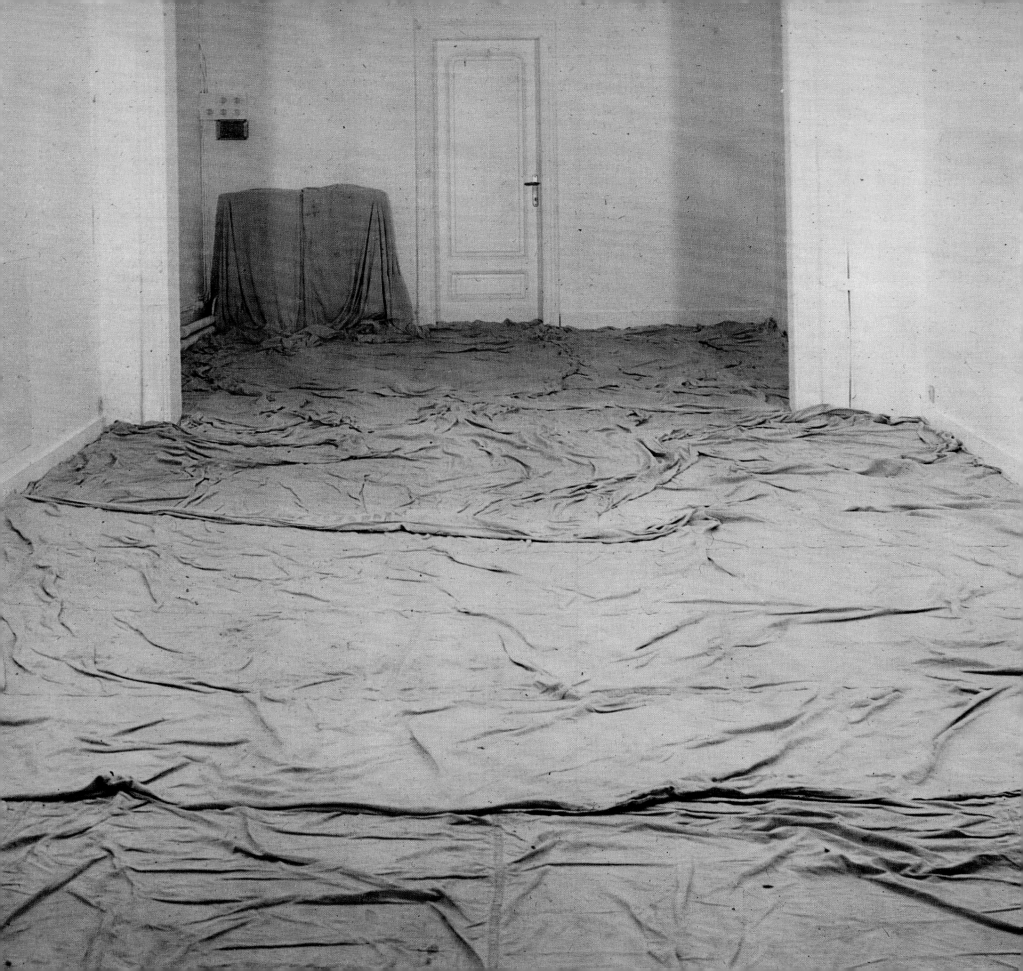

243. *Wrapped Floor*. Installation view at Wide White Space Gallery, Antwerp, 1969. Dropcloths and rope

244. *Wrapped Staircase*. Wide White Space Gallery, Antwerp, 1969. Dropcloths and rope

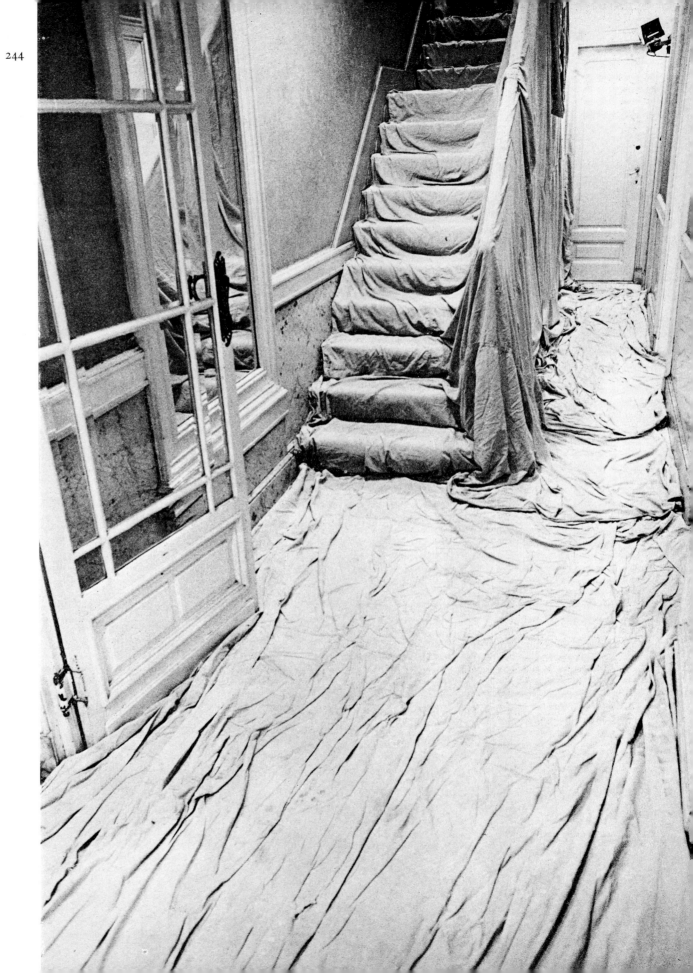

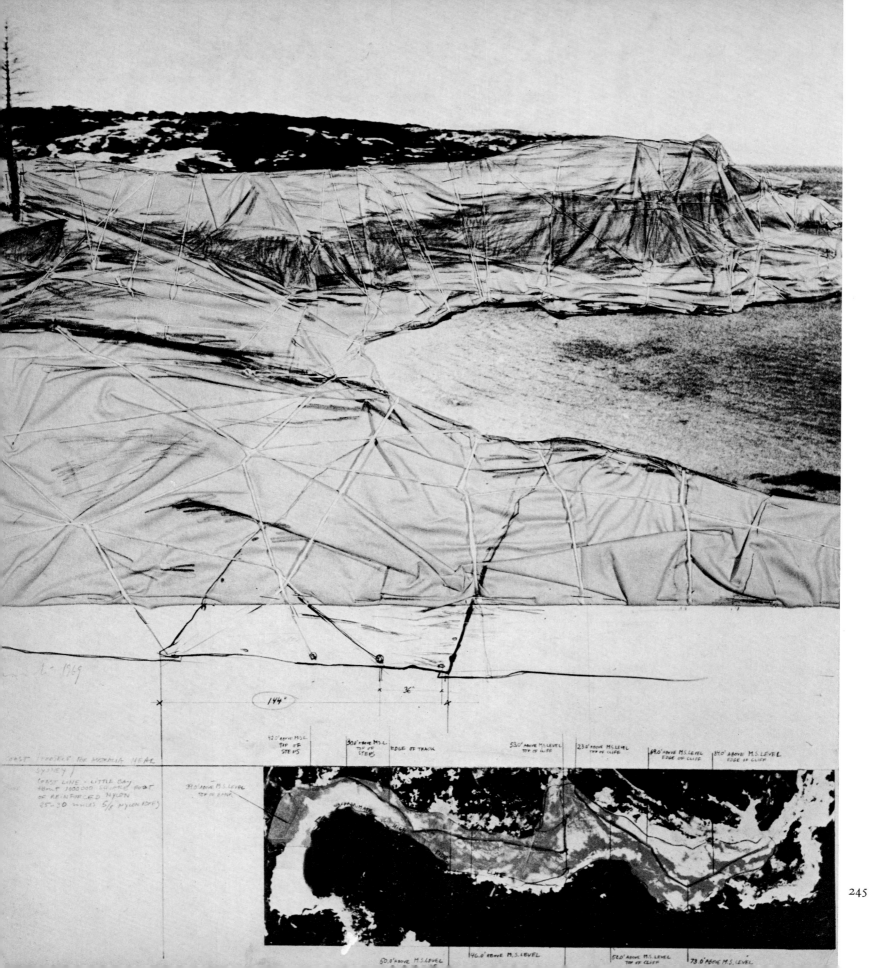

245

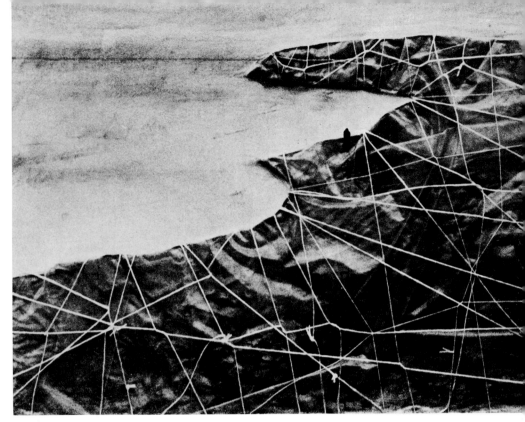

246

WRAPPED COAST. Plates 245–304.

Christo made a "terrestrial package" out of Little Bay, nine miles south-east of Sydney, Australia, in 1969. The cliff-lined shore area that he wrapped was approximately one mile in length, 150 to 800 feet in width, and averaged 50 feet in height. He packaged the coast with one million square feet of opaque plastic fabric and thirty-five miles of polypropylene rope. The monochrome fabric had the effect of masking out all coloristic and textural details while simultaneously emphasizing existing contours, bulges, and depressions, transforming the site into an artificial, synthetic-looking landscape. The realization required a tremendous amount of labor, and the physical work was occasionally hazardous. The wrapping took three weeks to complete, and remained in place for ten weeks.

247

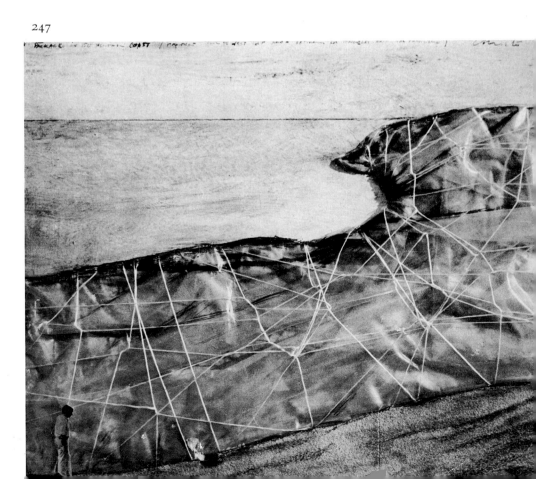

245. *Packed Coast*. Project for Australia. 1969. Photostat, cloth, twine, and pencil, 28 × 22 in. Collection Mr. and Mrs. Armand Bartos, New York City
246. *Packed Coast*. Project for West Coast near Los Angeles. 1968. Charcoal, colored pencil, polyethylene, and string on cardboard, 22 × 28 in. Collection Mr. and Mrs. Nathaniel H. Lieb, Philadelphia
247. *Packed Coast*. Project for West Coast. 1968. Charcoal, colored pencil, polyethylene, and string on cardboard, 22 × 28 in. Collection Mr. and Mrs. Milton S. Fox, New York City

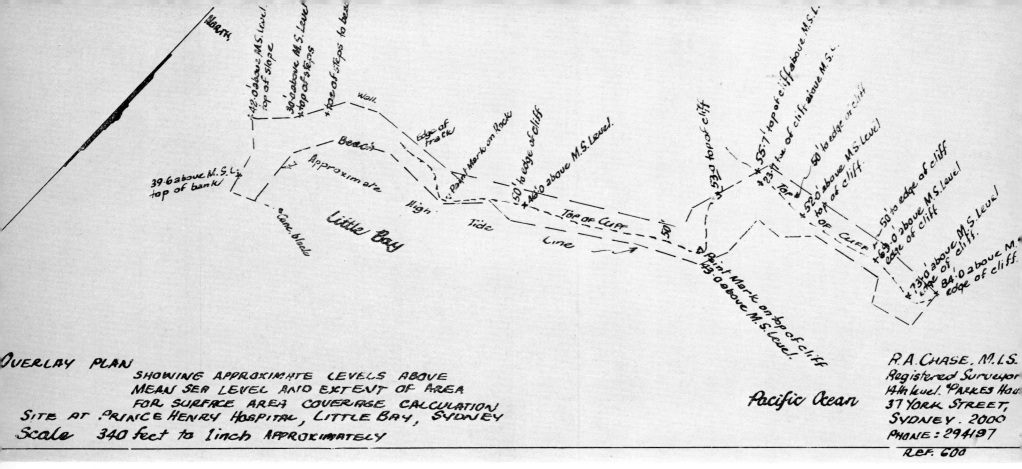

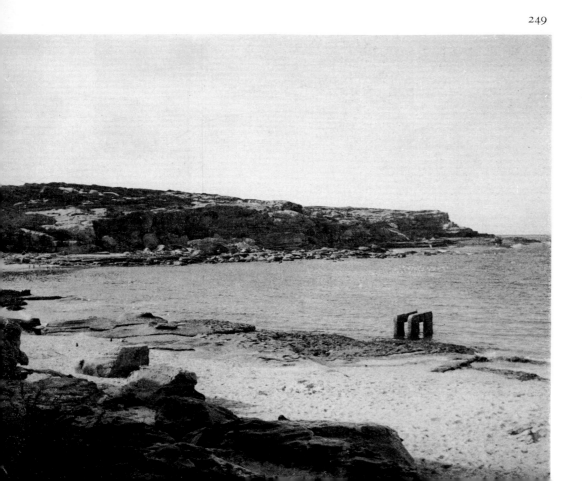

248. Surveyor's plan of Little Bay, near Sydney, Australia
249. Photographic view of Little Bay
250. Surveyor's contour map
251. Aerial photograph of Little Bay

251 (overleaf)

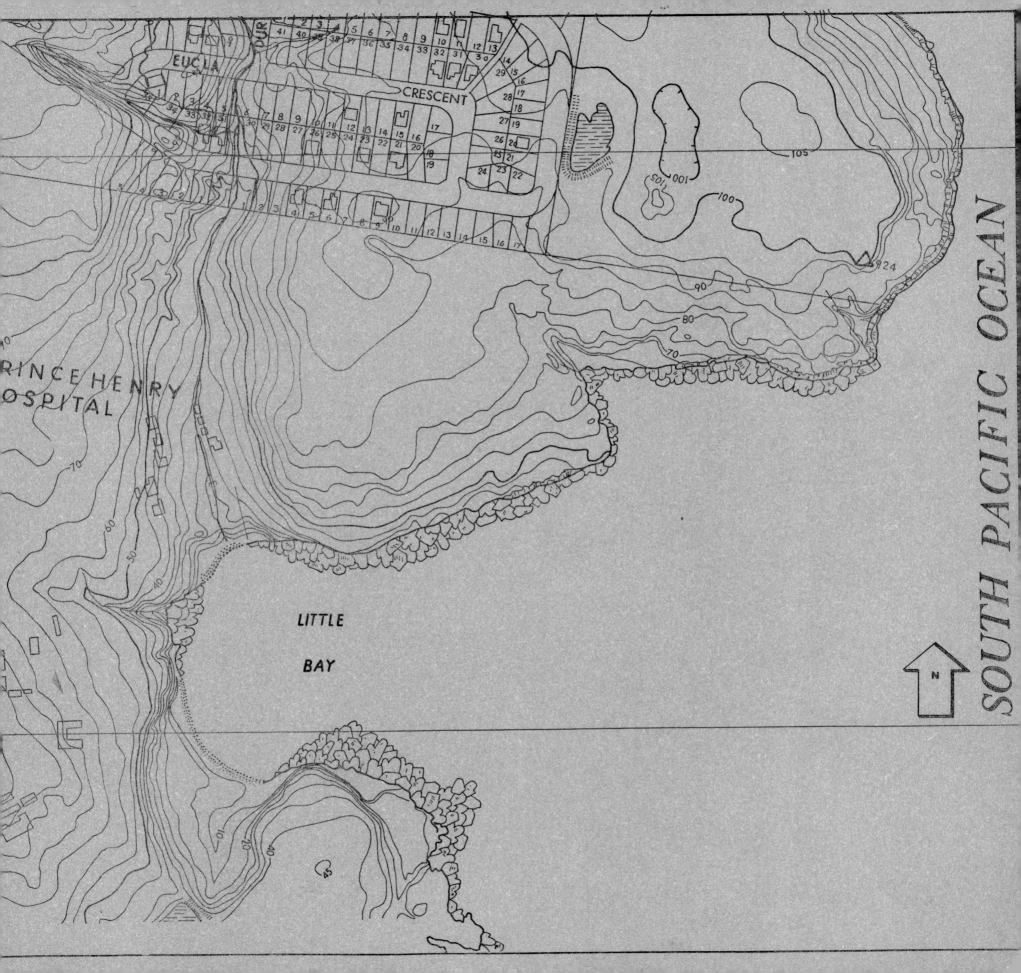

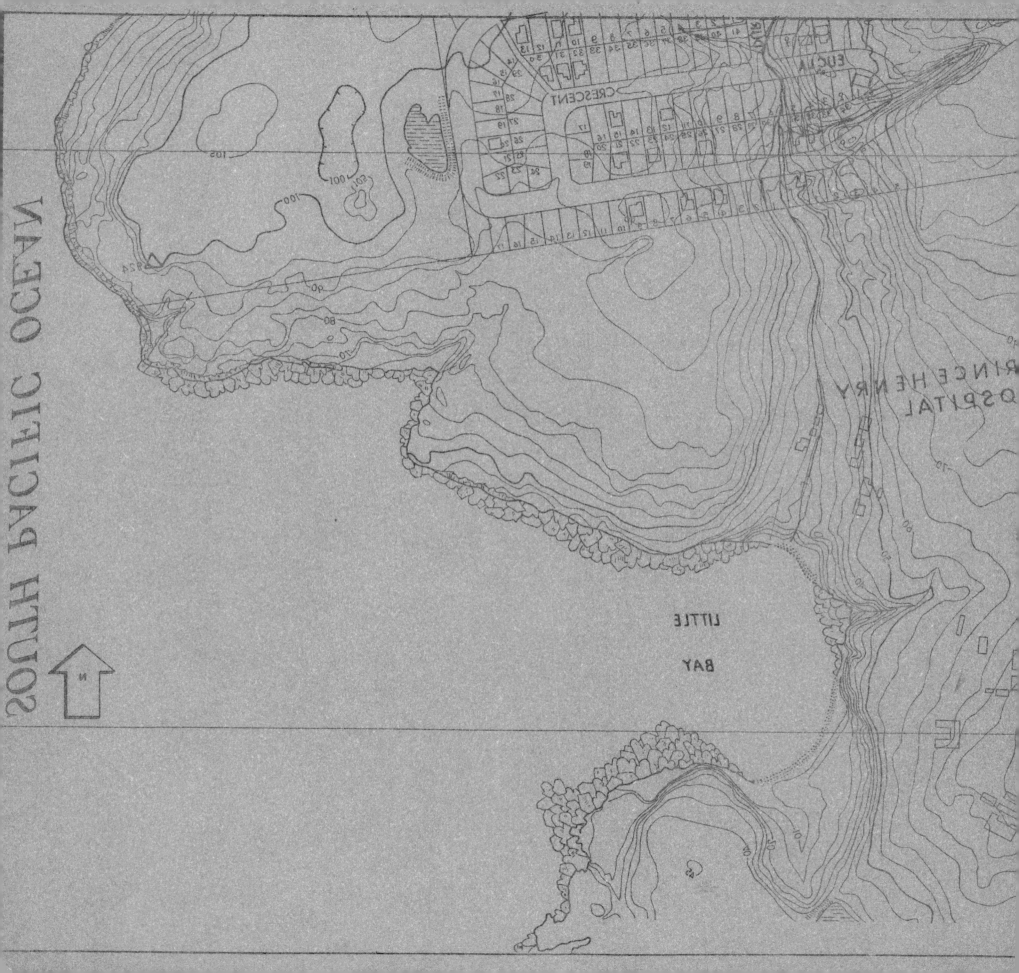

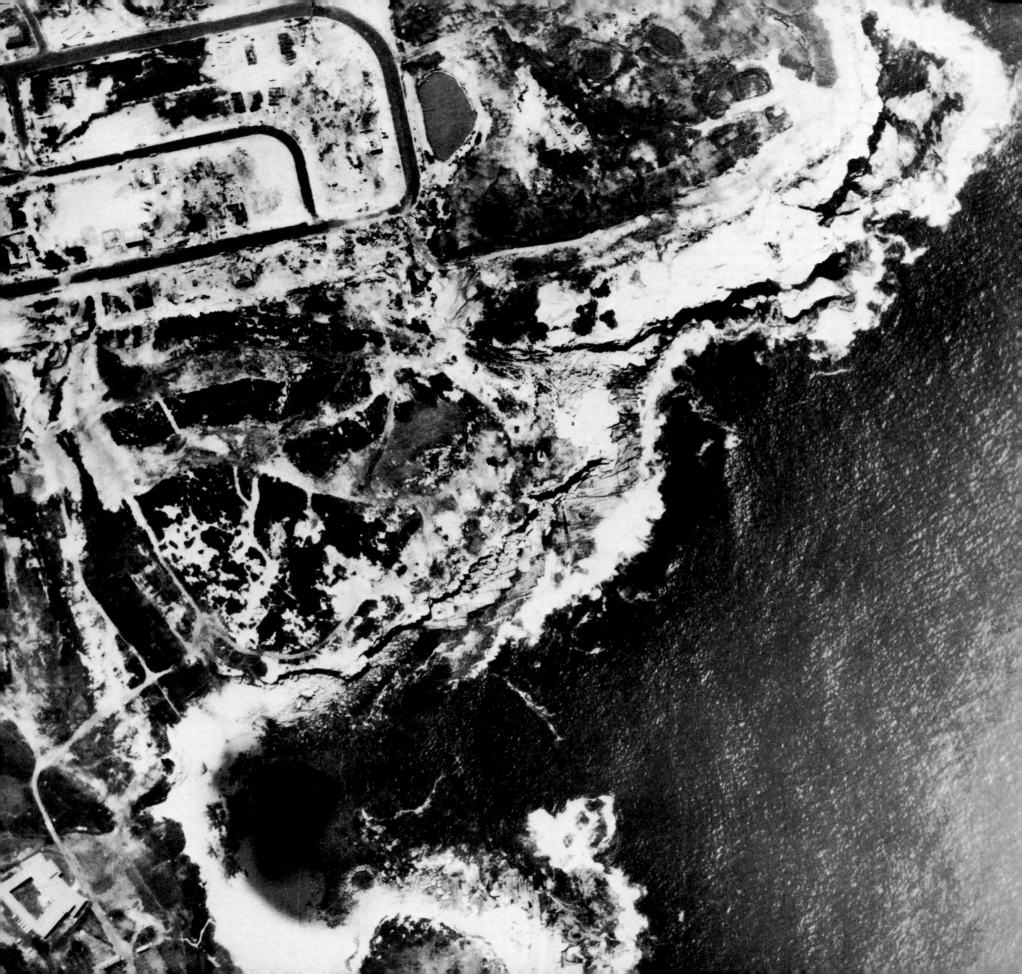

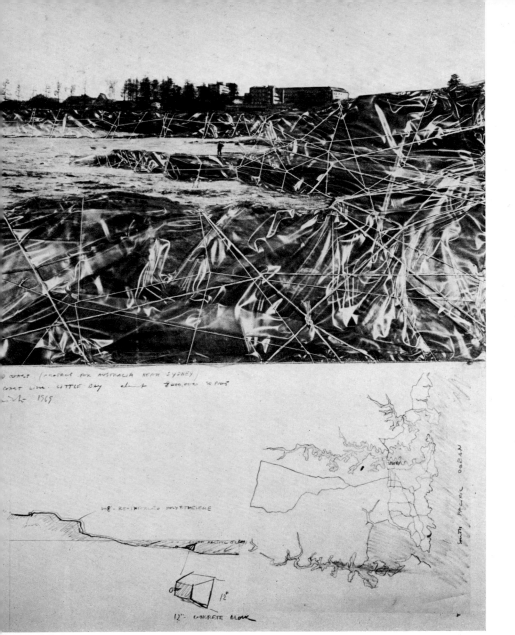

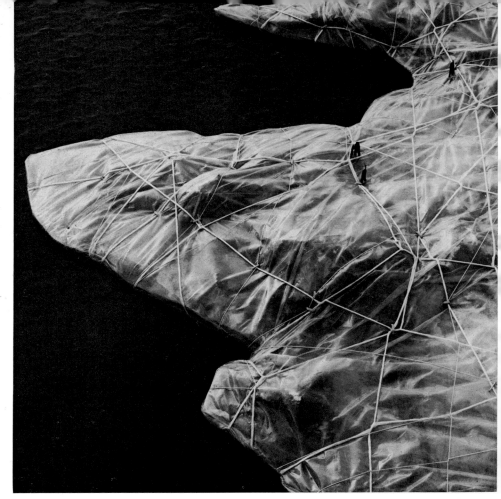

253

254

252

252. *Packed Coast*. Project for Australia. 1969. Photostat, polyethylene, twine, and colored pencil, 28×22 in. Collection John Kaldor, Sydney

253. *Packed Coast*. Scale model. 1969. Plexiglas, polyethylene, and twine, $3\frac{1}{2}×29×24$ in. The Harry N. Abrams Family Collection, New York City

254. Map of Sydney and vicinity, showing location of Little Bay (lower right corner)

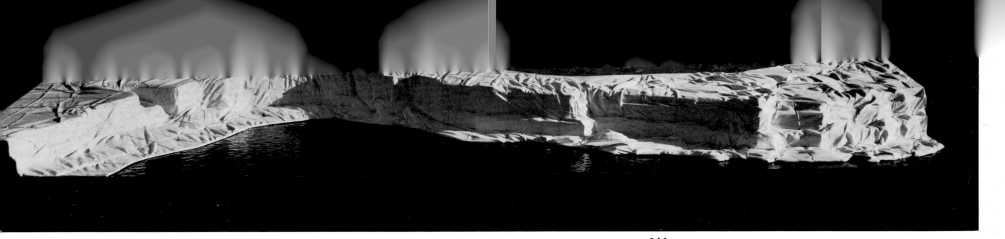

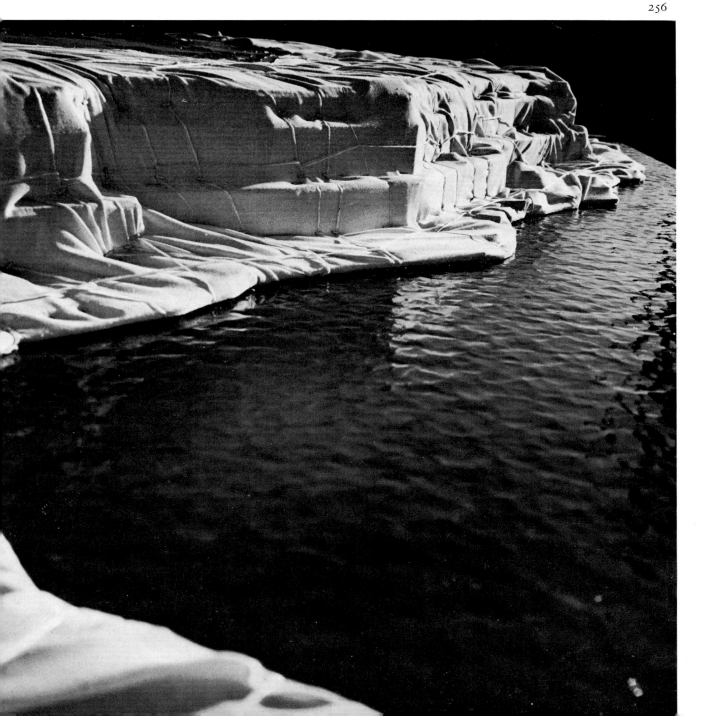

255. *Packed Coast*. Scale model. 1969. Plexiglas, fabric, and twine, $8\frac{1}{2} \times 96 \times 32$ in. Collection Laufs-Krefeld, Kaiser Wilhelm Museum, Krefeld, West Germany

256. Detail of above

257–61. The wrapping of Little Bay was begun October 5, 1969. Bolts of fabric were first placed in position along the coast, then seamstresses stitched together three rolls at a time before the fabric was draped on the site

262. The first area to be fully packed was a gully filled with large boulders. The surrounding cliffs averaged 50 feet in height

263–65. Wrapping the cliffs required a labor force made up of varying numbers of students, artists, engineers, unskilled laborers, and professional rock-climbers. Estimated total man-hours of work: 17,000

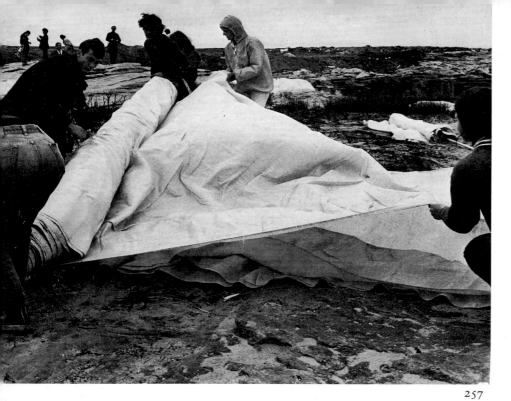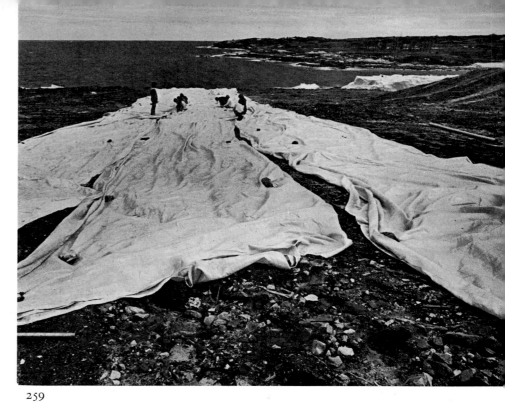

257

259

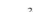261

258

260

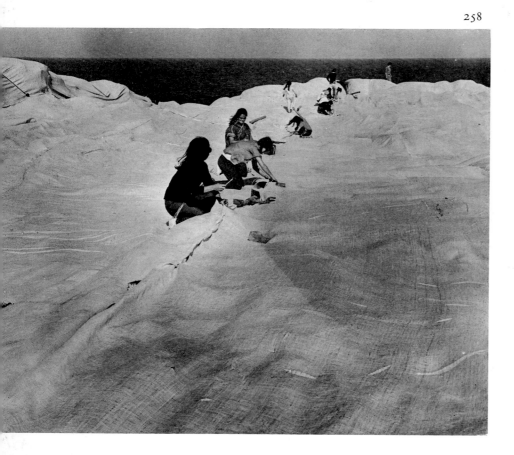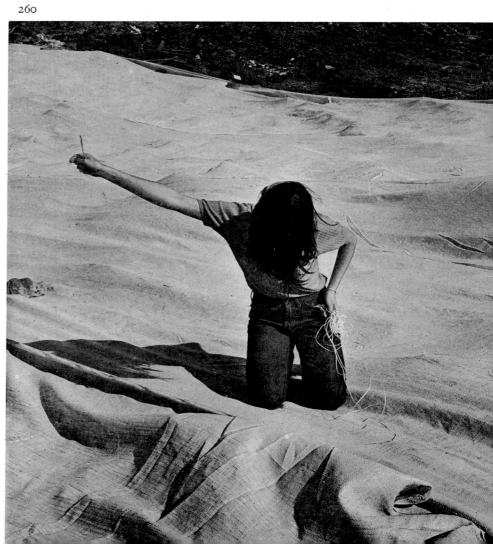

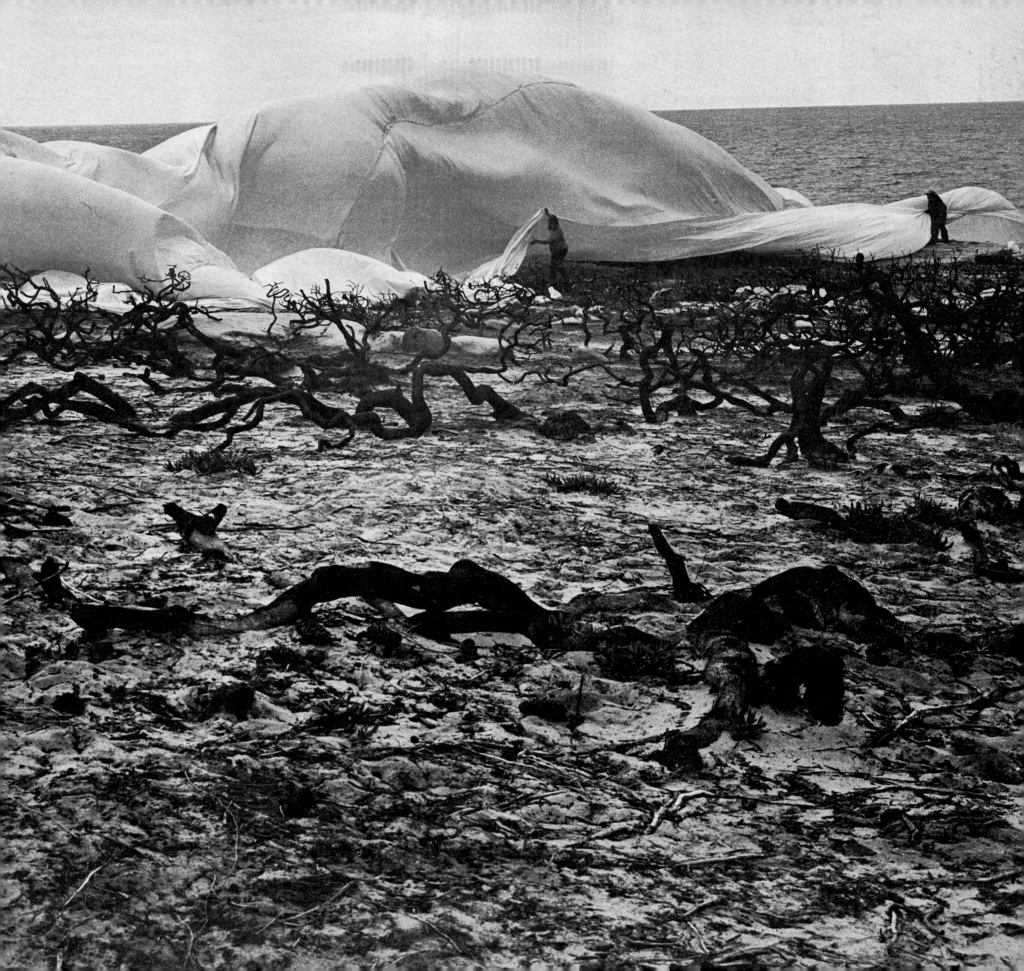

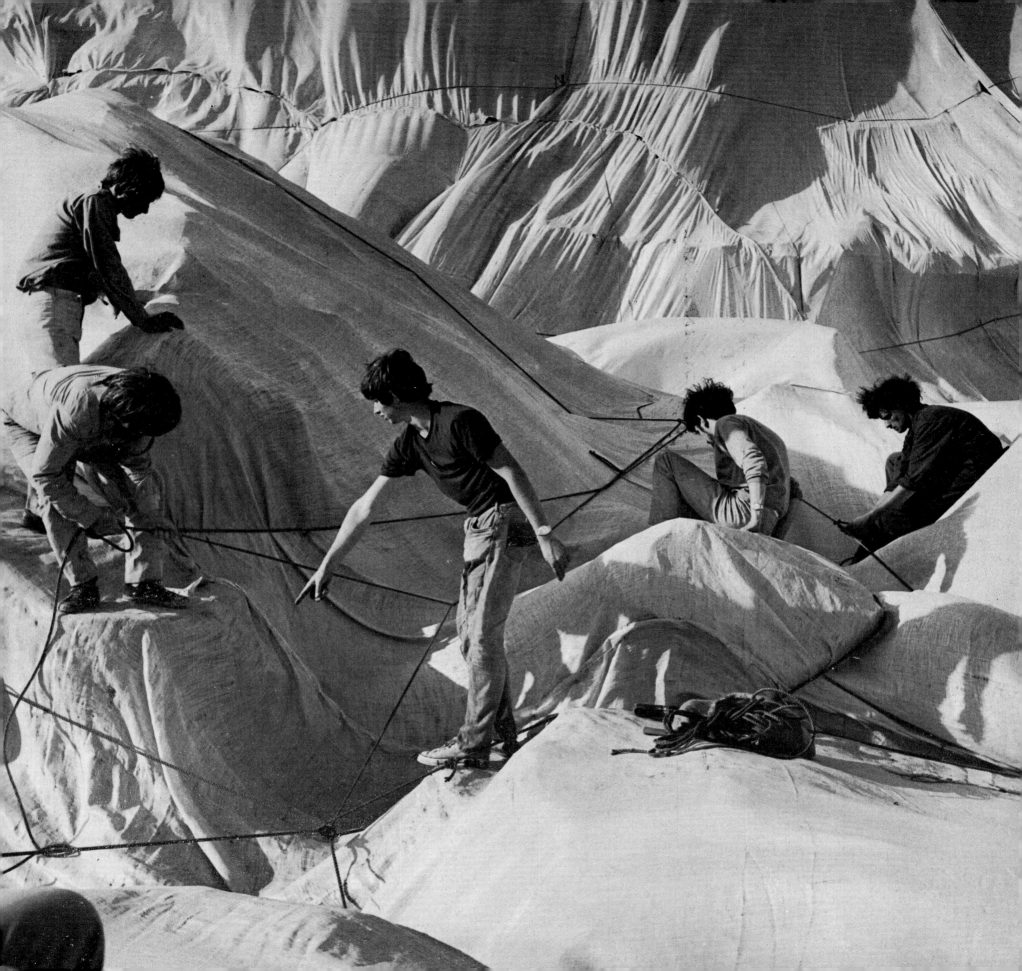

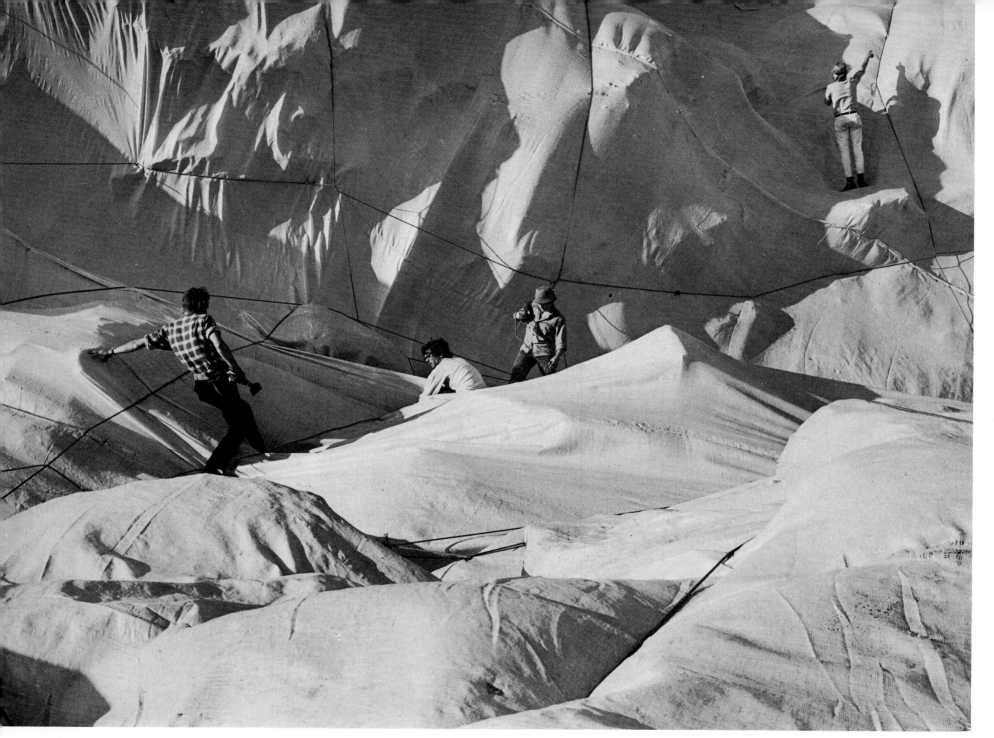

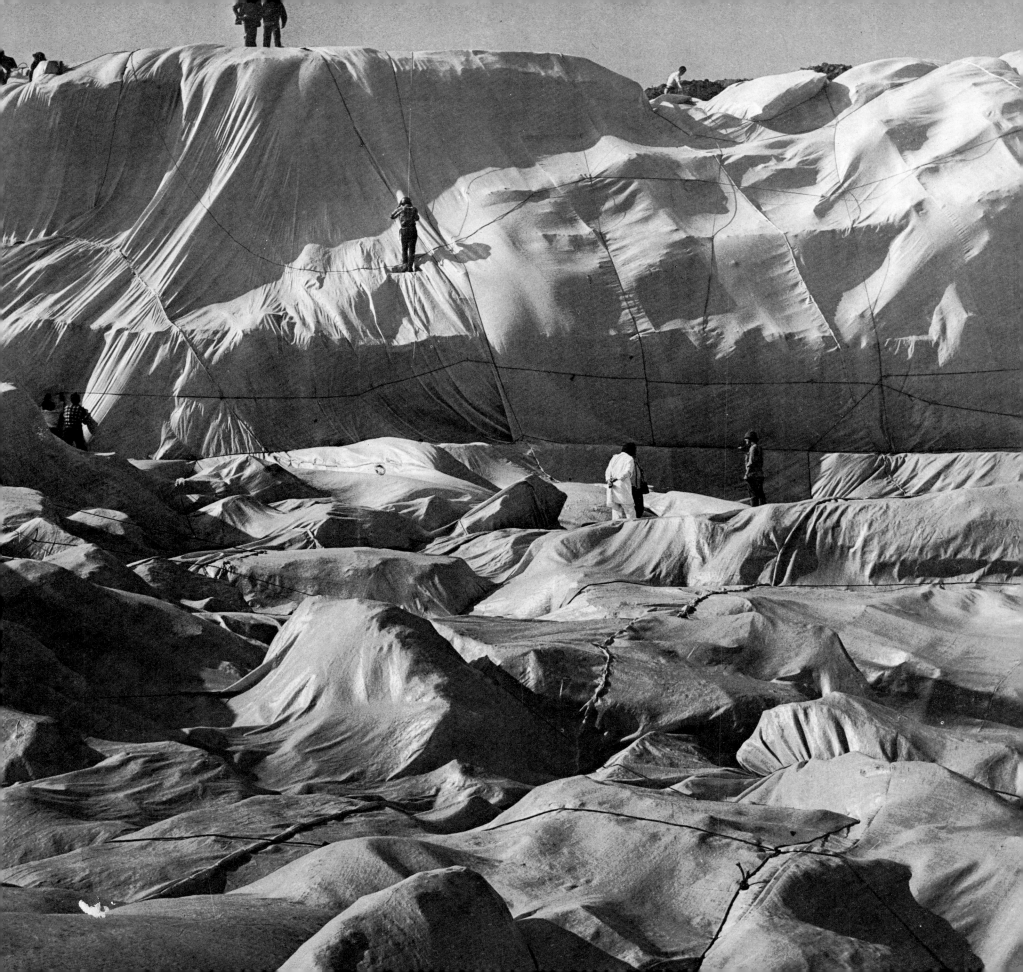

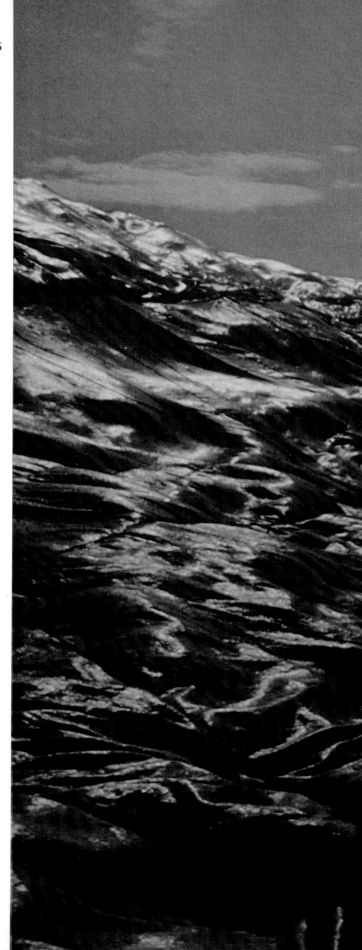

266. The appearance of the wrapped coast constantly changed as the amount of natural light and shadow varied, as in this late afternoon view looking toward the upper part of the gully

267–69. Views of the wrapped gully

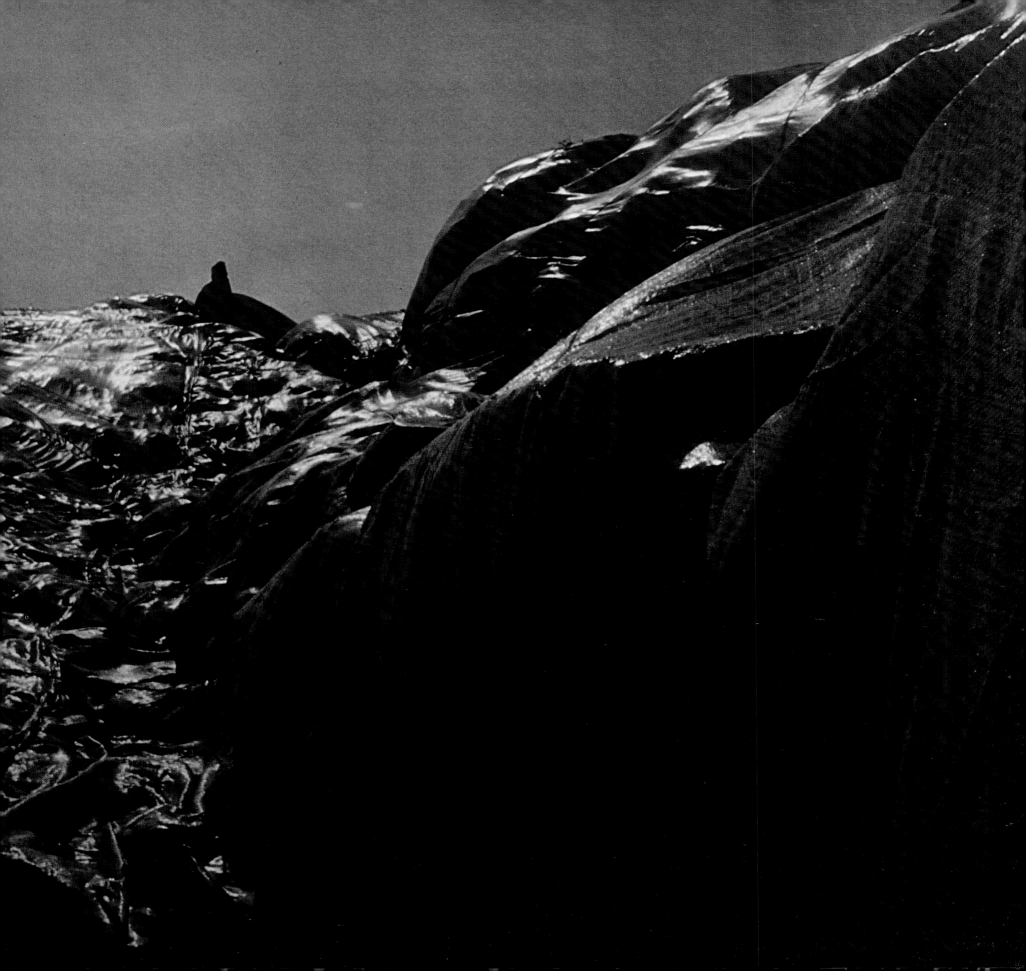

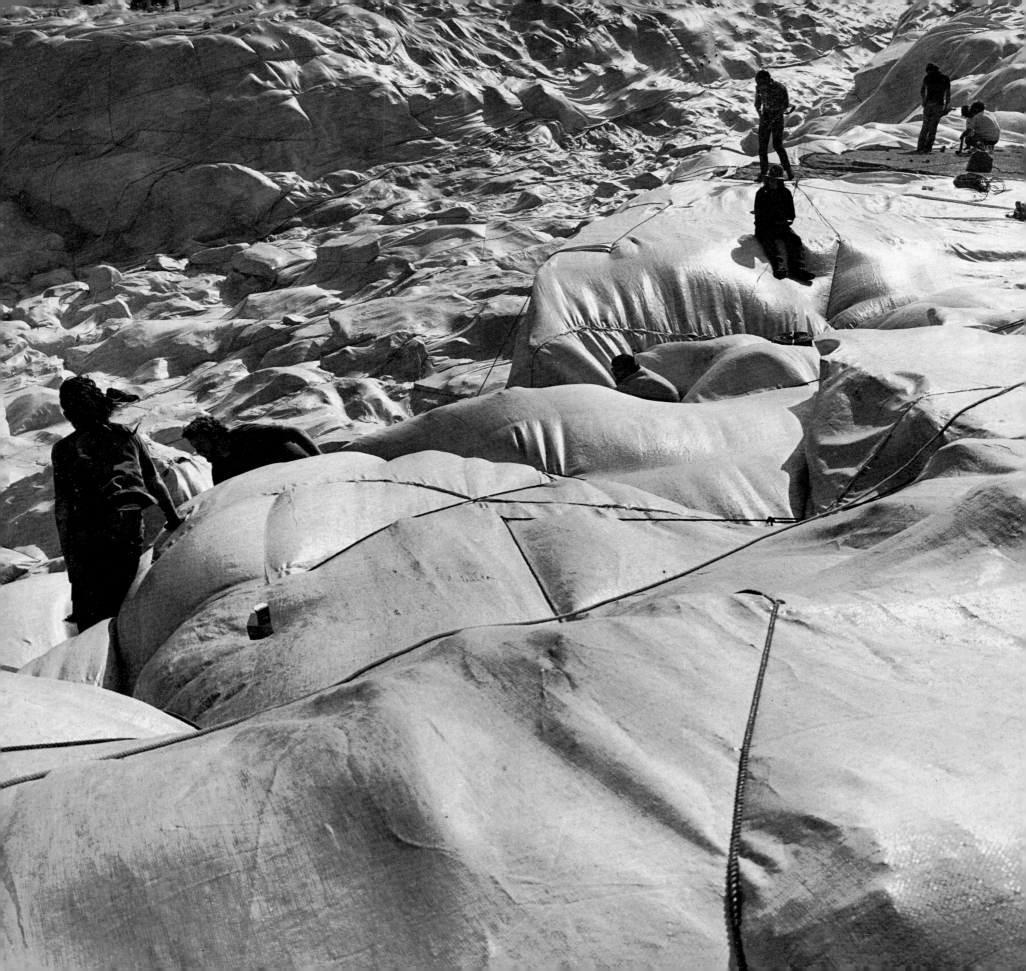

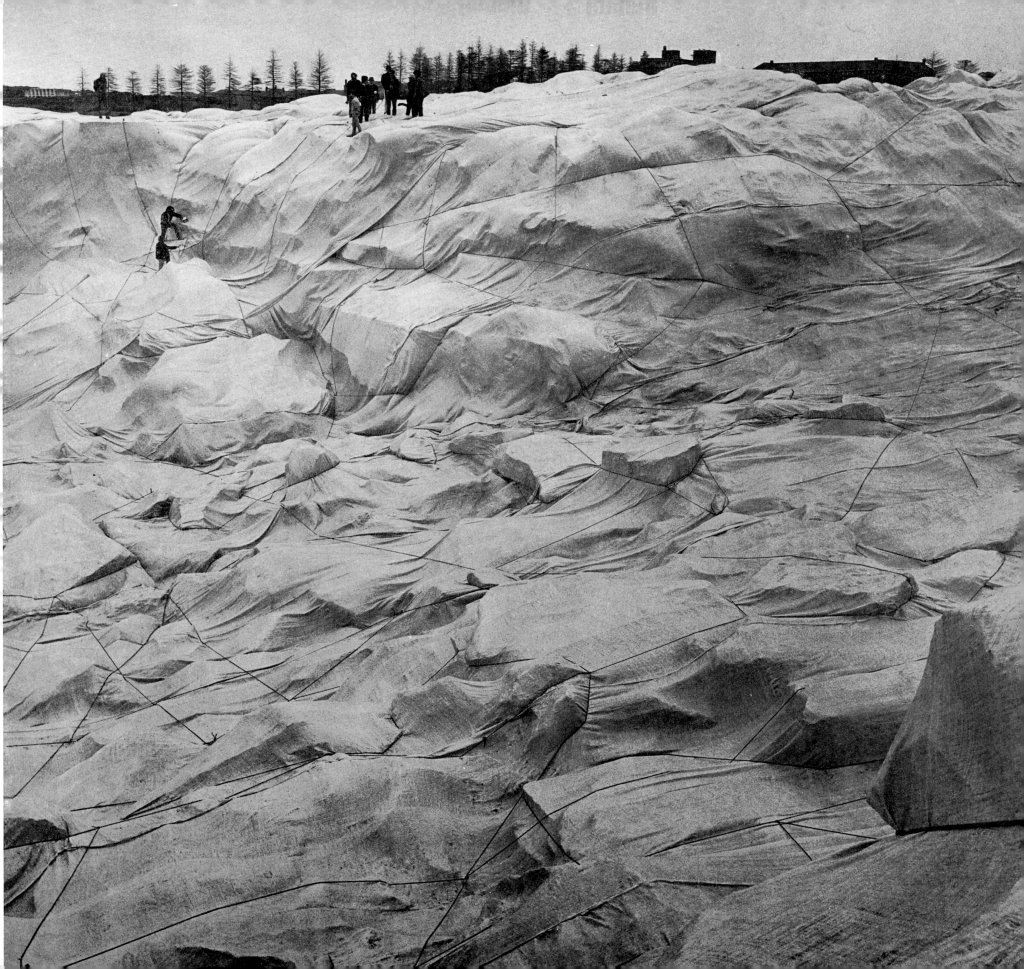

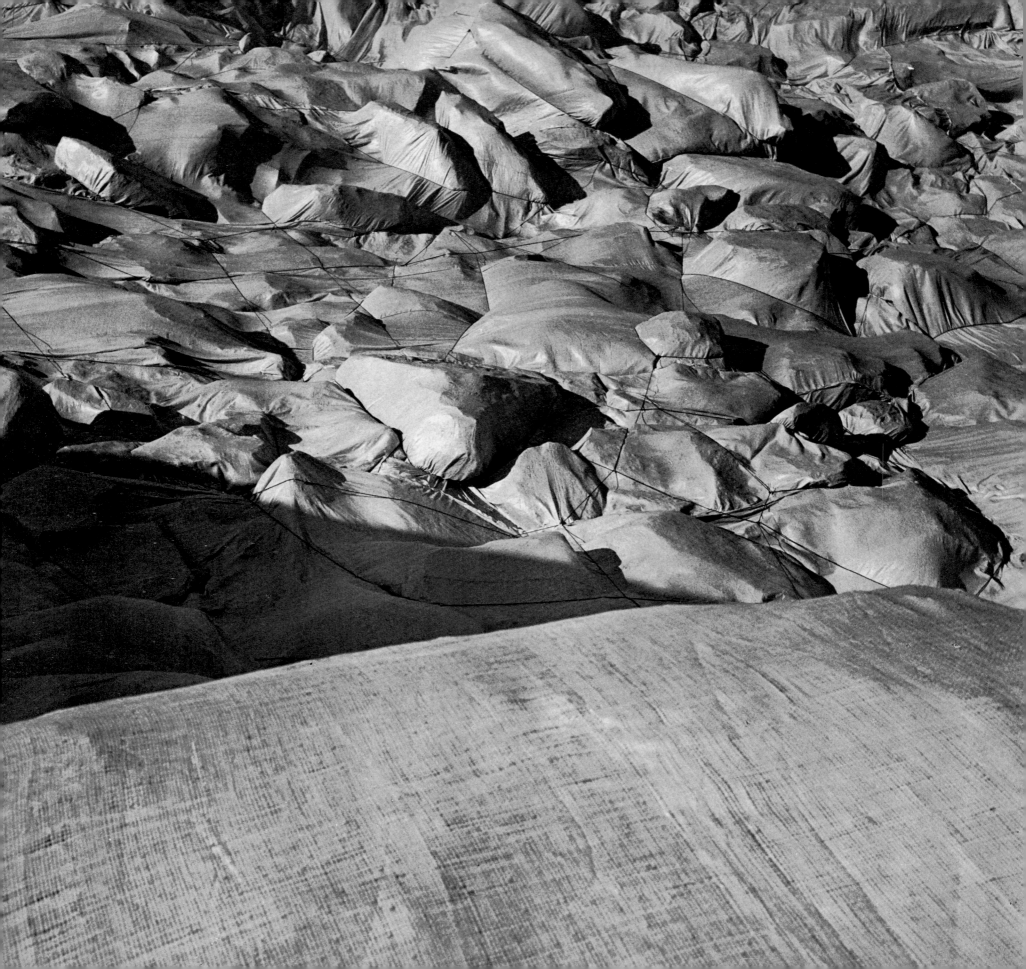

270. Workers, shown here near the northern end of the site, often found themselves occupying perilous cliffside footholds
271. The wrapping progressed methodically toward 84-foot-high headlands at the northern end of the site
272. View of the gully area
273. Clifftop sight-seers came daily to the wrapped coast
274. The fabric was prevented from blowing away by networks of rope fastened to the rock with steel studs. Surfside visitors were less secure, because the often treacherous waves made the smooth plastic fabric slippery

270

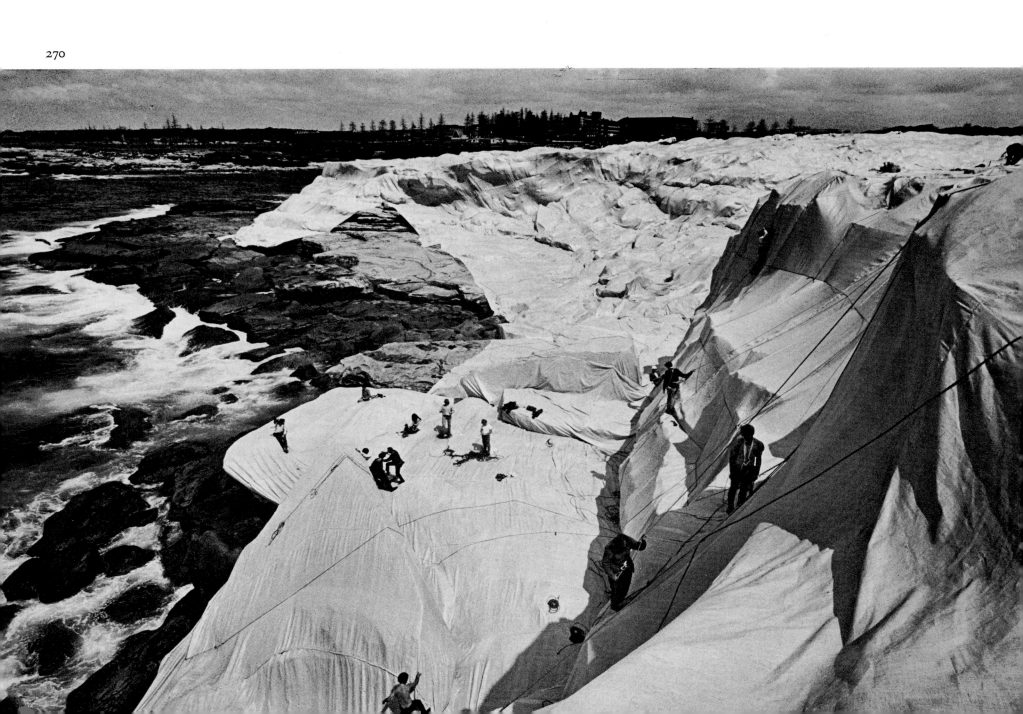

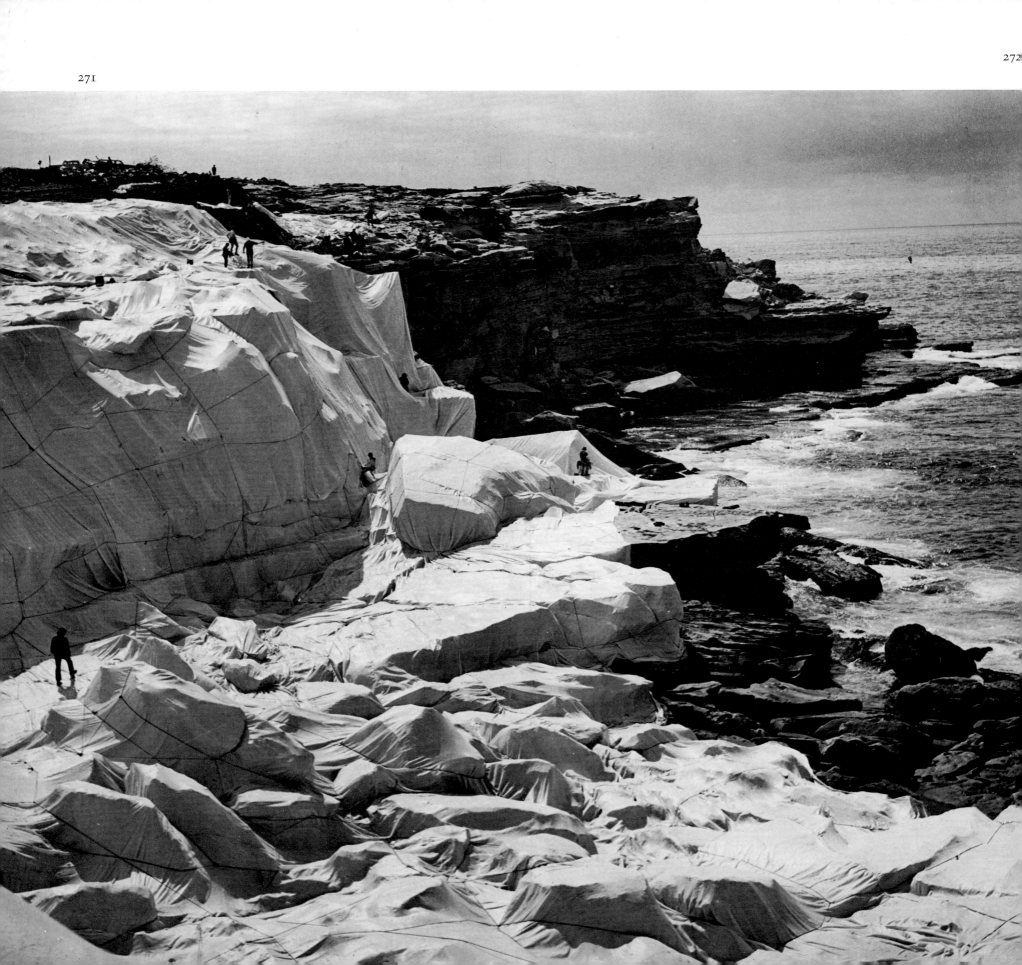

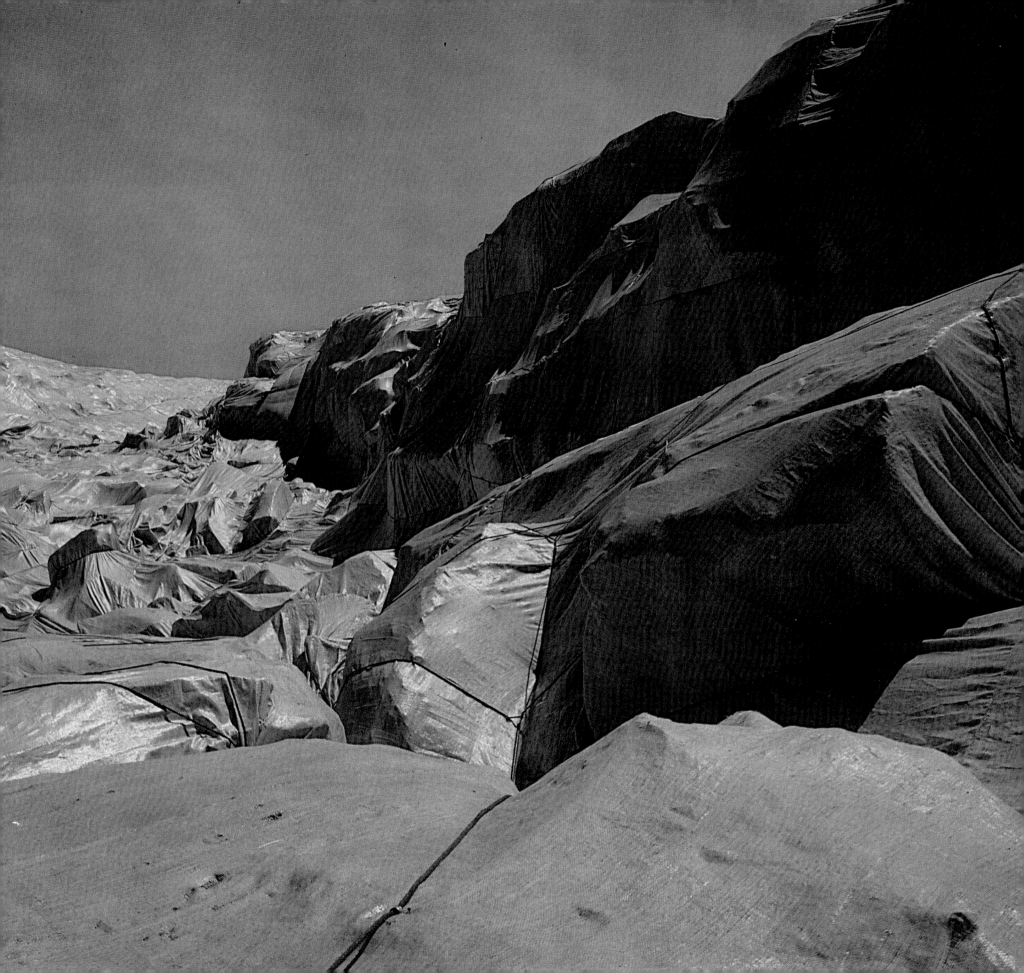

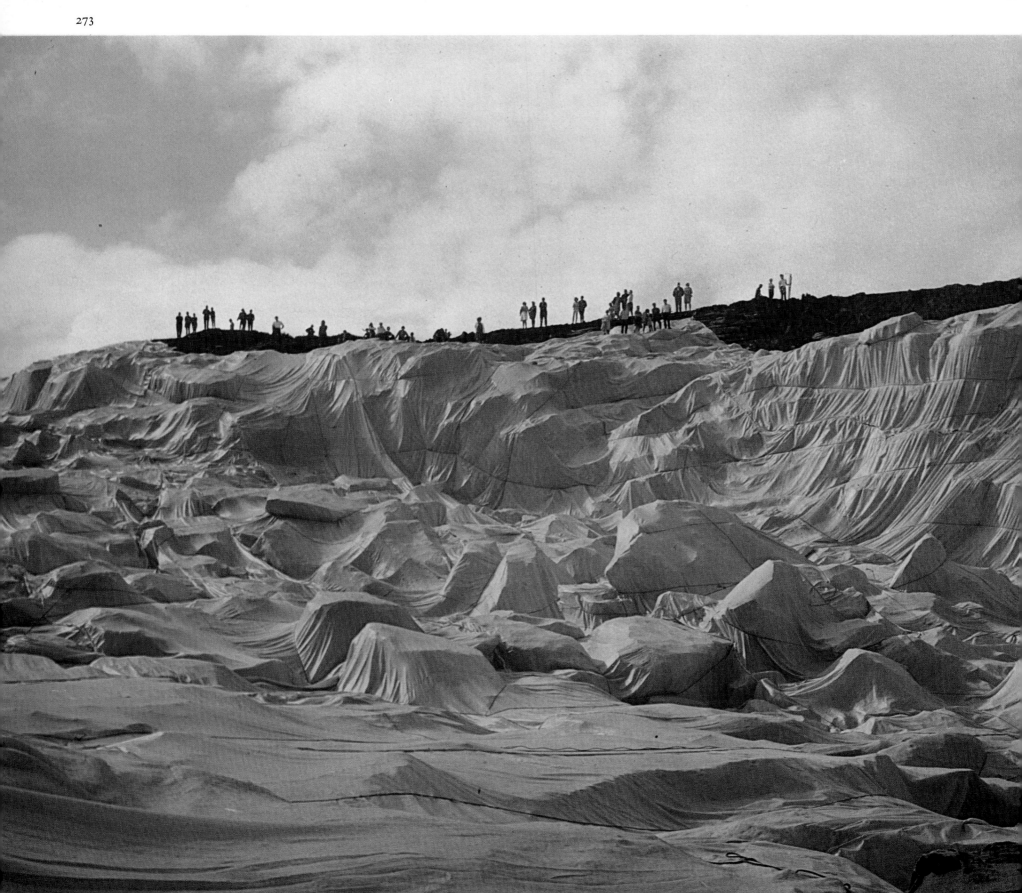

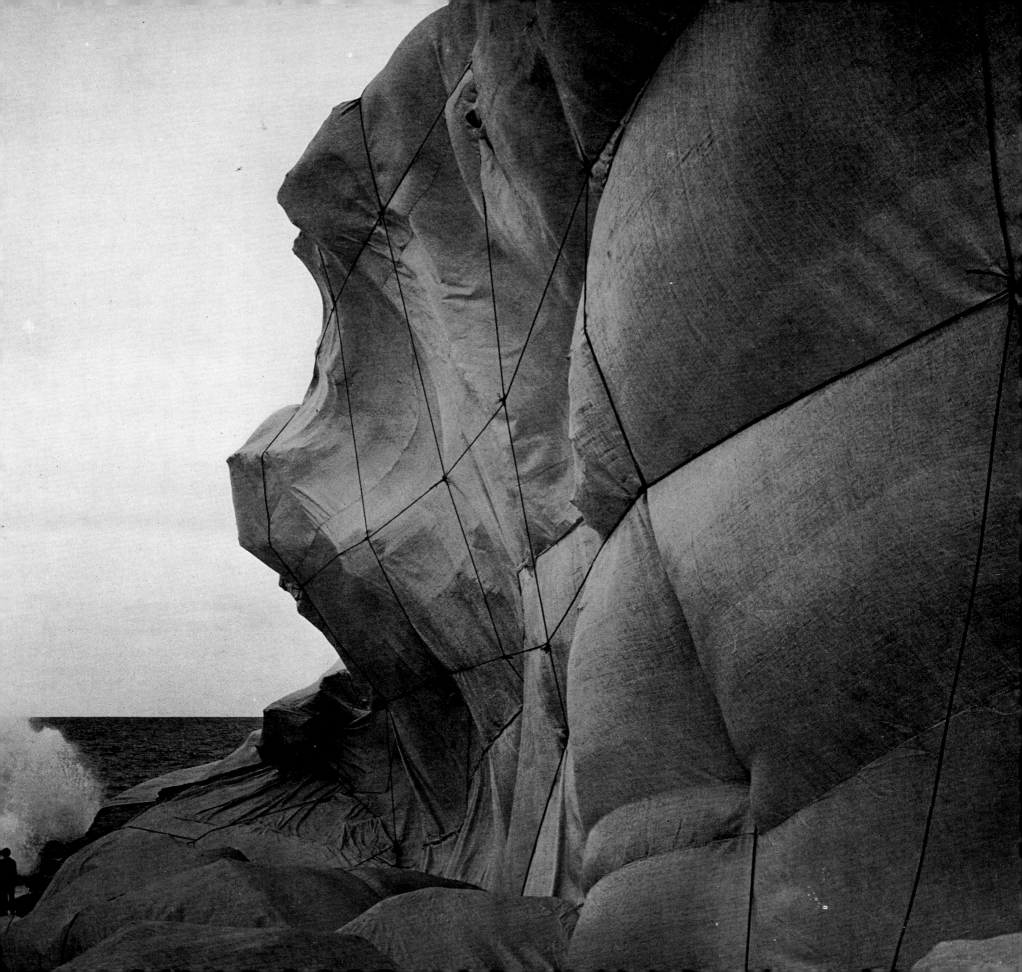

275. A detail of the wrapped embankment that suggests why viewers compared the site to everything from the white cliffs of Dover to a circus tent

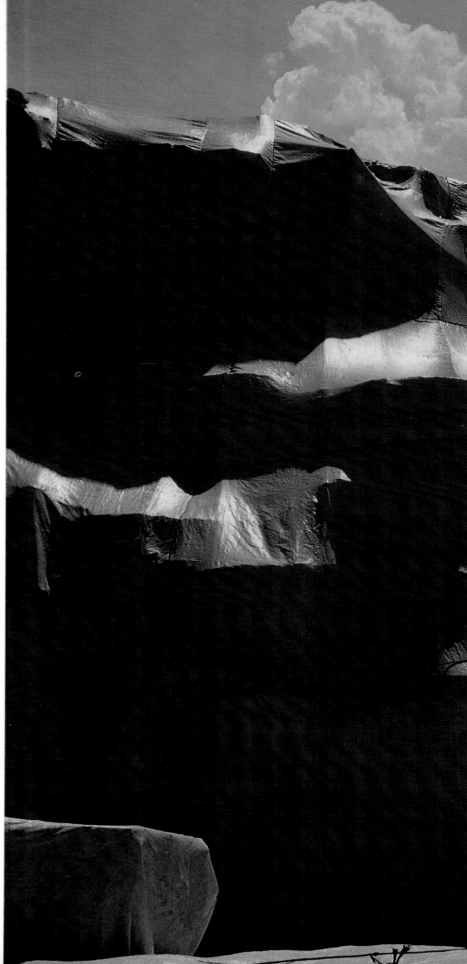

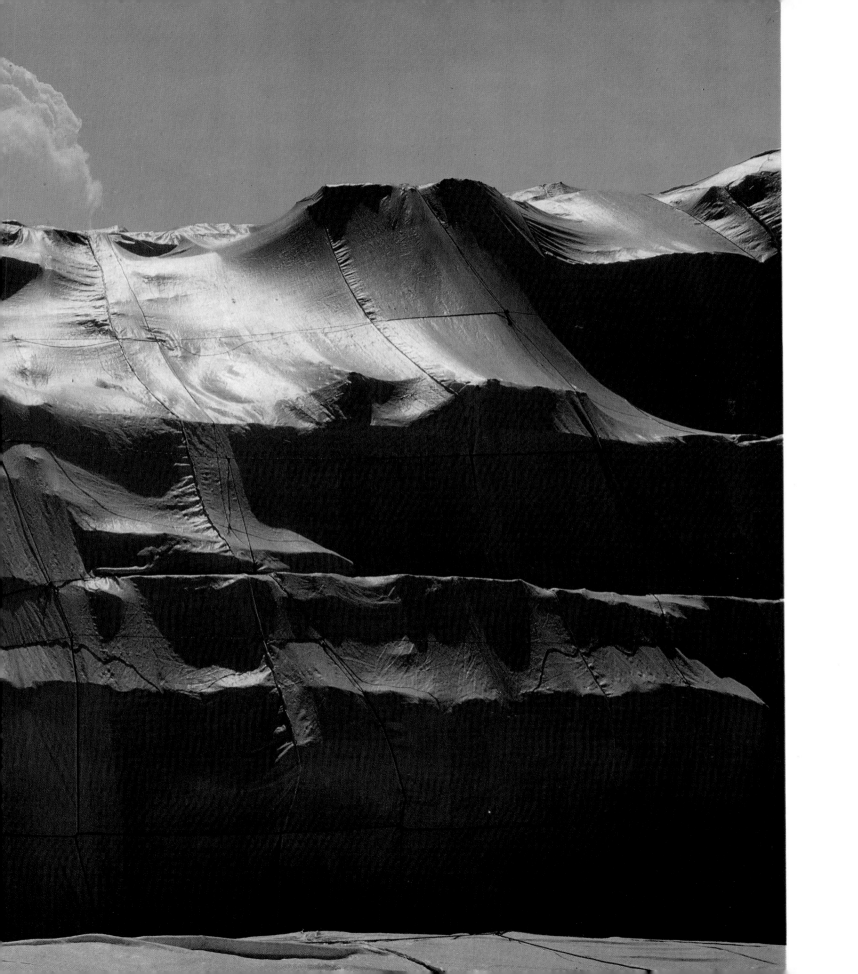

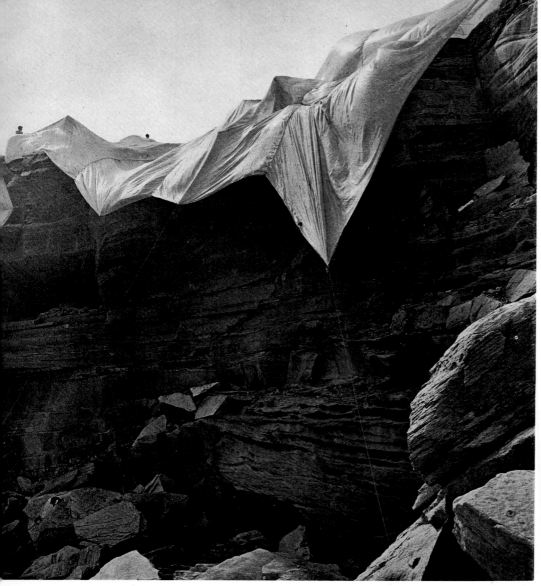
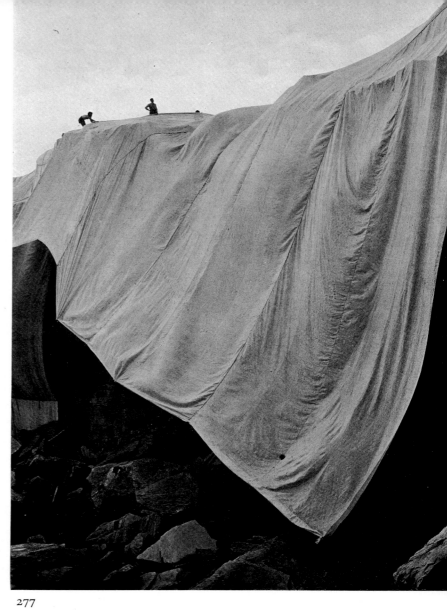

276

277

276–80. Workers used rope guidelines to drape the fabric over the side of the cliff

281. View from the northern end of the site, showing the gully area at left and a draped but not yet roped area at right

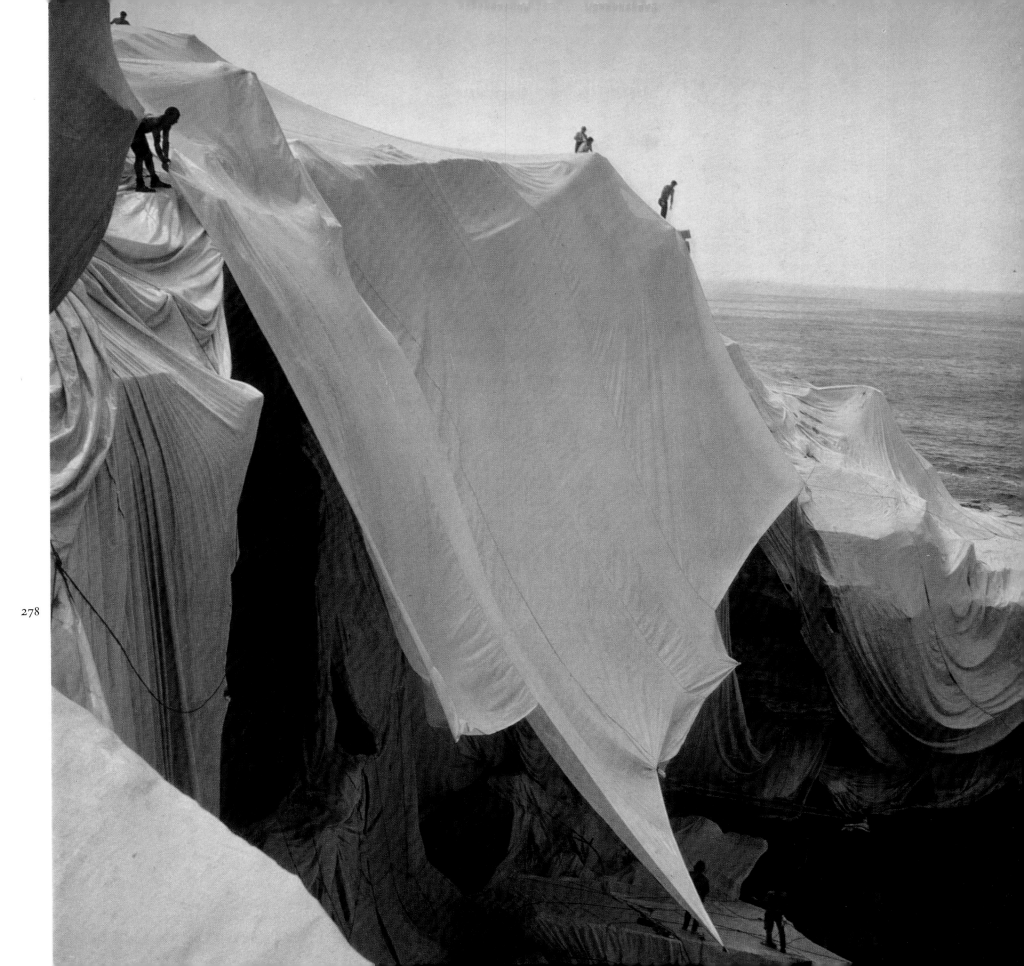

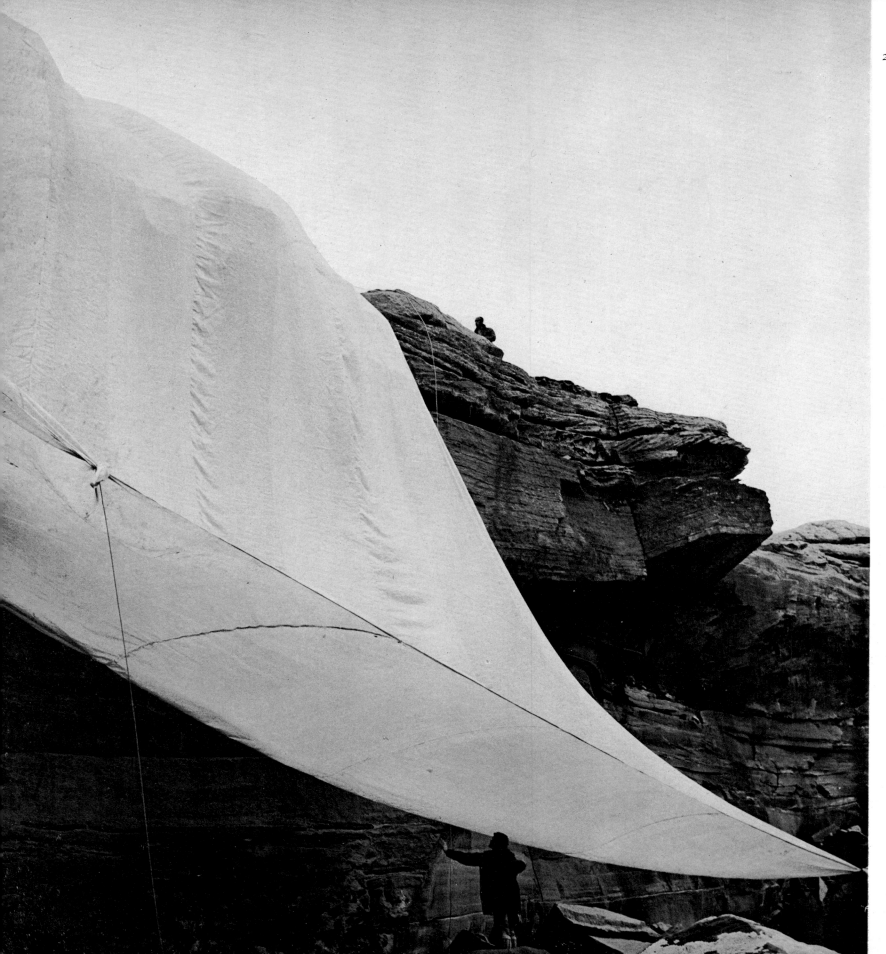

281 (overleaf)

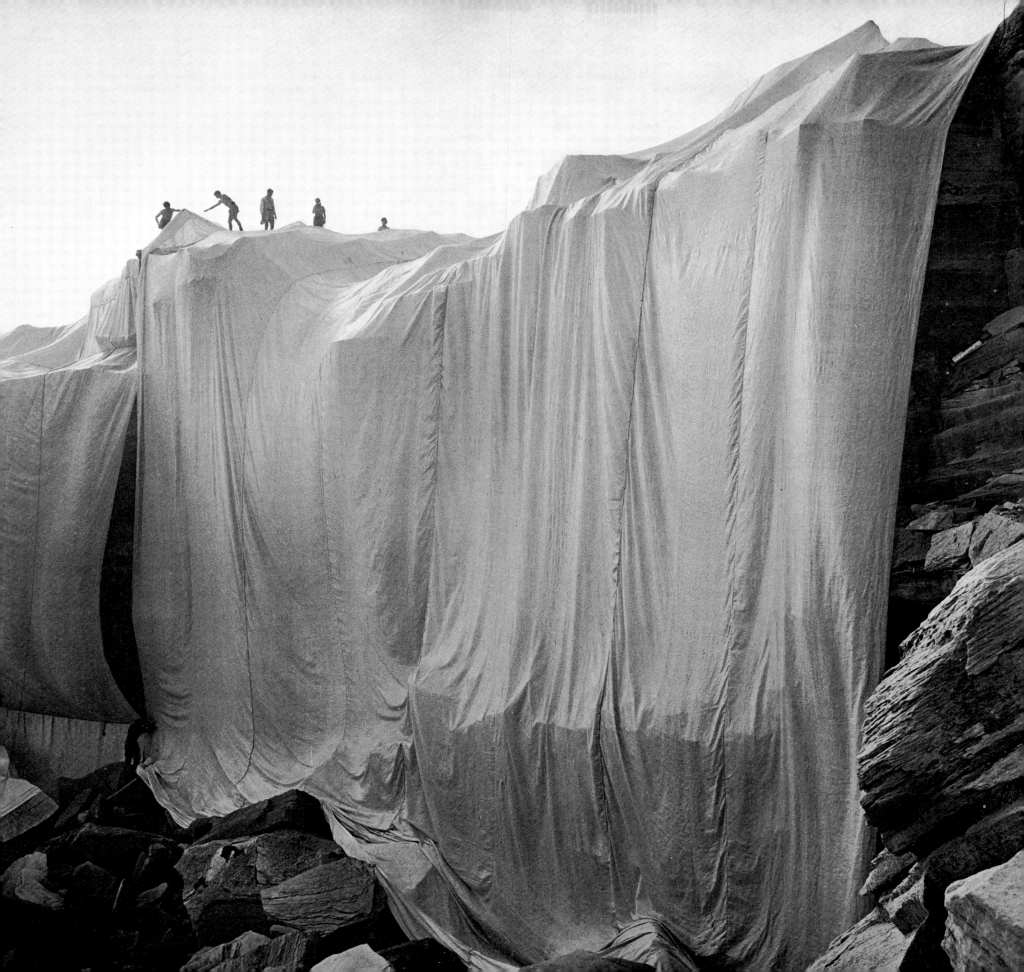

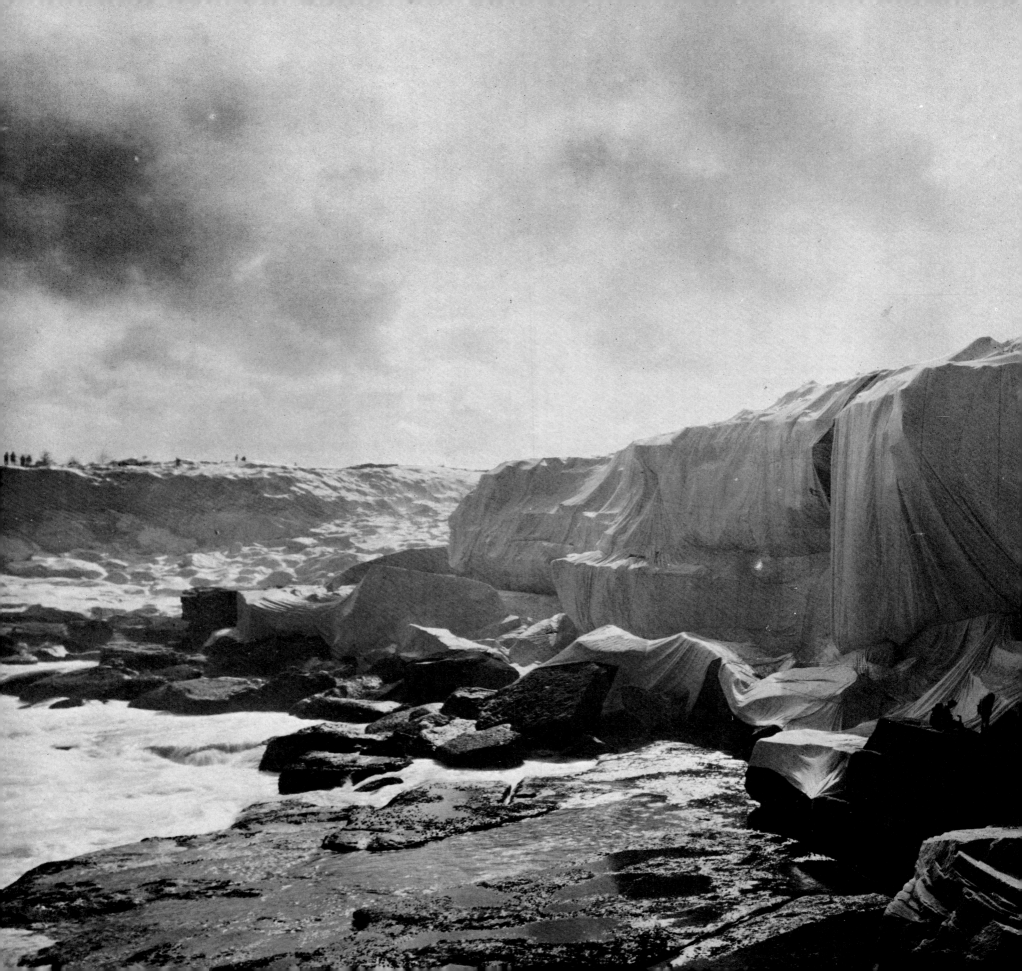

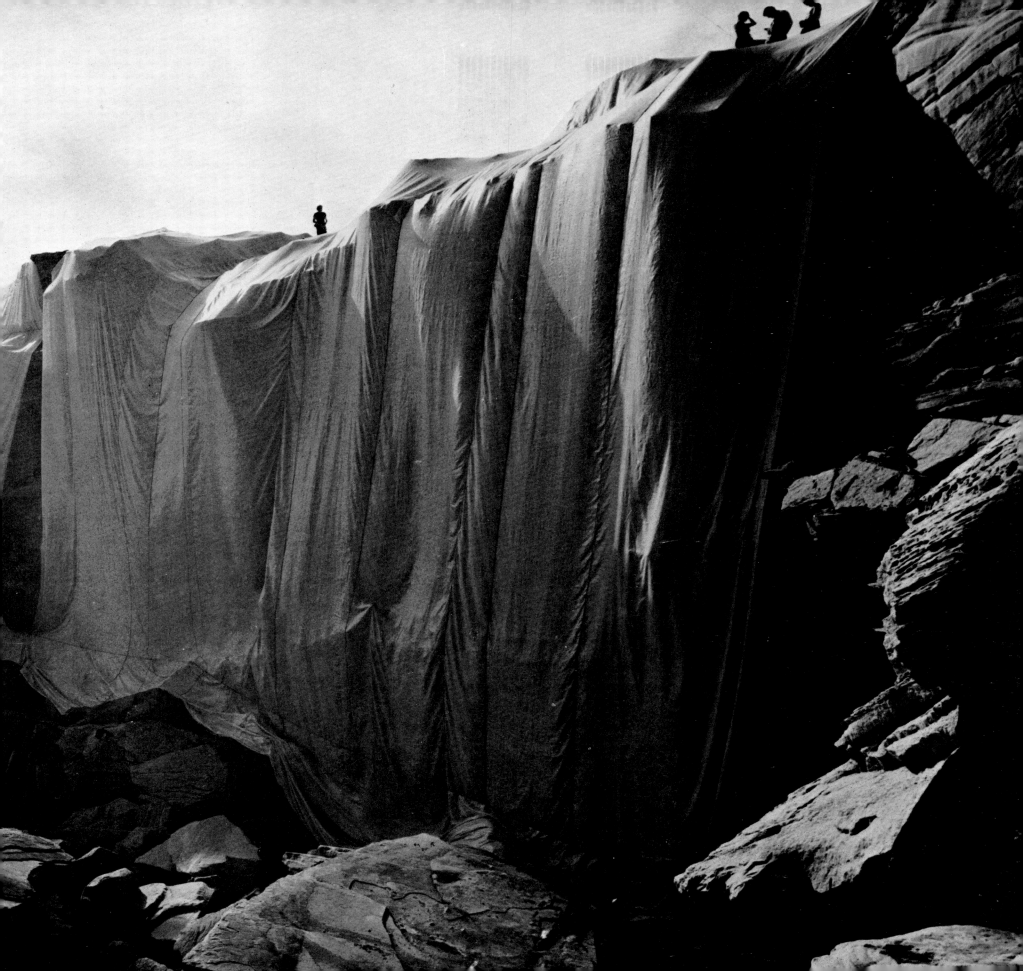

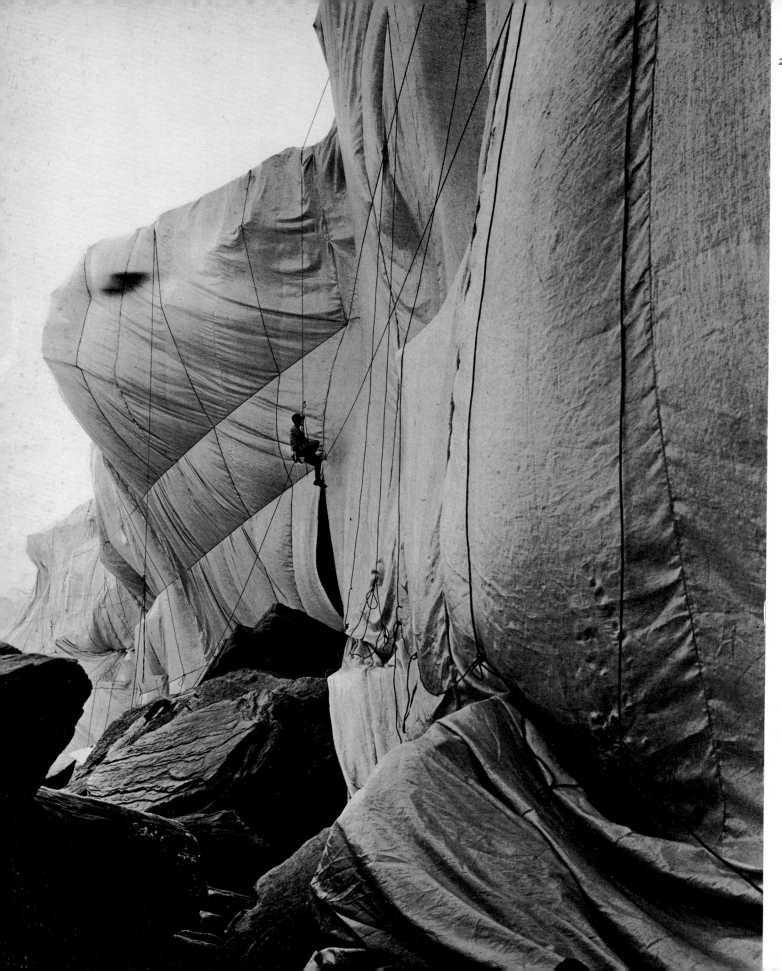

282–83. Professional rock-climbers stitch[
the fabric together and fasten[
the rope to the cliff by firing pisto[
set, threaded-steel studs into t[
rock. Twenty Ramset guns we[
used, and more than 25,000 charg[
were fired

284. View toward the northern end [
the site

284 (overleaf)

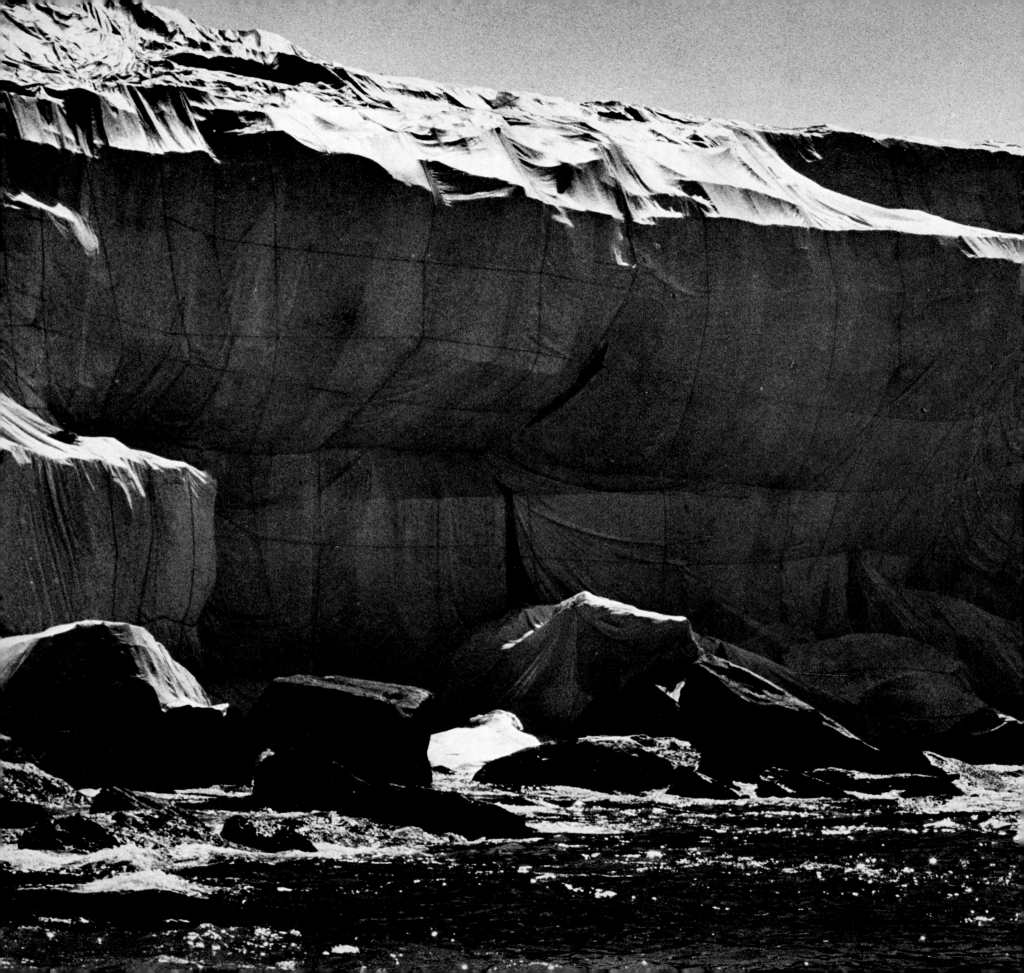

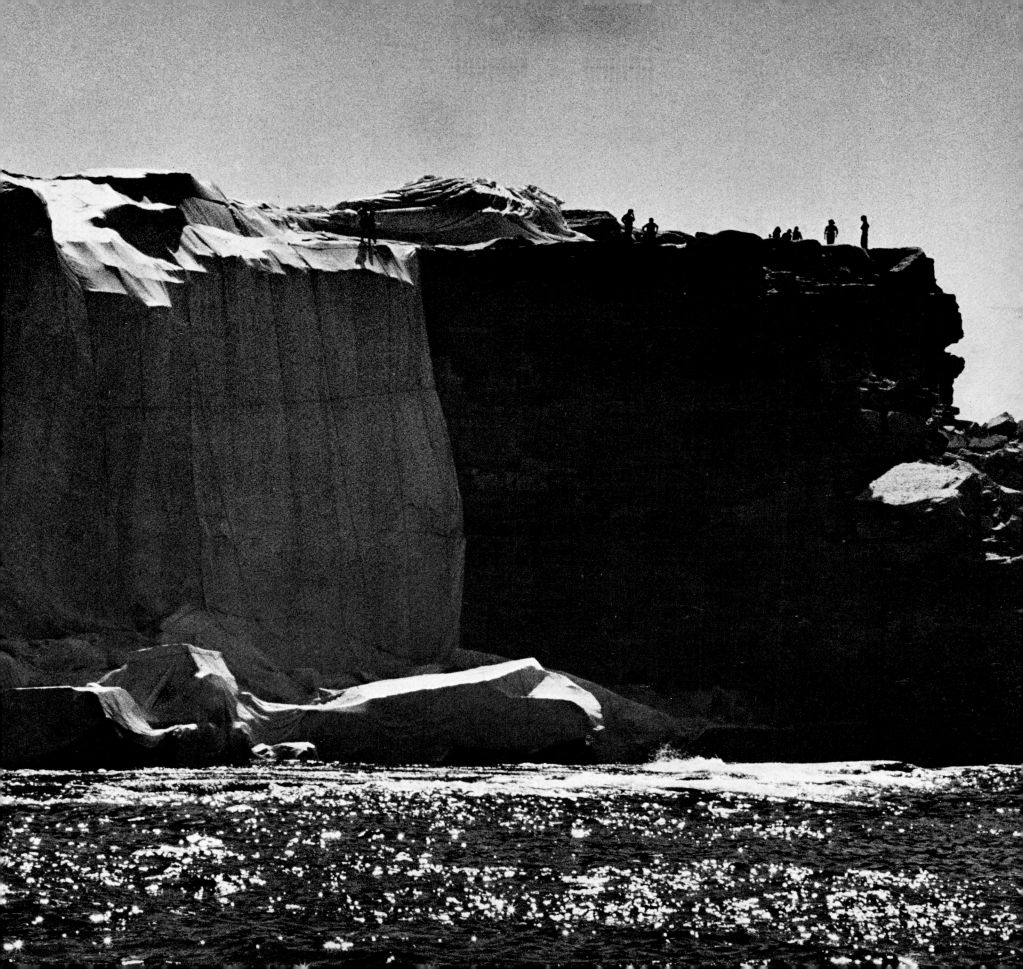

285–87. Strong winds often made it difficult to drape the fabric, even though it was loosely woven to enable the wind to pass through without causing too much billowing

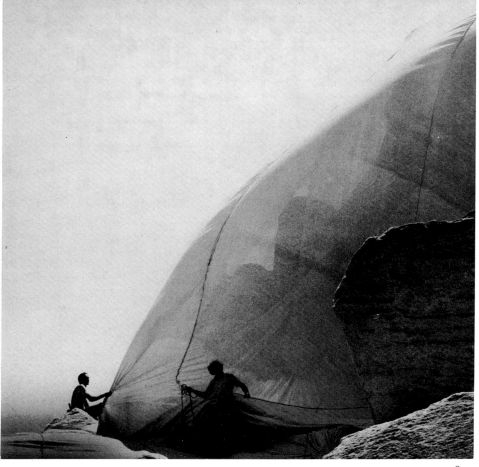

285

286

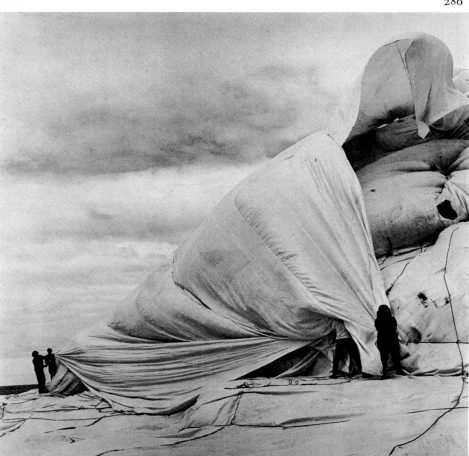

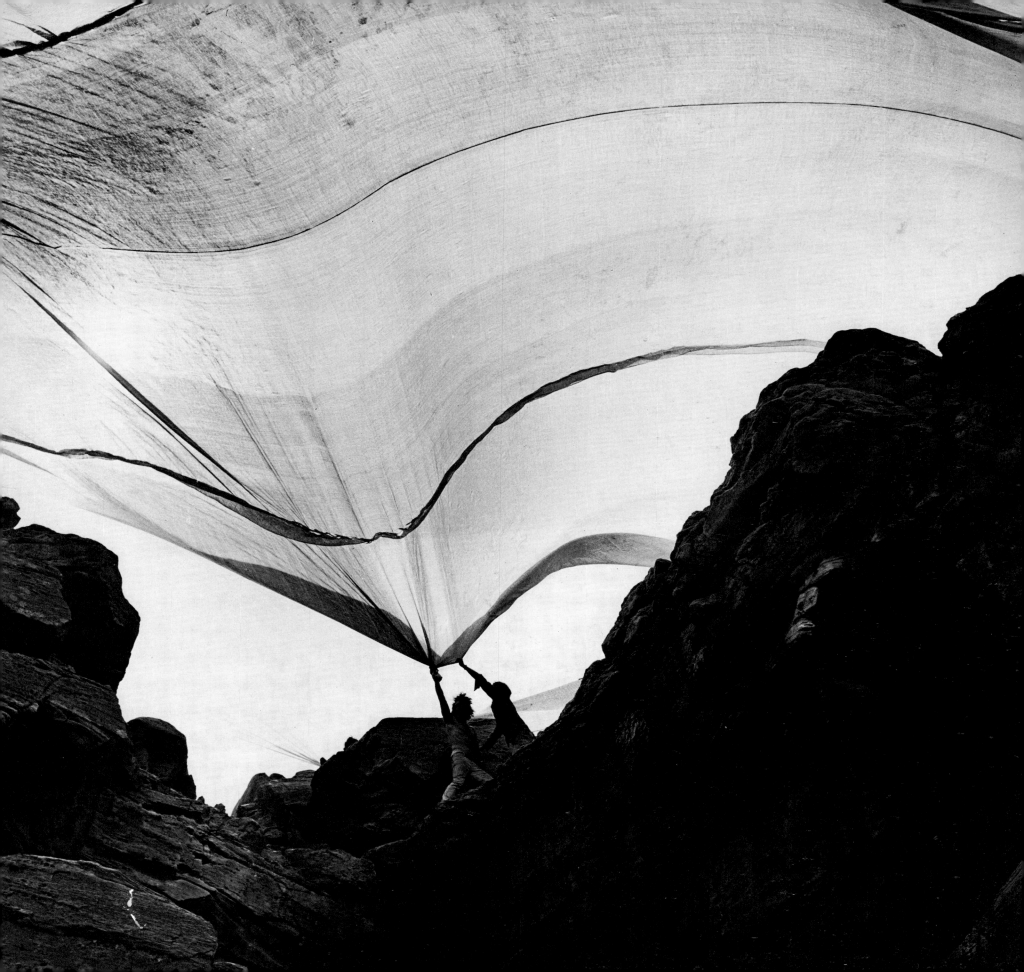

288–90. A cliff with a jutting rock toward the northern end of the site was one
of the most difficult areas to wrap

288

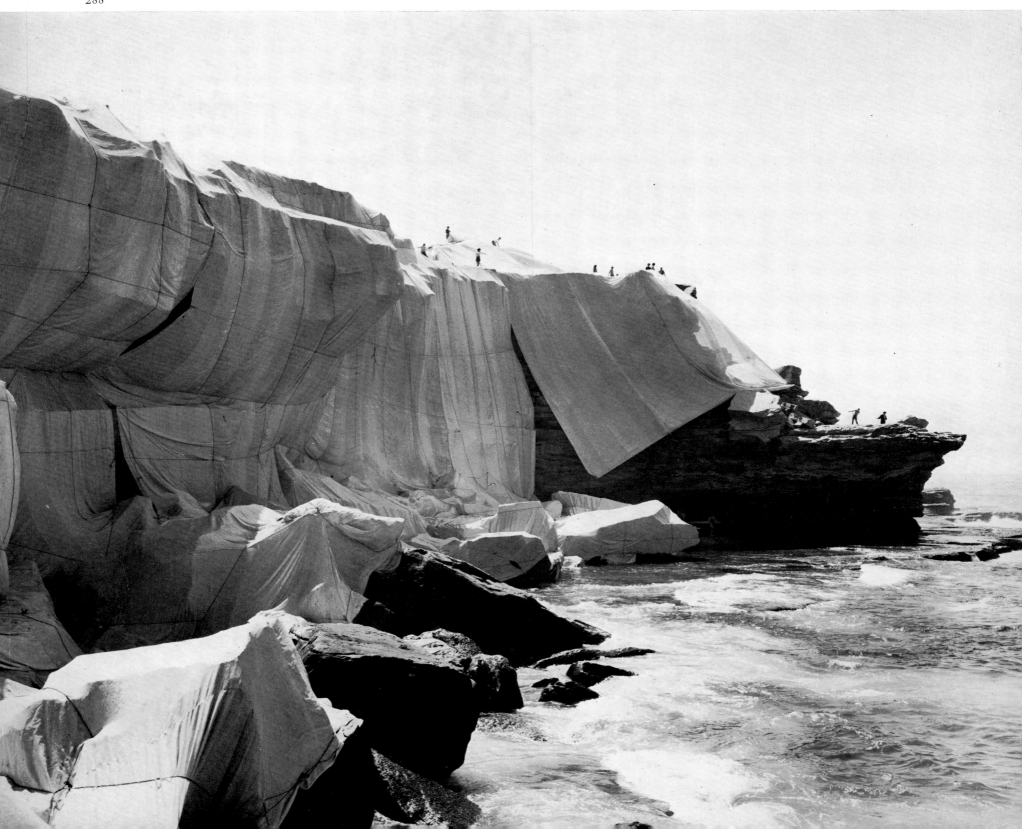

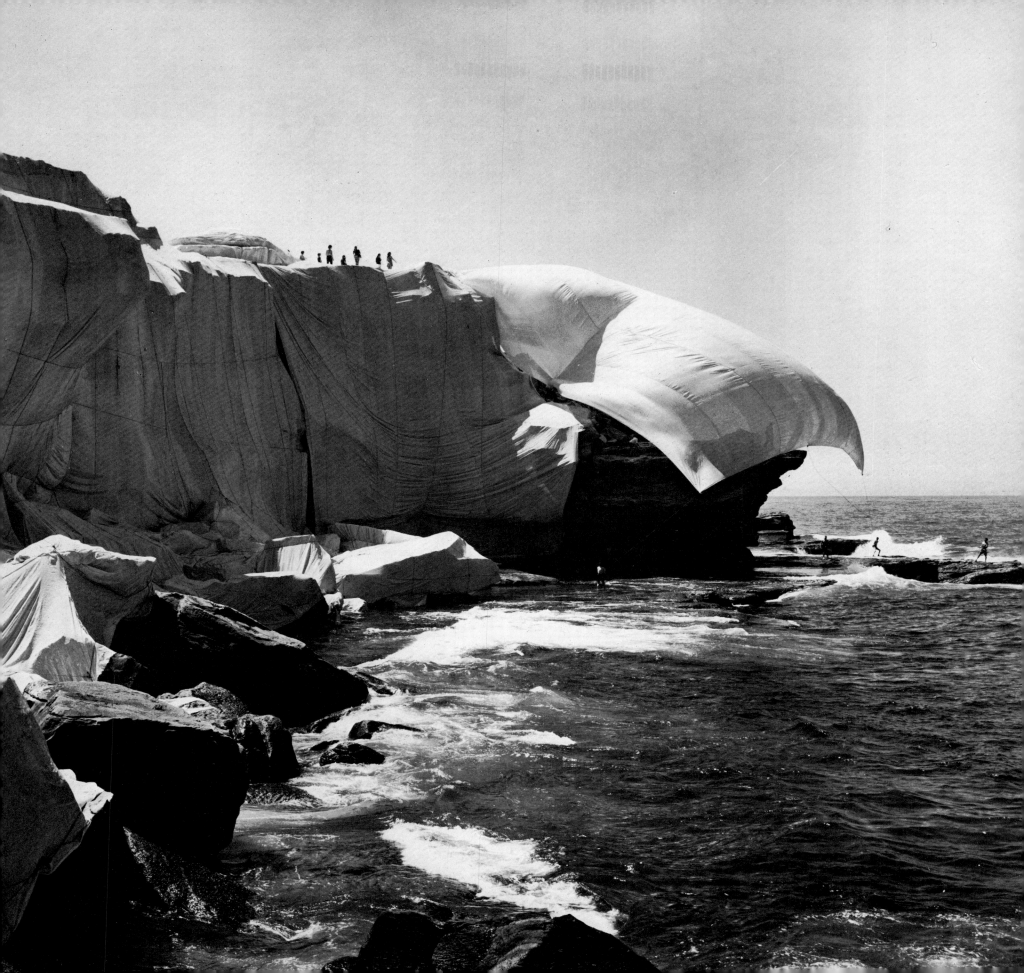

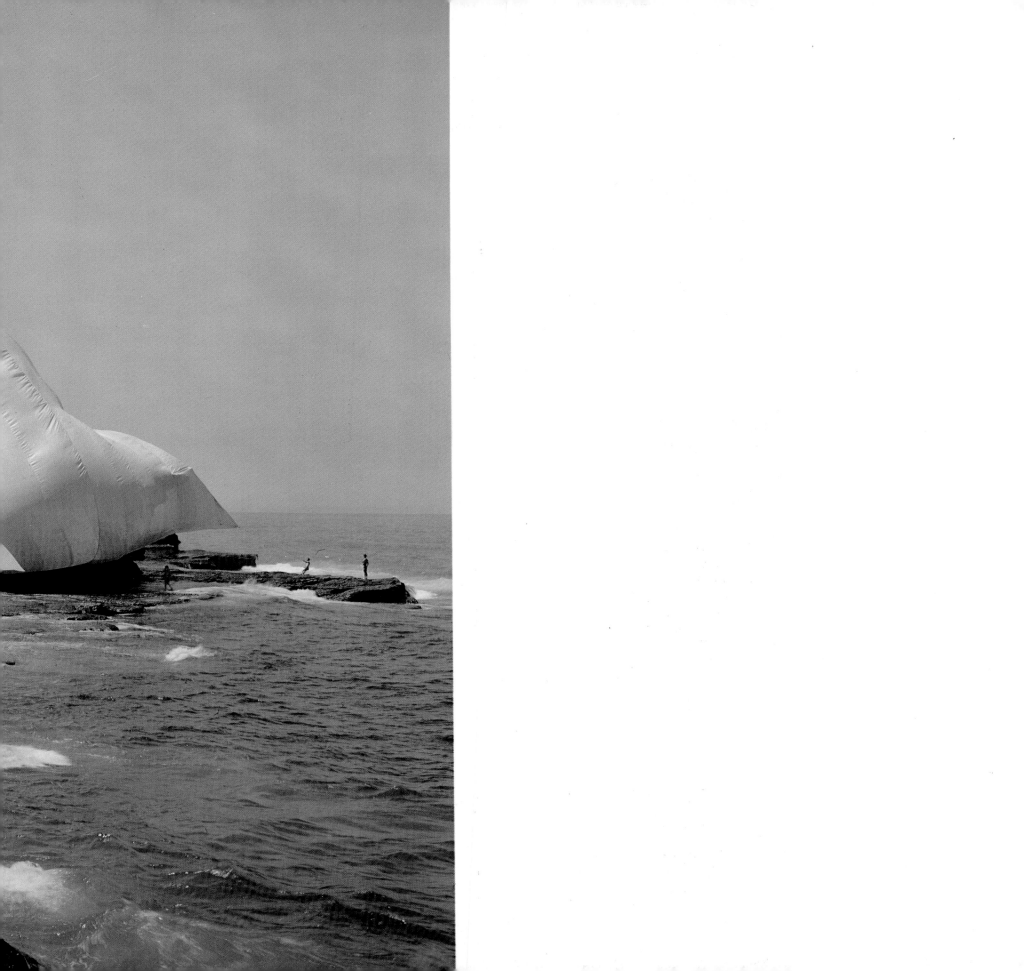

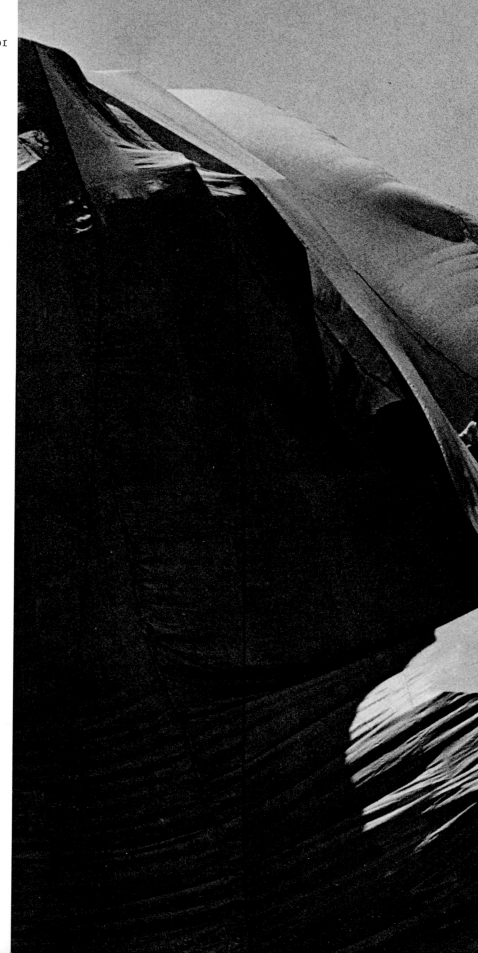

291. Fastening rope around the anvil-
like rock was a complicated task

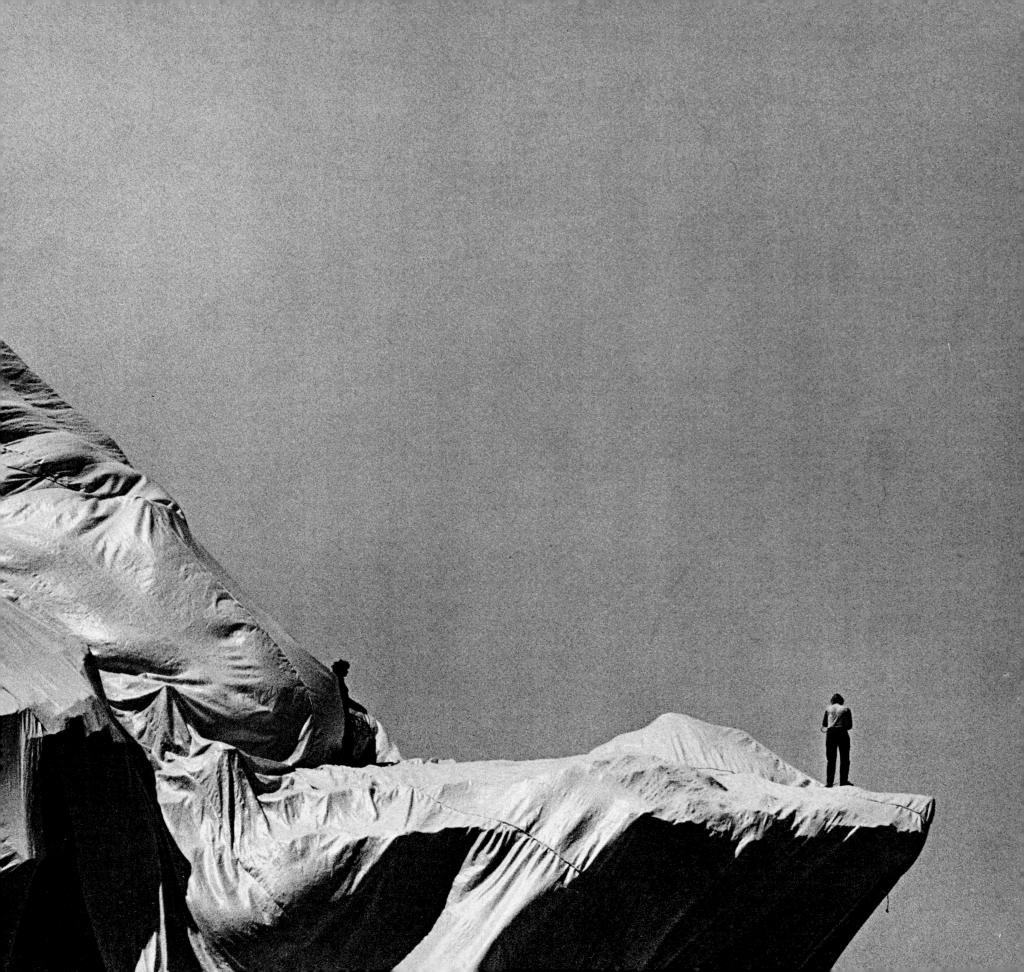

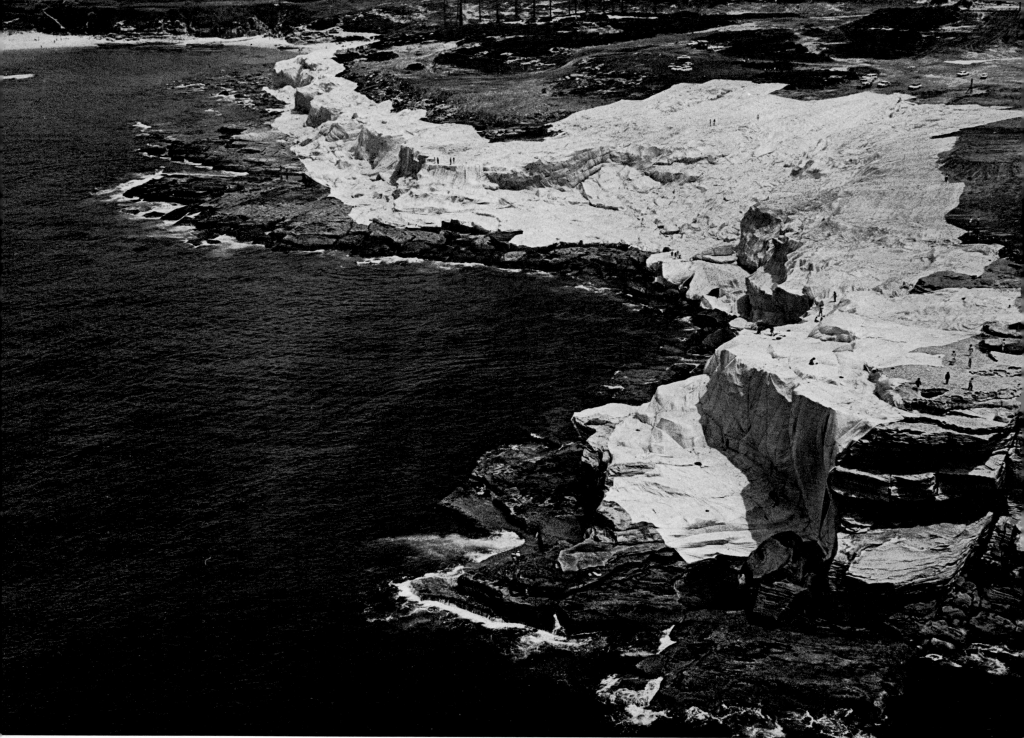

292

292. Aerial view
293. The wrapping extended over boulders in the surf

293

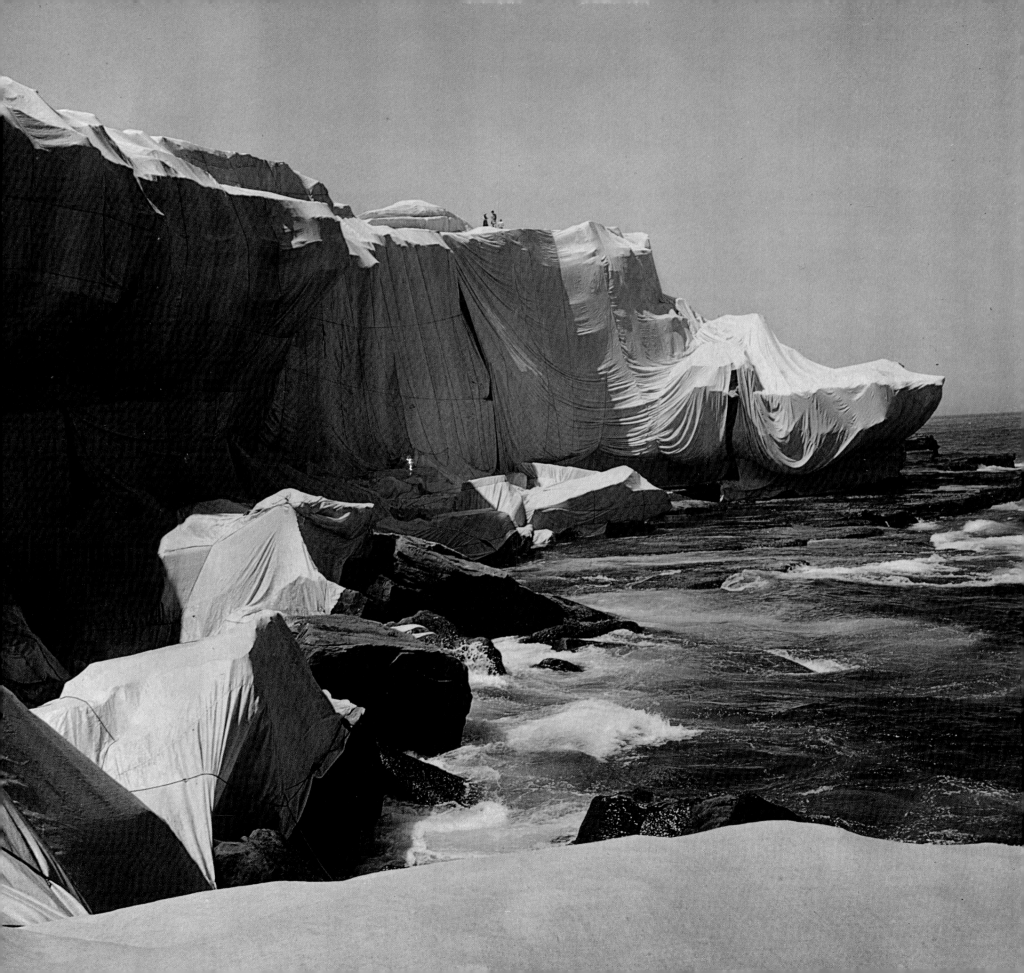

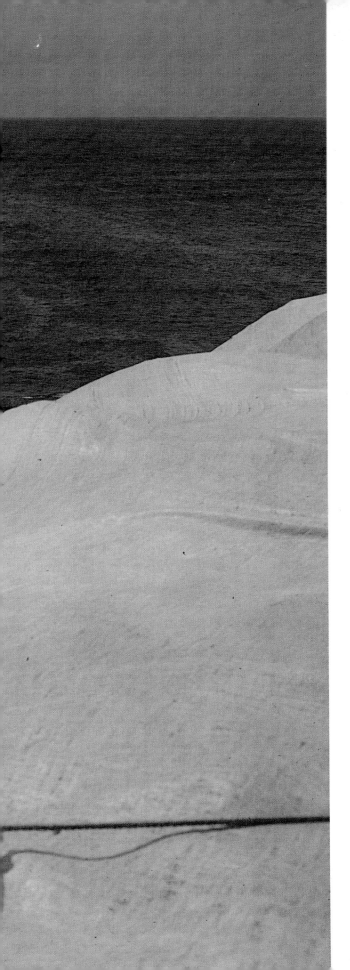

294. View from the south side of the
 gully
295. Sea-level view of Little Bay

295 (overleaf) ▶

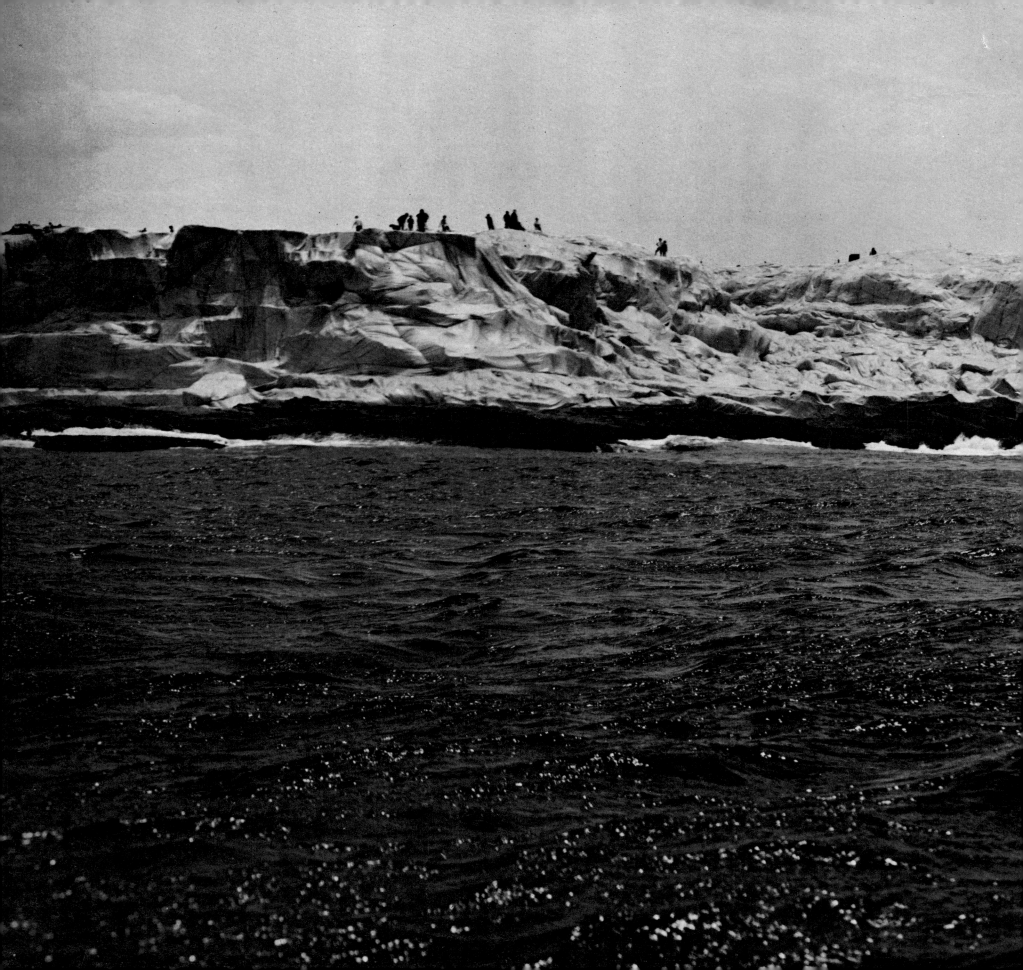

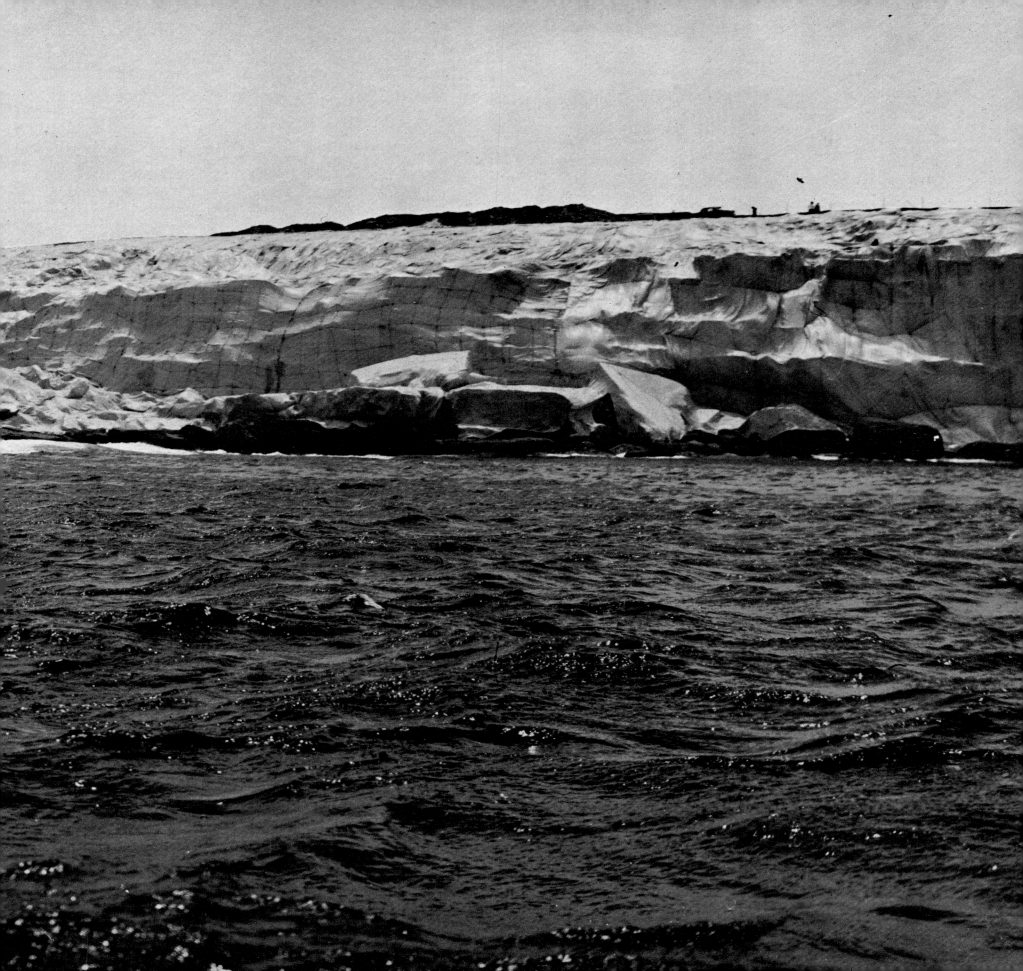

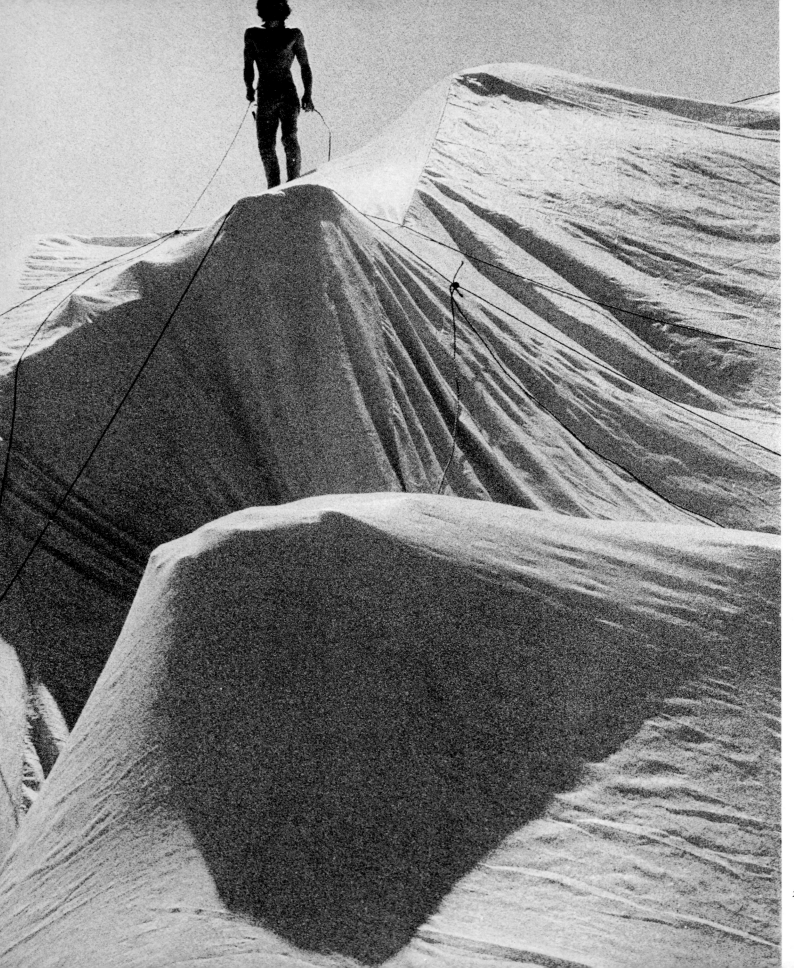

296. A worker ponders where to faste[n]
the ropes
297. Christo sometimes shouted direc[-]
tions from below

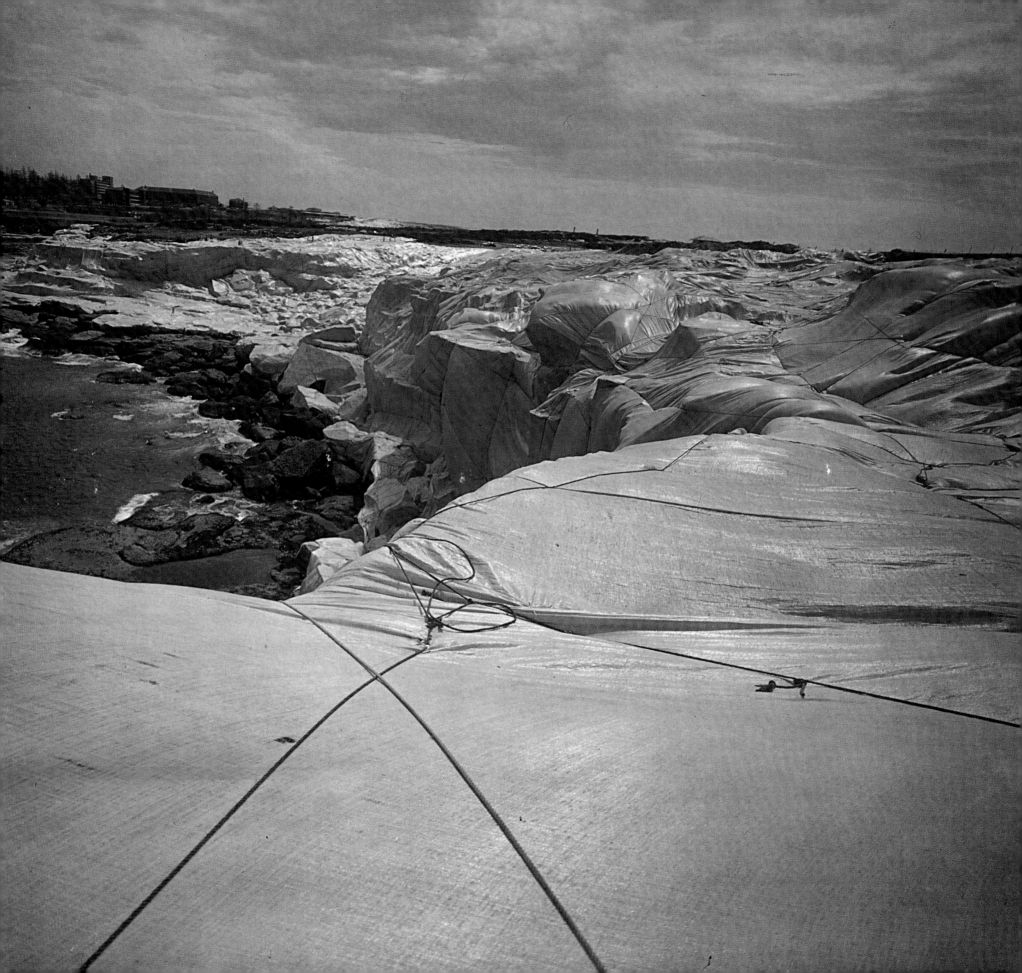

298. View from the 70-foot-high headlands near the northern end of the site
299. View from the adjacent "unwrapped" beach at the southern end of the site

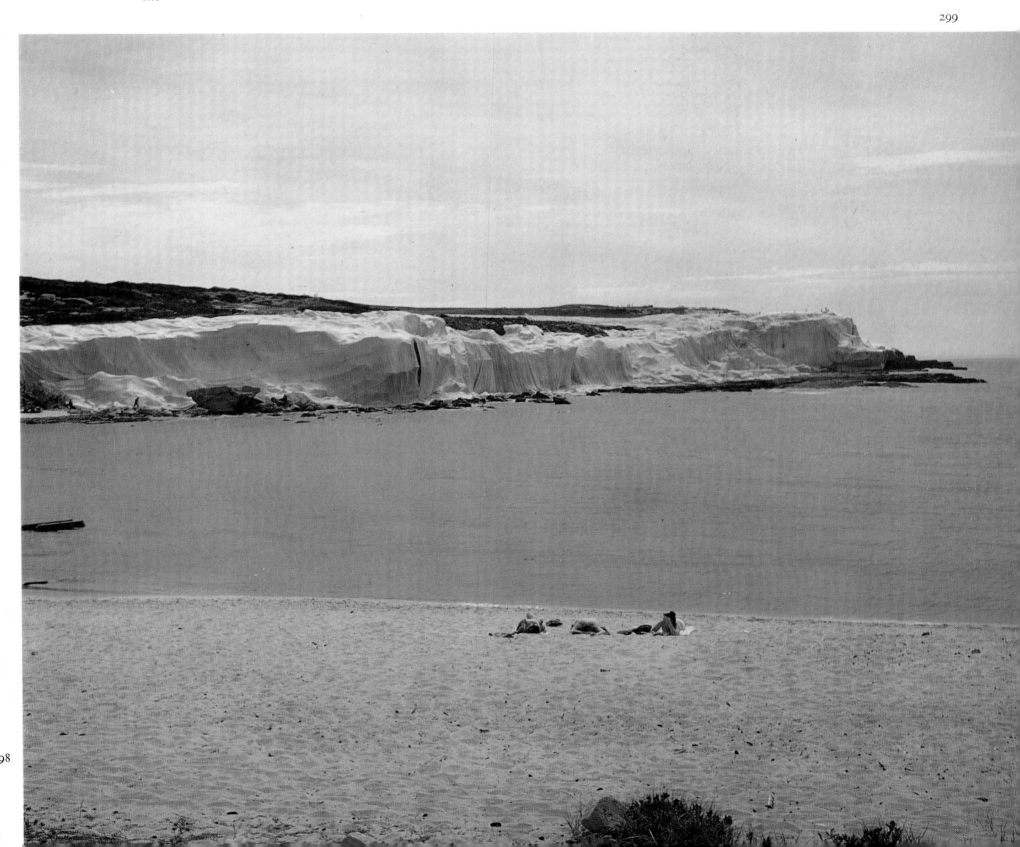

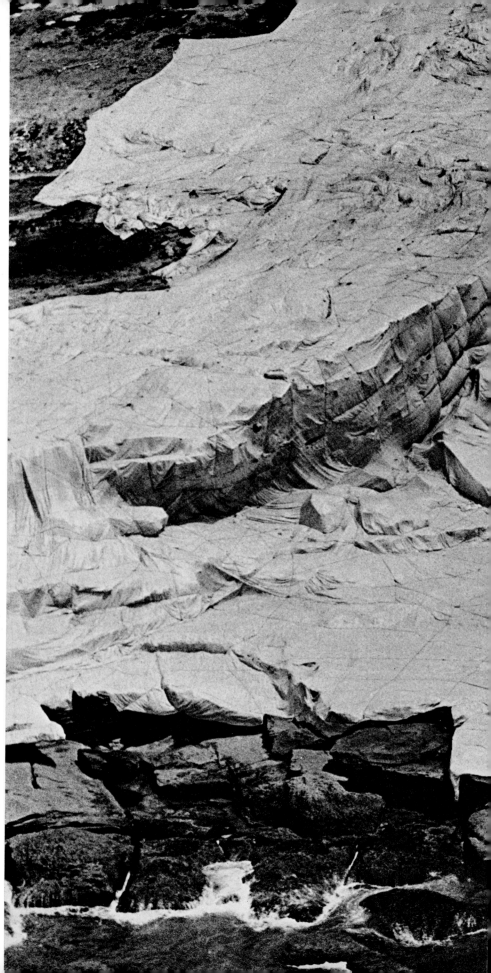

300. Aerial view
301. The rocks became partially unwrapped at low tide
302. Detail of the gully area, showing (in foreground) how rope was at-
 tached by steel fasteners to the rock
303. A shirtless student suns himself on a clifftop overlooking the gully and
 the northern end of the site
304. Aerial view of the completed package with suburban Sydney in the
 background. The wrapping was completed October 28, 1969, and
 remained in place until December 10, 1969

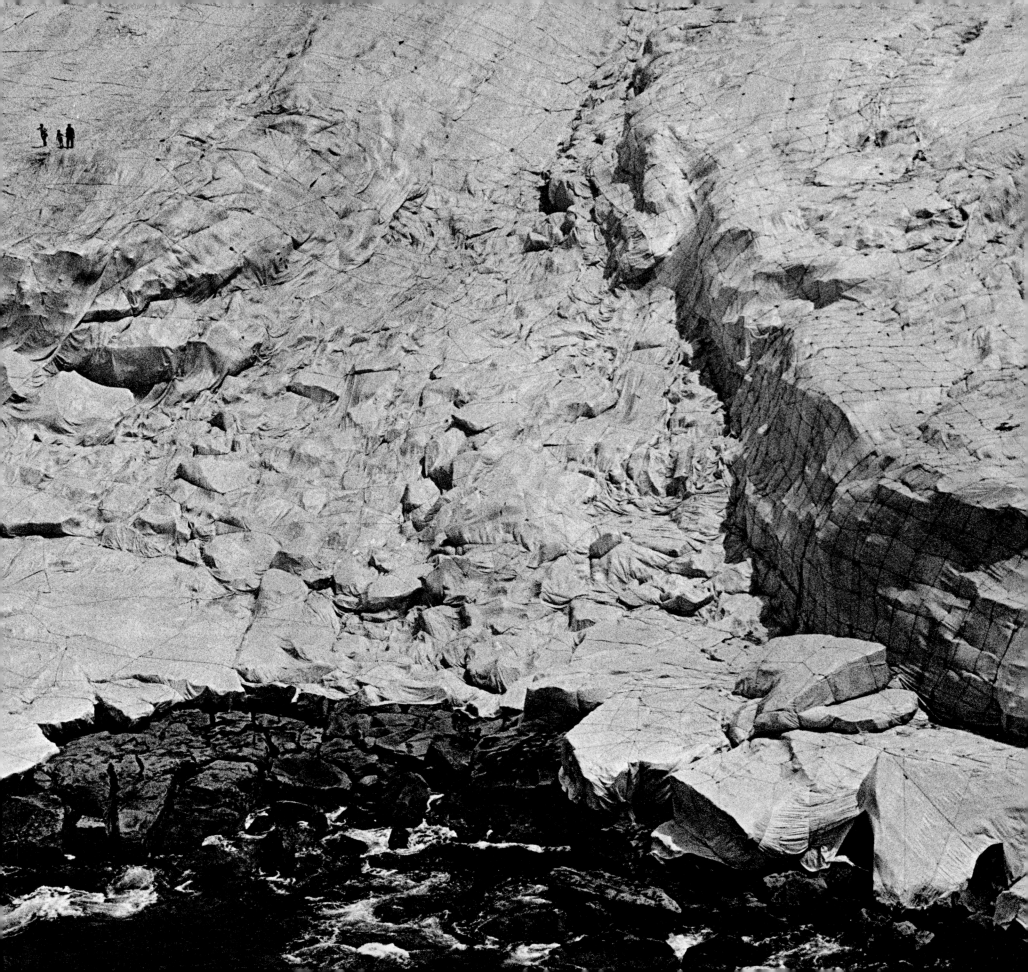

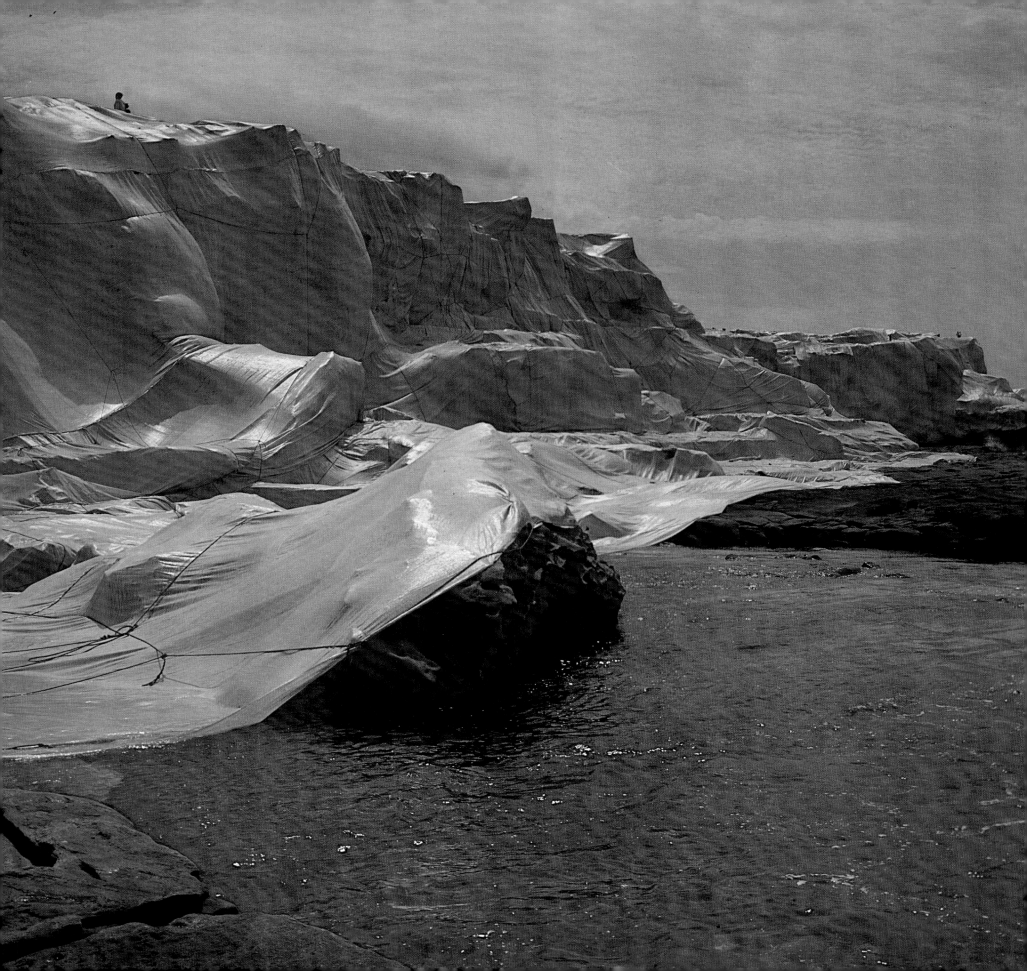

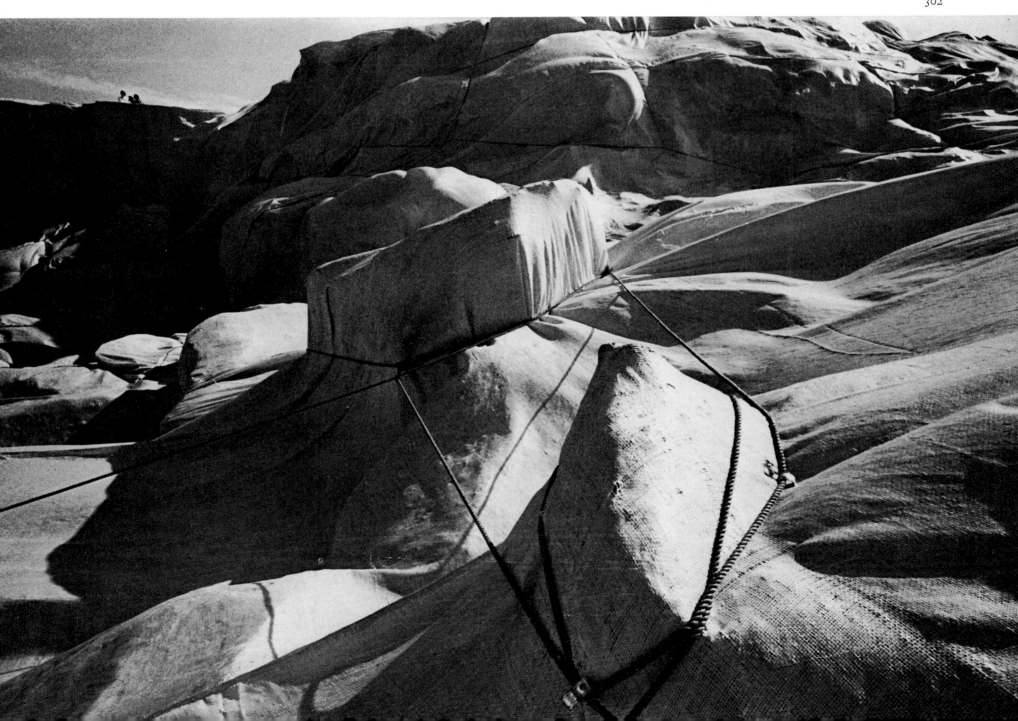

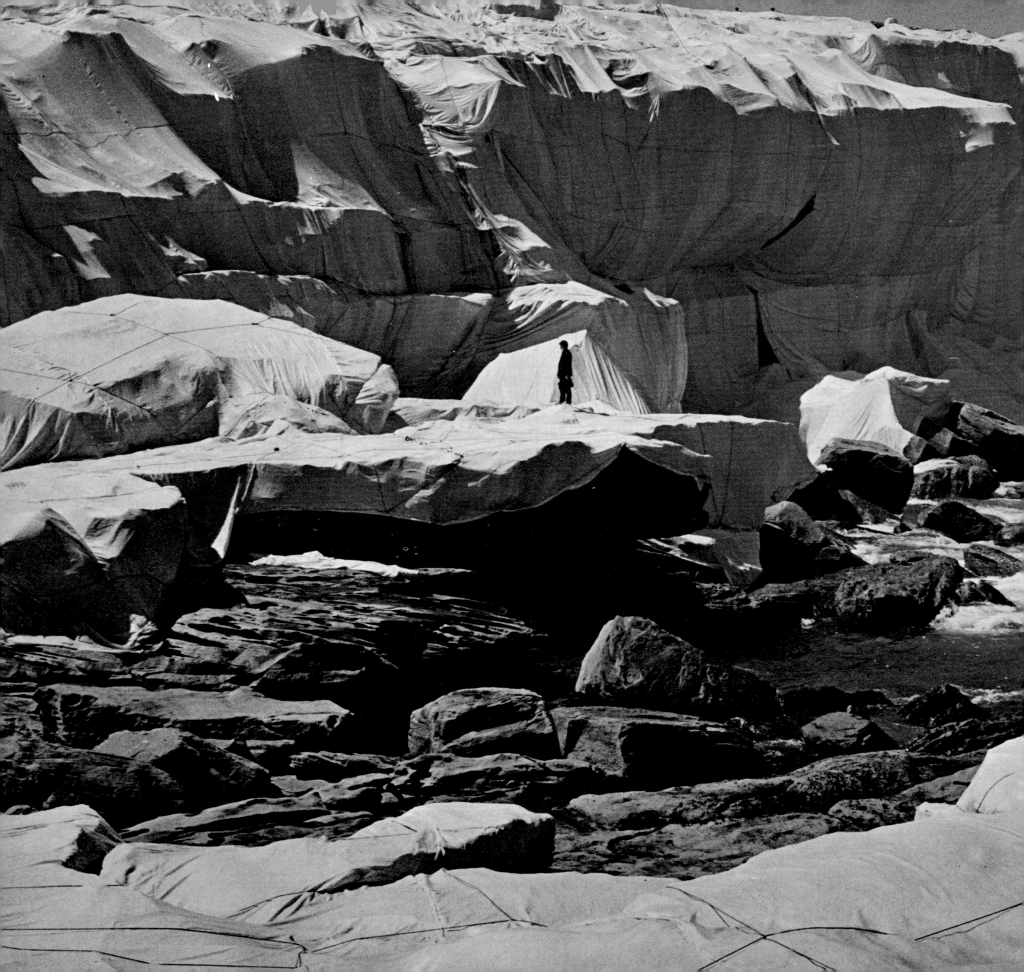

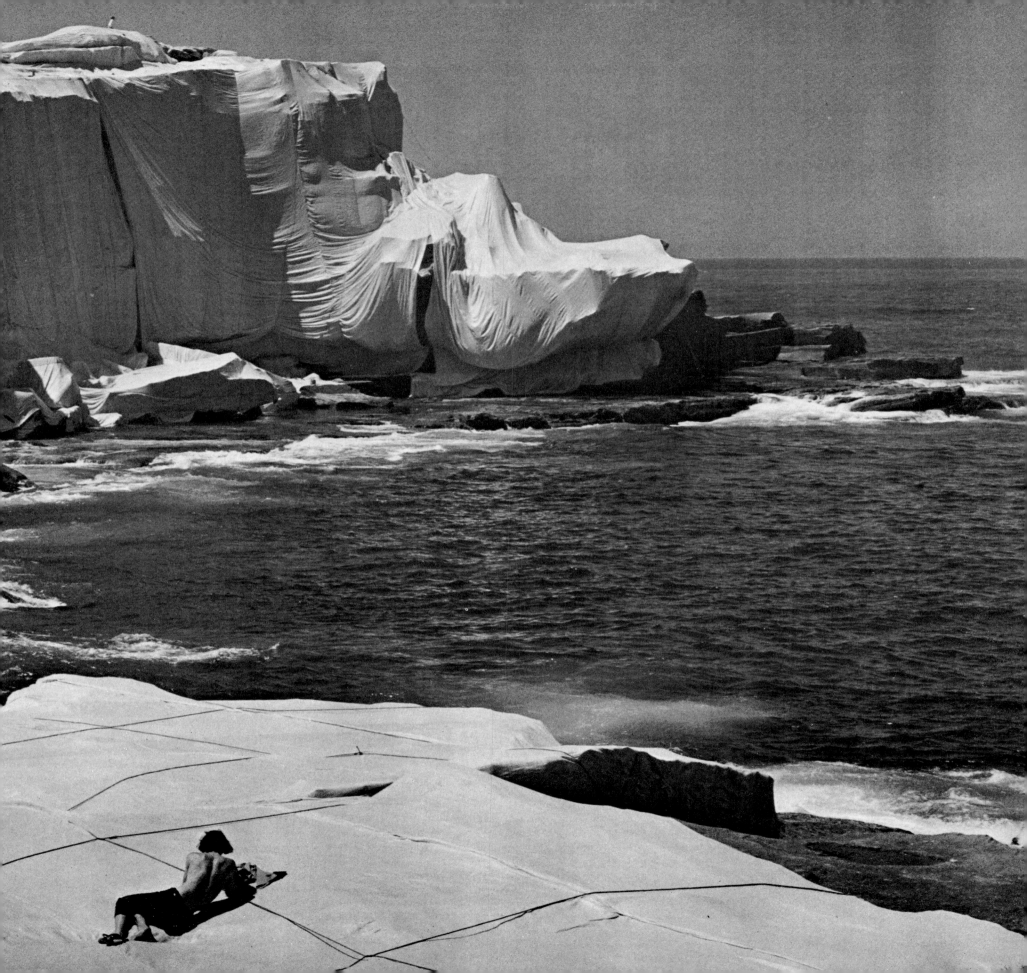

SELECTED BIBLIOGRAPHY

"All Package," *Time* (February 7, 1969).

Alloway, Lawrence. Introductory essay in *Christo*, catalogue of the exhibition at the Stedelijk van Abbemuseum, Eindhoven, The Netherlands, 1966. Contains bibliography.

————. "Christo and the New Scale," *Art International*, Lugano, vol. (September 20, 1968).

————. *Christo*, New York: Harry N. Abrams, Inc., 1969. Contains biography and extensive bibliography.

Ball, Ian. "Christo the Wrapper," *Daily Telegraph Magazine*, London 12, no. 7 (March 27, 1970).

Bekaert, Geert. "Gesprek met Christo," *Streven*, Antwerp (January, 1969).

Bourdon, David. "Christo's Store Fronts," *Domus*, Milan, no. 435 (February, 1966).

————. "Christo," *Art and Artists*, London (October, 1966).

————; Hahn, Otto; Restany, Pierre. *Christo*, Milan: Edizioni Apollinaire, 1966. Contains extensive bibliography.

Brook, Donald. "The Little Bay Affair," *Art and Australia*, Sydney (December, 1969).

Buzzati, Dino. "I Pacchi di Christo," *Corriere d'Informazione*, Milan (June 26–27, 1963).

Christo: 5,600 Cubic Meter Package, Munich: Verlag Wort und Bild, 1968. Technical texts by Professor Richard Tröstel and Dimiter S. Zagoroff.

Christo: Wrapped Coast, One Million Square Feet, Minneapolis, Minnesota: Contemporary Art Lithographers, 1969. Photographs by Shunk-Kender. Contains maps and technical data.

Gleeson, James. "Wrapping for a New Awareness," *Sun-Herald*, Sydney (July 13, 1969).

Gruen, John. "Christo Wraps the Museum," *New York Magazine* (June 24, 1968).

Hahn, Otto. "Christo's Packages," *Art International*, Lugano, vol. 9, no. 3 (April, 1965).

"Leerer Laden," *Der Spiegel*, Hamburg (August 12, 1968).

Lippard, Lucy R. *Pop Art*, New York: Frederick A. Praeger, Inc., 1966

Prokopoff, Stephen S. Introductory essay in *Christo: Monuments and Projects*, catalogue of the exhibition at the Institute of Contemporary Art, University of Pennsylvania, Philadelphia, 1968. Reprinted in *Art and Artists*, London (April, 1969). Contains extensive bibliography.

————. Preface in *Le Docker et Le Décor*, brochure of the exhibition at Galerie J, Paris, 1962.

————. Preface in *Pacco-Monumento di Christo*, brochure of the exhibition at Galleria Apollinaire, Milan, 1963.

Restany, Pierre. Preface in *Christo et Ses Alignements*, brochure of the exhibition at Galerie Haro Lauhus, Cologne, 1961.

————. "Un giovane neo-realista a Parigi," *Domus*, Milan, no. 402 (May, 1963). Also printed in *Nieuwe Realisten*, Gemeente Museum, The Hague, 1964. Contains biography, list of exhibitions, and bibliography.

————. "Les Store-Fronts de Christo: Une Architecture-Sculpture du Nouveau Réalisme," *Domus*, Milan, no. 435 (February, 1966).

Rubin, William S. Preface in *Christo Wraps the Museum*, brochure of the exhibition at the Museum of Modern Art, New York, 1968.

————. *Dada and Surrealist Art*, New York: Harry N. Abrams, Inc., 1969.

Schulze, Franz. "Why the Wrap-In?" *Panorama—Chicago Daily News* (January 25, 1969).

Trini, Tommaso. "Pneu-Reality," *Domus*, Milan, no. 467 (October, 1968).

————. "Wrapped Coast in Australia," *Domus*, Milan, no. 483 (February, 1970).

Van der Marck, Jan. "Christo," in *Eight Sculptors: The Ambiguous Image*, catalogue of the exhibition at the Walker Art Center, Minneapolis, Minnesota, 1966. Contains biography and selected bibliography.

————. "The Minneapolis Package: un pacco d'aria," *Domus*, Milan, no. 448 (March, 1967).

————. "Why Pack a Museum?" *Arts Canada*, Toronto (October, 1969).

————. Essay in *Christo*, catalogue of the exhibition at the National Gallery of Victoria, Melbourne (October, 1969). Contains biography and list of exhibitions.

PHOTO CREDITS

The illustrations in this book were made from photographs taken by the following photographers: Klaus Baum, René Bertholo, Ferdinand Boesch, Balz Burkhard, Thomas Cugini, Giacomelli, Harry Gruyaert, Anthony Haden-Guest, Carroll T. Hartwell, Ab de Jager, Jeanne-Claude Christo, Jacques-Dominique Lajoux, Ugo Mulas, Raymond de Seynes, Shunk-Kender, Charles Wilp, Harvey Zücker.